Twentieth-Century Design

Oxford History of Art

Jonathan M.Woodham has been involved with the development of design history as an area of academic study in Britain for many years. He is Professor in the History of Design at the University of Brighton, a leading centre for study and research in the field, where he is also Director of the Design History Research Centre. His publications include *Twentieth-Century Ornament: Decoration from 1900 to* *1990*, and he currently serves on the editorial boards of the *Journal of Design History* (OUP) and *Design Issues* (MIT). He is also chair of the Design History Society. He has been invited to contribute lectures and seminar presentations at home and abroad, including France, Italy, the United States, Russia, and Poland. He lives in Brighton with his wife and two sons.

Oxford History of Art

Twentieth-Century Design

Jonathan M. Woodham

OXFORD

UNIVERSITY PRESS

OXFORD

UNIVERSITY PRESS

Great Clarendon Street, Oxford OX2 6DP

Oxford New York

Auckland Bangkok Buenos Aires Cape Town
Chennai Dar es Salaam Delhi Hong Kong Istanbul Karachi
Kolkata Kuala Lumpur Madrid Melbourne Mexico City Mumbai
Nairobi São Paulo Shanghai Taipei Tokyo Toronto
Oxford is a registered trade mark of Oxford University Press
in the UK and in certain other countries

Oxford is a trade mark of Oxford University Press

© Jonathan M. Woodham 1997

First published 1997 by Oxford University Press

British Library Cataloguing in Publication Data
Data available

Library of Congress Cataloguing-in-Publication Data
Data available

ISBN 0–19–284204–8 Pbk

10 9 8 7

Picture Research by Elisabeth Agate
Designed by Esterson Lackersteen
Printed in Hong Kong
on acid-free paper by
C&C Offset Printing Co. Ltd

Contents

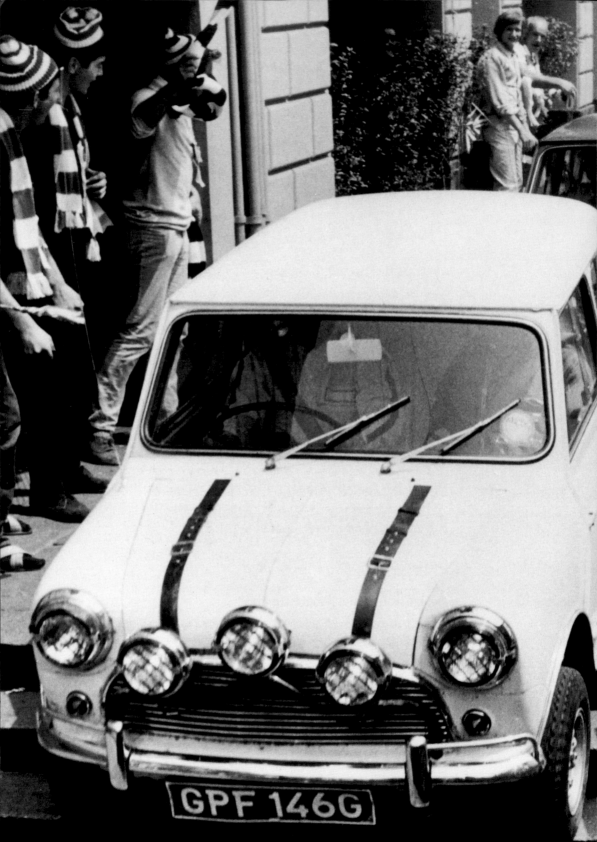

Introduction

The writing of a comprehensive single volume on the history of twentieth-century design is a daunting prospect, not simply in terms of the seemingly limitless range of products and associated meanings from which such a text might be fashioned but also in terms of the considerable geographical scope which might be encompassed. Changing centres of gravity of design activity, different and evolving national perspectives, imperial trading mechanisms and their legacy, the operation of multinational corporations and the creation of global products all have a potential bearing on the ways in which design may be historically evaluated. Furthermore, during its comparatively brief life as an area of academic study, the history of design has regularly provided a forum for vigorous debates about appropriate methods and approaches.[1] Its focus has shifted quite dramatically from the cultural high ground, where individual designers, style, and aesthetic significance were dominant considerations, onto the texture of everyday life in which far greater emphasis is placed on the role and behaviour of the consumer and user.

The values that were embraced by Nikolaus Pevsner's seminal text, *Pioneers of Modern Design: From William Morris to Walter Gropius*, first published in 1936,[2] now have a very dated feel, although it is a text which has undergone a number of key revisions and many reprints. As the publicity for the 1977 edition of the text proclaimed,

Sir Nikolaus Pevsner tells the exciting story of how the efforts of a relatively small group of men lifted our visual concepts away from stale Victorian Historicism and infused them once more with honesty, fitness of purpose and contemporary expression. He shows how the foundation of the best that surrounds us today was laid then by men who thought and taught as well as designed.[3]

Since the first publication of *Pioneers* more than sixty years ago the central focus of the history of design as a field of academic study has moved away from such explicit emphasis on the artistic creativity of celebrated individuals towards an evaluation of the wider social, economic, political, and technological climate in which design has been made and used. Texts such as Siegfried Giedion's *Mechanisation Takes*

Command: A Contribution to Anonymous History,[4] first published in 1948, and Herwin Schaefer's *The Roots of Modern Design: The Functional Tradition in the 19th Century*[5] of 1970, were among those which posited alternatives to the Pevsnerian canon in their exploration of the social and cultural impact of anonymous, vernacular design. In the 1980s Adrian Forty published *Objects of Desire: Design and Society 1750–1980*,[6] further undermining the traditional acceptance of the dominance of the designer in many design-historical studies. Published at a time when contemporary designers were widely celebrated in the media, his book was generally criticized in the design press since his underlying thesis was that a historical understanding of an object's significance and value resided in a wide range of influences and ideas, a complex social and cultural mix in which the designer was seen as a relatively minor consideration—if, indeed, he or she could be identified at all. The stress conventionally laid on celebrated individuals came under attack from anthropologists as well as design historians. Arguing that an understanding of design in industrialized society involved an analysis of modern consumption, the anthropologist Daniel Miller concurred with Forty's demythologizing of the 'designer as creator of mass culture' in his 1987 book *Material Culture and Mass Consumption*.[7]

As the Pevsnerian prioritization of concepts such as 'the best' gave way to the consideration of the realities of mass-consumption and the meaning of objects in everyday life, design history had also begun to reconsider the implications of gender in its construction. Just as feminist art historians such as Anthea Callen and Griselda Pollock had questioned the criteria implicit in art-historical practice in the late 1970s and 1980s,[8] so several writers concerned with the history of design have turned their attention to the typecasting of women as producers in particular fields of design such as the crafts or textiles.[9] The significance of the often complex relationship between women, design, and the history of design is one which now informs an increasing number of studies in the field[10] and provides the impetus for a reconsideration of many facets of design-historical interpretations in the twentieth century.

There are several barriers to overcoming the many inherent difficulties in arriving at an understanding of the wider issues affecting design and its consumption in daily life, past and present. Not the least of these, as many aspects of this publication indicate, is the question of the ways in which potential historical sources have survived, whether in the archival repositories of individual designers and leading companies, the self-published and inevitably partial accounts of organizations, institutions, and related personnel, or, indeed, artifacts which have been selected for display in a museum or exhibition context. Such evidence, as will be suggested in instances such as the Bauhaus in

Germany, the Council of Industrial Design in Britain, and the construction of corporate identity in the 1950s, has tended to dominate historical perceptions, taking little account of the broader patterns of consumption, taste, and socio-cultural significance. Whilst a single volume dealing with major issues of twentieth-century design, its significance and study, cannot present a fully articulated interpretation of design in everyday life, it is hoped that a number of the inherent complexities will have been signalled; also that the text will serve both to inform the reader about major considerations and to set a possible agenda for future investigations.

By addressing a range of themes such as 'national identity', 'heritage and nostalgia', and 'Postmodernism' I seek to reveal the limitations of studying design in overly neat decades or movements. Particular objects or designs change their meanings when used or viewed in different periods and places: William Morris textiles and wallpapers in the late nineteenth-century upper-middle-class English home or their Arthur Sanderson's reprinted counterparts in 1980s Manhattan apartments in the United States; the baseball cap as worn by American sporting heroes in the 1920s or by Eastern European teenagers in the 1990s; porcelain tableware for the Imperial Hotel, Tokyo, designed by Frank Lloyd Wright in the early 1920s or its Tiffany & Co, New York, reissue of 1980. Contrastingly, there are many other designs which have been in production throughout the period and continue to sell steadily, free from the vagaries of style and fashion that have outwardly characterized the periods in which they have been purchased.

This volume is centred on the Western industrialized world, with an emphasis on the more affluent nations of Europe, the United States, Scandinavia, and the Far East. Its prime focus relates to design and industrialized culture within that world, although a number of complex issues have had to be omitted for reasons of space, as well as a lack of developed and published research in the field. These include the ways in which design may be seen to have been mediated by notions of multiculturalism and regionalism within nation states, the implications of peristroika and the demolition of the Berlin Wall for design and patterns of consumption in Eastern Europe, or even the cultural impact of the package holiday and global travel for the everyday consumer. It is to be hoped that the absence of these and similar considerations will stimulate further publications that will complement and critically enhance this investigative foray into the broader picture of twentieth-century design.

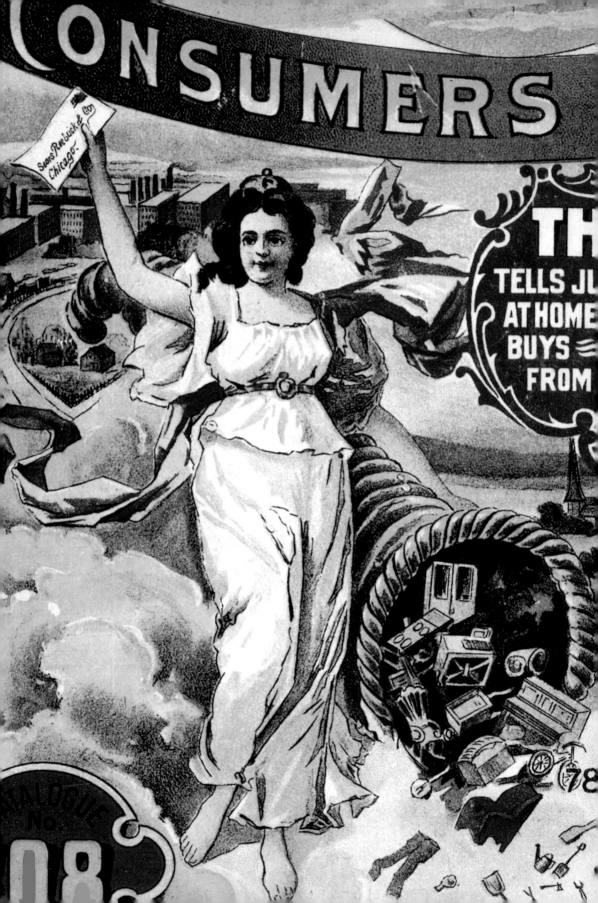

Towards the Twentieth Century

Detail of 2

1

During the nineteenth century manufacturers' relentless exploitation of new techniques and materials increasingly made accessible to middle-class consumers a wide range of objects with rich and elaborate decorative detailing in an encyclopaedic variety of historicizing styles. Superficially exuding a resonance of education and taste, such products had previously been the preserve of a cultural élite who often purchased furniture, furnishings, and domestic equipment which embodied the skills and virtuosity of individual craftsmen. This new class of widely available mass-produced goods was made possible through such processes as electroplating, stamping and moulding, and the exploration of materials such as gutta-percha, papier-mâché, or cast-iron which possessed rich possibilities for the imitation of more expensive and individually-produced artefacts and the lavish fabrication of decorative detailing.

Such designs were heavily criticized by many nineteenth-century critics, particularly in Britain by John Ruskin, William Morris, and Arts and Crafts followers, who not only viewed them as 'dishonest' through their 'inappropriate' use of materials and modes of construction, but also deplored what they felt were the dehumanizing consequences of industrialization for those involved in their manufacture. However, although such opinions, writings, and design practice aroused considerable interest amongst progressive designers and critics of the industrialization process in Europe and the United States in the later nineteenth century, their actual impact upon the majority of manufacturers involved in the mass-production of consumer goods was extremely limited.

By the closing years of the nineteenth century the significance of the various shifts in industrial power that had been taking place in Europe and North America for some time became increasingly apparent. Britain, once characterized as 'the workshop of the world', found her capacity for industrial innovation challenged not only by the United States, but also by a number of other countries including Germany. The latter, following her unification in 1871, had developed new steel, chemical, and electrical industries alongside the establishment of technical high schools which offered a positive educational

programme for engineers, manufacturers, and industrial managers. British concern about her own comparative trading position had been acknowledged in governmental circles since the early 1830s when Sir Robert Peel had attributed the decline in her exports to poor standards of design in British manufacture, a *cri de cœur* which has been voiced at times of significant economic crisis over the succeeding 160 years.[1] The superior industrial strategy of Germany and the United States was clearly identified in a Royal Commission of 1886, and by the turn of the century economic and industrial comparisons with these two countries were being made frequently in British journals and other publications. Furthermore, the twin concepts of Taylorism and Fordism developed in the United States in the early years of the twentieth century became highly influential throughout the industrialized world, and were important facets of her dominance in economic mass-production in the interwar years. Taylorism was a system which sought to achieve industrial efficiency on the factory floor. Devised by Frederick Winslow Taylor in the late nineteenth century through a series of 'time and motion' studies which broke down workplace activities into their most efficient constituent parts, it was documented in his *Principles of Scientific Management* of 1911. It was applied subsequently to several areas of human activity with consequent implications for design, such as in the planning of efficient, labour-saving kitchens and domestic equipment. Fordism related to Henry Ford's introduction of the moving assembly line for the Model T Ford automobile in 1913. Dramatically cutting down the time for car chassis production, it had obvious wider economic implications for standardized mass-production (and thus patterns of consumption) throughout the industrialized world.

By the early 1900s many of the key inventions which were to become fundamental to life in the new century were becoming increasingly available to the everyday consumer: electric lighting and domestic appliances; homogenizing communications media such as the telephone, the gramophone, and the cinema; and the automobile which also played a key role in bringing together rural and urban communities. Before long the radio and the aeroplane further transformed people's lives in terms of dissolving national and regional barriers.

Few progressive design theorists and practitioners managed to exert a significant impact in such areas prior to the First World War. However, there was a growing recognition of the importance of reconciling design thinking with the realities of mass-production technology if such an outlook was to have a significant bearing on everyday life. Amongst avant-garde design groups of the early twentieth century the Italian Futurists, founded by Filippo Tommaso Marinetti in 1909, were perhaps the most unequivocal in their embrace of the possibilities afforded by technological innovation and perceptions of the dynamism

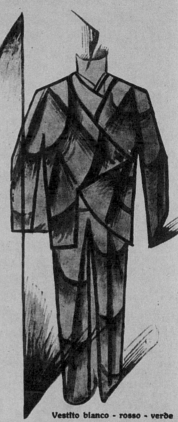

IL VESTITO ANTINEUTRALE

Manifesto futurista

Glorifichiamo la guerra, sola igiene del mondo.
MARINETTI.
(1° *Manifesto del Futurismo* - 20 Febbraio 1909)

Viva Asinari di Bernezzo!
MARINETTI.
(1° *Serata futurista* - Teatro Lirico, Milano, Febbraio 1910)

L'umanità si vestì sempre di **quiete,** di **paura,** di **cautela** o d'**indecisione,** portò sempre il lutto, o il piviale, o il mantello. Il corpo dell'uomo fu sempre diminuito da sfumature e da tinte **neutre,** avvilito dal nero, soffocato da cinture, imprigionato da panneggiamenti.

Fino ad oggi gli uomini usarono abiti di colori e forme statiche, cioè drappeggiati, solenni, gravi, incomodi e sacerdotali. Erano espressioni di timidezza, di malinconia e di **schiavitù,** negazione della vita muscolare, che soffocava in un passatismo anti-igienico di stoffe troppo pesanti e di mezze tinte tediose, effeminate o decadenti. Tonalità e ritmi di **pace desolante,** funeraria e deprimente.

OGGI vogliamo abolire:

1. — Tutte le tinte **neutre,** « carine », sbiadite, *fantasia,* semioscure e umilianti.

2. — Tutte le tinte e le foggie pedanti, professorali e teutoniche. I disegni a righe, a quadretti, a **puntini diplomatici.**

3. — I vestiti da lutto, nemmeno adatti per i becchini. Le morti eroiche non devono essere compiante, ma ricordate con vestiti rossi.

4. — L'equilibrio **mediocrista,** il cosidetto buon gusto e la cosidetta armonia di tinte e di forme, che frenano gli entusiasmi e rallentano il passo.

5. — La simmetria nel taglio, le linee **statiche,** che stancano, deprimono, contristano, legano i muscoli; l'uniformità di goffi risvolti e tutte le cincischiature. I bottoni inutili. I colletti e i polsini inamidati.

Noi futuristi vogliamo liberare la nostra razza da ogni **neutralità,** dall'indecisione paurosa e quietista, dal pessimismo negatore e dall'inerzia

Vestito bianco - rosso - verde portato dal parolibero futurista Cangiullo, nelle dimostrazioni dei Futuristi contro i professori tedescofili e neutralisti dell'Università di Roma (11-12 Dicembre 1914).

of modern city life. Although highly nationalistic, the Futurists firmly rejected the splendours of Italy's cultural past in favour of new advances in science and technology, embracing wholeheartedly the concept of change as an intrinsic aspect of their activities and ideology. Industrialization had made itself felt in Italy much later and more dramatically than in other European countries such as Germany, France, or Britain, where it had been evolving over a far longer period and it was not until after Italy's unification in 1861, when Rome became her capital a decade later, that the life and environment of the Italian city was radically altered. The most dramatic changes took place in the industrial north, which was the birthplace not only of Futurism but of many other avant-garde groupings far later in the century, of which the

best known were perhaps Studio Alchymia and Memphis: the first power station was constructed in Milan in 1883, and the first automobile factory opened in Turin in 1895. The racing car in particular was an important symbol of modernity for the Futurists, symbolizing speed and danger on the one hand, and, given the emergence of automobile racing at the turn of the century, a symbol of national pride and international competitiveness on the other. Although originally focused on literature and the fine arts, Futurist activity centred upon many other facets of contemporary life, including fashion [1], furniture, typography, interior design, architecture, cinema, photography, music, and the theatre. None the less, despite the apparent centrality of Futurism to twentieth-century life and undoubted influence on other avant-garde developments elsewhere in Europe prior to 1914, its significance for design was ultimately more symbolic than material.

The problematic legacy of the Arts and Crafts Movement

A number of design histories have laid particular emphasis on the impact of the Arts and Crafts Movement on progressive design thinking in the early years of the twentieth century.[2] In the years before the First World War the concerns of many of these theorists and practitioners were centred on a desire to bring about higher standards of design and aesthetic awareness, firmly allied to the economics of mass-production. However, their nineteenth-century predecessors, such as William Morris, had generally identified the mass-production process itself with the dehumanized working conditions prevalent in the majority of manufacturing industries. Their problem was how to marry, on a scale sufficient to provide affordable well-designed goods for the majority, the economics of mass-production to their requisite sense of the importance of job satisfaction and the 'joy of making' for the factory worker. They also relied upon the assumption that mass-consumers actually wanted to surround themselves with products which respected concepts such as 'truth to materials' and 'honesty of construction' and rejected the stylistic encyclopaedism which was the hallmark of most contemporary mass-produced goods. The realization that the overwhelming majority did not led design reformers and organizations throughout most of the twentieth century to lay the blame variously at the door of manufacturers, retailers, buyers, or the general public and, as corrective measures, to promote educational reforms in the visual arts, to mount didactic design exhibitions, to commission reports, to publish dedicated periodicals, and to utilize radio and television as media for 'elevating' public taste. Despite concerted moves in a number of countries, particularly Germany, to instil a greater awareness of the economic potential of design in the national and international marketplace, the resultant visible impact was largely restricted to the output of specific design workshops, particular displays at national

and international exhibitions, and the more abstract realms of ideological debate rather than in the output of the vast majority of factories producing consumer goods.

Retailing before 1914

By 1900 advertising agencies in the United States such as J. Walter Thompson, founded in New York in 1864, and N. W. Ayer & Son, founded in Philadelphia in 1869, had done much to help stimulate consumer demand and create desires, and their influence was reflected in the increasing sophistication of marketing techniques in Europe. Changes in retailing practice effected similar changes through the growth of department stores in the second half of the nineteenth century: the Magasin au Bon Marché and Le Printemps in Paris, R. H. Macy in New York, and Marshall Field in Chicago, were early leaders in the field.[3] Such stores brought together under one roof the whole gamut of industrially produced goods and soon became socially acceptable venues for unaccompanied women to meet as well as shop without damaging their reputations. By the early years of the twentieth century department stores, centrally-heated and electrically-lit, were a feature of cities across the industrialized world: the new buildings for the Tietz department store (1898) in Berlin, À l'Innovation (1901) in Brussels, the Magazzino Contratti (1903) in Milan, La Samaritaine (1905) in Paris, and Harrods (1901/5) and Selfridges (1908) in London all typified this new breed. The department store shopper was generally offered a wide range of products which, although also subject to the particular nuances of contemporary ephemeral styling, embraced a considerable range and diversity of historic styles in their decoration. Such stores were generally the province of the more well-to-do sectors of society, and their history has been more fully addressed than that of retailing establishments geared to the needs of working people, partly on account of the fact that their buildings and interiors were often commissioned from well-known architects and designers and that their wares have often been considered subsequently by design historians, collectors, and museums as aesthetically more significant and thus more worthy of research and preservation.[4] However, more recently there has been a far greater interest in the wider historical significance of shopping, both in behavioural terms and its importance and meaning across a wider social spectrum.[5]

An important insight into patterns of taste in late nineteenth- and early twentieth-century everyday life is revealed in mail-order shopping catalogues, an innovation which commenced in the United States with Montgomery Ward Mail Order in 1872. The mail-order catalogue soon grew from its origins as a single sheet to a comprehensive illustrated book which provided the full range of domestic goods, furniture and furnishings, clothing, and equipment, giving rural com-

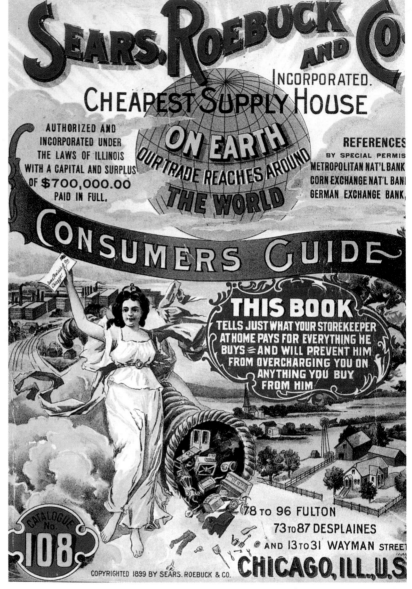

munities access to the more fashionable tastes of those living in the
major American cities. R. W. Sears produced his first mail-order cata-
logue in 1891, soon joining with Roebuck to form Sears Roebuck [2]. In
catering for the everyday needs of rural communities Sears Roebuck
and Montgomery Ward provided a potent challenge to the often
expensive general stores which were at the centre of such communities.
Often the largest book in the house other than the Bible, the mail-
order catalogue, or 'wish book' as it was often known, has been seen as
a guidebook to American living, one which also had a particular value
to immigrants as a means of achieving social conformity. Significantly,
both Montgomery Ward and Sears Roebuck were based in Chicago,

the centre of the American railway network. The tremendous growth of the railways, together with the modernization of the American postal system, ensured the overwhelming success of mail order and, by the outbreak of the First World War, consumers could purchase from catalogues almost anything from a complete house to a knife and fork, from a barn to the smallest item of agricultural equipment [3].

Mail order also developed on the other side of the Atlantic, thus providing the design historian with insights into wider patterns of consumption in Europe. In Germany, for example, the mail-order company of August Stukenbrok grew from its origins as a bicycle manufactury in 1890 to a powerful mail-order company which by 1914 was issuing more than a million catalogues per year.[6] Such catalogues, whether American or European, revealed a considerable predilection

3

Parlour Suites from the Sears Roebuck Catalogue, 1897

This page shows the rich variety of historicizing styles that purchasers across the United States were able to order for home delivery. The upholstering of the Turkish Parlor Suite (above) is 'in the latest design and patterns of imported goods' whilst the wooden-framed suite (centre), 'finished in imitation mahogany, a most desirable and attractive finish', has 'decorations in the way of hand carving [that] are decidedly unique and attractive'. The sheer range of styles and convenience of mail order purchase was very attractive to many consumers outside the larger cities.

for highly decorated products, particularly in the sphere of domestic furniture and furnishings. Cups and saucers, cutlery, glassware, door furniture, sewing machines, and countless other accoutrements of everyday living could be purchased in a plethora of styles drawn from a wide range of historic, cultural, and geographic roots. It was this widespread desire on the part of consumers for ephemeral styling or historicizing ornamentation and surface decoration that attracted the scorn of the design reformers of the early twentieth century. The latter sought increasingly to establish a design vocabulary and syntax which was compatible with the realities of modern mass-production technology, exploring the possibilities of new materials and forms which were infused with what they saw as the 'true spirit' of the twentieth century. However, such a radical shift away from the prevalent climate of historicism and the ephemerality of fashionable styling towards a set of attitudes which were receptive towards ideas about standardization and the establishment of product types was not without its own ideological problems even within more progressive circles, as will be discussed below.

The arts and crafts, design and industry: debates in Germany before 1914

Hermann Muthesius was one of the most important figures in design debates in Germany before 1914, providing a link between the Arts and Crafts Movement in Britain and the quest for a modern industrial design culture in Germany. Having been appointed as architectural attaché to the German Embassy in London in 1896, he came into contact with a number of leading British designers such as Charles Rennie Mackintosh and Walter Crane and wrote frequently about British architectural and design practice in reports, periodicals, and books, the best-known of which was the three-volume *Das Englische Haus* (*The English House*) of 1904/5. After returning to Germany in 1903 he was appointed to the Prussian Ministry of Trade and Commerce, and was charged with particular responsibility for art and design education. To forge stronger links between art and industry, he sought to reform education in the applied arts by placing a greater emphasis on workshop training. In order to facilitate such changes he influenced a number of key appointments: in 1903 Peter Behrens was made Director of the Düsseldorf School of Applied Arts, and Hans Poelzig Director of the Royal School of Arts and Crafts at Breslau; and in 1907 Bruno Paul was appointed to the Berlin School of Applied Arts. Muthesius' own appointment to the first Chair of the Applied Arts at Berlin Commercial University in 1907 caused a considerable furore. In his inaugural lecture entitled 'Die Bedeutung des Kunstgewerbes' ('The Significance of Applied Arts') he attacked German manufacturers for producing cheap and shoddy imitations of luxury goods, products

which he felt were exploiting the public's appetite for conspicuous consumption and stylistic fads rather than developing a set of values which respected materials and stood for quality. Muthesius sought to set a fresh agenda for modern design in German industry, which he saw as essential for economic success in the international marketplace. He argued that German goods ought to be recognized for their own positive characteristics of modernity, quality, and aesthetic excellence rather than as the poor, showy imitations of foreign goods which generally predominated. As a result Muthesius came under vociferous attack from many quarters, perhaps the most strident opposition coming from the Fachverband für die Wirtschaftlichen Interesse Kunstgewerbes (Trade Association for the Economic Interests of the Applied Arts), which had been founded in 1892 to promote the commercial interests of manufacturers in the applied arts. By 1907 the Fachverband, despite the comparatively recent date of its establishment, had become closely identified with traditional, conservative values in the applied arts and found its influence increasingly undermined by progressive thinking in the Werkstätten (Workshop) movement. The latter, through the bringing together of craft skills and artistic creativity in design production, sought to offer a fresh, well-designed alternative to the general mundaneity of everyday products. In fact a number of these workshops began to operate on a significant commercial scale, the most notable early examples being the Dresdener Werkstätten für Handwerkskunst (the Dresden Workshop for the Arts and Crafts) and the Munich-based Vereinigte Werkstätten für Kunst im Handwerk (the United Workshops for Art in Crafts), both of which were founded in 1898. By the early years of the new century the scope of their activity, which included ceramics, furniture, fitments, textiles, and other fields of design, embraced simple forms, a sense of practicality, and an appropriate use of materials closely allied to an understanding of the realities of production processes. By about 1902 Jugendstil (the German variant of Art Nouveau), which in the closing years of the nineteenth century had seemed to offer avant-garde artists and designers a vibrant alternative to the historicism of the artistic establishment, was superseded by a desire to explore an aesthetic which, through its appropriateness for machine production, could provide quality goods at a competitive price—at least for an educated middle-class clientele.

The Third German Applied Arts Exhibition, which was mounted in Dresden in 1906, marked a significant change in German design reform. In contrast with the two previous exhibitions, where manufacturers and organizations had been able to buy space and thus retain control over what was displayed, a selection committee was established in order to ensure that only artists and designers with modernizing tendencies were shown. In seeking to demonstrate that high standards

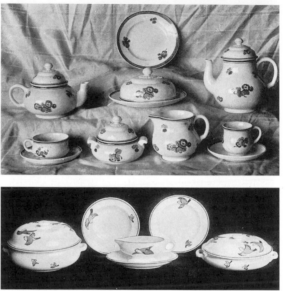

in design were potentially important dimensions of German social, cultural, and economic reform, the 1906 exhibition provided the impetus for the foundation of the Deutscher Werkbund (DWB) in Munich in October 1907.

Championed by the liberal-democratic politician Friedrich Naumann and Karl Schmidt, founder of the Dresdener Werkstätten für Handwerkskunst, the DWB sought to bring together artists and industrialists to improve the quality and design of German consumer products as part of the wider impetus to social, cultural, and economic reform. There were already in existence a number of organizations which also sought to bring about such reforms in Germany but the DWB had a more sharply defined membership, one which was restricted to those directly involved with furthering its aims.[7] Boasting 45 branches of local Werkbund groups, by 1914 its membership stood at 1,870, which ensured its significance and influence as a campaigning organization. As well as organizing symposia and mounting exhibitions, the DWB produced a wide range of propagandist pamphlets and other publications. The most significant of these were its Yearbooks which commenced publication in 1912, achieving sales of 20,000 by 1914.

Despite its prominence in accounts of German design of before the

First World War, the DWB was not an unqualified success: its impact upon the German consumer goods industry was limited, except in fields such as electrical appliances where the range of precedents was restricted. There was also considerable internal debate about the relative importance of standardization for modern German design, which came to a head in 1914 when two of the DWB's leading figures, Henry Van de Velde and Hermann Muthesius, clashed on ideological grounds. These had been simmering below the surface almost since the organization's founding in 1907. Muthesius, who even at the time of the 1906 Dresden Exhibition had been wary of the restrictions which a commitment to artistic individuality would impose upon German industry, argued that significant economic success linked to quality in manufacture could only be achieved through the adoption of forms which were compatible with mass-production. Van de Velde, on the other hand, felt that artistic creativity and freedom of expression was being strait-jacketed by economic, industrial, and political interests and that aesthetic quality in manufacture could only be brought about through artistic patronage. Such radically differing viewpoints were not new in DWB circles and had much to do with attempts by Van de Velde and his sympathizers to reassert the importance of the artist at the core of Werkbund policy. They sought to engineer a change in

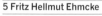

5 Fritz Hellmut Ehmcke

Deutscher Werkbund cigar box, 1914

The striking clarity of this packaging and typographic design reflects the more progressive strand of the Werkbund outlook just before the First World War. It may be seen as a two-dimensional counterpart to Walter Gropius's Model Factory and Administration Buildings at the 1914 Cologne Exhibition which have tended to dominate accounts of early modernism in twentieth-century design. Ehmcke also designed a number of publications and posters for the Werkbund at this time and, in 1918, the organization also published his *Amtliche Graphik*, a strong critique of graphic design commissioned by the State.

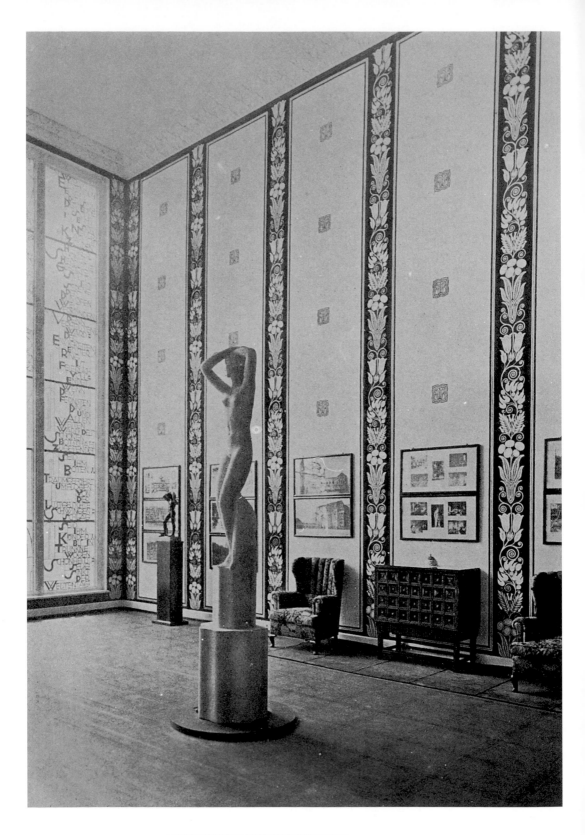

6

The Hamburg Room at the
Deutscher Werkbund
Exhibition at Cologne, 1914
As seen in the stoneware in
4, this room setting of goods
produced by leading Hamburg
manufacturers reveals the
considerable stylistic diversity
at the 1914 exhibition even in
progressive circles, including
furniture by J. D. Heyman,
decorative glass for a staircase
at the Hamburg School of Art
& Design, and hand-printed
wallpaper designed by C. O.
Czeschka, and the *Anchor*
pattern linoleum designed by
Bruno Paul.

leadership, although ultimately the membership as a whole preferred to ensure that the wider goals of the Werkbund would not be jeopardized by a fundamental rift in ideology at this stage of the organization's evolution.

A key event in the history of the DWB prior to the First World War was the mounting of a major exhibition in Cologne in 1914 which sought to put forward in material form the organization's achievements and outlook. In almost a hundred buildings, there was on show a tremendous range of both crafts-based and industrially produced design [**4**, **5**]. Although the appearance of many of the products and buildings endorsed a predominantly functional aesthetic, there was none the less quite a profusion of styles and approaches on show [**6**]: something of the neo-Baroque was evident in Paul Ludwig Troost's dining-room in the Bremen-Oldenburg House, reminiscences of Jugendstil in Van de Velde's Theatre and furniture, Neoclassicism in Behrens's furniture for the German Embassy in Leningrad, and Expressionism in Bruno Taut's Glass Pavilion, all of which contrasted strongly with the clean, functional, modern lines of Walter Gropius's Administration Building and Model Factory. None the less, it is the latter that have often been heavily emphasized by design historians in order to illustrate the positive achievements of the Cologne Exhibition and its significance in the genesis of modernism.

Peter Behrens and the Allgemeine Elektrizitäts Gesellschaft (AEG)

There were some notable instances where a progressive design outlook was adopted in German industry, most significantly in relation to the newly established electricity industry for which consumer products were not unduly tied to traditional formats. Manufacturers Siemens and AEG were the leaders in the field, being involved in all aspects of electricity from the construction of power stations to the manufacture of lightbulbs. Continuing in the company's enlightened policy in the employment of a number of leading architects and designers, Peter Behrens was appointed as design adviser to the AEG company in June 1907 and soon imposed a strong visual coherence for the company. This commenced with graphics, but further evolved through AEG buildings, appliances, shops, workers' housing, and other elements, which resulted in a strikingly modern corporate identity. This emphasis on a coherent aesthetic which was manifest in all aspects of the company's work was an important ingredient in market penetration at home and abroad [**7**]. Behrens's earliest product design work for the company was centred on the design of arc lamps, which were given clean efficient lines, an approach which he carried through into other product ranges such as electric kettles [**8**], fans, clocks, and domestic heaters. Because of the scale of its manufacturing base and the fact that the majority of

the AEG's products were being developed for new markets which were not dominated by design precedents, the company was able to impose its aesthetic outlook upon consumers in ways that older craft-based industries were unable: their products had strong roots in traditional forms and decoration, being largely responsive to consumers' anticipated expectations and aspirations.

Progressive design tendencies elsewhere in Europe

The German avant-garde was not alone in being influenced by the ideals of British Arts and Crafts writers and practitioners, many of whose work and beliefs were transmitted by the periodical *The Studio*, which was founded in 1893 and soon enjoyed an international readership. In Austria, for example, the Wiener Werkstätte (Vienna Workshops) was founded in 1903 by Josef Hofmann and Koloman Moser who much admired the simplicity of form inherent in the work of the British designers C. R. Ashbee (and his Guild of Handicraft) and Charles Rennie Mackintosh. The roots of the Wiener Werkstätte lay also in the late nineteenth-century Secessionist movement which was formed in opposition to the conservative values of the art establishment and which also extended its interests to the applied arts. Through participation in exhibitions and articles in periodicals featuring the applied arts the Werkstätte soon attracted international attention in progressive design circles, establishing a reputation for work in the textile, wallpaper, ceramic, jewellery, and furniture fields.

7 Peter Behrens
AEG Showroom, Berlin, *c.*1912
Behrens's appointment as artistic adviser to the AEG company in June 1907 marked a new direction in corporate policy, reflecting the company's desire to bring together art and industry in a modern industrial context. Much in line with the ideals of the Deutscher Werkbund, founded four months later, the adopted aesthetic embraced qualities which were attuned to progressive design thinking of the time: simplicity, efficiency, modernity, and advances in contemporary technology.

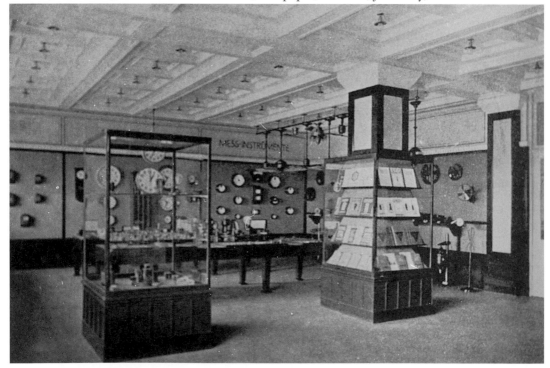

1912 brochure advertising nickel-plated and brass AEG Kettles, designed 1909

This illustration represents clearly Behrens's ideology, whether through the clear organization of the printed page, broken down into 'standardized' elements which, together, conveyed information in an efficient and integrated manner, or in the design of the kettles themselves. Following AEG's commitment to standardization in mass-production, Behrens's kettles could be produced in three basic forms (octagonal, half-oval, and cylindrical), in three finishes (brass, nickel-plated, or copper-plated), and three surface treatments. Variously combined, these offered consumers a wide range of choice at a competitive price.

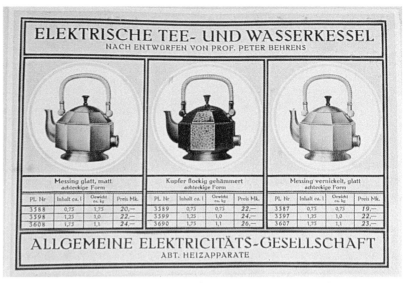

ELEKTRISCHE TEE- UND WASSERKESSEL
NACH ENTWÜRFEN VON PROF. PETER BEHRENS

Messing glatt, matt achteckige Form				Kupfer flockig gehämmert achteckige Form				Messing vernickelt, glatt achteckige Form			
PL. Nr	Inhalt ca. l	Oewicht ca. kg	Preis Mk.	PL. Nr	Inhalt ca. l	Oewicht ca. kg	Preis Mk.	PL. Nr	Inhalt ca. l	Oewicht ca. kg	Preis Mk.
3588	0,75	1,75	20,—	3589	0,75	0,75	22,—	3587	0,75	0,75	19,—
3598	1,25	1,0	22,—	3599	1,25	1,0	24,—	3597	1,25	1,0	22,—
3608	1,75	1,1	24,—	3690	1,75	1,1	26,—	3607	1,75	1,1	23,—

ALLGEMEINE ELEKTRICITÄTS-GESELLSCHAFT
ABT. HEIZAPPARATE

However, although over 100 craftsmen were employed within two years of its founding alongside an increasing emphasis on retailing outlets, its impact in terms of volume production and consumption by other than the wealthier sectors of society remained insignificant: industrialization in Austria was less developed than in Germany, France, and Britain, and the Werkstätte remained largely committed to the ethos of the artist-craftsman. The rectilinearity and simplicity of many of the designs in the earliest phase of the Wiener Werkstätte (which superficially appear to echo early twentieth-century German concerns for standardized forms and product types) were more significant for a symbolic, rather than actual, compatibility with the economic possibilities of modern industrial production.

In Britain the legacy of the Arts and Crafts endured for many years. Indeed, a respect for materials, concern for appropriate modes of construction, and a high premium on craftsmanship, can be discerned in much British design over the next half century or more, as in the furniture designs of Gordon Russell Ltd. in the 1930s or clothing, textile, and furniture designs produced under the Utility Scheme in the 1940s. However, in the early 1900s the difficulties of reconciling the ideals of producing well-designed goods at an affordable price with the economic realities of mass-production set the agenda for many years.

By the time of the Deutscher Werkbund's Cologne Exhibition of 1914 a number of British designers had begun to take note of the concerted attempts of Muthesius and others to bring about a closer relationship between design and industry. Harry Peach of the Dryad furniture company, the silversmith Harold Stabler, and the furniture designer and retailer Ambrose Heal were among those who visited the Cologne Exhibition, forming positive opinions about what had been achieved in Germany. Following the outbreak of war and the cessation

9 Edward Johnston

Signage for London Underground Electric Railways, post 1916

Johnston's *Railway* typography, commissioned by the highly influential design manager Frank Pick, marked a clear commitment to clean, easily read, and modern letterforms. After 1918 Johnston also redesigned the bar-and-circle motif which is now widely recognized as a key element in London Underground's corporate identity. Johnston worked for the company until 1933, the year in which Henry C. Beck's now classic underground map (a version of which is seen on the right of the illustration) was first printed.

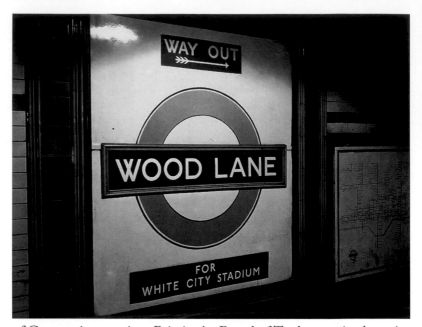

of German imports into Britain the Board of Trade organized a series of exhibitions of previously imported cheap German goods as potential exemplars for British industry to adopt. However, Peach, Heal, and others felt strongly that such exhibitions gave a false idea of the significant achievements made by certain sectors of German industry and sent a memorandum to that effect to the Permanent Secretary of the Board of Trade, Sir Hubert Llewellyn Smith, in January 1915. Their concerns resulted in the formation of the Design and Industries Association (DIA) in May of that year, a campaigning body of manufacturers, distributors, and designers which sought to instil in the general public 'a more intelligent demand . . . for what is best and soundest in design'[8] and to echo their belief that the 'machine enters to a greater or lesser extent into the making of all our products to-day'.[9] Despite such well-intentioned words, and the commitment of a small number of sympathetic educationalists, manufacturers, retailers, businessmen, and designers [**9**], the DIA's discernible impact upon the core of British manufacturing industry remained slight, a phenomenon which was also to be shared with post-First World War state-funded bodies such as the British Institute of Industrial Art, established in 1920,[10] and the Council for Art and Industry, set up in 1933.

Despite a number of initiatives such as the foundation of the Société de l'Art pour Tous in the early twentieth century there were no equivalents in France before the First World War to the Deutscher Werkbund in Germany or the DIA in Britain. However, the Société sought to promote a design aesthetic of simplicity, practicality, and everyday relevance, inspired by the outlook of British Arts and Crafts designers and theorists, publishing its own magazine. Despite a thriv-

ing membership of over 2,000 in the early 1900s, its impact as an effective campaigning body was slight. Ultimately little more successful was the Union Centrale des Arts Décoratifs which had been founded in the middle of the nineteenth century[11], seeking to forge links between industry and the arts under the slogan 'Beauty in Utility'. The Union was concerned to stimulate the production of better designed, high quality, affordable everyday products but, by the early 1900s, came under attack for its lack of commercial realism in the face of public taste, patterns of retailing, and the economics of mass-production. However, as in Britain, following the Deutscher Werkbund Cologne Exhibition of 1914 and the outbreak of the First World War, there were concerted attempts to reorganize French industry in order to compete more effectively with German industry after the war. In the years immediately preceding the war German imports had increasingly pervaded many aspects of daily life in France, and so in 1916 the state established the Comité Central Consultatif Technique des Arts Appliqués which looked to the Werkbund as a model for bringing about better standards of design in manufacturing industry. However, its founding remained more significant as a symbolic act of intent rather than the implementation of an effective programme of reform.

The more progressive tendencies in French design of this period were generally the province of the wealthier sectors of society, inclining towards the fine arts and high fashion where individual artistic expression flourished. Typifying such an outlook was the Société des Artistes Decorateurs, which was founded in 1901 to promote the decorative, industrial, and applied arts in France through the organization of exhibitions at home and abroad, together with the development of French design education. From 1907 the Société mounted annual exhibitions as a means of bringing new design ideas to the attention of the public, echoing the opportunities afforded by the annual shows of the Salon d'Automne (founded in 1903), which from 1906 had included a section devoted to the decorative arts. None the less, the inclinations of such groups leant towards the tastes of the more affluent sectors of the market where there was a strong emphasis on craftsmanship and quality, blended with a strong awareness of the heritage of the past. It was partly for this reason that a chill wind blew through the ranks of French designers in response to an exhibition of progressive German design by the Munich-based Vereinigte Werkstätten für Kunst im Handwerk at the Paris Salon d'Automne in 1910. Admired by a number of French critics for its simplicity, lack of ornamentation, and sense of co-ordination of furniture, furnishings, and room-settings, the French design world saw its compatibility with the ideology of mass-production as a threat to the belief in the freedom of artistic creativity untainted by the economics of the mass-market.

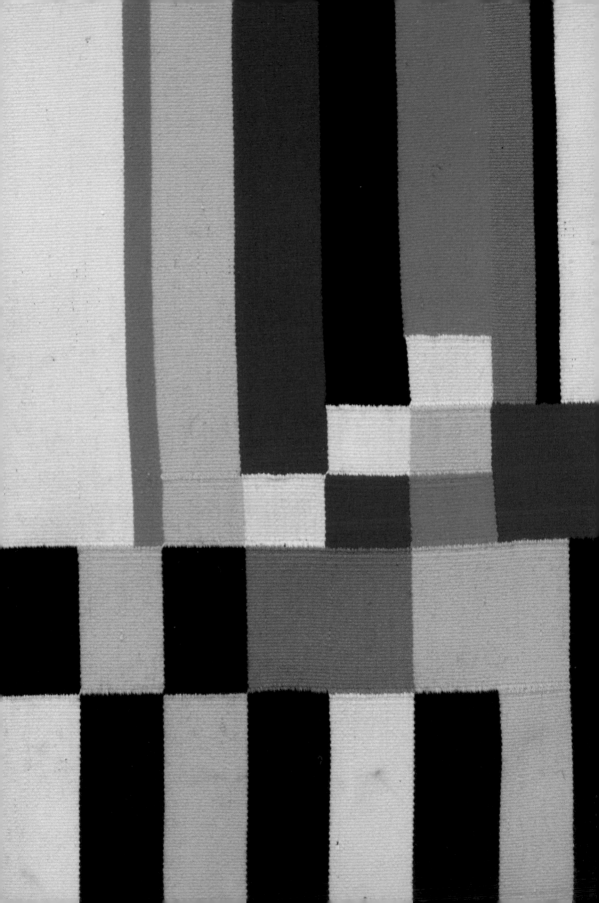

Design and Modernism

2

Modernism and the history of design

For several decades following the publication in 1936 of Nikolaus Pevsner's seminal text, *Pioneers of the Modern Movement*,[1] accounts of the history of twentieth century design were dominated by investigations into the Modern Movement and its antecedents in the design reform movement of the nineteenth century.[2] The reasons for this are historically and ideologically complex, and may be seen to derive from the widespread ready availability for historical analysis of the considerable legacy of the modernists' output. This has survived in terms both of design production and the written word, as evidenced in the collections of many leading museums, art libraries, and archives throughout the Western industrialized world. The long-standing ideological dominance of modernism has also been underpinned by moral and political connotations, given that many of its most vociferous opponents were closely associated with repressive regimes, such as those in National Socialist Germany and Stalinist Russia. The modernists saw themselves as the creators of a 'machine age' aesthetic truly redolent of the twentieth century which, freed from the shackles of historicism, explored new forms and materials that were felt to be symbolically, if not actually, compatible with the mass-production capacity of a progressive industrial culture[3] [**10**, **11**]. An additional consideration which has coloured more recent design-historical debates centred on modernism is the fact that much analysis has been predicated upon the theory and practice of celebrated individuals, with an emphasis on the celebration of aesthetic excellence. With the comparatively recent emergence of an interest in social anthropology and studies in material culture a significant number of scholars have sought to address the issues raised by wider patterns of design consumption and use.[4] Others have sought to reconsider modernism from a feminist perspective, raising important issues of professional and educational opportunity in the stereotyping of women within particular historical moments.[5]

Modernism: museums, archives, and libraries of art and design

The design legacy of many theorists and practitioners of modernism has been extensively preserved in museums and, through the very act of

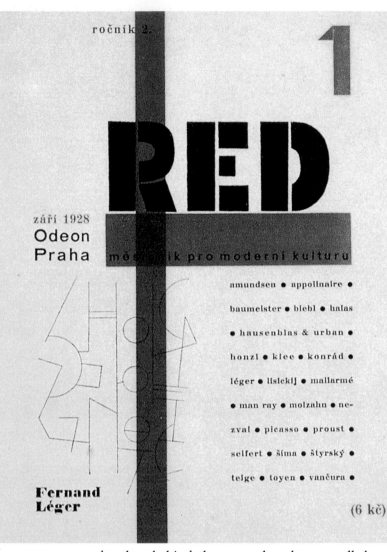

RED was the journal of the
Devetsil Group of avant-garde
artists, designers, architects,
and writers, founded in Prague
in 1920. Published by the
Odeon Press and edited by
the influential Karol Teige, it
was an important vehicle for
modernist ideas. The strong
horizontal and vertical bars,
stencil-like lettering of the
title, and the geometric
block of type ally this image
stylistically to progressive
developments in German and
Russian Constructivist design.

its exposure on pedestals or behind glass cases, has also generally been
viewed for its aesthetic qualities, divorced from any real sense of its
original everyday context and function. Such galleries and museums
have been powerful conditioning agents in the establishment of cul-
tural hierarchies. Perhaps the most celebrated example is the Museum
of Modern Art (MOMA) in New York. Established in 1929, it was
for many decades closely associated with the promotion of a 'Bauhaus
aesthetic'.[6] Its first specifically design-oriented show was the 1934
'Machine Art' Exhibition [12], organized by Philip Johnson, with an
emphasis on clean, geometric, and classic forms, symbolically and
materially attuned to new materials and modern mass-production
technology. Later in the decade, shows devoted to the work of Alvar
Aalto and the Bauhaus further consolidated MOMA's position as a
propagandist for the modern aesthetic, an association which was later

bolstered by Edgar Kaufmann's 'Good Design' exhibitions of the 1950s. Such an outlook became closely linked to the cultural imprint of the multinational corporation and what may be seen as the globalization of a very particular kind of modernist design culture. This became evident in many exhibitions and museum displays across the world, a theme which will be discussed in more detail in Chapter 6. Although self-evident, it is important to remember that such collections have been formed in the light of particular beliefs as to what was culturally significant at specific historical moments and that the high premium placed on aesthetic content necessarily distinguishes their exhibits from what was generally consumed, used, and experienced by the majority.

The modernist creed has also been reinforced by the constant production of avant-garde manifestos, magazines, and books in the early

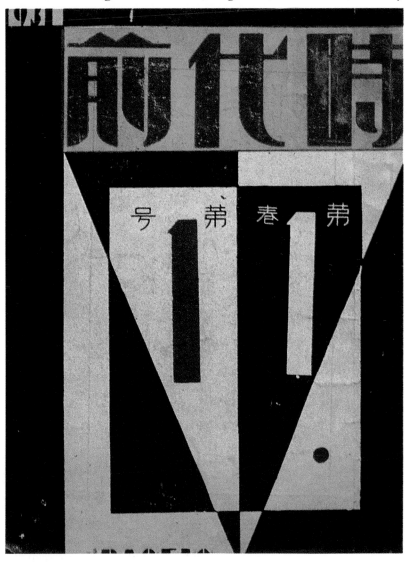

11 Qian Jun-tao

Ahead of the Times, published by Ahead of the Times Magazine Association, Shanghai, January 1931

During the 1920s and 1930s a significant number of Chinese designers, particularly those in the metropolitan centre of Shanghai, drew on influences from Europe and the United States, sustained by a widespread interest in western lifestyles. An increased commitment to the simplification of typographic form, blended with an interest in the functionalist symbolism of the arrangement of geometric elements on the page, echoed the exploration of abstract forms by western avant-garde designers. Qian Jun-tao was a leading figure in this progressive movement.

12

Installation view of the
Machine Art exhibition,
MOMA, New York, 1934

Held between 5 March and
29 April 1934, this exhibition
was curated by the arch-
modernist Philip Johnson.
Adopting a similar standpoint
to that explored by Herbert
Read in Britain in his book
Art and Industry, published
in the same year, Johnson
interpreted the functional
forms and materials of
aircraft propellers, industrial
insulators, and ball-bearings
in purely aesthetic terms.
Such emphasis on the clarity
of abstract form set MOMA
apart from the commercially
widespread application of
streamlined forms to all kinds
of objects.

twentieth century, many of which have been specifically oriented
towards an international readership. Furthermore, organizations com-
mitted to the promotion of modern design, such as the Deutscher
Werkbund (DWB), the Swedish Society of Industrial Design
(Svenska Slöjdföreningen) or the rather less effective Design and
Industries Association (DIA) in Britain, all left a legacy of exhibitions,
related catalogues, periodicals, and other publications which have
occupied the shelves of major art and design libraries ever since being
committed to print. A number of art, architectural, and design educa-
tional institutions have also left their mark through similar outputs.
Perhaps the most celebrated self-propagandist body in this respect has
been the Bauhaus, formed in Weimar, Germany, in 1919 under the
directorship of Walter Gropius, moving to Dessau in 1925 and thence
to Berlin in 1932, where it was finally closed by the Nazis in the follow-
ing year. Fourteen *Bauhausbücher* (Bauhaus Books) were published
between 1925 and 1930, explaining Bauhaus aims, objectives and prac-
tice to an international readership. It also published a journal, *Bauhaus*,
which appeared in fifteen issues at intervals between 1926 and 1931.
Furthermore, the Bauhaus Archive was founded in Darmstadt in 1960
(moving to Berlin in 1971), another stimulus for research into the his-
tory and ideology of the institution, a process which subsequently con-
tinued through the mounting of exhibitions such as *Fifty Years Bauhaus*
which travelled in Europe and North and South America between
1968 and 1971. Similar developments concerning Bauhaus heritage

were taking place in East Germany, with the mounting of a major exhibition in 1967 which led to the formation of a Bauhaus archive in Dessau.[7] Until comparatively recently the ready availability of such resources for historians has tended to overshadow research into the wider patterns of design manufacture and consumption in Germany in the 1920s and 1930s.[8]

Modernism: moral and political dimensions

The moral dimension of modernism originated in the nineteenth-century design reform movement. It reflected a growing belief in early twentieth-century avant-garde design circles that products which both disguised their modes of construction through ornamental embellishment and were out of tune with the 'spirit of the age' (or *Zeitgeist*) were exemplars of 'bad' design. Adolf Loos, an important theorist of the early twentieth century who had been characterized by Pevsner as a 'Pioneer' of modernism, went so far as to claim in his celebrated text *Ornament und Verbrechen* (Ornament and Crime) of 1908:

the modern ornamentalist is either a cultural laggard or a pathological case. He himself is forced to disown his work after three years. His productions are unbearable to cultured persons now, and will become so to others in a little while.[9]

Writing almost two decades later the architect-designer Le Corbusier, a central figure in the modernist debate, further clarified the moral implications of such an outlook in *L'Art décoratif d'aujourd'hui* (*The Decorative Art of Today*) of 1925 in which he declared forthrightly:

Trash is always abundantly decorated; the luxury object is well-made, neat and clean, pure and healthy, and its bareness reveals the quality of its manufacture. It is to industry that we owe the reversal in this state of affairs: a cast-iron stove overflowing with decoration costs less than a plain one; amidst the surging leaf patterns flaws in the casting cannot be seen.[10]

For Corbusier the adjectives 'neat', 'clean', and 'pure' were linked with healthiness; there was also an implicit charge of deceit in his account of ornamentation as a disguise for flaws in manufacture, a rather more measured view than Loos's inference that the ornamentalist was not only criminal but somehow mentally unstable. However, bound up in the writings of both is a sense of cultural élitism: Loos's claim that the ornamental designer's 'productions are unbearable to cultured persons now, and will become so to others in a little while', presages Corbusier's assertion, also from *The Decorative Art of Today*, that 'the more cultivated a people becomes, the more decoration disappears'. Indeed, in a turn of phrase which many today would find distasteful, Corbusier went on to deplore the fact that 'decorative objects flood the shelves of the Department Stores; they sell cheaply to shop-girls'.

The modernists' spiritual affinity for abstract forms and new materials was also wedded to a democratic ideal whereby the majority would be able to enjoy an improved quality of life in a hygienic, healthy, and modern environment. This social utopian commitment was potently expressed in the housing and design programmes implemented by progressive municipalities in Holland and Germany and, with considerable variation in intensity, realization, and influence, in a wide range of other countries including France, Italy, the USSR, Czechoslovakia, Hungary, Poland, Sweden, Denmark, Britain, the United States, and Japan. At its heart modernism was committed to a social and cultural agenda which was not constrained by national boundaries; indeed, the internationalizing outlook which characterized many of its publications and products received tangible recognition at the Museum of Modern Art (MOMA) in New York in 1932 when the art historian Henry Russell Hitchcock and architect Philip Johnson mounted an exhibition entitled 'Modern Architecture—International Exhibition'. The term 'International Style' was adopted both in the accompanying publication and in Russell and Hitchcock's book of the same year *The International Style: Architecture since 1922*.[11]

With heightened political tensions spreading across Europe in the later 1920s, further exacerbated by the economic consequences of the 1929 Wall Street crash, there was a strong reawakening of nationalism and a growing antipathy to what was often portrayed as the 'cultural Bolshevism' of the internationalizing modernist outlook. In the face of international economic crisis there was a widespread reassertion of national values and traditions, together with a rejection of the modernist agenda of abstract forms, new materials, and modern technology; the modernist antipathy to historical references in design, architecture, and the visual arts, found itself under increasing attack from the National Socialist Party under Adolf Hitler in Germany and the dictates of Socialist Realism under Josef Stalin in the USSR. As will be indicated later, the position in Fascist Italy under Mussolini was rather more ambivalent although still a battle of ideologies, whilst in the calmer political climate of Scandinavia and Holland modernism found considerable room for expression and development. In many other countries the modernist aesthetic was most fully represented in the pages of the architectural and design press, exhibitions, related reviews and caricature and was generally oriented more to the tastes of a sophisticated élite than to effecting any significant change in the demands of the mass-market.

Modernist design: a working definition

The Modern Movement is generally seen to have developed in two main phases: the first originated in the theories and practice of the design reformers of the late nineteenth century, gathering impetus in

the years before the outbreak of war in 1914 and coming to fruition in the early 1920s; the second phase, known as the International Style, can be seen to have run from the later 1920s through to the 1960s. In the 1950s it became a powerful form of expression for the architecture and interiors of multinational corporations, but by the 1960s was associated by many critics, theorists, and practitioners with a sense of social alienation and cultural remoteness in a fast-changing, pluralist, and multicultural society dominated by the mass media. Such Postmodernist critiques were considerably bolstered by popular associations of modernism with social and economic problems in mass-housing and urban planning, and a style of aesthetic anonymity.

Although modernism has perhaps been most visible in terms of its architectural legacy it none the less generated widespread experimentation and production in many fields of design including appliances, ceramics, glassware, furniture and fittings, carpets, textiles, typography, posters, and wallpaper. Its appearance was generally characterized by clean, geometric forms, the use of modern materials such as chromium-plated steel and glass, and plain surfaces articulated by the abstract manipulation of light and shade. The use of colour was often restrained, with an emphasis on white, off-white, grey, and black. When decoration was applied its appearance generally conformed to the abstract aesthetic which had been forged by the artistic avant-garde in the years leading up to the First World War, but had found fuller expression in the work of the Constructivists in Eastern Europe, those associated with De Stijl, and others in the early 1920s. All such characteristics of modernism were felt to be unambiguous affirmations of twentieth-century life, symbolically attuned to the possibilities of modern materials and manufacturing processes. However, although this drive to adopt a creative vocabulary imbued with the new 'functionalism' of the twentieth century looked to the creation of standardized forms and types in furniture and equipment, such 'functionalism' was often far more symbolic than material. The adage so often associated with modernism, 'form follows function' can be seen as the culmination of the acrimonious 'Standardization Debate' which took place between Henry van de Velde and Hermann Muthesius at the Deutscher Werkbund congress of 1914, when Muthesius' commitment to *Typisierung* (standardization), based on economic as well as aesthetic grounds, was opposed by those who felt that this restricted the creativity of the individual designer.[12]

Modern movement design: the First World War and its aftermath

The massive disruption engendered by the First World War ensured that German efforts to establish an emphatically twentieth-century aesthetic, typified by the more progressive factions of the Deutscher Werkbund and evident in the work of Pieter Behrens at the AEG,

Tea and Coffee Service from the *Deutsches Warenbuch*, 1915

Selected by a group of experts drawn from the Werkbund, the *Warenbuch* was intended to bring about a more widespread acceptance of well-designed German products as well as to educate the consumer in matters of domestic taste. Consisting of 248 pages of German household goods in current production, it also listed prices and suppliers, rather as *Das Frankfurter Register* was to do later in the following decade (see **24**).

were substantially disrupted. None the less, the war also bolstered German initiatives to break free of foreign cultural influences as well as providing the impetus to establish a system of standards for industry. This was realized in 1917 when the Normenausschuss der Deutschen Industrie (Standards Commission of German Industry) was founded, an important body which continued to play a key role after the war. Nor was design propaganda entirely forgotten: in 1915 the Deutscher Werkbund and the Dürerbund[13] jointly published the *Deutsches Warenbuch* [13], a handbook of well-designed German products, together with prices and retail outlets. Originally planned in 1913, its effect was somewhat diminished by the war although it was favourably received by a wide range of organizations and individuals.

Progressive design initiatives were taken up elsewhere during the war years, especially in Holland which remained neutral. The most important fulcrum for debate was the De Stijl group, which was founded by Theo van Doesburg in 1917, together with a magazine of the same title. The De Stijl group included fine artists, architects, and designers, with its early outlook conditioned by the work and thought of the painter Piet Mondrian, who had been considerably influenced by the work of the French Cubist painters before the outbreak of war. The Dutch architect and designer H. P. Berlage, whose own manipulation of form and space revealed links with the American architect and designer Frank Lloyd Wright, was another formative influence on the movement. The De Stijl designers sought to explore an elemental design vocabulary in their search for a modern, harmonious aesthetic. Equilibrium was to be achieved through the balance of verticals and horizontals and the restriction of the design palette to the primary

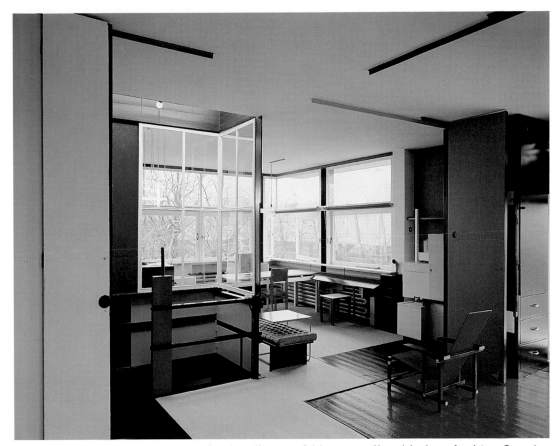

14 Gerrit Rietveld

Interior of the Schröder House, Utrecht, 1924

Rietveld's first major architectural project was built in the same year that Van Doesburg set out his manifestos on architecture in the magazine *De Stijl*. Planned in conjunction with Mrs Truus Schröder-Schräder, who had commissioned the house from Rietveld, the interior demonstrated many of the aesthetic principles of De Stijl, and was a balance of interlocking planes and forms articulated by the primary colours—red, yellow, and blue—and black, white, and grey.

colours of red, yellow, and blue as well as black and white. Interior designs by Van Doesburg, including stained glass windows, tiled floors, and mosaics, textiles by Bart van der Leck and Vilmos Huszár and furniture by Gerrit Rietveld, including his famous experimental Red/Blue chair, typified the early agenda of the group. By the early 1920s, the De Stijl aesthetic took on a more international profile as modernism generally began to attract more critical attention: Rietveld's 1924 design for the Schröder House in Utrecht [**14**] was the most striking realization of its outlook where abstract, geometric forms, symbolically compatible with modern mass-production technology, were manipulated both with regard to external detailing and internal spaces and furniture.

This search for universal forms in Holland in many ways paralleled Muthesius' commitment to standardization in the debates at the Deutscher Werkbund before the First World War, although with an emphasis on its symbolism rather than its technological practicalities. This quest for modern, abstract form, symbolically reflective of the twentieth century [**15**, **16**], was also taking place elsewhere, as in Russia, where Constructivism became an important focus in progressive design circles.

Following the October Revolution of 1917 many Russian avant-garde artists and designers committed themselves to propaganda, including theatre and poster design. However, by 1920, rifts occurred amongst the avant-garde, with concern expressed about the way in which utilitarian concern was leading to the stifling of individual artistic creativity. Artists such as Wassily Kandinsky (who went on to work at the Bauhaus in Germany) believed in the primacy of the creative expression of the individual in art whereas others, including Alexander Rodchenko, his wife Varvara Stepanova [17], and Vladimir Tatlin, committed themselves to work with a more utilitarian bent, geared to the needs of society, employing forms compatible with the potential of modern mass-production technology [18, 19]. El Lissitsky was another highly influential Russian with a strong commitment to the establishment of an international vocabulary of form. Travelling extensively between Russia and other European countries in the 1920s, he forged links with De Stijl and other progressive groups and published in Berlin a journal *Vesch* (Object) in which he sought to reconcile art with mass-production.

The Bauhaus 1919–1933: Weimar, Dessau, Berlin

Perhaps surprisingly, given Walter Gropius's commitment at the Werkbund Exhibition at Cologne in 1914 to notions of standardization, the manipulation of modern materials, and an industrial aesthetic, the early years of the Bauhaus were closely linked with Expressionism. Such a radical change of outlook immediately after the war undoubtedly sprang from the subsequent antipathy of many designers (particularly on the left of the political spectrum) to large-

scale industry, which was felt to have played an important part in pre-
cipitating Germany's involvement in the First World War. In 1919
Gropius was the chairman of the radical Arbeitsrat für Kunst
(Worker's Council for Art), the programme of which embraced a com-
mitment to crafts training and the unification of all the arts, undoubt-
edly influencing the spiritual intensity of the Bauhaus Founding
Manifesto of 1919. Something of this expressionist spirit may be seen
in one of the most important early Bauhaus projects, the wooden
Sommerfeld House.[14] Designed by Gropius and Hannes Meyer in
1921, it provided an early opportunity for design collaboration on a
large scale, embracing the architecture as a framework for all the fields
of design contained within it, including elaborate woodcarvings by

Sports clothes by Stepanova
and graphics for *Dobrolyet* by
Rodchenko from *LEF*
magazine, Moscow, 1923

LEF (1923–5) was an
important outlet for Russian
Constructivist debate. Varvara
Stepanova, renowned for her
striking textile and clothing
designs, and her husband
Alexander Rodchenko were
leading figures in the
movement. Their concerns
were to utilize art and design
as potent and progressive
forces in the construction
of a new society, aligning
symbolically the abstract
forms of their artist vocabularly
to the machine age.

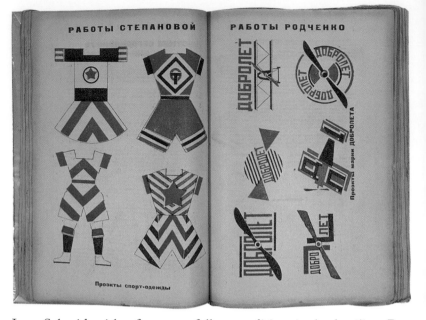

Joost Schmidt with reference to folk art traditions in the detailing. But
within two years a distinct shift of design outlook was discernible, no
doubt engendered by the need to demonstrate the economic relevance
of the school to the Thuringian State government which funded it, an
authority with which the Bauhaus had an increasingly fraught political
and ideological relationship. Once again a design aesthetic which
explored forms compatible with the ethos of modern mass-production
technology was clearly visible, even if its realisation was achieved by
craft modes of construction. This could be seen in Gropius's own office
[20], throughout which the contrast of horizontal and vertical articu-
lated both furniture and fittings, particularly in the lighting fitting,
which was designed by Gropius himself, echoed solutions by
Constructivist designers in Russia and Hungary or De Stijl in
Holland. This marked a much more international design orientation
[21], itself stimulated by several events which took place in Weimar in
the early 1920s: the arrival of Van Doesburg in 1921, the mounting of a
Dada/Constructivist conference at which Van Doesburg, El Lissitsky,
the Hungarian Constructivist Lázló Moholy-Nagy, and his wife Lucia
participated, and the appointment to the Bauhaus staff of the Russian
painter Wassily Kandinsky and Moholy-Nagy in 1922 and 1923 respec-
tively. In 1923 the Bauhaus also mounted an exhibition in order to
defend itself against increasing criticism from its funding authority
and elsewhere. The centrepiece, a physical manifesto, was the 'func-
tional' Haus am Horn, designed by Adolf Meyer and Georg Muche,
for which the interior furniture, fittings, and equipment were produced
as prototypes for industry by a number of the Bauhaus workshops.
These were especially evident in the kitchen, the design of which was

Textile designs by Popova, from *LEF* magazine, Moscow, 1923

Liubov Popova, like Stepanova, was an important figure in the regeneration of the Soviet textile industry, both of them working for the Tsindei factory near Moscow in the early 1920s. The strong geometrical leanings of these designs are shared by those seen in **17**.

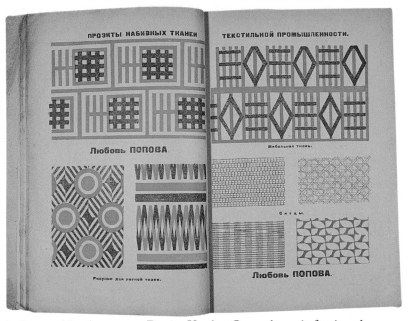

influenced by the weaver Benita Koche-Otte who, reinforcing the general expectations of women at the Bauhaus, was brought in to lend 'a woman's view' in the male arena of industrial design.[15] A new Bauhaus slogan, 'Art and Technology: a New Unity' was adopted by Gropius, a firm rejection of the handicraft ethos which he reiterated in a contemporary speech to the Werkbund conference also held in Weimar in the summer of 1923.

Gropius had recognized the importance of establishing links with industry as a vital means of helping to alleviate Bauhaus dependency on the Thuringian State government. To this end a business manager was appointed in 1923 but, particularly during the remaining years at Weimar, his task was fraught with problems, not the least being the incapacity of the various Bauhaus workshops to meet delivery deadlines. Displays at trade fairs were also poorly handled, with many goods overpriced. As a result the Bauhaus saw many of its potential outlets located at the more exclusive end of the market [**22**, **23**].[16]

The firm commitment to a fusion between art and technology was even more emphatically expressed in the new buildings, interiors, furniture, and fittings at Dessau, where the Bauhaus had been forced to move for political reasons in 1925–6. The commitment to industrial prototypes was more rigorously pursued in the later 1920s, despite the departure from the staff of Gropius and Moholy-Nagy in 1928, soon followed by two other influential teachers (and former Bauhaus graduates), the graphic designer Herbert Bayer and furniture designer Marcel Breuer. A number of lighting designs were put into production by the Leipzig manufacturers Körting and Mathiesen, wallpapers by Rasch Brothers & Co of Hanover, and textile designs by Polytextil-

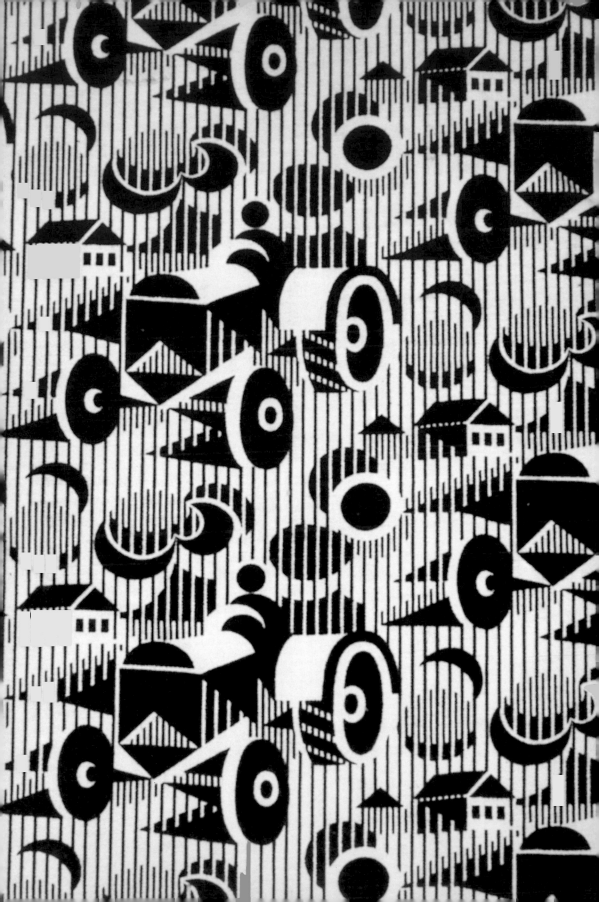

Late 1920s textile, USSR
The design of this textile
blends the geometric
abstraction of the progressive
tendencies in Russian
Constructivism with
recognizable and politically
potent forms of symbolism.

Gesellschaft in Berlin, Pausa in Stuttgart, and the Deutschen Werkstätten in Dresden. In fact, the Weaving Workshop at the Dessau Bauhaus under the direction of Gunta Stötzl was one of the leading centres for training in the field and was the only one that qualified women graduates to work for industry.

The removal of the Bauhaus to Berlin in 1932, in the face of implacable opposition from the National Socialist City Council in Dessau, and its final demise in the following year have been widely documented and have perhaps increased its ideological cachet for later historians. Furthermore, many architects and designers working in Germany fled the increasingly oppressive Nazi regime and moved to Britain, the United States, and elsewhere, thus sharpening debates on, and knowledge of (at least in progressive circles), both the modernist aesthetic and Bauhaus educational practice.

The Bauhaus: some issues in interpretation and historical location

As indicated earlier, for many years the Bauhaus, formed in Weimar in 1919 under the directorship of Walter Gropius, has subsequently played a dominant role in considerations of the Modern Movement in Germany. Its lifespan almost directly coincided with the culturally fertile period of the Weimar Republic, established in 1919 and terminating with the election of the National Socialists under Adolf Hitler in 1933, and many of the wider social, economic, and political tensions engendered during those years mirrored the problems and successes of the institution. In addition to the Bauhaus's own considerable propagandist output concerning its own activities, there have been many subsequent useful published historical evaluations and collections of documentary material, as well as exhibitions celebrating the work of associated artists, architects and designers.[17]

As has been argued earlier, this notoriety has tended to obscure the achievements and concerns of other important art institutions in contemporary Germany, including those at Berlin, Breslau, Dusseldorf, Essen, Stuttgart, and Frankfurt. For example, the latter, formed in 1923 from an amalgamation of the existing School of Handicrafts and Institute of Art and Architecture, was also renowned in the 1920s and increasingly forged links with industry, particularly in printing and textiles. Like that of the Bauhaus its curriculum became progressively specialized and attracted onto its staff Bauhaus graduates such as Christian Dell, as well as eliciting contributions to its programme from leading designers and architects such as Ferdinand Kramer (also a Bauhaus graduate) and Ernst May (the Frankfurt City Architect).

The prominence of the Bauhaus has also tended to overshadow the activities of other culturally significant German organizations that had an important bearing on design production in the same years, most

Director's Office at the
Bauhaus, Weimar, 1923
Gropius's office was open to
the public as part of the 1923
Bauhaus exhibition, reflecting
other aspects of the modern
interior shown in the Haus am
Horn (see **26**). The geometric
character of the furniture,
designed by Gropius,
endorsed the modernist
preoccupation with an
aesthetic compatible,
at least symbolically,
with contemporary mass-
production technology.
The industrial character of
the light-fitting, also by Gropius
(closely following a 1922
design by the De Stijl designer,
Rietveld), the wall-hanging by
Else Mögelin, and the rug by
Gertrud Arndt, both students
in the Weaving Workshop,
were similarly conceived.

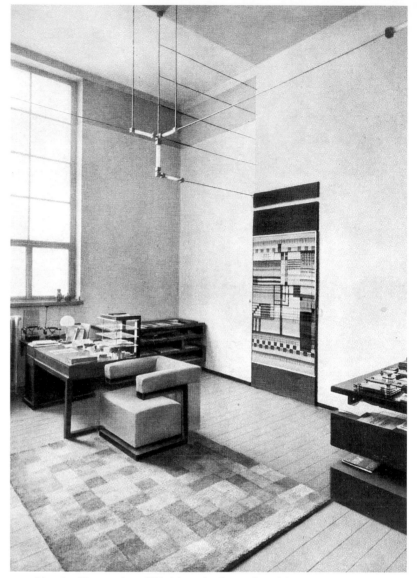

notably the Deutscher Werkbund. Considered by historians to be a
significant shaping influence on the roots of the Modern Movement, it
has generally received most scrutiny in the period from its foundation
in 1907 to the occurrence of the seminal Werkbund Exhibition in
Cologne in 1914, the culminating point of Pevsner's *Pioneers of Modern
Design*. Indeed, as the Canadian historian Joan Campbell argued in
the introduction to her authoritative publication, *The German
Werkbund: The Politics of Reform in the Applied Arts*:

the impressive achievements of the early Bauhaus are not sufficient reasons to
neglect the contributions of the Weimar Werkbund to the cause of modern
architecture and design. Moreover, because the Werkbund was one of the few

21 Ruth Hollós

Tapestry, Dessau, 1926

Hollós was a student in the Weaving Workshop at the Bauhaus from 1924, receiving her diploma in 1930. A pupil of the highly influential women's teacher Gunta Stölzl, she designed many textiles as prototypes for industry. The strongly structured, abstract forms of this tapestry symbolically echo such concerns, linking it with avant-garde modernists working in other fields. She also worked on several larger commissions such as the Theatre Café in Dessau.

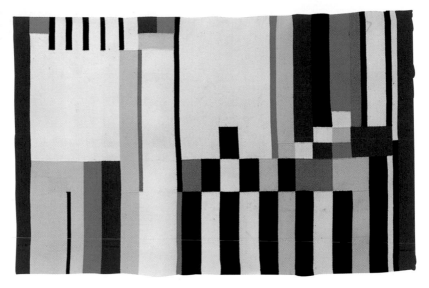

national cultural institutions to survive from the Second Reich into the Third, examination of its ideals can illuminate both the extraordinary flowering of the modern spirit commonly designated as "Weimar Culture" and the intellectual-cultural origins of National Socialism.[18]

However, it is also the case that such wider historical emphases on the commitment to modernism of both the Deutscher Werkbund and the Bauhaus have tended to overshadow the wider realities of design production and everyday consumption in contemporary Germany, considerations which have largely been overlooked in publications on the period.

More recently research into the structure and workings of the Bauhaus has addressed the role of women at the institution, the restrictions of which had far wider social and industrial implications in Germany (and elsewhere). Magdalene Droste, in an essay entitled 'Women in the Arts and Crafts and in Industrial Design 1890–1933' drew attention to the ways in which Walter Gropius sought to limit the number of female students at the Bauhaus through the introduction, from 1920, of a more rigorous entry policy, 'particularly for the female sex, whose number is excessive'.[19] Furthermore, in a climate in which there were clear male conceptions that arts and crafts practice (generally associated with women) might be seen to threaten the successful realization of the stated goal of the institution—architectural proficiency—he sought to restrict women's opportunities after completion of the foundation course to weaving, pottery, or bookbinding. Where women such as Marianne Brandt and Alma Büscher did emerge to a position of some prominence in other fields, metalwork and furniture respectively, this very much flew in the face of the general assumption that design for industry was a male preserve.

The wider climate of modern design in Germany in the 1920s

Just as the unambiguous prosecution of the modernist cause at the Bauhaus was evidenced by its 1923 exhibition and the move towards the production of industrial prototypes, the DWB re-emerged from a period of ideological confusion in the immediate postwar years. With a marked shift away from a position of economic impotence and affiliation with the idea of the cultural and economic significance of the crafts, it once again became a significant campaigning body for the reconciliation of design excellence with modern industry. This was intimately linked to the halting of the inflationary spiral at the end of 1923 and more invigorating future prospects for German industry.

During the mid-1920s the DWB became an important sponsor of

22 Herbert Bayer

Brochure advertising Bauhaus products, 1925

Bayer was in charge of the printing workshop at the Dessau Bauhaus from 1925 to 1928. The clarity of the design and structured layout of this brochure page was characteristic of progressive typographers of the period. The use of sans-serif letterforms, often accentuated by bold underlining, was favoured by Bayer who was influenced by the work of Moholy-Nagy, El Lissitsky, and Van Doesburg.

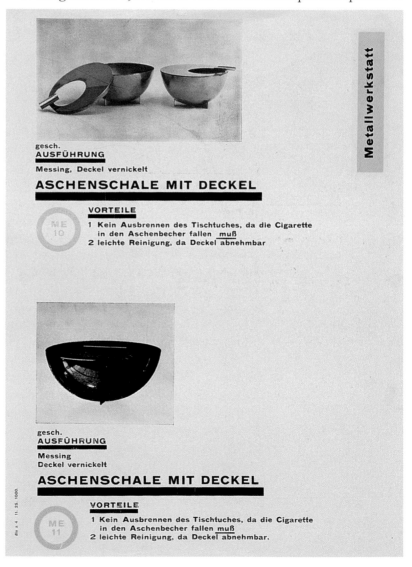

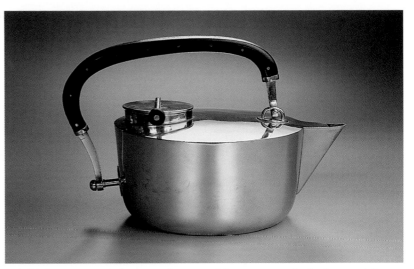

exhibitions promoting modern architecture and design, with an emphasis on many aspects of its wider social relevance. An important travelling exhibition reflecting this new spirit was entitled *Form ohne Ornament* (Form without Ornament).[20] First shown in Stuttgart in 1924, it included both craft- and machine-produced goods and embodied a broad commitment to the rejection of historical ornamentation and the individualism of postwar Expressionism. Furthermore it helped to ferment the idea of developing standardized forms compatible with modern modes of production. Such a functionalist outlook began to sound the alarm bells in traditional art industries where a premium was placed on traditional craft skills, an alarm which was to articulate itself far more vociferously at the Weissenhof housing exhibition of 1927. But in other ways the 1924 exhibition was rooted in the past since, in the accompanying publication, women were associated with the crafts and 'primitive' design whereas men were linked with 'technical' design, reinforcing their nineteenth-century stereotype-casting at the centre of cultural and industrial change.[21]

The DWB magazine *Die Form* resumed publication in 1925[22] and soon became a highly influential mouthpiece for progressive ideas, being read by the avant-garde at home and abroad. None the less, it is important not to underestimate the relative lack of enthusiasm of German industry for the widespread adoption of such ideas in the domestic marketplace. Indeed, opportunities to realize them were comparatively short-lived since, by the late 1920s, German industrial production began to decline with the lessening of foreign investment and the successive economic crises that followed the Wall Street Crash of 1929. As a result, the membership of the DWB dropped markedly, and in the polarized political climate of the times it found itself increasingly unable to defend itself against accusations of 'cultural bolshevism' from the political Right and cultural élitism from the Left.

Lighting by Wilhelm Wagenfeld from *Das Frankfurter Register*, 17, 1931

In the later 1920s there were concerted efforts to promote Frankfurt as an emphatically modern, twentieth-century city, much stimulated by the appointment of Ludwig Landmann as Oberbürgermeister in 1924. The radical municipal achievements in architecture and design were furthered in the pages of the monthly journal *Das Neue Frankfurt* which was published from 1926 to 1934. Its supplement, the *Frankfurter Register*, contained many examples of modern design in everyday life, and often included prices and details of retail outlets.

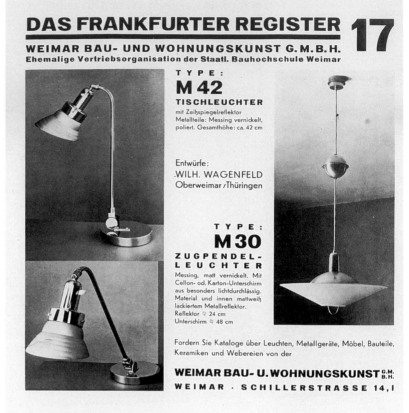

Like the Bauhaus before it, the DWB eventually fell prey to the cultural repression of the National Socialists.

Municipal patronage also played an important role in the dissemination of modernist design and planning in Germany in the mid-1920s. This had originated in the general shift away from private to public patronage in the period of spiralling inflation of the early 1920s, and was considerably boosted by the greater economic stability in the mid-1920s brought about by substantial American investment. Progressive concepts such as the *Neue Gestaltung* (New Design), *Neue Bauen* (New Architecture) and the *Neues Wohnen* (New Lifestyle) became rallying calls for the avant-garde, reflecting a desire to embrace the material advantages which could result from the whole-hearted embrace of modern mass-production technology, new materials and, above all, the true spirit of the twentieth century. In this respect the world-shattering consequences of the First World War had marked a much more emphatic break with the past than had the literal passing of the old century in 1900. Magazines such as *Das Neue Frankfurt* and *Das Neue Berlin*, which commenced publication in 1926 and 1929 respectively, argued for the recognition of the social as well as aesthetic value of modern architecture and design. A related publication, the *Frank-*

furt Register was also an extremely telling vehicle for the dissemination of the modernist project. Effectively a sales catalogue for the promotion of modern design for everyday life, with sections devoted to lighting [**24**], furniture, and other facets of interior design, it pursued, from a municipal perspective, similar objectives to the *Deutsches Warenbuch* published jointly by the Dürerbund and the Deutscher Werkbund in 1915, to which reference has already been made [**13**]. Ernst May, in charge of Frankfurt's municipal housing programme, brought a number of modernist aspirations to life in the provision of mass-housing. Such dwellings saw the development of special building techniques and were equipped with functionalist furniture and fittings tailored to the practicalities of efficient living in small spaces (*Existenzminimum*). One of the most noteworthy solutions was the Frankfurt kitchen, the planning of which was achieved by a team working under the Viennese architect-designer Grete Schütte-Lihotsky.

The Frankfurt kitchen: a design solution for twentieth-century living

The planning of efficient, pleasant kitchens had been a concern of the women's movement in Germany for some time but, in the post-First World War period, was allied to a rethinking of the role of the housewife within the home. The growth of interest in the concept of 'scientific management' in the home was especially attractive as it afforded the role of housewife the prospect of acquiring status as well as 'professional' connotations through its adoption.[23]

Considerable impetus was given by the translation into German in 1922 of the American Christine Frederick's *Scientific Management in the Home* of 1915 in which considerable emphasis was placed on the kitchen. She argued for the removal from the kitchen of activities unrelated to the preparation of food in order that it could be made smaller and thus less wasteful in terms of movements around it. Another widely read text which promoted this new spirit in the domestic arena was Edna Meyer's *Der Neue Haushalt*. First published in 1926, it had gone into 40 editions by 1932. She collaborated with the Dutch architect-designer J. J. P. Oud on kitchen design at the Weissenhof Siedlungen exhibition of 1927, a feature which received considerable critical acclaim. Also important in this field of design was Greta Schütte-Lihotsky who had been influenced by Heinrich Tessenow, an important pioneer in the analysis of the design of small apartments, and was also well aware of Oud's work, having worked in Rotterdam where some of his most important schemes had evolved. Called in by the Frankfurt City Architect Ernst May, Grete Schütte-Lihotsky sought to bring about a fruitful collaboration between architects, housewives, and manufacturers to arrive at the most appropriate means of approaching housework.[24] Much more systematically con-

ceived than the labour-saving kitchen of the Haus am Horn seen at the 1923 Bauhaus exhibition, the size and layout of the Frankfurt kitchen [**25, 26**] was determined by time-and-motion studies, although the aim was also to produce a pleasant, as well as efficient, environment. To this end psychological considerations were also incorporated into the design, which took careful account of the use of colour as well as the sizes of the window and the opening into the adjoining family room. Costs were kept low by the use of factory prefabrication, and different versions of the kitchen were incorporated into a range of the new housing estates in 1920s Frankfurt and reflected the trends towards an increasing nationally instituted standardization of many household goods and kitchen equipment.

The concept of *Existenzminimum* (compact living) was discussed extensively at the 1929 Congrès Internationaux d'Architecture Moderne (CIAM) conference in Frankfurt, and many modernist designers explored ideas of space-saving. Such experiments were important facets of their social utopianist aims and were proposed in many European and Scandinavian countries. In Russia, for example, El Lissitsky designed a 'compartment kitchen' in Moscow in 1928; in Finland, at the 1930 Minimum Apartment Exhibition in Helsinki Town Hall, Aino Aalto designed a minimum kitchen, which included a rubbish bin on wheels and tables with extendable surfaces at which

25

Blueprint for the Frankfurt Kitchen, designed by Grete Schütte-Lihotzky, 1924

The ergonomic functionalism of the Frankfurt Kitchen reflected a desire to provide high standards of design in mass-housing. With built-in cupboards, storage units, and work-surfaces, the space-saving ideas looked back to the design of ship and railway galleys as well as to the highly influential *Scientific Management in the Home* (1915) by Christine Frederick. The practicality of the Frankfurt design was furthered by the provision of a swivel-stool from which the housewife could easily reach the sink, chopping board, and food storage.

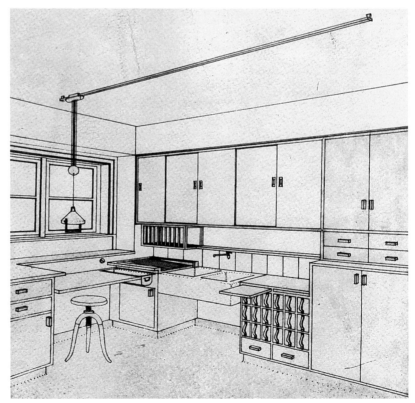

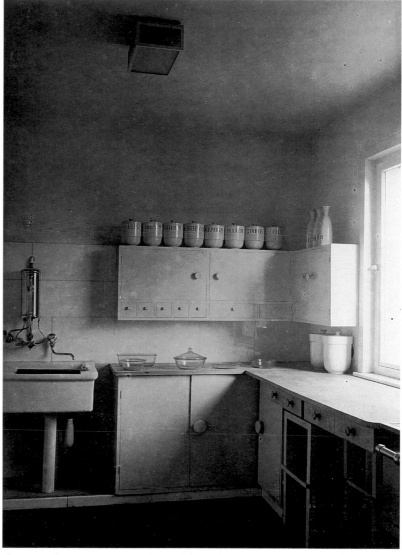

Haus am Horn kitchen, designed by Benita Otte and Ernst Gebhardt, Bauhaus Exhibition, 1923

The Haus am Horn marked an unambiguous commitment to a modernist vocabulary of form seen both in its stark, undecorated exterior and the clarity of internal spatial organization. The fitted kitchen units, built in the Bauhaus cabinet-making workshops, reveal a growing commitment to notions of standardization and economic mass-production technology, an outlook echoed in Theodor Bogler's earthenware containers seen above the cupboard, mass-produced by Velten-Vordamm, as well as the glassware on the work surface which was manufactured by Schott & Gen.

the person preparing meals could work; in the same year a Minimum Flat Exhibition was mounted in Warsaw; and in Britain in 1933–4 Wells Coates produced a galley-kitchen design for his 'Minimum Flats' at Lawn Road, London.

Die Wohnung: the Weissenhof Siedlungen exhibition, Stuttgart, 1927

Perhaps the most celebrated and unambiguous manifestation of modernism in Germany was the *Die Wohnung* (The Dwelling) exhibition held in Stuttgart in 1927, reflecting the high status afforded architecture in the modernist canon. Organized on behalf of the Deutscher Werkbund by the German architect and designer Ludwig Mies van der Rohe on the Weissenhof Estate, Stuttgart, it included about sixty

27 Hermann Gretsch

Model 1382 service,
Porzellanfabrik Arzberg, 1931

The clean, undercoated forms
of this service endorsed the
'good design' principles of the
German Werkbund, but also
revealed the often ambivalent
attitude to modernism of the
National Socialists since it
remained in production
during the 1930s (and after
the Second World War).
Gretsch, as a consultant to
the Arzberg porcelain factory
from 1931 onwards, continued
to promote similar formal
considerations in his
publication *Gestaltendes
Handwerk* (Creative
Handicrafts) of 1940.

housing designs by sixteen of the leading protagonists of the Modern Movement, including Le Corbusier from France, Mart Stam and J. J. P. Oud from Holland, Victor Bourgeois from Belgium, and Gropius and Mies himself from Germany. The modernist forms seen in the architecture, furniture, and fittings did much to establish the notion of an 'International Style' as critics were able to see that the work of architects and designers from a number of countries, including Germany, was stylistically homogeneous. This gave rise to growing hostility in Germany to an aesthetic which disregarded indigenous traditions: the flat roofs of the buildings were seen as incompatible with the German character. The exhibition was also a forum for the display of modern home furnishings and provoked conservative furniture manufacturers to attempt to prevent avant-garde furniture by Marcel Breuer and others being shown. The exhibition did much to centralize criticism of the avant-garde, and modernist designers and architects were increasingly portrayed as embodying harmful moral and political characteristics, often being associated with Bolshevist, Jewish, and other 'undesirable' or 'foreign' origins.

Although modern design was generally suppressed under the Nazis for such reasons as had become apparent at Stuttgart in 1927, the design historian John Heskett has argued that standardization and rationalization continued to exert an important impact on economic planning, particularly with regard to rearmament and militarization.[25] Despite the widespread adoption of an emphatically *völkisch* aesthetic under the Nazis guidelines were still produced for neat, functional design in housing, domestic furnishings, and equipment, and the work of many Modern Movement designers who had come to the fore in the 1920s, such as the metalware and glass designer Wilhelm Wagenfeld or the industrial ceramic designer, Hermann Gretsch, continued in production throughout the 1930s. Gretsch's porcelain service for Arzberg of 1931 [**27**] exemplified the clean-formed 'functional' aesthetic of the

modernists which continued in production for more than fifty years. The extent to which the Modern Movement could still be seen in Germany as late as 1939 was apparent in the *Deutsche Warenkunde*, an official state publication of approved designs in current production.

Modernism in France: Le Corbusier and the UAM

In France Le Corbusier was undoubtedly the most prominent figure in modernist circles, having links with a number of the pioneers before 1914, most notably Peter Behrens, in whose Berlin office he worked in 1910–11. Corbusier remained at the forefront of modernism until after the Second World War. Active in many creative fields, including architecture and planning, design, and the Fine Arts, he also produced a number of important theoretical texts. *Vers une architecture* of 1923 in particular was an important vehicle for the dissemination of the modernism across Europe and beyond, drawing attention to the aesthetic significance of modern anonymously designed cars, aeroplanes, or grain silos.

The 1925 Exposition Internationale des Arts Décoratifs et Industriels in Paris has often been viewed by design historians as an important forum for the material embodiment of conflicting design ideologies in the interwar years. Here, the austere, modern aesthetic of Le Corbusier's celebrated Pavillon de l'Esprit Nouveau [**28**] clearly indicated the huge ideological gulf which lay between the decorative excesses of the expensive creations of the French *ensembliers*, which were predominant throughout much of the Exhibition, and the modernists' spiritual affinity with notions of standardization, the exploration of new materials, and firm embrace of the contemporary spirit.

28 Le Corbusier

Interior of Pavillon de l'Esprit Nouveau, Exposition Des Arts Décoratifs et Industriels, Paris, 1925

Corbusier's Pavilion was opposed to the major aim of the 1925 Paris Exposition, that of promoting French decorative arts and design. Instead, his design assumed an uncompromisingly modern aesthetic which the exhibition authorities sought to censor. Inspired by the economic use of space in ocean liners, the modular storage system (known as 'casiers') was designed by Corbusier and used here as a space divider. Even the paintings on the walls, in Purist style, were in keeping with the ethos of the machine age.

Corbusier's commitment to the poetics of the utilitarian object could be seen in the clean forms of the interior fittings and furniture, most of which was mass-produced.

As has already been noted, Le Corbusier's ideas relating to interior design were characterized in his book *L'Art décoratif d'aujourd'hui* of 1925, first published as a series of articles in his magazine *L'Esprit nouveau*. Here he argued that interior design and furniture should, like architecture, embrace notions of rationalization and standardization, concepts brought to life in the furniture, storage systems, and paintings (by himself and Fernand Léger) in his 1925 pavilion. Corbusier's ideas for furniture were developed further at the 1929 Salon d'Automne exhibition, at which Charlotte Perriand collaborated with him and his brother Pierre Jeanneret.[26] Their output included modular storage systems to define interior spaces, as well as the celebrated *Chaise Longue* and *Fauteuil Grand Confort* armchair, which have subsequently become design 'classics'.

The wider climate of design politics in France reflected similar oppositions to those evidenced at the 1925 Exposition, set against the retrospective historic encyclopaedism in design for the mass market. The latter, largely uncollected and under-researched on account of its perceived lack of cultural cachet, was unrepresented by the advocacy of the other main factions: the politically radical modernists, collectively represented by the Union des Artistes Modernes (UAM), which sought 'balance, logic, and purity' in its designs, and the more conservative Société des Artistes Décorateurs, from whom the founding members of the UAM had seceded in 1930. Under the directorship of René Herbst the UAM included Le Corbusier, Charlotte Perriand, Robert Mallet-Stevens, Eileen Gray, Louis Sognot, Charlotte Alix, and Pierre Chareau. But, despite the social utopianist commitment of such designers, the market for their design work, like that of many modernists, was largely restricted to the affluent tastes of a metropolitan cultural élite.

Modernism in Fascist Italy

The radical embrace of technological, social, and cultural change by the Futurists so evident in their manifestos of the years immediately following the foundation of the group in 1909 did not, as some art, architectural, and design historians have implied, fade out with the death of a number of its adherents in the First World War. This in part stemmed from Marinetti's close political links with Mussolini and Fascism, but also from the increasing marginalization of the movement in the architectural and design debates of the later 1920s and 1930s. Despite the efforts of Giacomo Balla, Enrico Prampolini, and Fortunato Depero to promote experimental Futurist interior design, furniture, and decorative objects in exhibitions in Rome and Milan in

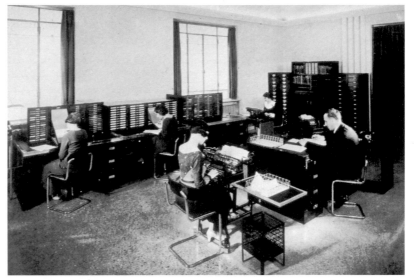

1918 and 1919, the most potent expressions of this essentially metropolitan movement were to be found in dramatic graphic representations of futuristic cityscapes and poster designs. None the less, the Futurists' emphatic rejection of Italy's cultural heritage was paralleled in the work of the architects-designers of Group 7, which was formed in 1926 and was the first clear expression of the spirit and aesthetics of the Modern Movement in Italy.[27]

The leading figures of the group were Luigi Figini, Gino Pollini and Giuseppe Terragni. Known as Rationalists, their work embraced the prevailing modernist aesthetic of clean, abstract forms spiritually attuned to modern life, materials, and technology; committed to a spirit of dynamic cultural change, they hoped that Rationalism would be adopted as *the* official Fascist aesthetic. It has been suggested by a number of historians that their failure to achieve such an objective stemmed from their commitment to an internationalist outlook.[28]

The Rationalists gained only few commissions in the public sector, and their reputation is based in part on the critical attentions afforded private commissions in the late 1920s and early 1930s, such as Figini, Pollini, and Luciano Baldessari's interior for the Craja Bar in Milan (1930) or the Parker shop interiors (1934), also in Milan, by Edoardo Persico and Marcello Nizzoli. Magazines such as *Domus*, founded by Gio Ponti in 1928, and *Casabella*[29] provided further vehicles for the dissemination of their work. However, exhibitions provided the most potent means of expression for the avant-garde. The most significant were the Triennali, first held on a two-year cycle in Monza in 1923 under the title 'International Biennale of the Decorative Arts' before moving to Milan ten years later as the 'International Triennale of Decorative and Modern Industrial Art'.[30] These exhibitions provided progressive Italian designers with opportunities not only to put their

Salon furniture, Nordiska Kompaniet, 1917

There were concerted attempts to improve standards of Swedish public taste in everyday design, particularly through individuals such as Gregor Paulsson and organizations such as the Swedish Society of Industrial Design which organized the influential *Home Exhibition* in 1917. The Nordiske Kompaniet department store, under the guidance of the architect Carl Bergsten, promoted furniture combining traditional arts-and-crafts qualities with larger-scale production runs. This constrasted with more radical tendencies which culminated in the functionalism of the 1930 Stockholm Exhibition.

ideas into practice in a number of one-off commissions but also to exhibit them alongside other leading foreign designers and architects: at the 1930 Triennale functionalist interiors were exhibited by the Berlin Werkbund, including lamps and fittings from the Dessau Bauhaus, chairs by Mies van der Rohe, and equipment by Siemens and AEG; the 1933 Trienale included photographs of CIAM work by Le Corbusier, Gropius, Mies, and Melnikov; and in 1936 the Finnish designer Aino Aalto was awarded a gold medal, the birchwood furniture by her husband Alvar also attracting interest. But the efforts of the Italian Rationalists at the Triennali and other exhibitions to place the modernist agenda within the public domain remained largely unsuccessful [**29**].

However, the Fascist regime's relationship with the modernist aesthetic was by no means as publicly hostile as that which prevailed in Nazi Germany, for there were a number of instances where Rationalist designers were directly involved with design which promoted the Fascist regime, whether at celebratory political exhibitions or Fascist buildings, their interiors and furnishings. The best known example of the latter is Giuseppe Terragni's House of Fascism of 1933–6. However, the difficulties of reconciling a modern, internationalizing aesthetic with the propagandist demands for visually accessible symbols of a political regime steeped in notions of a Roma Secunda were rarely overcome in the 1930s.

Scandinavian Modern

The term 'Scandinavian Modern' as a concept has tended to provide a stylistic umbrella for progressive designing in Sweden, Finland,

Norway, and Denmark. However, whilst there were undoubtedly common features in their aesthetic concerns—the value of craftsmanship, empathy with natural materials, and respect for the creative imagination of the designer—there were in fact clear political and cultural differences.[31]

The Svenska Slödföreningen (Swedish Society of Industrial Design) did much to promote the modernist cause in Sweden, tempered by a historic commitment to preserve the aesthetic and creative qualities of the crafts. Although the Society had been founded as far back as 1845, the demographic changes brought about by widespread migration from the countryside to the cities in the late nineteenth and early twentieth centuries led to a re-evaluation of its social role. As with the Deutscher Werkbund, with which Gregor Paulsson (later the Society's Director) had developed links before the First World War, the Svenska Slödföreningen sought to raise the quality of life by bringing about improved standards of design in everyday life. The Swedish design climate (like the Dutch) was not disrupted by involvement in the First World War and during this period bridges between art and industry continued to be developed. A key manifestation of this alliance of aesthetic awareness, manufacturing processes, and social purpose was the *Home* Exhibition put on by the Society in Stockholm in 1917. Often seen by design historians as a seminal show, it consisted of twenty-three fully furnished interiors, the results of a competition for the design of furnishings, fittings, and equipment for one- and two-bedroomed flats. Prizes were awarded right across the design spectrum, from carpets to domestic appliances. As was apparent in Gunnar Asplund's kitchen-living room, there was something of a compromise between the ethos of crafts production and the simplicity of form and decoration compatible with industrial production. As with

31 Wilhelm Kåge

Praktika I, model X, *Weekend* pattern dinner service for Gustavsberg, 1933

Kåge, the Art Director at the Gustavsberg ceramics factory from 1917 to 1947, introduced this dinner service at a time when there were strong ideological conflicts between functionalist and traditionalist designers in the wake of the austere modernism of the 1930 Stockholm Exhibition. The somewhat stark design lived up to the practicality of its title, with stackable cups and interchangeable lids. It was favoured by the critics and shunned by the public.

Wilhelm Kåge's *Blue Lily* tableware, also produced in 1917 and geared to the pockets of the working-class, such efforts to elevate standards of design in everyday life were in fact generally rejected by consumers in favour of traditional heavier, more decorative products [**30**].

Despite fresh initiatives such as the Svenska Slödföreningen's collaboration with AB Svenska Möbelfabrikerna, one of the largest furniture manufacturers in Sweden, in the production of 'beautiful' mass-produced furniture, there was an ambiguous commitment to modernism during the 1920s. Two major strands of Swedish design had emerged by the end of the decade: the first of these, promoted by the Svenska Slödföreningen, its director Gregor Paulsson, and Gunnar Asplund, was committed to a 'functionalist' aesthetic, blended with the social utopianism of the German modernists; the second embraced an aesthetic rooted in the arts and crafts, an outlook particularly evident in the glass and ceramics industries, the principal exponents of which were the glassmakers Orrefors and the Gustavsberg and Rörstrand porcelain manufactories.

The Stockholm 1930 Exhibition was a clear affirmation of faith in the contemporary spirit and attracted a considerable amount of attention abroad. Given shape by the tripartite alliance of Paulsson, Asplund, and the Svenska Slödföreningen, it sought to ally modern design with a sense of social purpose and presented an agenda relevant to the dynamics of twentieth-century life. Advertising, one of the most potent forms of expression of the latter, was at its core, together with transport, communications, and the urban environment: housing projects, furnished flats, and interiors were displayed alongside school and hospital exhibits, and the modernist commitment to ideas of standard-

32 Alvar Aalto

Paimio armchair, no. 41, 1931/2

Perhaps his most celebrated design, this elegant plywood chair for the Paimio Tuberculosis Sanatorium reveals Aalto's interpretation of the modernist canon. Using a natural material (wood) he endowed it with a more humanizing face than the uncompromising tubular steel essays of many modernists outside Scandinavia. Plywood proved an attractive medium on account both of its price and malleability.

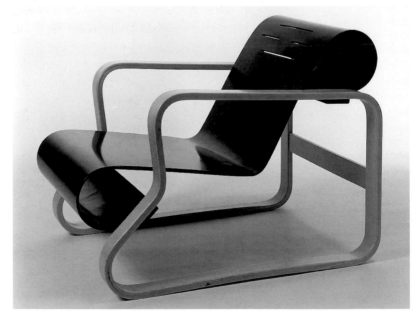

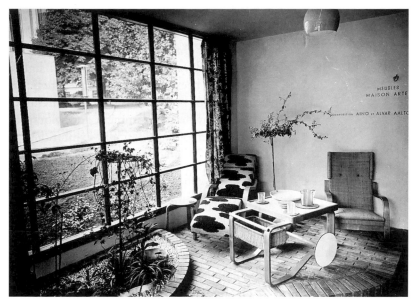

ization and mass-production was highly visible. Opposition to the rather stark and austere qualities of the machine aesthetic which generally prevailed at the exhibition was animated and led to considerable debate between those representing *funkis* [**31**] (functionalism) and *tradis* (tradition). Amongst the factions which expressed particular concern were the conservative furniture manufacturers, who set out to suggest that standardized designs with a minimum of decoration would lead to unemployment in the industry and that innovation might lead to price inflation.

Following this there were a number of exhibitions during the 1930s which set out a less radical agenda, often in conjunction with the Svenska Möbelfabrikerna, including the display of interiors and furniture by Svenskt Tenn at the Galerie Moderne in 1931 and the Modern Home Exhibition of 1933, where the sharply articulated clarity of space in interior spaces was softened by furniture and equipment which blended modernism with more traditional forms. Natural materials played a far more prominent role, and this more humanizing interpretation of the modernist ideal, which became known as Swedish Modern, was evident in the work of Bruno Mathsson and the Viennese architect-designer Josef Frank, who settled in Sweden in the early 1930s and became increasingly familiar as a propagandist of this 'softer' modernism to a wider international audience through the design press, exhibitions and the export trade.

The more publicly acceptable face of modernism through this greater exploration of natural materials was also evident in other Scandinavian countries in the interwar years. In Finland the Arabia factory[32] established an international reputation for its ceramics and glass products, together with the Karhula glassworks. Individual

Chapter 4). But, as was the case in other European countries, there were also marked tensions in Eastern Europe between those who looked to international developments in design and those who sought to define national identity through association with vernacular, peasant and craft traditions. Such tensions came to the fore in Poland in connection with her display at the Paris Exposition des Arts Décoratifs of 1925, where the craft-oriented, applied arts outlook of the Cracow Workshops was seen by progressive factions as irrelevant to the realities of modern twentieth-century life. After the First World War Warsaw had emerged as the centre of the avant-garde, with many of her designers having studied elsewhere in Europe, including Austria, Germany, and Russia. Aware of the outlook of De Stijl and Russian Constructivism, progressive artists rallied under the title Blok, also the name of their magazine, in 1924. Although lasting only two years, the group was increasingly riven by debates, similar to those which had taken place a few years earlier in Russia, in which the autonomy of artistic creativity and abstract form as agents of social and cultural change in their own right was posited against a commitment to harnessing modern forms to the possibilities of mass-production technology. Many of those representing a more functional outlook became members of Praesens, formed in 1926, an internationally oriented group focused around a journal of the same name. As with many of their modernist counterparts elsewhere in Europe, architecture was seen to be at the root of a social and aesthetic revolution. However, as in many other countries, the number of opportunities to implement the modernist agenda was limited by the prevailing economic conditions. Despite a number of noteworthy experiments in working-class

35 Adolf Syszko-Bohusz and Andrej Pronaszko

Boudoir furniture, Presidential Castle, Wisła, 1930

In the light of contemporary debates between progressive and traditionalist factions, the adoption of an emphatically modern aesthetic for an official commission caused considerable debate in the Polish architectural and design press. This confident use of chromium-plated tubular steel in furniture manufactured in Poland marked the influence of the Praesens group in avant-garde circles. However, such modernist designs were never put into large-scale industrial production and the modernist cause became more muted as the 1930s unfolded.

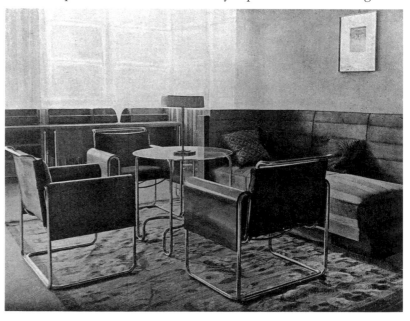

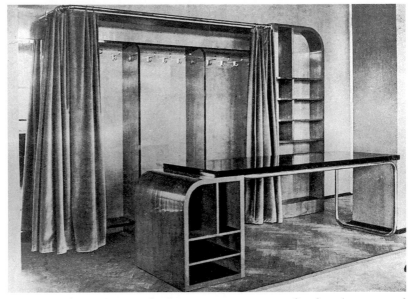

housing, the majority of achievements were confined to houses and apartments for the wealthy [**35**, **36**] and, as the 1930s unfolded, there was a move away from more 'internationalizing' tendencies towards a position in which the modernist spirit was tempered with a greater acknowledgement of vernacular and regional considerations.

Like the Bauhaus in Germany, educational establishments in Eastern Europe were also important vehicles for the spread of modernism. For example, in Russia the Constructivist outlook of the Moscow Vkhutemas school of design, founded in 1920, provided an important stimulus for the training of artists in industry, closely allied to the desire for cultural regeneration; in Poland the School of Architecture at Warsaw Polytechnic was a powerful advocate of the new spirit in design. Elsewhere there were other educational institutions which were modernizing in their educational philosophy as, for example, the Bratislava School of Applied Arts, founded in Czechoslovakia in 1928 under the directorship of Josef Vydra. Stressing a close relationship between architecture, the applied arts, and industrial production, its aim was to modernize, and raise standards of, domestic manufacture. However, as in Germany a few years earlier, the oppressive political climate of the late 1930s forced the school to close its doors in 1939.

Commerce, Consumerism, and Design

3

The United States: design and consumption as a way of life

As will be clear from the preceding chapters, a considerable gulf existed between the aspirations of progressive designers, theorists, and reforming organizations and the realities of mass-consumption. In 1920s Europe the attention of the avant-garde was largely directed towards a particular notion of the *Zeitgeist*, or 'spirit of the age', which looked to abstract forms and their symbolic, rather than functional, relationship with modernity together with the economic implications of standardization and mass-production technology. However, in the United States, notions of contemporaneity found material realization in popular perceptions of the power of technology to create exciting new products for mass consumption. There was also an intensification of consumers' levels of material expectation and aspiration through the calculated awakening of their latent desires by manufacturers, designers, and advertisers [**37**]. During this period the American advertising industry was transformed from a relatively unsophisticated medium to one which began to pay far greater attention to possibilities offered by an understanding of consumer psychology. Furthermore, the increasing influence on everyday life of the cinema, gramophone, the automobile, and the large-scale corporation did much to interest the general public in the dramatic utopias envisaged by many industrial designers in exhibitions, such as the Chicago Century of Progress Exhibition of 1933/4 and the New York World's Fair of 1939/40, or even in popularizing texts, such as Norman Bel Geddes's propagandist *Horizons* of 1932.

The First World War had had a considerable effect on US industrial capacity, leading to a doubling of industrial production and significant increases in purchasing power in the following decade. There were other factors which affected such changes: the end of mass immigration in 1921 further stimulated the growth in the mechanization of labour; the expansion of the electricity supply industry alongside a housing boom led to a dramatic increase in the volume and range of domestic appliances which themselves became consumerist symbols stylistically expressive of an ephemeral contemporary lifestyle; and the further adoption of new methods of factory management and the implications of rationalization, standardization, and scientific man-

37

Marbett's (White Tower)
Restaurant, Camden,
NJ, 1938

This roadside New Jersey
restaurant, the first de luxe
White Tower outlet, was an
archetypal symbol of 1930s
American commercial life,
the name Marbett's being
adopted to give the allusion
of competition. The Deco-
inspired glazed, curving
windows, the striped
horizontal decorative, and
neon bands had, by the 1930s,
a particularly American flavour.
The rounded corners reflected
the vogue for streamlining,
and the prominent signage
tower recognized the
importance of communicating
with passing automobile
traffic. The usherettes'
'commander' performed
his work on rollerskates.

agement embraced by the Taylorist and Fordist outlook of the pre-
First World War era. However, despite such positive stimuli, the mar-
ket had begun to reach saturation point by the mid-1920s, and the
increasing employment of designers to boost sales through the
restyling of the appearance of a wide variety of products had only a lim-
ited effect on the wider economic horizon, which was conditioned by a
severe slump, culminating in the Wall Street Crash of 1929. Perhaps
the most significant expression of the economic opportunities afforded
by the implementation of a consumer-oriented design policy in the
1920s was in the automobile industry, particularly at General Motors,
where the introduction of an annual body change and an increasing
choice of colours did much to boost sales and encourage the acceptance
of built-in obsolescence.

The growth of the industrial design profession in the United States

The Wall Street Crash of 1929 had a devastating impact on the
American economy. It also brought about significant changes in the
profession of the industrial designer, which moved away from concerns
with the outward styling of products towards a more developed under-
standing of materials, manufacturing processes, marketing strategies,
and consumer aspirations. In business circles, through the agency of
such key texts as Roy Sheldon and Egmont Arens's *Consumer En-
gineering: A New Technique for Prosperity* of 1932,[1] increasing currency
was also given to the idea that 'consumer engineering' was a potent
means of shortening the cycle of consumption through its emphasis on

the fashionability and ephemerality of everyday goods. Otherwise known as 'planned obsolescence', such an outlook was a significant factor in the recovery of the American industrial economy and achieved credibility as an important ingredient of business strategy through its utilization of studies in behavioural psychology and market research.

It was in such a milieu that the first generation of American industrial designers emerged as notable figures: Norman Bel Geddes, Harold Van Doren, Henry Dreyfuss, Lurelle Guild, Raymond Loewy, Walter Dorwin Teague, Harold Van Doren, and Russel Wright were amongst the better known. Since there was no vocationally-oriented training available to them,[2] they came from a diverse range of backgrounds including engineering, illustration, advertising, and theatre design. Many of them, particularly Bel Geddes and Loewy, were adroit self-publicists and were given further credibility by frequent discussions of the potential role of industrial design in the American business magazine *Fortune*. Founded in 1930 by the publisher Henry Luce, in addition to the promotion of design as an important adjunct of business the magazine set high standards in editorial design circles and featured many dramatic covers that articulated the progressive technological spirit with which many members of the American public identified in the 1930s. Norman Bel Geddes, in his highly propagandist and futuristic text of 1932, *Horizons in Industrial Design*, even went so far as to portray industrial design as the true art form of the twentieth century when he wrote:

When automobiles, railway cars, airships, steamships or other objects of an industrial nature stimulate you in the same way that you are stimulated when you look at the Parthenon, at the windows of Chartres, at the Moses of Michelangelo, or at the frescoes of Giotto, you will have every right to speak to them as works of art.

Just as surely as the artists of the fourteenth century are remembered by their cathedrals, so will those of the twentieth be remembered for their factories and the products of those factories.[3]

Raymond Loewy, who was accorded celebrity status after the Second World War through his appearance on the cover of *Time* magazine in 1949 [**38**], surrounded by many of the key products designed in his offices, had also done much to promote a mythical picture of himself as an individual who altered single-handedly the visible form of the material environment of North America. With a keen eye for publicity he was often portrayed in photographs standing on Loewy-designed railway locomotives, seated in Loewy-designed automobiles, or nonchalantly posed in a fictive, laboratory-like, industrial designer's studio, such as that shown at the Metropolitan Museum of Art's Contemporary Industrial Art Exposition of 1934.

American industrial design: the creation of myths

Much has been written about the visual impact on the everyday mater-
ial environment exerted by a number of leading designers. As has been
suggested, industrial designers themselves[4] did much to celebrate their
role in the developing consumerist climate of the 1930s, a tendency
subsequently carried further by many historians and museum exhibi-
tions.[5] They were also featured in a number of publications, ranging
from articles in the design and business press through to features in the
Sunday supplements. Furthermore, leading industrial designers
worked for major corporations thus rendering their output highly vis-
ible and pervasive: Teague's clients included Kodak, Ford, and Texaco,
Loewy's Sears Roebuck, the Pennsylvania Railroad, and Studebaker,
Bel Geddes's Standard Gas Equipment Company and General

Motors, and Dreyfuss's Bell Telephone and New York Central Railroad. Vacuum cleaners, cookers, refrigerators [**39**], radios, clocks, shops, packaging, furniture, office equipment, automobiles [**40**], trucks, and passenger coaches, railway locomotives and rolling stock, aircraft interiors and ocean liners were among the almost limitless range of commodities to which they helped give contemporary material expression [**41**].

However, as considered briefly in Chapter 1, an undue emphasis on the notion of 'Pioneers' and the achievements of individual celebrities tends to distort their importance. As Daniel Miller argued in his attack on what he saw to be prevalent design-historical practice in *Material Culture and Mass Consumption* of 1987, this could be seen as 'a form of pseudo art history, in which the task is to locate great individuals such

39 Raymond Loewy

Coldspot Refrigerator for Sears Roebuck, 1935

This was one of Loewy's most celebrated early commissions. Loewy was brought in by Sears Roebuck in 1932 to design a new refrigerator for its range, resulting in the Coldspot of 1935. As can be seen here, it was sold on far more than functional terms: the consumer is asked to 'Study its Beauty'. As well as many innovatory features like rustproof aluminium shelving, its rounded, streamlined form, complete with logo, exudes a spirit of contemporaneity, endowing a domestic object with the same qualities found in automobiles.

as Raymond Loewy or Norman Bel Geddes and portray them as the creators of modern mass culture'.[6] As an anthropologist Miller was arguing for greater recognition of the transformation of goods in consumption as a means of understanding material culture, but even from a more conventional historical perspective undue emphasis on the individual is somewhat misleading. Harold Van Doren in his 1940 text, *Industrial Design: A Practical Guide*,[7] stressed the importance of specialist collaboration as a means of achieving greater levels of effectiveness in the industrial design profession and suggested that a design team should include a designer, an engineer, a technical expert, a manufacturer, a merchandiser, and others with a knowledge of production planning and channels of distribution. Indeed, in the 1930s the offices of leading industrial designers were often quite sizeable: in 1934 Bel Geddes's office embraced design, drafting, modelling, and technical activities, employing about 30 with outside specialists being brought in as required; by 1937 Teague employed 25; and by the end of the decade the flamboyant Loewy employed 60. None the less, although much of the literature of American industrial design has tended to emphasize the positive achievements of the emergent design profession, this was not a representative picture of the ways in which it was recognized by industry at the time. Harold Van Doren, as late as 1940, was at pains to stress that the designer's position in industry was still tenuous, with the majority of manufacturers either unconvinced by, or unaware of, the efficacy of design as a business tool. He related that many of them were unused to budgeting appropriately for the implementation of a design programme and expected immediate results rather than the necessity of investment in longer-term strategies.

The mass media as stimuli for consumption

Like the highly influential mail-order catalogue, the radio did much to bring about a greater homogeneity in national patterns of taste, especially with the erosion of regional barriers through the formation of national radio networks by NBC and CBS, respectively in 1926 and 1927. During the 1930s the cost of radio purchase had fallen dramatically and small ('baby') radios retailed for as little as $10, making them widely accessible to most income groups. Just as the *Volksempfänger* ('People's Radio') was an important instrument of political propaganda in Germany under the Third Reich, so the radio in the United States was an important advertising medium for the goods and services of large-scale corporations. By the later 1930s radio advertising was highly significant in economic terms, and advertisers competed to promote all kinds of products at prime listening times. These included radios themselves, gramophones, domestic appliances, kitchen equipment, home furnishings, and automobiles, as well as foodstuffs and other domestic goods.

Several writers[8] have suggested strong parallels between the futurist Utopias of popularizing industrial designers such as Norman Bel Geddes and the visions described in contemporary science fiction, a genre which flourished in the late 1920s and early 1930s. The same years also saw the birth of the popular comic-strip heroes Buck Rogers, Flash Gordon, and Superman, and magazines such as Hugo Gernsback's *Amazing Stories, Astounding Stories*, and *Wonder Stories* collectively sold more than 1.5 million issues per annum at the height of their popularity in 1935. Concepts such as speed and change, and the exploration of the possibilities of new materials, together with the development of new modes of transport and appliances were also common to both the more extravagant futures portrayed by Bel Geddes and many science-fiction writers, illustrators, and film makers. There

41 Staubsauger

Champion vacuum cleaner, Type OK, Holland, late 1930s

The dramatic shape of this chromium-plated, streamlined vacuum cleaner reveals the extent to which American-inspired styling had permeated European markets, with the fascination for the aerodynamic forms of contemporary transport designs permeating the domestic arena.

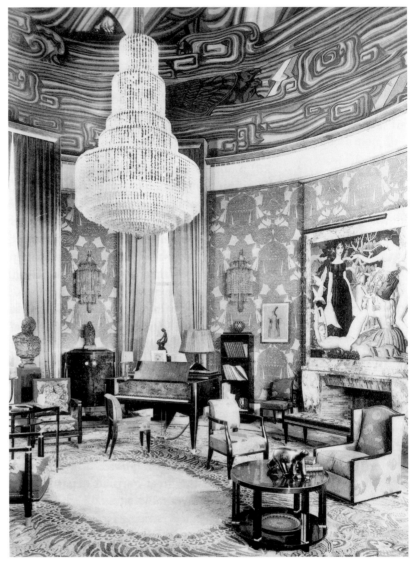

44 Jacques-Emil Ruhlmann

Interior of the *Hotel d'un Collectioneur*, Exposition des Arts Decoratifs et Industriels, Paris, 1925

This pavilion epitomized the underlying aim of the 1925 Exposition—to reassert French prestige in the decorative arts and crafts. The luxurious display included the work of many of the leading French contemporary decorative artists as a counterpart to the many items of furniture designed by Ruhlmann himself. A prominent figure in such work, with his own furniture workshops, he also designed textiles, carpets, and other elements for the creation of a complete ensemble.

the French sections, which amounted to about two-thirds of the whole 57-acre site. Many of the most dazzling French displays were located in the displays of the Société des Artistes Décorateurs. Entitled 'Reception Rooms and Private Apartments of a French Embassy', it occupied twenty-five fully furnished rooms set round a three-sided courtyard. The Smoking Room by Jean Dunand, with its Cubist-inspired forms and decorative motifs, stepped silver ceiling set off against highlights of red lacquer, and wall facings of black lacquer, attracted considerable attention. However, its relevance to the average consumer was restricted to glamorous reinterpretations in Hollywood film sets, modernistic cinema foyers, and other public spaces intended to impress their occupants [**46**], such as restaurants, the interiors of ocean liners [**47**], or the foyers of important business enterprises.

Paris 1925 and the United States

Although not a participant at the 1925 Paris Exposition des Arts Décoratifs et Industriels,[15] the United States appointed a commission of over a hundred representatives drawn from a wide range of industries and institutions to visit it and report on the state of contemporary European design. Charles Richards, Director of the American Association of Museums, headed the commission and subsequently organized a touring exhibition of designs drawn from the 1925 exhibition which was shown in nine museums in the USA, commencing with the Metropolitan Museum in New York. Drawing on diverse sources such as Fauvism, Cubism, Purism, and African art, the Art Deco style was characterized by flat, geometric abstract motifs used in a decorative manner, often deriving from sunbursts, lightning flashes, fountains, flowers, and other organic forms. Such abstract forms soon became fashionable, and the style was actively promoted by leading stores throughout the country, many of whom also mounted exhibitions.[16] In New York, artists such as Erté and Raoul Dufy designed for the Amalgamated Silk and Onondaga Companies, and firms such as Cheney Brothers and F. Schumacher & Co marketed French textiles alongside other ranges.

45 André Fréchet

Lahalle and Lavard, reception hall for the Studium-Louvre Pavilion, Exposition des Arts Décoratifs et Industriels, Paris, 1925

Many of the qualities found in Ruhlmann's pavilion (**44**) are reflected here, but at more affordable prices. The Studium-Louvre was one of the major Parisian department stores with its own decorating studios. The 1925 Exposition offered them an unprecedented opportunity to show potential clients the fullest display of designs which could grace the fashionable Art Deco home.

formulae, can be seen to embrace notions of national identity in design, as will be discussed in Chapter 4. Similarly, the floral patterns adorning countless tea-cups and furnishing textiles may be interpreted as communicators of an 'essential' Englishness rather than summarily dismissed as hackneyed designs.

The Art Deco style exerted a significant impact in Britain across many design media and was a highly commercial style, including many items at the cheap, novelty end of the market. Its flat, coloured, geometric patterns could be found in the 'sunrise' motifs (contemporary symbols of health) on thousands of wooden garden gates, front doors, gable ends, packaging, fabric designs, carpets, tableware, jewellery, and other ornamental products. Its zig-zag, chevron, and other geometric patterns could also be found in typography, posters, and shop-fronts. The Deco vocabulary was widely adopted in both interior and exterior designs for cinemas, particularly those associated with Oscar Deutsch's Odeon chain. Other notable commissions included Ronald Atkinson's 1932 foyer of the Daily Express Building in Fleet Street, London, Oliver Bernard's foyers for the Strand Palace Hotel of 1929–30 and the J. Lyons and Company Ltd's New Oxford Street Corner House in central London, and Wallis, Gilbert, and Partners' Hoover factory in West London of 1931–2. There were also a number of potteries producing a wide range of artifacts, including tea and coffee services, bowls, vases, and ornaments at prices which many could afford. Among the more notable manufacturers were Carlton Ware, Foley Potteries, A. E. Gray, and Shelley Potteries [49]; women designers, including Susie Cooper, Clarice Cliff, and Charlotte Rhead, were also prominent in the field.

Other sites of commercial display: England and France

Barometers of commercial production and consumer interest in Britain may be found in trade catalogues and periodicals, as well as the range of home-making magazines which grew considerably after the war. The vast range of exhibits at the annual British Industries Fairs (which commenced on an annual basis in 1915 as a manufacturers' 'shopwindow') and the displays and show houses at the increasingly popular *Daily Mail* Ideal Home Exhibitions are also revealing. The latter commenced in 1908, with 160,000 visitors in its first year, and nearly 700,000 even in the depression of the early 1930s. In the 1950s and 1960s there were regularly more than 1 million visitors, tailing off in the later 1970s and early 1980s to an average of about 900,000. Many of the exhibitions were widely reported in the media, and catalogues and related ephemera, including visual material, are extant.[22]

In France the idea of domestic management caught the public imagination. Martine Segalen, social anthropologist, sociologist, and historian has described the Salon des Art Ménagers (SAM, Exhibition

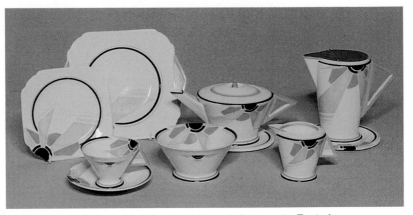

of Domestic Science) held as public exhibitions in Paris between 1923 and 1983 as

the most vocal institution providing the French popular classes with information, norms, and education on all aspects of housing furnishing, home decoration and domestic management. As a producer and consumer society developed, in which producers undertook to develop goods geared towards the home, the SAM occupied an instrumental position between those who manufactured domestic goods and those who were expected to buy them.[23]

It began in the Champ de Mars in Paris in 1923 as the 'Salon des Appareils Ménagers' with a clear focus on domestic appliances, attracting over 100,000 visitors, and moved to the Grand Palais in 1926 where it was retitled the 'Salon des Arts Ménagers'. In the same year Paulette Bernège founded the Institut d'Organisation Ménagère (Institute for Household Organization) and in 1932 was a key figure in the establishment of the Ligue d'Organisation Ménagère (League for Household Organization). The prime mover behind the Salons themselves was Jules-Louis Breton, who had been Under-Secretary for State for inventions during the war, and who also coined the term 'arts ménagers'. Both Breton and Bernège were important figures in what was essentially an educational movement, one which attracted increasing public interest. (In Britain perhaps the nearest equivalent was the Council for Scientific Management in the Home—COSMITH—which had begun in 1931.) By the 1930s the Salons had embraced the exhibition of furniture and room settings, and the work of members of the UAM (Union des Artistes Modernes) was frequently featured. In 1939 the Salon attracted 608,000, a figure which rose in the postwar years to more than 1,400,000 in 1955. However, as patterns of consumption changed and marketing and retailing mechanisms became increasingly sophisticated, the socio-educational role of the Salons was diminished, leading to their final demise as public events in 1983.

Design and National Identity

Paris 1925 and 1937: tradition, vernacular design, and national identity

The study of international exhibitions reveals much about the designing of national identity,[1] although the design and content of national pavilions were often constructed to portray particular facets of nation states [50] or political regimes. As such they may be seen as bearers of myths rather than accurate reflections of more deep-seated national traits. Having examined in Chapter 3 the intended focus of the projection of French decorative arts and craftsmanship at the 1925 Exposition des Arts Décoratifs et Industriels in Paris, we turn now to other dimensions of this and its 1937 successor.

Although the 1925 exhibition regulations had stipulated that only 'articles of modern aspiration and real originality should be shown', a stipulation which led to a certain amount of confusion before the exhibition and a considerable amount of criticism afterwards, a number of nations sought to stress their artistic heritage as a continuing and important ingredient of their current identity. Just as the French artistes-décorateurs had acknowledged past styles and traditions in their lavish room settings, furniture, and furnishings, so a number of other countries looked to their artistic roots in peasant and folk art traditions as an important feature of their exhibits. This was true of the Polish displays which were underwritten by the Polish government, eager to promote a positive national identity on the international stage.

Founded in Cracow in 1901, the Polish Applied Art Society (Towarzystwo Polska Sztuka Stosowana) had sought to identify specifically Polish characteristics in design as a unifying force in the face of the complex political and boundary shifts with which Poland was faced.[2] This nationalizing impetus was revived by the formation in 1913 of the Cracow Workshops, which also vigorously promoted a Polish style rooted in vernacular and peasant traditions. After the end of the First World War the aesthetic and ideological aspirations of Cracow School designers were increasingly influential, culminating in their dominance in the national exhibit at the Paris Exposition of 1925. The Polish Pavilion, designed by Józef Czajkowski, contained colourful murals (which drew upon peasant festivals and Slavic myths for

50 Y. Utida and Y. Matsui

Interior of the Japanese
Pavilion at the New York
World's Fair, 1939

The Japanese Pavilion, set in
a traditional Japanese garden,
laid particular emphasis on
the country's cultural heritage.
The Grand Hall shown here
exhibits many of the artistic
traits associated with her past,
styles increasingly recognized
in the West since the mid-
nineteenth century. Such a
projection of national
identity, complete with tea
ceremony and kimono-clad
attendants, avoided the
political and economic
problems engendered by
Japanese manufacturers'
cheap imitation of many
western products in the
1920s and 1930s.

their subject matter), tapestries, furniture, and fittings which were
every bit as coherent as the ensembles of the French artistes-
décorateurs [**51**, **52**]. Reflecting the Arts and Crafts origins of many of
the main exhibitors and wedding the vernacular with the contem-
porary, the display attracted favourable attention from the Exposition
juries.

At the 1937 Exposition Internationale des Arts et des Techniques
Appliqués à la Vie Moderne the importance of national projection
through design was especially evident in the striking propagandist
architecture and displays of the German, Soviet, and Italian Pavilions.[3]
Josep Lluis Sert's Pavilion of the Spanish Republic, its very presence a
symbol of anti-Fascism, was also highly politicized. The displays of the
Fascist and totalitarian pavilions stressed industrial and technological
achievements alongside overt visual propaganda reinforcing the
mythological constructs which tied the present to long-standing tradi-
tions and heritage. The Spanish Pavilion, on the other hand, unam-
biguously laid stress on art and culture as powerful expressions of a free
and democratic state.

In such a highly charged political and propagandist context it is
unsurprising that some countries at the 1937 Exposition actually sought
to suppress peasant handicraft in their displays, considering that they
were symptomatic of a 'backward' past rather than stimulating con-
temporary reinterpretations of tradition. However, popular, peasant,

51 Józef Czajkowski

Chair for the office in the Polish Pavilion at the Paris Expositions des Arts Décoratifs et Industriels Modernes, 1925

The design of this chair embraced the beliefs of the Cracow School which sought to further the idea of a Polish national style, drawing inspiration from the forms and decorative motifs of peasant art. Although the carving of the arms and the patterned textile on the seat and back looked to vernacular traditions, it should not be seen as literally retrospective. For its designers it represented the modern re-affirmation of a culture which had been under political threat since before the Treaty of Versailles in 1919.

and folk art featured in more than sixty pavilions. A number of exhibiting countries chose to set such work within a modernizing context, whilst others sought to stress unambiguously national, and thus indigenous, characteristics in their crafts [**53**, **54**]. The Hungarian,[4] Rumanian, Polish, and Portuguese pavilions exhibited the most vital displays of peasant art. The Polish displays, set within a modernist setting, endorsed the vernacular as an important aspect of national culture. In addition to the luxury goods displayed by French designers in the main pavilions, French regional and historical styles were also shown in the Centre Régional. The more exotic decorative styles drawn from the different cultures of the French colonies could be seen in the Île de Cygnes, which included exhibits from French Equatorial Africa and the Cameroons, as well as Indochinese craft shops and Moroccan markets.

British identity in design: retrospection and ruralism

In the first sentence of her 1989 book on *British Design: Image and Identity*, the Dutch design historian Frederique Huygen characterized certain aspects of the projection of Britain:

British design: Burberry raincoats, floral interior fabrics, Jaguars, Shetland pullovers, Dunhill lighters, and Wedgwood pottery. Tradition, respectability and quality. This sort of Britishness forms but part of this book, for there are many more faces to British design than the clichés listed above.[5]

Writing over forty years earlier, John Gloag, a tireless campaigner for the acceptance of a modernist aesthetic in British industry, had identified another range of clichés in *The English Tradition in Design* when he railed against what he perceived as a false tradition in twentieth-century English design. He felt it was

submerged by a wave of faking and imitation, and the real English genius was marked by a false 'Olde England'—a shoddy and flimsy form of taste which still persists. Only very slowly is it being realised that 'ye olde England' is neither real nor English but a hollow sham.[6]

Whether a 'false' tradition or not, like the clichés identified by Huygen, 'Olde England' has played a significant role in the sociology of British design,[7] whether reflected in the style of housing and furnishings purchased by millions in the interwar years, or in many aspects of the official projection of British values, history, and heritage at home and abroad. The Tudor world evoked from the latter half of the nineteenth century onwards was emphatically rural in its composition. Many writers, commentators, and others believed that the true essence of England was to be found in the countryside, rather than the false, essentially 'un-English' values of urban life.[8] This emphasis on a pre-industrial heritage was also used in a number of international exhi-

bitions for the official projection of Britain, from the Paris Universelle Exhibition of 1867 onwards. As Britain's industrial leadership came under increasing threat from other countries in the later nineteenth century, so it was considered important to display her imperial powers as significantly predating the industrialization process.

Such a retrospective profile continued to be developed in the public arena in the early twentieth century and was celebrated at the British Empire Exhibition held at Wembley in 1924/5. It is not an exhibition to which historians of British design[9] have devoted a great deal of attention, despite the fact that it covered 216 acres of North London, involved an expenditure in excess of £4.5 million, and attracted 17.5 million visitors in its first season.[10] This contrasts with the considerable design-historical attention devoted to the Paris Exposition Internationale des Arts Décoratifs et Industriels which attracted one-third of the number of visitors and was confined to a site of a quarter of the size. It should be remembered also that views of the declining potency of the British Empire as a force of popular significance between the wars were heavily influenced by writers such as Robert Graves, George Orwell, and other intellectuals whose opinions have been interpreted as widely representative.[11] The British Empire Exhibition at Wembley provided an important vehicle for reinforcing or moulding contemporary attitudes, since much of the imagery on display utilized archetypal symbols of power and authority and constantly evoked Britain's historical and imperial heritage. For many, in the economically turbulent climate of the 1920s, trading within the British Empire offered a route to future economic prosperity. In support of this idea the state-funded Empire Marketing Board (1926–33)

52 Józef Czajkowski and Wojciech Jastrzebowski

Office interior in the Polish Pavilion, Paris, 1925

Planned as an office for a government official this ensemble by leading members of the Cracow School represented a strong affirmation of national identity. In common with parallel debates in other countries, the display attracted hostility inside Poland where progressive factions argued for an unambiguously modern and international aesthetic rather than what was interpreted as passéist national romanticism. Such attacks were largely generated by those associated with Blok, a group founded in Warsaw in 1924.

53

The Tractor, textile design by
V. Maslov, USSR, late 1920s

The overt political message
of this textile print celebrated
the national importance of
agricultural progress as an
element of Stalinist ideology
and can be linked to the
hcroization of the agricultural
worker in many posters of the
1930s. In line with the political
outlook of the late 1920s and
1930s such evocative cultural
propaganda paved the way for
Socialist Realism, spelling the
demise of the less obviously
didactic avant-garde forms of
the Constructivists.

displayed constantly changing displays of striking posters in promi-
nent sites in the major towns and cities of Britain as a means of pro-
moting imperial trade.

The conservative, historicizing tastes of the British consumer were
evident in many parts of the Wembley exhibition, including the Palace
of Industry, where the section devoted to furniture, floor coverings,
and textiles was seen to exemplify the belief that 'all modern decoration
must be more or less based on tradition'.[12] Whilst by no means all
rooms were devoted to past British styles and traditions, the Palace of
Arts contained a historical résumé of rooms decorated in the styles of
1750, the 1820s, 1852, 1888, and 1924, and the furniture and interior
design firm Waring & Gillow display rooms included a Georgian
library; many other traditional forms were to be found in furniture and
furnishings of the gas and electricity exhibits. Similar historicist incli-
nations were in evidence at the annual *Daily Mail* Ideal Home
Exhibitions, the British Industries Fairs, and in the majority of furni-
ture stores. This sense of retrospection and identification with a pre-
industrial past was also evident in the many hundreds of thousands of
Mock-Tudor houses which were erected in the rapidly growing sub-
urbs of the interwar years, replete with barge-boarded gables, leaded
windows, and heavy oak front doors with coloured stained-glass insets
of Elizabethan galleons and other references to bygone eras [**55**]. Much

of the furniture in the living areas of such houses also exuded a similar sense of historical retrospection, blending with wood-panelled halls and dining rooms, fireplaces with inglenook seats, and Jacobean style dining suites with machine-cut and stamped mouldings.

Another important aspect of British national identity promoted abroad related to leisure and recreation, a feature which was prominent in the British Section at the Monza exhibition of 1930 [**56**]. *The Studio* commented that 'the Englishman invented modern sport and stands supreme in the design and execution of its appliances, both for field and games, and the present group [of objects] symbolises a few of the things that find their way into a man's dressing room today'.[13] Included were golf clubs, tennis rackets, and boxing gloves, 'all of the finest workmanship', exhibited by Lillywhites, brightly coloured blazers by Ryder and Amies of Cambridge, and a sporting gun by Greener. The leather and sporting goods shown at the Exhibition were favourably reviewed. Sporting and leather goods were also singled out for praise at the British Industrial Art Exhibition held in Copenhagen the following year.

At the much larger Paris International Exhibition of 1937 the official British display concentrated on the theme of the English weekend, reinforcing the idea endorsed by a number of contemporary

54

Central Russian Folk Art, USSR Pavilion, Paris Internationale Exposition, 1937

Such traditional designs were at the root of a vernacular, peasant culture which the State sought to promote alongside the wider heroization of workers on the land.

The *Henry VIII* Dining-Lounge, Bolsom's Furniture Catalogue, c.1935

Such oak furniture with 'an authentic dark Antique finish' was firmly associated with an incontrovertibly British historic past. Widely affordable through hire purchase schemes, it reflected the retrospective outlook of many British consumers in the interwar years. A natural counterpart to the countless leaded-windowed mock-Tudor houses which were a significant feature of speculatively built suburbia of the 1930s, such designs accorded with leanings towards an economic future vested in the British Empire, rather than the more competitive markets of Europe.

writers and critics that the countryside was the essence of England. Widely represented in contemporary photographs, paintings, posters, and poems, the countryside was also seen as a location for shooting, hunting, walking, and entertaining. In the British Pavilion the photo-mural display included scenes of harvesting, ploughing, village cricket, country houses, cathedrals, and landscape views. As Christopher Hussey remarked in the Exhibition Catalogue:

Though circumstances may compel him to live and work in cities, the Englishman is still in most cases a countryman at heart to the extent of preferring to take his pleasure in the country.

When he can afford it, he has his own weekend cottage, his ideal being a picturesque old yeoman's dwelling with an old-fashioned garden. There he can, for two days a week, indulge the romantic dream that he is a country gentleman and be refreshed by the complete contrast to his everyday life.[14]

But, as at Monza and Copenhagen and other British exhibitions of the period, at the Paris Exhibition there was also a considerable emphasis on the significant display of sporting goods and equipment. Cricket, golf, tennis, fishing, football, and darts were seen as embodiments of the English spirit and heritage. Sport had also played an important, though unofficial, part in imperial policy by exporting notions of a 'British way of life' and 'fair play': cricket was a particular conveyor of such ideals, bringing with it notions of green lawns, afternoon tea, and reminiscences of the archetypal village green beside the church. All such ideas represented a projection of national identity distinct from the overt and aggressive propagandist outlook of a number of other countries at the 1937 Exhibition, especially Germany and the USSR. As was remarked by a member of the organizing body for the

Gentleman's Sporting
Equipment from the British
Display at Monza, 1930

The association of the British
with high-quality sporting
goods was a feature of many
displays of British goods
abroad in the interwar years,
most notably at Paris in 1937
where notions of 'fair play'
were in marked contrast to
the more overt political
propaganda of Germany and
the USSR. Included in this
illustration is 'an appropriately
simple chest of drawers',
fashioned from Empire woods
and designed by Betty Joel.

British display, the 'British Pavilion at an Exhibition ought to be a demonstration of the way of living in a non-totalitarian state and should not be a trade exhibit.'[15] As the photographic historian John Taylor has pointed out in his study *A Dream of England*,[16] images of the English countryside were particularly important aspects of propaganda. For example, in *Picture Post* of 13 July 1940, striking contrasts were made between photographs of the English and German ways of life. England was typically symbolized by a photograph of a country cottage which stood for 'England: where each one can work out his own life' or a half-timbered house representing 'England: where a man's home is still his castle'. Conversely, the German way of life was represented as regimented, mechanized, and totalitarian. On the cover

57 E. Ravilious

Boat Race earthenware bowl, manufactured by Josiah Wedgewood & Sons, 1938

Although working in a contemporary graphic style, Ravilious also drew upon traditional techniques of form and decoration. Transfer-printed and overpainted in enamel colours, the subject is the Oxford and Cambridge Boat Race, a national event since its inception in 1829. It took its place alongside other national institutions identified in Stephen Tallents' booklet *The Projection of England* (1932) which argued for the promotion abroad of traditional aspects of the English character and way of life.

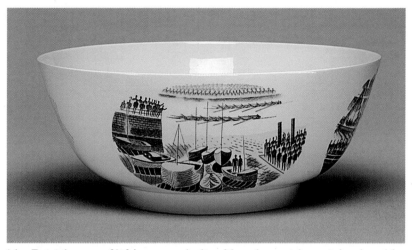

'the British way of life' was symbolized by a boy with a cricket bat, 'the German way of life' by a uniformed militaristic Hitler youth.

In 1932 an important document in terms of cultural propaganda was written by Stephen Tallents. Entitled *The Projection of England*[17] it invoked a number of British attributes such as 'a reputation for coolness' in national character, 'a reputation for disinterestedness' in international affairs, 'a reputation for fair dealing' in commerce, 'a reputation for quality' in manufacture, and 'a reputation for fair play' in sport. He also pointed to important 'institutions and excellencies' which included Oxford, Bond Street, the English countryside, the English home, English servants, football, foxhunting, gardening, and tailoring [**57**, **58**].

While many such traits were clearly in evidence at the British display in Paris 1937, they continued to be an important part of the projection of British national identity in the post-second World War era. Where the overseas promotion of British identity in design was concerned there were two very different standpoints, both funded by the Board of Trade. One represented the 'good design' ethos of the Council of Industrial Design, the other, more favoured, supported that of a historic heritage rooted in the past, paired with British inventiveness and scientific achievements such as the Dounreay reactor or the Jodrell Bank telescope. In general terms, historians of British design[18] have concentrated on the former to the virtual exclusion of the latter, which was even supported by a special Board of Trade display package for British weeks abroad, entitled *Past and Present*.[19] Even at an important international exhibition, such as that at Brussels in 1958, there was a commemorative wall-plaque in one of the courtyards of the official British display, proudly proclaiming that 'in Britain roses grow on tea cups and wallpapers'.

The close relationship between the countryside and 'Englishness' has been sustained in many areas of design. Perhaps most obviously,

ARRANGEMENT OF 56 SEATER DOUBLE DECK BUS (Central)
Approved Colour Scheme.

TYPE S.T.L. II DRAWING No BP. 103/1

58

Approved colour scheme for an STL double-decker London bus from a hand-painted specification book prepared at Chiswick works, late 1940s

The red double-decker London bus became an archetypal symbol of Britain at many exhibitions and trade shows from the 1930s onwards, being used to promote the Festival of Britain of 1951 in a promotional tour through Scandinavia, Germany, Holland, Belgium, Luxembourg, and France. Such readily recognizable symbols of Britain continued to be part of official propaganda overseas for several decades despite the aesthetic didacticism of the essentially modernist Council for Art and Industry and Council of Industrial Design.

this can be seen in the output of the clothing and interior decoration company Laura Ashley which, since its origins in fabric prints in the 1950s, has become identified with an 'English country look' in clothing, wallpapers, and other cottage and chintz accessories. Its international outlets around the globe have all continued to promote this characteristic national identity. This is also evidenced in many other fields. In ceramics, for example, the *Old Country Roses* tableware range designed by Harold Holdcroft in 1962 for Royal Albert, has sold almost 100 million pieces around the world. It proves the enduring attraction of the 'country garden' theme [**138**], first introduced by the company in 1893.

Germany: the two faces of national identity in design in the 1930s

As the design historian John Heskett has argued in a number of publications[19] there has been an oversimplification of German design identity in the interwar years. This has often been characterized by the portrayal of the Weimar Republic as a period in which modernism flourished to the apparent exclusion of other styles and traditions; also

59 'Kleinempfänger'

Little Radio, Germany, 1938
This straightforward functional
State product, with ornament
almost entirely restricted to
the eagle and swastika motif
of the Third Reich, was in
many ways attuned to the
modernist aesthetic of the
1920s which the Nazi regime
outwardly did so much to
discredit in a number of fields
of design and architecture.

60

Members of the
Reichsarbeitsdienst (RAD)
listening to a radio broadcast,
1935
These members of the Men's
Division of the State Labour
Force are gathered round a
Volksempfänger VE 301,
People's Radio. Originally
designed by Walter Maria
Kersting in 1928, it was put
into mass-production in 1933.
The original design was
modified only by the addition
of the eagle and swastika
emblem. Subsidized by the
State, sales had passed 12
million by 1939. As with the
Kleinempfänger radio (**59**),
this design revealed the
willingness of the
regime to adopt modernist
solutions, using modern
materials (moulded plastic),
where appropriate.

by the view that its symbolically functional aesthetic was brought to an abrupt end with the appointment of Adolf Hitler as Chancellor in 1933, when an avowedly anti-modernist aesthetic was imposed. Some of the reasons for the heavy emphasis placed on modernism by art, architectural, and design historians have been addressed in Chapter 2. However, although a *völkisch* aesthetic can be discerned in many areas relating to the design for the home and other fields where tradition might be expected to play an evocative role, a rational, modernist aesthetic continued to prevail in many other, often economically significant, key areas of production in Germany under the Third Reich [**59**, **60**]. However, it may be argued, recent efforts to show that much design in Third Reich Germany formed a continuity with Weimar modernism[21] may now be swinging the pendulum away from a proper understanding of the true levels of production and consumption of vernacular, ordinary, types. The 'hidden traditions' of everyday consumption largely missing from historical evaluation of design in other countries may also be overlooked in accounts of Germany in the 1930s.

As has been seen in Chapter 2, tensions between the internationalizing spirit of the modernists and the increasingly nationalist tendencies of conservative manufacturers and the political right simmered uneasily in the 1920s, coming to the fore at the Weissenhof Siedlungen housing exhibition in Stuttgart in 1927. As the 1920s evolved craftsworkers saw their employment opportunities increasingly threatened by the widespread introduction of American-influenced standardized and rationalized methods of production in many industries, an efficiency drive furthered by the Reichskuratorium für Wirtschaftlichkeit (State Efficiency Board) which had been established in 1921. Their position became acute as the national economic

Illustrated cover of *Kampf der Gefahr* (Fight Against Danger), December 1939

This portrayal of a German family reflected the traditional values of home-making espoused by the National Socialists in the 1930s. Despite the homely qualities typified by the carved chairback and tablecloth, the unambiguously modernist design of Herman Gretsch's coffee pot on the tabletop (see **27**), first produced by Arzberg in 1931, also finds a place in such a propagandist image.

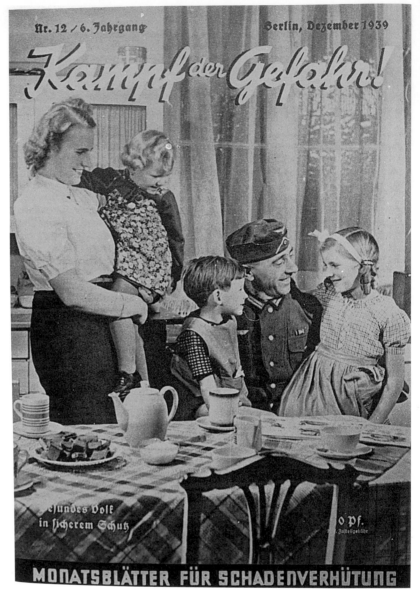

climate deteriorated dramatically in the late 1920s, particularly after the Wall Street Crash of 1929. This led to a period of considerable volatility in which the National Socialist (Nazi) Party emerged as an increasingly powerful political force. Paul Schultze-Naumburg emerged as spokesman for the supremacy of 'authentic' German values, epitomized by folk crafts and traditions, and toured Germany advocating a true national art based on notions of *Blut und Boden* (blood and soil).

In February 1929 Alfred Rosenberg, a National Socialist, formed the Kampfbund für Deutsche Kultur (Militant League for German Culture) which denounced avant-garde culture as degenerate. It also

allied itself closely with the craftsworkers who, despite the propagandist activities of the Arbeitsgemeinschaft für Handwerkskultur (Council for Craft Culture) which had been founded in 1922, did not feel that they had significantly influential representation for their views. In fact, their support, actively encouraged by promises of a more influential role in the future, was significant in the emergence of the Nazi Party. Such an outlook was sustained for a brief period following Hitler's election as Chancellor in 1933 when *völkisch* and *heimatlich* ideals appeared to be politically favoured.

Such ideals found their fullest expression in public art and political propaganda, although they were also often followed through architecturally[22] by the utilization of traditional vernacular forms in housing and in hostels for the Hitler Youth. Such ideas were also taken up in many state commissions for furniture and furnishings for government buildings and party headquarters, as well as in domestic furniture, furnishings, and equipment. In design terms it was in the German home that the ethos of traditional forms was most fully and unambiguously exploited [**61, 62**]. Sabine Weißler[23] emphasized the domestic role that women were expected to play in the Third Reich. They were portrayed as guardians of 'the home of the children, of old memories and of sacred ideas' with the added responsibility for its appearance. As Weißler argued, this meant the favouring of furniture produced from

German softwoods at the expense of 'bolshevik' tubular steel products, of hand-embroidered cushions rather than heavily upholstered chairs, and of crisp cotton clothing rather than French frippery. Thrift, orderliness, and simplicity were viewed as commendable virtues.

The Deutscher Werkbund, an active supporter of the *Neue Zeit* in the mid-1920s, found its position increasingly compromised both by the economic crisis in the late 1920s (which led to a significant fall in membership and thus funding) and by its relationship with the National Socialists. In fact, in 1933 it fell into the orbit of the National Socialism, linked to the Kampfbund für Deutsche Kultur, before being incorporated into the Reichskulturkammer (Reich Chamber of Culture) where its influence was gradually curtailed.[24]

In 1934 the Schönheit der Arbeit (Beauty in Work) division of the Labour Front was established, an important body for promoting German national identity in design. It sought to 'awaken joy in work and kindle in the worker the will to organize his working world in a beautiful and dignified and friendly manner'.[25] In this spirit the organization developed model designs for furniture, tableware [**63**], and lighting, and designed interiors for works canteens and offices and recreation centres. A number of historians have seen these as adhering to Bauhaus and Werkbund principles,[26] but in many instances such designs can also be related to traditional German vernacular forms.

None the less, there were a number of significant German designers who had worked for industry in the modernist idiom before the advent of the Third Reich and continued to do so during the 1930s. These included William Wagenfeld, well-known for his glassware, tableware, and lighting, the textile and wallpaper designer Margaret Hildebrand, Heinz Löffelhardt and Hermann Gretsch [**27**], who designed furniture ceramics and glass. Their products were seen to

NATIONALSOZIALIST... KRAFT SPORNTE EISENBAHN UND
LUFTVERKEHR ZU UNGEAHNT... ...UNG DER GESCHWINDIGKEIT AN.
GLEICHZEITIG ERHÖHTE SICH DIE SICH... ALLER VERKEHRSMITTEL GRÖSSTE
BEQUEMLICHKEIT MACHT DAS REISEN D... DIE SCHÖNEN DEUTSCHEN LANDE
BESONDERS REIZVOLL. DEUTSC... ...EPPELINE UND FLUGZEUGE
ÜBERBRÜCKEN ... OZEANE.

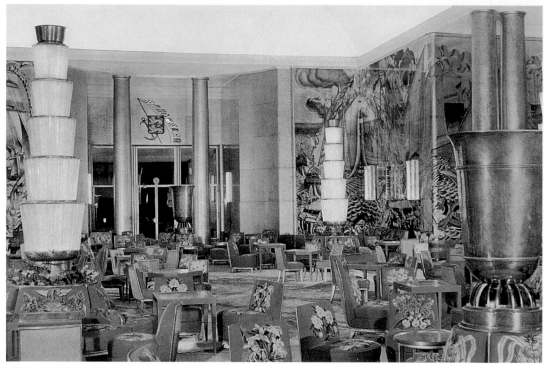

65

Grande Salon of the *Normandie*, ocean liner, 1932–5

The 1920s had seen the proliferation of luxury liners, providing the opportunity to promote national prestige and design leadership. Many ships were subsidized by the French government, and like the 1925 Paris Exposition, provided the opportunity for the display of the best of national craftsmanship. The *Normandie*, with its predominantly Art Deco styling, involved many leading French practitioners.

have an important economic role in the drive to increase foreign exports, as well as promoting German taste as modern in its outlook. Many of their designs could be found in the 1939 *Deutsches Warenbüche*, a National Socialist Catalogue of commended designs in current production.

However, the concept of Schönheit der Technik' (the Beauty of Technology) was also an important element in national projection and identity, symbolizing the progressive nature of the regime at home and abroad, whether in such innovations as the streamlined *Flying Hamburger* diesel-electric train which entered service on the German State Railways in 1933, the network of sweeping autobahns, or giant airships such as the LZ 129 *Hindenburg* which sliced the time off transatlantic travel [64]. Fully embracing the modernist aesthetic as an appropriate counterpart to its own technological contemporaneity, its symbolically functional tubular steel furniture was a feature of the public areas. Different countries used design for travel for other nationalistic ends [65].

Italy: design and Fascism

Like Hitler's Germany, Mussolini's Italy was characterized by an ambivalence in the ways in which she was represented in the years following Mussolini's historic march on Rome in 1922. As has been shown in Chapter 2, there was a period when Italy's own version of the Modern Movement—Rationalism—aspired to become the material

embodiment of Fascism. It never had the same opportunities as its German counterpart, which was adopted enthusiastically for a while in the mid-1920s by forward-looking municipalities such as Frankfurt and Stuttgart, with additional support from the industrially-oriented Deutscher Werkbund. None the less, it was adopted for a number of important Fascist exhibitions, as well as both private and public architectural commissions.

Many of the most obvious and striking symbols of Fascist iconography adopted the symbolism of power of Ancient Rome, linking past grandeur with contemporary ambitions and future aspirations [**66**]. The most instantly recognizable of these were the *fasci* (fasces) which were adopted as the official emblem of the Fascist regime in 1926. These were bundles of rods bound together, with or without an axe, which were carried ceremoniously before high-ranking Roman magistrates. These *fasci* could be seen everywhere, from their transmutation into the columns of triumphal arches such as the *Monumento alla Vittoria* war memorial (1925–8) at Bolzano by Marcello Piacentini,

66

'Radiorurale', built with slight variations by various companies, 1934

This standard model was manufactured especially for the farming communities, symbolized in the ear of corn curving round the speaker, itself emblazoned with an abstracted rendering in aluminium of the ceremonial fasci (bundles of rods, with axes, carried before the magistrates in Ancient Rome). Such propagandist symbols of the Fascist regime linked the past with the modern medium of broadcasting. These radios were sold through the Ente Radiorurale at a special political price, half the commercial rate in order to encourage the growth of a rural audience.

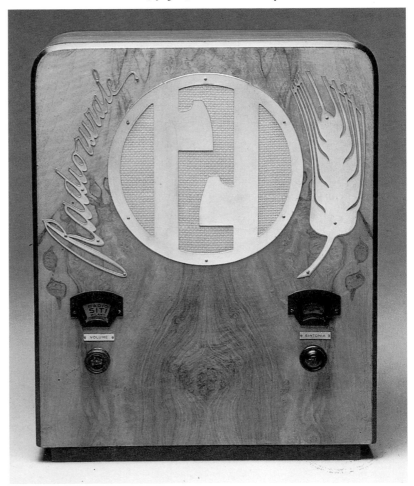

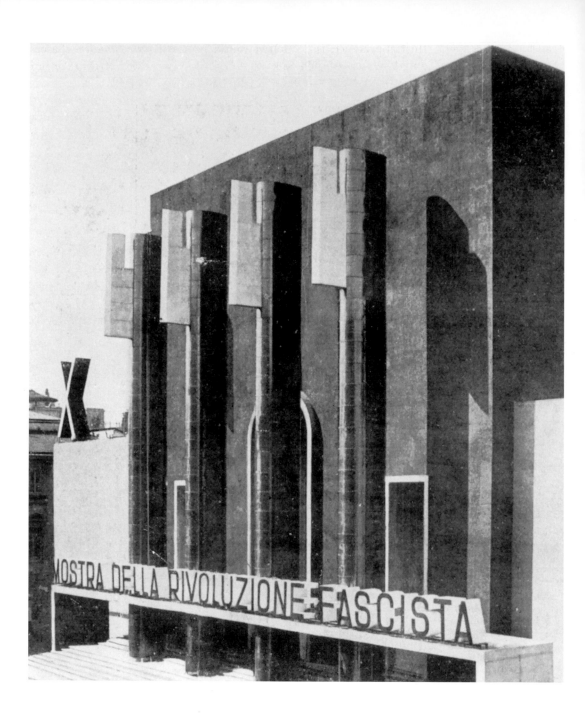

their appearance as decorative motifs on the *Fasci e Bandieri* (Fasces and Flags) patterned silk by Gio Ponti for the Vittorio Ferrari Company in 1930, their attachment to the egg-shaped radiator grilles of FIAT *littorine* trains, to their featuring as sleeve badges and publicity for the uniforms of the Gioventù Italiana di Littorio (the Fascist Youth Organization). Rationalist architects were given opportunities to incorporate them into settings for important exhibitions, such as that marking the tenth anniversary of the Fascist Revolution in Rome in 1932 [**67**]; the Palazzo dell'Esposizione was given a temporary façade by Adalberto Libera and Mario de Renzi which incorporated four twenty-five metres high *fasci*.

As in Germany, technological achievements were important elements in promoting the progressive nature of the regime. These could be seen both in the air and on the land. The S.55 twin-engined, twin-hulled seaplane captured the public imagination. It was designed by the aeronautical engineer Alessandro Marchetti, and became a symbol of Fascism after a number of highly publicized long-distance flights. Another field marked by notable Fascist achievement was the modernization and electrification of the railways, perhaps an unsurprising development given the fact that many early provincial Fascist leaders were former railway employees, usually either stationmasters or white-collar employees. A prototype of the Breda electric train ETR 200 was shown at the V Triennale of 1933 in Milan. Giuseppe Pagano designed the streamlined exterior and Gio Ponti the interior, which boasted high standards of comfort; a second design was commissioned from Ponti and Paolo Masera in 1935, and the ETR went into

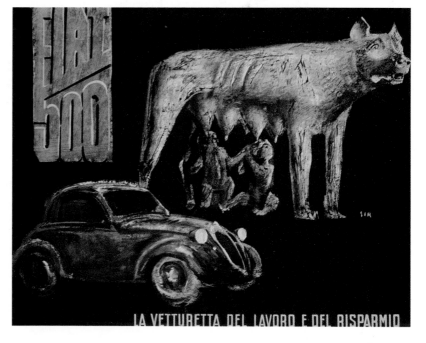

69 Ruth Reeves

Manhattan, block-printed
cotton for W. & J. Sloane,
New York City, 1930

The Cubist-influenced
vocabulary adopted by
Reeves in this striking design
is overshadowed by her
exploration of the
unambiguously American
imagery of New York City,
characterized by the everyday
metropolitan images of
skyscrapers, ocean liners,
railway trains, factories,
switchboard operators, and
a secretary at her typewriter.
Such a quest for an American
identity in design was shared
by many designers at the time.

70 Russell Wright

American Way displays at Macy's, New York, 1940

Wright's project, involving a full range of home furnishings produced by a co-operative of sixty-five artists, craftsmen, and manufacturers, sought to demonstrate the vitality of modern American design in both craft and mass-production. Wright travelled across America, selecting goods for the range. Chosen designs were displayed in ensembles in department stores in order to suggest ways in which consumers might combine products. Although the scheme was launched with a fanfare of publicity and for a brief period caught the public eye, difficulties with supply and quality control led to its abandonment in 1942.

service on the Milan–Rome line in 1936, travelling at speeds of up to 110 mph.

The autostrada network was another legacy of the Fascist era, accompanied by a dramatic rise in car ownership, from just over 47,000 in 1922 to 345,000 in 1938. The FIAT company had a virtual monopoly of automobile production, launching a number of celebrated models in the interwar years. One of the most famous of these was the 1936 Fiat 500 or *Topolino*, designed by Dante Giocosa. The smallest production car in the world, it was promoted in publicity as 'Bella, Comoda, Economica' and continued in production until 1955. However, the Fascist ambivalence between an alliance with imagery which drew on the traditions of Ancient Rome (or *Romanità*) and that which was inextricably linked to modernity in the form of new technology is revealed in contemporary automobile advertising. For example, Mario Sironi's 1936 poster for the FIAT 500 as *La Vetturetta del Lavoro e del Risparmio* (the little car for work and economy) shows the automobile set against an image of the She-Wolf of Rome, suckling Romulus and Remus [**68**]. Four years earlier, Giuseppe Romano had designed a poster which represented a range of cars dwarfed by monumental stone letters spelling FIAT, assembled in the form of a triumphal arch.

The search for a national identity in interwar design in the United States.

The almost encyclopaedic variety of styles upon which American designers were able to draw in the interwar years in many ways reflected the cultural diversity of the population of the United States. References back to Hispanic heritage seen in Spanish Colonial Revival in the South-West or the American Colonial Style of the North-East were all part of the efforts of a number of organizations[27] to arrive at an

Up in the sky

Drink
Coca-Cola
Del... nd Refreshing

...the comfort and pleasure of
the pause that refreshes

On Eastern Air Transport's giant 18-passenger planes, flying between New York and Atlanta, charming hostesses offer ice-cold Coca-Cola and *the pause that refreshes*. This same comfort and pleasure is given on the big ships of other companies that fly from coast to coast and over other routes.

Thus through skyways, as on highways, railways and busy streets, ice-cold Coca-Cola is always ready to help speed you on your way—refreshed. Its tingling, delicious taste and cool, wholesome after-sense of refreshment add life to action or pleasure to leisure. The Coca-Cola Company, Atlanta, Ga.

LISTEN IN
Grantland Rice —Famous
Sports Champions
Coca-Cola Orchestra.
Every Wed. 10:30 p. m.
Eastern Standard Time
Coast-to-Coast
NBC Network

OVER NINE MILLION A DAY . . . IT HAD TO BE GOOD TO GET WHERE IT IS

'Up in the Sky', Coca-Cola
advertisement from the
Saturday Evening Post,
USA, 1920s

Coca-Cola, invented in
1886, has become one of the
most potent symbols of the
American way of life. From
the early years of the century
its publicity campaigns were
mounted on a sophisticated
level, with all kinds of
associated promotional
material, as well as an annual
budget exceeding $1 million
by 1914. The distinctively
shaped bottle seen here,
designed by Alexander
Samuelson, was adopted
by the company in 1915.
The company's association
with modern transportation
systems ('through
skyways, as on highways,
railways and busy streets')
presages its growing
international presence.

indigenous American style. However, a much more potent unifying force was provided by the increasing significance of the city, the inhabitants of which reflected much of the cultural diversity of the American population. Furthermore, in the years following the end of mass immigration in 1921, the preoccupations of American industrial designers were largely centred upon an essentially urban, industrialized experience. As a result, many designers explored different city themes as an iconographic basis for producing inherently American designs. For example, Paul T. Frankl produced a number of bookcases in the form of a skyscraper as part of this drive to establish an American-based iconography in the late 1920s. In fact, the skyscraper motif provided many other designers in a number of fields with a potent form of expression. For example, Harold Van Doren and John Gordon Rideout's plastic cased radio of 1933 for Air-King Products Co. of Brooklyn follows the stepped form of skyscrapers; Ruth Reeves's celebrated block-printed cotton pattern of 1930 for the New York firm of W. & J. Sloane, *Manhattan*, is dominated by the verticality of many vistas of the New York skyline [69], a motif adopted by many other textile designers of the period. Although revealing French stylistic influences in its form of expression, it was the urban content that constituted a truly American dimension. The iconography of everyday life also provided a specifically American form of design [70]. For example, in 1926 Edward Steichen explored the possibilities of textile design using photographs of common objects such as cigarettes and matches as the basis for silk designs produced by the Stehli Silk Corporation of New York, an adventurous company which promoted work by a number of American designers. One of their best-known ranges consisted of the American Prints series of 1927, which featured such designs as Neyea McMein's *Hollywood*, Ralph Barton's *Gentlemen Prefer Blondes*, and Clayton Knight's *Manhattan*.

However, by the time that American industrial designers had begun to exert a widespread visual impact on everyday life in the 1930s, American national identity in design was increasingly associated with the symbolism of technological progress [71], a theme exploited to the full by the large American corporations at the New York World's Fair of 1939/40. This image continued to predominate for some years after the end of the Second World War, especially in those increasingly affluent European countries where ownership of all kinds of domestic appliances became the norm.

The Second World War: Reconstruction and Affluence

5

The United States after the war: technology and consumption

The Second World War did much to develop business organizational techniques and more efficient modes of production; between 1940 and 1945 the United States devoted 40 per cent of its productive economy to wartime needs, investing $25 billion in new plant and equipment in what the War Production Board called 'the greatest expansion of industry in the history of the country'. There were also notable advances in the production of new materials and machinery, with considerable developments in the chemical and electronic industries. However, as in Britain, restrictions were imposed on particular areas of production: MOMA in New York mounted a *Useful Objects in Wartime* exhibition in 1942, displaying areas of non-priority status such as pottery, glass, paper, and plywood. MOMA was not as influential as many histories of design have implied, but its 'Taste-Makers', as Russell Lynes[1] and others have styled them, preached a creed which was in some ways analogous to the Utility canon: anti-obsolescent and opposed to styling for profit; like the austere aesthetic associated with Utility, it also failed to capture the imagination of everyday consumers. On a wider front, the War Board also limited the range of products available to the public, with President Roosevelt placing a price ceiling on many goods. None the less, as in Britain, from about 1943 onwards, there was a growing emphasis on planning for the postwar period, with expectations of future prosperity dramatically captured in the Libby-Owens-Ford 'Day after Tomorrow's Kitchen', designed by H. Creston Dohner, which was shown in 'mock-up' form in many leading department stores across the United States. It was reported[2] that this 'dream kitchen' was 'a public sensation' and was visited by more than 1.6 million in the 15 months that three identical displays were on show. Complete with 'picture window', the futuristic design represented a move towards the flexibility of a work/living space and the General Motors/Frigidaire 'Kitchens of Tomorrow' which were frequently displayed in the following decade [**76**].

In a series of twelve articles published in 1953 and 1954, *Fortune* magazine identified a number of significant aspects of what it characterized as the 'Changing American Market' of the early 1950s and

Levitt and Sons were the most
important developers of
suburbia in the USA in the
post-Second World War years,
building nearly 17,500 houses
in Levittown, Long Island
between 1947 and 1951,
before expanding into New
Jersey and Pennsylvania.
Using highly industrialized
methods of volume building
the company offered
housebuyers an affordable
package which came to typify
the American Dream—
traditionally styled, generally
conforming to a clapperboard
Cape Cod (Anglo-Saxon)
cottage ideal, with a high level
of built-in extras.

beyond. The authors, Gilbert Burck and Sanford Parker, summarized the key points of the investigation thus:

It has analyzed the unforeseen and amazing rise in the American birth rate. It has recorded the unparalleled rise in the nation's living standards, and the postwar rise of a 'great new moneyed middle class, growing larger, wealthier, more uniform, and yet more various'. It has described the economic implications of the phenomenal popularity of suburban life. It has examined individual markets, present and prospective, for cars, houses, food, appliances, clothes, luxuries and leisure-time spending.[3]

This analysis attracted interest in the design press, *Industrial Design* carrying an article on 'The Designer's Stake in the Changing American Market' in April 1954.[4] Much was made of the growth in what was seen as the middle-class market with its increased levels of disposable income and thus developing opportunities for the designer. Such opportunities were sustained by the rapid growth of suburbia, with a consequent rise in demand for labour-saving appliances, tableware, and utensils.

This phenomenal growth of suburbia in the postwar years was stimulated by the ambitions of the housebuilding and property-developing firm of Levitt & Sons, which set the pattern for many others. Between 1947 and 1951 William J. Levitt's company built nearly 17,500 houses in the first Levittown on Long Island and in the early 1950s expanded its activities into Pennsylvania and New Jersey. The houses combined the traditional styling of the Cape Cod cottage with modern constructional techniques and offered a whole range of enticing all-inclusive features, such as refrigerators, washing machines, built-in

televisions, and white picket fences [**72, 73**]. As *Harper's Magazine* reported in 1948:

'A dream house', Levitt wrote, for a GE ad, 'is a house the buyer and his family will want to live in a long time . . . an electric kitchen-laundry is the one big item that gives the homeowner all the advantages and conveniences that make his home truly livable'. To include a Bendix washer in the sales price may seem frivolous and extravagant, but it is worth every bit of the cost in sales appeal and publicity. 'And it will sell faster', Levitt added. His house is the Model-T equivalent of the rose covered cottage—or Cape Coddage, as someone has called it. It is meant to look like the Little Home of One's Own that was the subsidiary myth of the American Dream long before Charlie Chaplin put it into 'Modern Times'.[5]

Levittowners, as the inhabitants were known, were soon seen to represent the norm, one resident and his family being singled out as early as 1951 as 'the average American'. The social mores and attitudes of this group were recorded in the detailed two-year-long study made by Herbert Gans in his book, *Levittowners*, after moving into the third Levittown in Willingboro, New Jersey. However, as Betty Friedan made clear in *The Feminine Mystique*, published in 1963, for the American housewife the conventional picture of the suburban idyll, sustained by Lucy and Ricky's move from town to suburb in the popular television situation comedy *I Love Lucy*, proved highly problematic for many of the female inhabitants who had surrendered careers and independence in search of the American Dream. None the less, in the early 1950s there was a widespread perception that the suburban housewife

73

Component parts of a Levitt Home prior to on-site assembly, *c.*1950

Illustrated here are the basic components of the Levitt package prior to erection. The all-inclusive domestic equipment stands on the standardized concrete base, including cooker, washing-machine, refrigerator, storage systems, and sundry other elements, right down to the characteristic white picket fence. According to *Fortune* magazine of October, 1952, the Levitt factory on Long Island was producing materials for one four-roomed house every sixteen minutes.

Cadillac Fleetwood advertisement, late 1950s
The styling of this 1959 model reveals many qualities associated with the archetypal American 1950s car, symbolizing the conspicuous consumption of the period: a long, low body, curved 'wraparound' windscreen, and extensive 'sculptural' detailing in chrome on the radiator grille and rear end. The detailing of the latter relates to the contemporary fascination with the Jet Age, the rear lights simulating 'rocket-burn'. The rear tail 'fin' had first appeared on a Cadillac in 1948, inspired by Harly J. Earl, the General Motors director of styling.

The world's most eloquent possession... *Cadillac*

It would be difficult to recount *all* the wonderful things that a Cadillac car indicates about its owner. But it is readily apparent, we think, that it now speaks more eloquently than ever of his good taste and judgment. Cadillac's new beauty, for instance, is graceful and inspiring as never before. This new Cadillac refinement is equally evident in the car's interiors—in the rare quality of its fabrics, leathers and appointments . . . and in the care and skill of its Fleetwood tailoring and craftsmanship. And then, of course, there is the car's marvelous new performance and handling ease. We suggest you visit your Cadillac dealer soon. You'll quickly see why the new "car of cars" has been accorded the most brilliant reception in Cadillac history.

CADILLAC MOTOR CAR DIVISION · GENERAL MOTORS CORPORATION
EVERY WINDOW OF EVERY CADILLAC IS SAFETY PLATE GLASS

was the dream image of the young American women and the envy, it was said, of women all over the world. The American housewife—freed by science and labour-saving appliances from the drudgery, the dangers of childbirth, and the illnesses of her grandmother. She was healthy, beautiful, educated, concerned only about her husband, her children, her home. As a housewife and mother, she was respected as a full and equal partner to man in his world. She was free to choose automobiles, clothes, appliances, supermarkets; she had everything that women ever dreamed of.[6]

The postwar suburban growth also saw the development of larger shopping centres and malls in place of the more conventional shopping 'strips', in which smaller shops were lined up alongside a supermarket which acted as an attraction. These had developed in the years following the First World War, when a number of much larger centres were built, accessible only by car. The first of these was the Country Club Plaza in Kansas City, Missouri, constructed by J. C. Nichols in 1922.

The post-Second World War pattern of much larger developments was set by the Northgate Shopping Centre, erected in a Seattle suburb in 1950. It was in the form of a mall of forty shops, centred around a Bon Marché department store, with segregated parking and underground access for delivery vehicles. The first covered mall, the Southdale Center, opened six years later in a suburb of Minneapolis, in many ways set the pattern for subsequent developments around the world.

Another essential ingredient of postwar suburban life was the possession of an automobile. Although production was extremely limited in the middle of the war, by 1949 it was running at over 5 million per annum. By 1950 it reached 8 million, with the figure rising until 1955, the apex of the boom. The automobile became an emblem of conspicuous consumption in itself, but also exerted a considerable impact on the ornament and signage of the urban environment, whether in terms of drive-in cinemas, restaurants, motels, shopping centres, car washes, or simply signs which could be read and absorbed quickly while travelling down the highway at speed, a semiotic phenomenon addressed in Robert Venturi and others' 1972 book, *Learning from Las Vegas*.[7] 'California Coffee Shop Modern'[8] did much to develop such an architectural currency in the 1950s, with raised roof-lines and elaborate neon signs. It was also at this time that the distinctive architecture and signage of McDonalds restaurants evolved, a striking corporate image of yellow parabolic arches integrated into the roadside hamburger bars and echoed in the roadside signs.

This era of conspicuous consumption has been seen as the age of

75

General Motors Show, Los Angeles, 1954
These motor shows were important publicity and sales showpieces for General Motors, showing a range of new models as well as futuristic non-production 'dream cars' against which consumer reactions could be tested. This was a similar outlook to that adopted by many major American corporations in the 'World of Tomorrow' seen at the New York World's Fair of 1939–40.

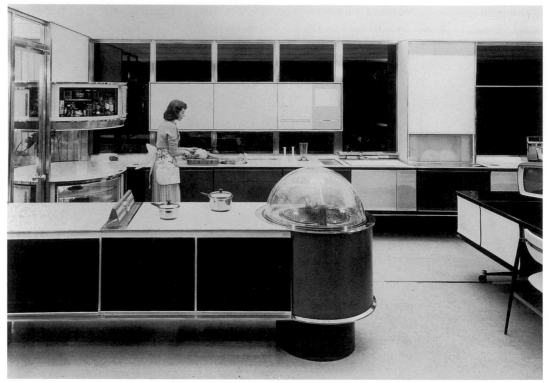

76

Frigidaire *Kitchen of Tomorrow*, 1956

Part of General Motors since 1919, Frigidaire began to exhibit 'dream kitchens' in 1956. Among many futuristic features seen here were an ultrasonic dishwasher, an IBM Electro-recipe file which automatically activated an ingredients dispenser, and rising storage cabinets. In the foreground is the cooking surface, a wipe-clean marble work-top punctuated with in-built heating elements, together with a Thermopane domed oven powered by quartz lamps. Behind the housewife is a Roto-storage system which could also be checked externally by tradespeople to facilitate automatic replenishment.

'Populuxe', a term employed by the critic Thomas Hine in his 1987 book of the same title[9] to denote populism, popularity, and luxury. He defined it further as 'not merely having things. It is having things in a way they'd never been had before, and it is an expression of outright vulgar joy in being able to live so well'.[10] This was epitomized most obviously in the styling of the American automobile in the 1950s, characterized by the extravagant chrome excesses of radiator grilles and tail-fins, both of which drew heavily on the symbolism of rocketry and jet engines [**74**, **75**]. The tail-fin had first appeared in a restrained form on a Harley Earl-designed Cadillac of 1948, but became a major feature of styling in the 1950s; the wrap-around windscreen which gave the feel of being in a cockpit was introduced by Oldsmobile in 1954; instrumentation became increasingly ostentatious in the range of dials and controls arranged round the driver; and the advertising language used to sell features became increasingly evocative of space. Key figures in this styling rivalry were Virgil Exner at Chrysler, George Walker at Ford, and Harley Earl at General Motors. The latter was the first designer in a major industry to become a corporate Vice-President and by the mid-1950s General Motors' Styling Section had grown to about 850, increasing to 1,400 by the time he retired in 1959. Earl was also involved in work in the Products and Exhibits studio, which was responsible for Frigidaire products as well as promotional exhibitions such as the 'Motoramas', the first of which was held at the Waldorf-

Astoria Hotel in New York in 1953. These exhibitions introduced 'dream cars' to the public, models which were never actually put into production but which carried futurist features to test, or condition, public opinion.

The control layouts of automobiles influenced the control panels of cookers, and other aspects of detailing could be found on many other domestic appliances, juke-boxes, and other products which relied on 'up-to-the-minute' styling for success in the market-place. In the buoyant consumer climate of 1953 the Frigidaire Division of General Motors adopted a similar strategy to that of the Motoramas in the first of their *Kitchen of Tomorrow* events, which was also mounted at the Waldorf-Astoria Hotel in New York. Three years later the Frigidaire *Kitchen of Tomorrow* [**76**] sought to seduce consumers with such futuristic equipment as a loudspeaker telephone able to be answered from anywhere in the kitchen, to record messages, and to send and receive written messages; a Roto-storage centre with dry, refrigerated, and frozen sections, which could be rotated with external access so that tradesmen could check and refill them with staple items as required; a laundry which would be activated automatically when the weight in any of three bins reached eight pounds; and an ultrasonic dishwasher/drier/sterilizer.

By the end of the decade doubts about many aspects of conspicuous consumption had begun to be voiced by organizations such as the Consumers Union, moralizing critics such as Vance Packard, ardent campaigners such as Ralph Nader, designers such as Richard Neutra, and economists such as J. K. Galbraith. A number of these questions are explored further in Chapter 10.

Britain: utility and beyond

As has been discussed in Chapters 2 and 3, there was a significant gulf in interwar Britain between the aspirations of those who sought to promote modernism and the realities of the market-place. Nikolaus Pevsner himself openly acknowledged the difficulties of changing patterns of design consumption without radical social change in his 1937 *Enquiry into Industrial Art in England*.[11] He believed that the causes of the prevalence of poorly designed goods were more deep-seated than indifference on the part of manufacturers, retailers, buyers, and consumers, and that a firm commitment to slum-clearance, rehousing, and improved standards of environmental planning was necessary in order to provide a climate in which design debates would have meaning.

It was perhaps ironic that it needed an outbreak of war in 1939 for a number of the design reformers of the interwar years to convert their ideals and aesthetic creeds into a wider material reality. This opportunity arose with the establishment by the Board of Trade of the Utility

Scheme in 1942, which was to affect many areas of design through state-imposed control of materials, specifications, and availability of a range of goods including furniture and furnishings, bedding, household textiles, glass, knitwear, clothing, hosiery, and footwear [**77**]. A Furniture Advisory Committee was soon established, the membership of which included stalwarts from the interwar design campaigns: Elizabeth Denby, John Gloag, and Gordon Russell. Also advising were three furniture manufacturers and a consumer. As was remarked at the time in an editorial in the *Architectural Review*, a sympathetic advocate of design reform, Utility offered

a social opportunity of the first order. If here, with all the force that government monopoly gives at present, something had been done that could have satisfied both the experienced and the discriminating, and the wide manifold public for which the furniture is intended, a step forward might have been taken of more importance than anything so far accomplished by DIA propaganda, exhibitions and the exhibitions of the few adventurous designers.[12]

The scope of design activities embraced by Utility was considerably enhanced in 1943 by the appointment of a Utility Design Panel under the chairmanship of Gordon Russell. This included his brother R. D. Russell and the furniture designers Edwin Clinch and H. T. Cutler who had produced designs for Utility furniture. They were subsequently joined by Enid Marx who designed furniture fabrics and Jacques Groag, former pupil of Adolf Loos. Despite efforts to enthuse the public through the mounting of promotional exhibitions and publication of catalogues and articles in the press, both the public and industry remained at best lukewarm to the idea of a state-imposed, standardized aesthetic in their everyday lives, even if for many it ensured standards of quality and economy—in other words a kind of consumer protection. However, as the Utility guidelines were increasingly relaxed in the later 1940s the fashion-conscious or historicizing qualities in design of the 1930s that those involved with Utility hoped would recede into the background of the public's desires in the postwar years soon assumed a highly desirable allure.[13] The public remained unconvinced by the modernist adage 'less is more', even when blended with British craftsmanship and humanizing materials. Instead they once more inclined towards what Anthony Bertram described in 1946 as 'The Enemies of Design': 'Indifference itself, the Hitler of the gang, Cheapness First, Unnecessary Novelty, Borrowed Glory, Mass Production, Articraftiness and Fashion Snobbery'.[14]

During the war years various other bodies were active in promoting design both as a social and as an economic force, particularly as optimism grew about the likely outcome of the war.[15] These included the Council for the Encouragement of Music and the Arts (CEMA) and the Central Institute of Art and Design (CIAD), both of which had

The exhibition lasted three weeks, attracting over 30,000 visitors and the favourable attention of the popular press. As can be seen here, the furniture was very austere in appearance, conforming to the design specifications laid down by the State Utility Furniture Advisory Committee. In many ways it conformed to the design reform ideals of the campaigners of the interwar years, unsurprising perhaps since the Committee included stalwarts such as Gordon Russell and John Gloag.

been established in 1939. The CIAD was particularly concerned with the development of postwar export trade and initiated contracts for design research in a range of industries, including cotton, wool, and plastics. The state was also concerned to promote industrial design as a positive force in the postwar market-place. The unpublished Weir *Report on Industrial Design and Art in Industry* of 1943 and the Meynell–Hoskins *Report on Art Training* of 1944 both supported the idea of establishing an independent design council. Late in 1944 Sir Hugh Dalton established the Council of Industrial Design (COID) under the chairmanship of the textile industrialist Sir Thomas Barlow, with S. C. Leslie as its first director.[16] However, the social formation of the COID was such that many provincial manufacturers felt suspicious about the supposed cultural élitism of a body firmly rooted in the metropolitan taste-making circles of the South-East of England.

From Britain Can Make it to the Festival of Britain

The most significant foray into the public domain was the COID's organization of the 'Britain Can Make It' (BCMI) Exhibition of 1946, held in London. Over 5,000 objects were shown in an effort to convince manufacturers, retailers, the public, and foreign buyers that design was of critical importance in the postwar period. As with much design history involving propagandist organizations with a vested interest in promoting themselves as successful in realizing their aims, it is difficult to disentangle myth from fact in the case of BCMI. Fortunately, the COID commissioned the Mass Observation organization to undertake a survey of the public's response to the exhibition[17] which, conducted around 2,523 interviews of exhibition visitors, revealed significant gaps between the COID's interpretation of the

78

Die-lines as issued to manufacturers participating in the Festival Pattern Group, c.1950

The Festival Pattern Group was conceived by Mark Hartland Thomas, the COID's industrial officer. Inspired by a paper he had heard at a 1949 conference which introduced designers to a range of visual sources from other arts and sciences, he decided to use crystallography diagrams as the basis of a new decorative scheme. It was launched at the Festival of Britain (Britain led the world in crystallography) and could be found on carpets, curtains, tableware, glass, and other surfaces capable of carrying pattern. Twenty-six manufacturers from different industries collaborated together as the Festival Pattern Group.

needs of rather crudely defined social groups and their actual perceptions. In fact, in September 1946, *The Economist* had already drawn attention to the need for systematic research into design, raising questions about the importance of sociology in the design process. The COID's *ad hoc* sociology was at its most apparent in the furnished room settings in the exhibition which, according to a Mass Observation survey, was one of the most popular sections of the show. Rather than any sociologically-informed display of the specific needs of particular social groups a sense of social paternalism was evident in the rooms designed for fictitious families, encapsulated in Nicholas Bentley's wiry line drawings in the catalogue, accompanied by prose thumbnail sketches by the poet John Betjeman.

When accounts of events are written mainly by their initiators, they tend to celebrate the most optimistic, ideal, and reassuring aspects. This was particularly so in relation to the Festival of Britain of 1951, where the COID, under its director Gordon Russell, was heavily involved in the selection of all goods seen at the main Festival sites in London, Glasgow, and Ulster. Much of the history of British design in the early postwar years has been constructed from published sources which not only centre on the COID but also support a positive view of the Council's achievements. Such sources include the *Annual Reports* (important vehicles for persuading the COID's paymaster, the Board of Trade, of its effectiveness), *Design* magazine, its mouthpiece to industry and the design profession, the autobiographies of key personnel such as Gordon Russell[18] and Paul Reilly,[19] written many years afterwards. The Festival Catalogue, *Design in the Festival*, published by the Design Council, sold 95,000 copies: its widespread availability has also furthered a particular interpretation of the COID position. However, a more complex view was broached in *A Tonic to the Nation: The Festival of Britain 1951*,[20] published in 1976, in which a number of myths about British design in the 1950s were dispelled. Two principal illusions were disposed of by Reyner Banham in his perceptive essay[21] in which he argued that it was untrue to maintain either that 'the Festival of Britain created a style that was new and valuably English' or that 'this style was influential, especially on popular taste'. However, there is another myth that needs to be dispelled, that of unequivocal support for state intervention in design matters. Within two years of the closure of the Festival officials within the Treasury were arguing that the COID, for all its aesthetic policing of design in 1951, should be closed down.

None the less, although the impact of the Festival Style or, as it was also known, the 'Contemporary Style' was comparatively short-lived, it made itself felt in a variety of everyday spheres from packaging design to plant pot holders and from sideboards to shopping plazas. Typified by the wiry linearity of Ernest Race's *Antelope* chair and a

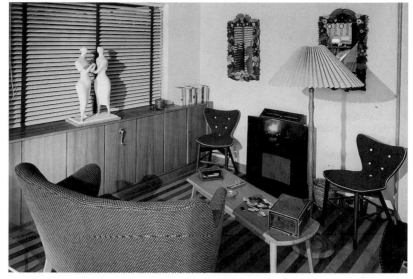

Parlour, designed by Eden and Bianca Minns from the Homes and Gardens Pavilion on the South Bank, London, at the Festival of Britain, 1951

One of many interiors showing examplars of modern British design selected by the COID, it reflects the modernizing tendencies supported by that organization in the postwar years: built-in units under the window, and lightweight furniture (particularly the parlour chairs and coffee table), suitable for living in smaller rooms. Behind the venetian blinds was a wind-up plate-glass window, working on the same principle as a car window.

number of Lucienne Day's textile designs the style was widely disseminated in magazines and stores geared towards the tastes of a middle-class market [**78**]. It is noteworthy that ten years later Gerald Barry, the Festival's Director General, saw its legacy as limited to the light industrial sector, particularly tableware, furniture, lighting, and textiles.[22] Indeed, the Festival Style has also been seen to mark the end of an era [**79**, **80**], rather than heralding a renaissance of British design [**81**]. For many ordinary consumers, however, the partiality for traditional patterns in tableware, carpets and wallpapers, and other artifacts of everyday living remained a significant aspect of the market-place. None the less, as will be shown in Chapter 8, higher levels of employment and disposable income made the alluring image of consumerism in the United States increasingly attractive both to theorists and the wider public in Britain, sustained by the American cinema, the advent of commercial television, glossy magazines, and popular music.

Italy: postwar ideals

Following the end of the war the Italian economy made an impressive recovery. In terms of exports this can be measured in comparative terms: between 1951 and 1962, whilst Britain's exports increased by 29 per cent, and France's by 86 per cent, West Germany's rose by 247 per cent and Italy's by 259 per cent. Only Japan, with a growth of 378 per cent, made more significant progress.

Italian design established a reputation for style and sophistication in a number of fields where design is a significant factor including automobiles, furniture and furnishings, lighting, interior design, and fashion. The concept of a truly Italian style became a reality during the 1950s, alongside the postwar regeneration of Italian industry.

At the end of the war, industrial output in Italy was scarcely a fifth

Füred and Lelle furniture sets manufactured in the Metal-Furniture Factory, Hungary, 1950s

The Hungarian equivalent of 1950s Contemporary Style British furniture reflects a similar preoccupation with providing practical designs which fitted easily into post-war housing developments of the early 1950s. The bold, abstract patterns of the carpets reflect a parallel commitment to modernity.

of what it had been in 1938. None the less, by 1948, the Italian economy had recovered to its prewar level, aided both by protectionist policies and the activities of the Istituto per la Riconstruzione Industriale (IRI) which had been established under Mussolini in 1933 to stimulate industrial growth. In 1946 there was a strong anti-fascist dimension to Italy's coalition government, with significant representation of both the socialist and communist parties. Many Italian intellectuals were strongly committed to the political left and believed that they had a potentially significant role in the reconstruction of a democratic society. This outlook was expressed materially at the RIMA (Riunione Italiana per le Mostre di Arredamento) exhibition of popular furnishing in Milan in 1946 [**82, 83**], where concepts of modernity, flexibility, space-saving, and practicality predominated as well as a commitment to designs which could be produced at prices which put them in the reach of the majority. Ernesto Rogers, who had taken over the editorship of *Domus* in the same year, identified the main objectives of the exhibition as 'economy, practicality and good taste', themes which also ran through his magazine at the time. Similarly, the first postwar Milan Triennale of 1947 was devoted to the theme of reconstruction, with a particular emphasis on the working-class home. This preoccupation with 'democratic' design could be seen in a number of products such as Corradino D'Ascanio's *Vespa* motor scooter for Piaggio of 1946 [**84**], Cesare Pallavicino's Lambretta Innocenti scooter of 1947, and, though later, the 1953 Iso-Isetta mini-car and Dante Giocosa's *Nuova 500* (New Cinquecento) FIAT of 1957.

Italian style in the 1950s

As Andrea Branzi remarked in *The Hot House: Italian New Wave*

Design,[23] Italian design of the 1950s should really be seen to begin in 1948 and end in 1962, a period marked by centrist politics and an economic boom. It has been convincingly argued[24] that the United States not only played a significant role in re-invigorating the Italian economy but also, in the effort to increase production, recognized that design was a tool that could be used to develop new markets and promote new patterns of consumption in Italy. The 1948 elections marked a clear shift away from leftist politics towards the centre, a change of emphasis which was also seen in design with a move away from democratic idealism towards a more style-conscious aesthetic, geared to the pockets of the more affluent sectors of society. Gio Ponti resumed editorship of *Domus* in 1948 and did much to promote a new language of modern design.

The Italian design aesthetic that emerged at about this time was characterized by organic, sculptural forms which could be found in a diverse range of objects [**85**] including the 1946 *Vespa* motor scooter, Pininfarina's Cisitalia Berlinetta 202 automobile of 1947, Marcello Nizzoli's *Lexicon 80* typewriter for Olivetti of 1948, and Giulio Minoletti's ETR railway train and Gio Ponti's La Pavoni coffee machine, both of 1949. The flowing forms of such designs [**86**] shared a vocabulary with contemporary sculpture by Hans Arp, Max Bill, and Henry Moore, as well as design work by Charles Eames and Eero Saarinen in the United States which had been published in *Domus*. In the architectural field there were also similar interests in organic form, articulated by the APAO (Association for Organic Architecture,

81 Alec Issigonis

Austin Mini (1959) as seen in the Paramount Picture Corporation's film *The Italian Job*, 1969

Following the Suez crisis of 1956, the British Motor Corporation decided to design a small, economical family car, resulting in the production of the Mini in 1959. Its innovations included the space-saving transverse engine which provided a capacious interor in relation to its external dimensions. It was not particularly successful when launched but, following successes in the Monte Carlo Rally of 1964 and 1965, its sales passed one million in 1965. Its attractive price ensured widespread appeal, and it became a symbol both of British Pop and urban chic.

founded in Rome in 1944) and Bruno Zevi (who wrote *Verso un architettura organico* in 1945). Both saw organic form as offering a more humanizing face of modernism than that of the austere and standardized vocabulary of the Rationalists [**87**, **88**].

Links with the United States

The United States provided Italy with important financial aid through the Marshall Plan, providing knowledge of modern mass-production technology, which lay at the root of the dramatic increases in output in the automobile, textile, office equipment, and petrochemical industries. However, there were other important links between Italy and the United States which helped to promote an international awareness of Italian design at this period.

Many Italians had emigrated to Italy before the First World War and had maintained family links since then. These had been reinforced by many of the American armed forces in Europe during and after the Second World War and were further stimulated by the development of the postwar tourist trade. But of more specific importance for design promotion was the mounting by the Art Institute of America of the 1950 exhibition of 'Italy at Work: Her Renaissance in Design Today',[25] which toured a large number of major American museums. The show of about 2,500 items included prototypes for furniture, lighting, and other industrial products, as well as a wide range of current lines including a Lambretta motor scooter, items of office equipment, and coffee machines. All the exhibits were placed within special settings commissioned from Italian designers. The crafts too were prominent in the show not only because they represented a particularly important aspect of Italian design in the postwar period but also because the United States had done much to further their development. As a means of initiating this, Handicraft Development Incorporated in America had been set up in 1945 in the United States as a non-profit-

making organization, and in 1947 it opened the House of Italian Handicrafts in New York as a means of linking Italian craftsworkers with American distributors.[26] In Italy the organization operated as CADMA (the Committee for Assistance and Distribution of Materials to Artisans) with representation in Florence, Milan, Venice, and Naples.

American knowledge of Italian design was also furthered by other exhibitions, such as MOMA's travelling show on the theme of 'The Modern Movement in Italy: Architecture and Design'. In fact, MOMA's patronage of modern Italian design both through shows and acquisitions did much to reinforce its cultural and artistic status.[27] M. Singer & Sons of New York also promoted furniture by Ponti, Mollino, and Parisi in the early 1950s, as did Altamira and Knoll. Italian fashion design also attracted increasing attention during the 1950s when leading American stores began to promote it.

Another important means of promoting developments and debates in Italian design to a wider international audience was afforded by the Milan Triennali. Those in 1951, 1954, and 1957 were all concerned with themes in industrial design: 'The Production of Art', 'Europe', and 'Compulsory Schooling'. At the X Triennale of 1951 the section entitled 'The Form of the Useful', organized by Ludovico Bellgioioso and Enrico Peressutti, concentrated on industrial aesthetics and gave rise to criticism that there was insufficient emphasis on the social and economic dimensions of design. However, experimentation was much in evidence, particularly in the work of Marco Zanuso, Carlo Mollino, and Franco Albini. Zanuso experimented with foam rubber furniture for Arflex, a subsidiary of Pirelli, winning the Medaglio d'Oro and

83 Ignazio Gardella

Little Sideboard (Piccola Credenza), RIMA Exhibition, Milan, 1946

This sideboard, which can be opened from both sides, and thus act as a spatial divider, is a neat and ingenious solution for the provision of utilitarian furniture of 'good taste', very different from the Utility furniture still being produced in Britain at the time (see **77**).

Workers riding Piaggio *Vespa* motor scooters designed by Corradino d'Ascanio at the Piaggio factory, Pontedera, January 1949

Designed in 1946, the streamlined styling of the *Vespa* was an aesthetically refined solution to the problem of providing an economic and practical form of transport in the period of *ricostruzione*. Without the gender-specific implication of traditional motorcyle design it later became a popular symbol of youth culture, particularly of the Mods in Britain in the 1960s, and remained in production until 1987.

The sculptural quality of its styling was apparent in other transport products of the later 1940s, including Pininfarina's *Cisitalia* automobile (1946) and Minoletti's ETR railway train (1949).

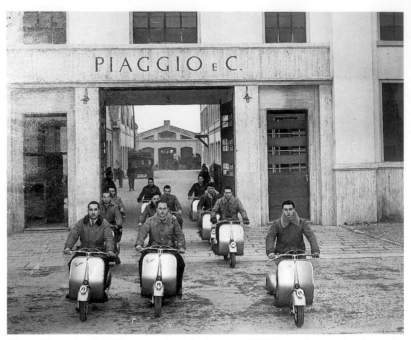

Gran Premio; Mollino explored the possibilities of organic form in furniture; Albini experimented with combinations of modern forms and craft traditions, as in his *Margherita* wickerwork chair. This 'rediscovery' of craft traditions in the 1950s did much to unleash the creative potential of form in furniture, ceramics, glass, metal, and plastics.

Italian design was also promoted on the commercial front, particularly through the major department store La Rinascente which, as it had done in the autarchic climate of the 1930s, sought to influence Italian taste, commissioning leading designers such as Ponti and Albini to design for the mass market. Furthermore, after mounting a series of 'good design' exhibitions in the early 1950s the store launched the Compasso d'Oro award scheme in 1954 as a means of encouraging better technological and aesthetic standards. The awards did much to promote modern Italian design at home and abroad.

The Kartell Company can be identified closely with the rise of Italian design at this time. Founded by Giulio Castelli in Milan in 1949, it soon emerged as one of the leaders of stylish plastic products. Its first product was a ski rack for automobiles, designed by Carlo Barassi and Roberto Menghi, perhaps indicating the orientation of design-conscious companies towards an affluent middle-class clientele. During the 1950s Kartell manufactured a wide range of products: housewares, lighting, and industrial goods [**89**]. Gino Colombini was in charge of the company's technical office and did much to establish its reputation for design, particularly through the Compasso d'Oro awards in which he regularly featured, commencing with second prize in 1955. Other renowned designers for the company have included Joe

85 Gio Ponti

Zeta sanitaryware for Ideal Standard, 1954

Ponti, one of the most important figures in twentieth-century Italian design, shows a sense of sculptural, organic purity in his design solution for the production of everyday artefacts. Without their taps and fittings they reveal the aesthetic elegance for which his designs were renowned, whether interiors, furniture, textiles, ceramics, cutlery, or architecture.

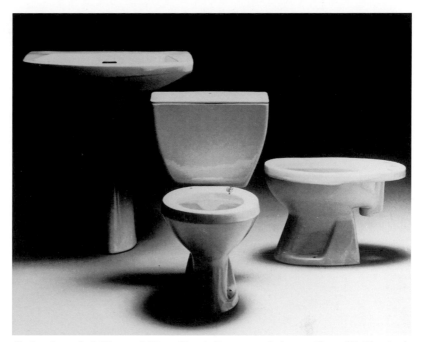

Colombo, Achille and Pier Castiglione, and Anna Castelli-Ferrieri. However, the company's success did not derive simply from a commitment to design. An essential element was an emphasis on research and technological innovation and in 1954 the company established a European pool for the exchange of technology and marketing analysis as a means of promoting plastics more widely.

By the end of the decade a number of innovative companies placing a premium on design had established a reputation. Typical of this trend were Arteluce (founded in 1939), Brion Vega (established 1945) [**90**], Tecno (established 1952), Gavina (established 1953), and Zanotta (established 1954). These joined larger companies with a much longer association with high standards of design such as Olivetti, Lancia, Alfa Romeo, and FIAT. The years from 1959 to 1962 marked the culmination of the postwar selective marketing strategies for domestic products, automobiles, and petrochemical products, as well as growing levels of affluence and conspicuous consumption. However, the emphasis on style, status, and product aesthetics on which the Italian design reputation was based in the European and North American markets began to attract an increasing amount of criticism from certain sectors of the Italian design profession which believed that social and environmental considerations were being sacrificed in the name of art. This conflict between socio-economic relevance and aesthetic contemplation, which had found particular focus at the Triennali, became increasingly acrimonious as the Italian economy began to run into difficulties in the early 1960s. The elections of 1963 saw a resurgence of leftist politics and the Communist Party, mirrored by the growing cri-

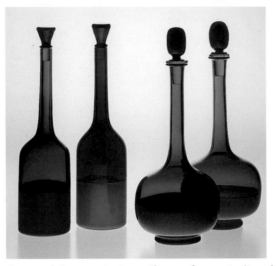

tique of the restrictive effects of a capitalist-dominated economy on
the social and creative potential of design, a critique which found
potent expression in the Radical or Anti-Design movement of the later
1960s.

Germany: reconstruction and Wirtschaftswunder (economic miracle)

The destruction of much of Germany's industrial base in the Second
World War made possible radical innovation, and by the early 1950s
the first signs of an 'economic miracle' were apparent: between 1950
and 1964 West Germany's gross national product (GNP) rose faster
than in any other European country; in the same years industrial out-
put increased sixfold; between 1949 and 1950 foreign trade doubled,
and between 1954 and 64 it trebled. This was a period of considerable
consumer demand which also saw the establishment of new industries
to accommodate it.

American influence was a significant factor in Germany's postwar
reorientation and many leading German industrialists, like their
Japanese, French, and British counterparts, visited Detroit and other
major manufacturing centres in the United States in order to study
progressive management techniques and industrial organization.
There are also a number of parallels which may be usefully drawn
between the Germany of the 1920s and that of the 1950s. Both were
periods of stabilization and economic recovery after a major war in
which Germany had been on the losing side; both saw important injec-
tions of American finance and were accompanied by social and cultural
readjustment. In the 1920s there had been a strong American influence
in many sectors of German society:[28] Henry Ford's autobiography sold
more than 200,000 copies, and Taylorism exerted a strong influence on
industrial practice; wider everyday American values asserted them-

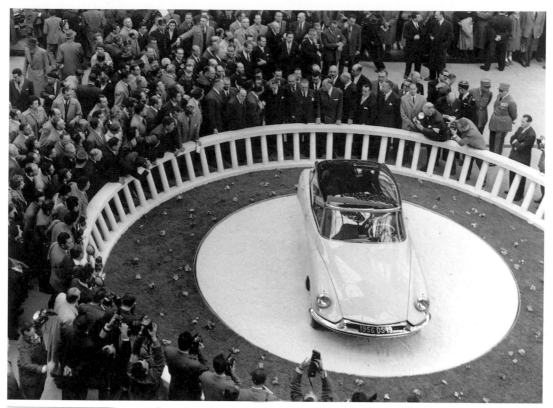

87

Citroën DS display at the Salon d'Automobile, Paris, 1955

First seen publicly in France at the 1955 Salon, the organic, tapered form of the DS (pronounced 'déesse', meaning goddess) had been shown without wheels at the Turin Motor Show of 1953, rendering it almost as a piece of abstract sculpture. Very much in keeping with wider international interest in organic form, the DS set new standards of styling, comfort, and ride. The interior styling, particularly that of the dashboard and the steering column, exuded an aura of technological progress. Between 1955 and 1975 almost one and a half million DS cars were manufactured.

selves in the spheres of culture, style, and material possessions. Similarly, in the 1950s, for some Germans, American models exuded a strong flavour of capitalist democracy, and the study of American management techniques and the approaches of the Harvard Business School were influential in the commercial and industrial sectors. Immediately after the war, magazines such as *Business Week* and *Time* were so sought after that there was a black market demand for them. Furthermore, by 1952 over 500 significant German companies were controlled by American capital, particularly in areas such as electrical products, automobiles, and chemicals. After the war, many American cultural values were also transmitted by the overwhelming presence of American troops, just as was the case in Japan under General MacArthur. Coca-Cola, which had first been produced in Germany in 1929, was relaunched there in 1949, and by the mid-1950s there were 96 bottling plants in West Germany. American films promoted the American way of life and many American brand names were widely recognized. It is perhaps unsurprising that, given such influences, streamlining was manifest in a wide range of domestic and other appliances as well as in automobile styling, such as that of the Hansa 1500 Borgward of 1949, which looked back to American car styling of the late 1930s [**91**], or the mid-1950s Kapitan, the tail-fins of which were clearly inspired by American precedent.

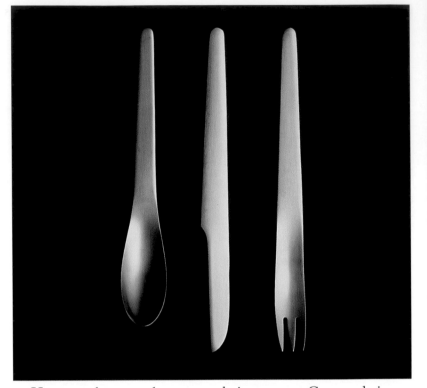

However, there was also a strong desire amongst German designers to establish themselves on a sounder professional footing than had been the case in the interwar years. As one means of persuading commerce and industry of their economic worth designers placed an increased emphasis on the need to adopt a more systematic and scientific analysis of design problems. This also signalled a clear ideological shift away from the *völkisch* characteristics associated with the Third Reich. As will be investigated further in Chapter 7, this scientific approach was particularly associated with the development of the curriculum at the highly influential Hochschule für Gestaltung, where teaching commenced in 1953, as well as with products made by Braun in which notions of 'functional beauty' were emphasized. For many years the dominant trend amongst manufacturers was to place a premium on design, a trend sustained by official and industrially supported organizations promoting 'good design'. The Rat für Formgebung (German Design Council), the Neue Sammlung Gallery in Munich, the Deutscher Werkbund [**92**, **93**], the Institut für Neue Technische Form at Darmstadt, and Industrieform at Essen all sought to stress the economic and aesthetic benefits of rational design.

Opposed to this aesthetic associated with what became known as 'scientific operationalism' was an outlook that favoured the organic as the basis for furniture, textile, product, and architectural design. In the late 1940s it shared common ground with many designers in Italy,

89 Kartell

Cover page from the company magazine *Qualität*, no. 6, Winter 1957

This illustration shows a wide range of plastic domestic products manufactured by the Kartell company, founded by Guilio Castelli in Milan in 1949. These include the rectangular tub at the base of the 'tree' (Compasso d'Oro prizewinner, 1957) and the bucket hanging from the lowest 'branch' (Compasso d'Oro prizewinner, 1955), both designed by Gino Columbini who was head of Kartell's technical office. High standards of colourful design in everyday products soon expanded to plastic lighting and furniture for which the company became increasingly renowned internationally in the following decades.

Britain, Holland, France, and the United States, embracing notions of artistic creativity, individuality, freedom of inspiration, and an interest in the arts and crafts. Contemporary fine art practice also provided inspiration, particularly action painting, which appeared to offer the means of expression appropriate for a new, dynamic era in German life. Links with the organic work of Charles Eames in the United States could be discerned in the work of the German furniture designer Egon Eiermann, as in his 1953 Model SE18 folding chair manufactured by Wilde + Spieth, one of the best-selling wooden chairs of the 1950s, and much more obviously in Georg Leowald's stacking chair of 1954 for Wilkening + Hahne. In textile design the influence of abstract expressionism can be seen in Willi Baumeister's curtain fabric designs for Pausa AG in 1955, whilst in architecture Hans Scharoun's flowing forms for the Berlin Philharmonic of 1960–3 give it a dramatic realization.

Consumption in everyday life

One of the problems with developing a fuller history of design, as has been seen in many areas of this study, is to do justice to the wider patterns of consumption and everyday life. The difficulties of investigating sufficient material evidence in the face of archival and museological determinants of (high) cultural significance are still in the process of being addressed. Lorenz Eitner, in a 1958 article on 'Industrial design in Postwar Germany',[29] drew attention to a survey of home furnishings of German women of all classes and all age groups over 18 carried out in 1954. Its results were as follows: of all women questioned 2 per cent were still attached to the Wilhelminian grandeur of carved oak and potted palms; nearly 60 per cent were content with the flowered chintz, simulated wood grains, and heavy overstuffings of current department store best-sellers; while 30 per cent preferred the style which might be called 'subdued modern' or 'Swedish middle-brow', with its blond woods, chaste shapes, and unadorned surfaces. More advanced designs were favoured by a far smaller group, though of the younger women (under 30 years old) 10 per cent voted for what could be called 'Knoll International', a modernist aesthetic adopted in the public spaces of many corporate buildings. A further breakdown of the sample showed that the modern idiom ('Swedish' or 'International') was preferred by 44 per cent of women between 18 and 29 years, 28 per cent of working class wives, 44 per cent of self-employed women, and 54 per cent of female wage earners. It was most popular in towns of middle size, less so in metropolitan or rural areas.

Despite the emergence of the New Left and the economic recession of the mid-1960s, designers generally remained unmoved either by critiques of what J. K. Galbraith termed the 'affluent society' or the increasing sensitivity to social and environmental issues. In the 1970s,

however, a number of designers in Germany began to question the continuing validity of the dominant rational, functionalist aesthetic. Among them was Luigi Colani, whose designs provoked fierce criticism from his peers. His work exhibited a pronounced biomorphic character, as in his Drop profile tea service for Rosenthal of 1974, sanitary-ware designs for Villeroy & Boch, or the T-90 range of cameras for Canon. In the 1980s the German design consultancy, Frogdesign, has also taken a line opposed to the quasi-scientific approach to design in a number of its brightly coloured, organic designs, even coining the phrase 'form follows fun' to underline its philosophy. By this time Berlin had emerged as an avant-garde centre of significance, becoming the nexus for what has been termed the New German Design. Essentially a critique of the functionalist tradition, whether in terms of the symbolic functionalism of Bauhaus design or post-Ulm rationalism, groups like Berlinetta and Stiletto [**94**] provided a radical opposition to the orthodoxy of Good Design.

Japanese design in the postwar period: myths and stereotypes

The post-Second World War period has marked a significant change in attitudes to Japanese design, both within Japanese manufacturing industry and abroad. There was a marked reconsideration of the dominant view of Japan, characterized by Pierre Loti in his best-selling novel *Madame Chrysanthemum* of 1887, where the country was portrayed as exotic and alluring, peopled by erotic women and devious and unethical men.[30] Further stereotypes had evolved in the twentieth century, particularly in reaction to the threat which Japan's economically priced exports increasingly posed to her Western competitors. The anxiety that the Japanese would flood the Western markets with cheap

90 Marco Zanuso & Richard Sapper

Television 201 for Brionvega, 1969

Brionvega, originally a radio manufacturing company, moved into the production of televisions in the early 1950s with the advent of the Italian television network. In the early 1960s the company commissioned Zanuso and Sapper to develop a number of innovative radios and televisions. As can be seen in this illustration the fact that this acrylic cube is a television is concealed when the set is not in use, resembling a stylish, if minimalist, black box.

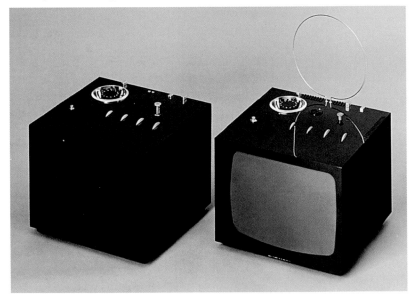

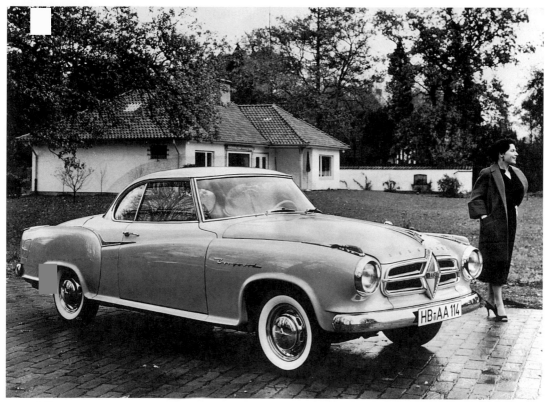

91

Isabella coupé, Borgward, West Germany, 1956

Even though there was considerable debate about the distinctiveness of German design in the 1950s, American influence continued to exert a powerful allure on many aspects of everyday life. Just as late 1930s American automobile styling had influenced a number of late 1940s and early 1950s models, the *Isabella* coupé echoes a number of styling traits seen in the USA in the late 1940s.

goods was felt in a number of countries. In Britain, for example, this surfaced increasingly in the textile and pottery industries, with a number of accusations of Japanese sharp practice being raised in the House of Commons. In November 1950, A. Davies MP drew the attention of the President of the Board of Trade to what he saw as unfair competition, asking whether he was 'aware that I have in my hand a sample of British pottery which is being coloured, designed, produced and sold at eight times the price at which the Japanese copy is being marketed in Canada and the United States'.[31]

Similar views were held in the motor-cycle industry, as revealed by the remarks of the President of the British Cycle and Motor Manufacturers when visiting a large trade show in London in 1951. As experience has shown only too clearly, he vastly underestimated the capacity of the competition when he confidently declared that he did not think that 'the Japanese would be able to beat us in European markets . . . though [before the war] they had ousted us temporarily from South East Asian markets, the consumers seemed to have learnt that it was worth while to pay for a good quality British product'.[32]

From this time onwards many other stereotypical views were sustained in the West, particularly that of a people selflessly dedicated to the success of the companies for which they worked. Perhaps in response to Prime Minister Ikeda's 'national income doubling policy'

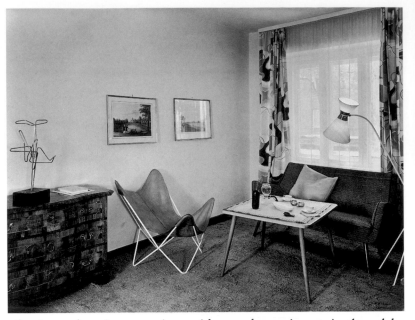

of 1960, such a view was given widespread prominence in the celebrated account in *Time* magazine in 1961 where it was reported that, at the start of each day's work, executives and workers together sang the following verse:

> For the building of a new Japan
> Let's put our strength and mind together,
> Doing our best to promote production,
> Sending our goods to the people of the world
> Endlessly and continuously,
> Like water gushing from a fountain.
> Grow industry, grow, grow, grow!
> Harmony and Sincerity!
> Matsushita Electric.[33]

By the early 1980s the development of the Japanese economy and manufacturing industry, as well as the high levels of investment in plant, equipment, and Research & Development, had been subjected to a much more serious analysis in other countries eager to learn from her economic success. Lawrence Franko, in his book *The Threat of Japanese Multinationals—How the West Can Respond*[34] of 1983, stressed a number of facts that were not widely realized: that the Japanese worked fewer hours on average in manufacturing than their counterparts in Britain, Switzerland, Germany, the Netherlands, and Finland; that there were many Japanese companies which in fact performed badly, went bankrupt, or needed to be rescued; that Japan was less strong in the fields of aerospace, agricultural machinery, custom machine tools and dies, precision and scientific instruments, and computer software; and that Japan had no significant lead over her Western competitors in

One of the Bijenkorf
department store displays
from 'Pioneers of Today'
display, Amsterdam, 1961

In 1948 the Bijenkorf store
began a series of modern
furnishing displays called *Ons
Huis Ons Thuis (One's House
is a Home)*, promoting designs
by progressive Dutch
manufacturers. The range
became increasingly
international in scope and this
illustration shows one of nine
historic settings where the
work of design 'pioneers'
was contrasted with more
commercial products. Here
the pioneering work of
Eames (foreground) is
contrasted with everyday
1950s design (background).

pharmaceuticals, civil engineering, construction, mass-transit systems, telecommunications, or computers. However, at the time that Franko's remarks were published, less than forty years from the end of the war, Japan had emerged with a powerful economy as well as a high reputation for design in a number of fields, from motor vehicles to electrical appliances, from office equipment to cameras and video-recorders, and from graphic design to high fashion. Although by the 1990s about half of the corporate identity programmes in Japan were executed by American consultancies (thus aiding global projection), since the 1950s there had been an increasing stress on design within companies such as Honda, Toyota, Matsushita, Canon, Sharp, Toshiba, or Sony where there were vast numbers of in-house designers; individual Japanese designers such as Issey Miyake and Rei Kawakubo in fashion, Masanori Umeda and Shiro Kuramata in furniture (both designing for Memphis in Milan), and Ikko Tanaka and Tadanori Yokoo in graphics all became internationally recognized; GK Industrial Design Associates, a pioneering Japanese design consultancy, grew from modest beginnings in 1957 as a group of six student graduates who had studied under Professor Iwataro Koike[35] at Tokyo National University of Fine Arts to a multinational enterprise with offices in the United States and the Netherlands.

The American occupation and influence

After her humiliating defeat in the Second World War, the major task facing the Japanese government was the reconstruction of the national economy. Many important social, economic, and political reforms initiated by the Allied Headquarters (GHQ) under General MacArthur

The Honda *Super Cub* motor cycle was launched in Japan in 1958, becoming an immediate success through its economy, practicality, and easy handling. It became an important weapon in establishing a base for Honda in the lucrative consumer markets of the USA. The American Honda Motor Co. Inc. was established in Los Angeles in 1959, working closely with Grey Advertising Inc. to change attitudes to motor cycles in a car-dominated country. The resulting slogan, 'You Meet the Nicest People on a Honda', was aimed at all walks of life and was succeeded by 'The Nicest Things Happen on a Honda'.

You meet the nicest people on a Honda. And the remarkable thing is the low cost of it all. Prices start about $215.* Insurance is painless. Upkeep negligible. Honda's four-stroke engine demands 200 miles from a gallon of gas. And gets it. Plenty of drive. That's how you stay at the top of the class. World's biggest seller. HONDA

addition to the increasing prevalence of design management in Japanese companies, Computer Aided Design (CAD) has been an important consideration, alongside Computer Aided Manufacture (CAM).

An important product in the establishment of the Japanese reputation in design was the Honda *Super Cub* motorcycle, which became the world's most successful model [**96**], leading to comparisons with the Volkswagen Beetle and Ford Model T. Launched in 1958, it set the standard for lightweight motorcycles until well into the 1960s—by 1967 five million had been sold. The *Super Cub* provided an opportunity to establish Honda on the American market in 1959. A dip in sales in the USA in 1966 was countered for a while by the introduction of a range of gaudily coloured, psychedelic patterned *Tiger Cubs*; the 'step-through' design, its light weight, and easy handling made it also easy for women to ride. The company produced cars from 1962 onwards, establishing itself with the highly successful front-wheel drive N360

mini-car of 1967 and the 1300 model of 1968, and gaining international recognition with the launch of the *Civic* in 1972.

The Tokyo Olympic Games of 1964 did much to open up a worldwide interest in Japan, stimulated by the media. The 1960s was also a period of rapid economic growth and liberalization. Since then Japanese industrial design has established itself in a number of fields, including the automobile and motorcycle industries, audiovisual equipment, domestic appliances, cameras, watches, office and factory automation systems, telecommunications, advanced medical electronics equipment, and a range of equipment within the heavy industrial sector.

Research & Development has played an important role for many Japanese companies as a means of achieving a strong market position. Its results can be seen in the miniaturization of many products from transistor radios and televisions to 'capsule' hotels. For Sony this was exemplified by the introduction of the Walkman in 1979 (which has since been given more than 350 variants by the company's designers); in 1981 the Profeel television was introduced; in 1982 the compact disc player was introduced jointly between CBS/Sony, Philips, and Deutsche Grammophon. All have been widely imitated.

By the 1980s, aided by a number of initiatives such as the launch of the biennial Osaka International Design Festival in 1983 (for further details of this and other initiatives see Chapter 7), Japan was recognized as an international centre for design, with many foreign architects and designers working in Tokyo and other major cities. These included Norman Foster, Michael Graves, Ernesto Rogers, and Nigel Coates, all of whom worked in genres with distinctive cultural values. However, much successful Japanese design has stemmed from its own technologically innovative qualities developed by individual companies, which are, in turn, swiftly imitated by numerous others. There are also significant design fields, such as furniture and tableware, where cultural resonance is important to consumers and in which, with the exception of the expensive output of 'New International Style' designers, Japan has made little impression abroad.

Multinational Corporations and Global Products

6

The corporate personality: invention and identity

From a critical perspective it may be argued that the idea of corporate identity or personality, as articulated by designers and consultancies, is often little more than a contradiction in terms [**97, 98**]. Some of the ways in which symbols and imagery from the past have been used to validate particular outlooks have been considered in the 1983 collection of essays edited by Eric Hobsbawm and Terence Ranger entitled *The Invention of Tradition*.[1]

Interestingly, at the end of the decade, this book was viewed by Wally Olins, a leading figure in corporate identity design and chairman of the design consultancy Wolff Olins, as 'fascinating' and 'brilliant', perhaps acknowledging the relevance of the two key words of the title for those working in his profession.[2] Furthermore, the power to communicate a very selective portrayal of company activity through a major element in corporate communication, the annual company report,[3] was also seen by Olins as a particular kind of invention:

In the world of the annual report there are many similarities with Lewis Carroll's *Alice in Wonderland*. Big things can look small and small things look big. The world is neatly parcelled up into sections that suit a company's organisation. Brazil, for example, disappears with most of South America and all of Africa into a place called 'Rest of the World'. All the people who work for the corporation have, of course, made major contributions to the business . . .

There are no divisions, no splits, no rifts. Everything in the garden is just lovely.[4]

Corporate projection and identity creation

The corporate identity creation business developed dramatically with the growth of multinational corporations and the emergence of global products such as Coca-Cola, McDonald's hamburgers [**99**] or the Sony Walkman [**100, 101**]. It was an aspect of the design profession that became increasingly significant in the post-Second World War period. F. H. K. Henrion, who established Henrion Design Associates (HDA) in 1951, was a pioneer in the field in Britain and, in 1967, defined corporate identity thus:

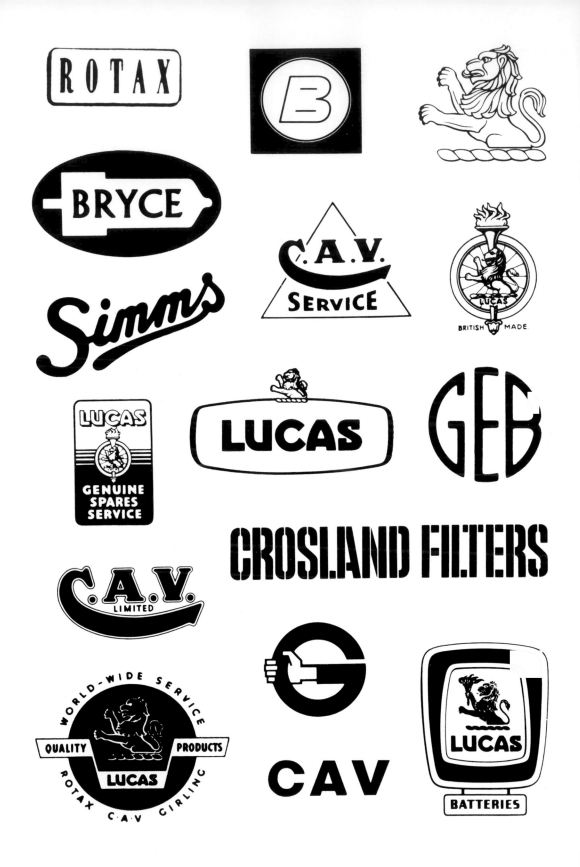

97 Pre-Pentagram

Lucas Identity Programme: Constituent Companies: individual trade marks and symbols for Lucas subsidiaries before redesign, illustrated in Pentagram, 1970s

98 Pentagram

Lucas Identity Programme: Constituent Companies (after redesign), 1975

Corporate identity design became an increasingly important aspect of commercial and industrial life in the post-1945 decades. In this instance Lucas Industries called in the Pentagram design consultancy to reassess its corporate projection. In **97** the uncoordinated imagery of Lucas's constituent companies failed to communicate its global significance and size in terms of manufacturing parts for the aerospace, automotive, and industrial sectors. Pentagram proposed the 'Lucas Diagonal' as a solution (**98**), a diagonal stripe which could be emblazoned on the products, manuals, packaging, transport vehicles, and other visible aspects of company identity. Together with a corporate alphabet and the controlled use of colour, it was felt that this gave all constituent elements a visual coherence and obvious common link which was previously lacking.

A corporation has many points of contact with various groups of people. It has premises, works, products, packaging, stationery, forms, vehicles, publications and uniforms, as well as the usual kind of promotional activities. These things are seen by customers, agents, suppliers, financiers, shareholders, competitors, the press, and the general public, as well as its own staff. The people in these groups build up their idea of the corporation from what they see and experience of it. An image is therefore an intangible and essentially complicated thing, involving the effect of many and varied factors on many and varied people with many and varied interests.[5]

In effect, Henrion was highlighting both the need to promote a clear and coherent image in the quest for corporate success and the abilities and expertise of design consultancies to bring such perceptions effectively into the public arena. However, with the growth of interest in the concept of design management in the 1970s and 1980s, it was suggested with increasing frequency that corporate identity initiatives should be closely integrated with company infrastructure and policy initiatives. In this evolving climate Wally Olins consistently argued strongly for such a linking of corporate personality with the painstaking analysis of management structures and marketing strategies. Writing in the late 1980s, he pronounced:

We are entering an epoch in which only those corporations making highly competitive products will survive. This means, in the longer term, that products from major companies around the world will become increasingly similar. Inevitably, this means that the whole of a company's personality, its identity, will become the most significant factor in making a choice between one company and its products and another.[6]

Problems of evaluation

Such a positive affirmation by a design consultant of the corporate need for the expression of individual personality in the face of increasing homogeneity of products indirectly highlights the difficulties inherent in a historical evaluation of the relative economic significance of corporate identity creation in the post-Second World War period.

99 Stanley C. Meeston

McDonald's at Des Plaines, Illinois, 1955

Hamburgers were first marketed from White Castle restaurant outlets which were launched in Wichita, Kansas in 1921 (see also **34**), the decade in which fast-food franchising was launched by Howard Johnson. Other well-known chains included Harland Sanders's Kentucky Fried Chicken, which was prominent by the 1950s. However, it was the readily identifiable corporate symbolism of McDonald's (later including the parabolic arches as part of its logo) which represented the American lifestyle across the world. McDonald's is the world's largest food-service organization and the leading brand-name in the United States.

This is particularly problematic if the weight of evidence is drawn from the design profession itself since, as the twentieth century has unfolded and consumerism blossomed, it has become significantly more important for the growing ranks of design consultants and the burgeoning design press to convince the business and manufacturing sectors that design can play a critical economic role in the market-place. This perceived need for a positive portrayal of the effectiveness of corporate identity design has resulted in numerous articles and texts written by those in, or closely connected with, the design profession. The British design historian and theorist Steve Baker, in an extremely useful Olins-focused evaluation of historical approaches to corporate identity design published in 1989, highlighted the problem thus:

Olins is an aggressive publicist of his firm's approach to corporate identity; he claimed in 1988 that 'there's nobody else from Britain apart from us doing it properly'. His writings must, of course, be understood as inseparable from his business activities. In a 1981 article in *Designer* called 'Getting New Business', he suggested that any effective design consultant should ensure that they published articles in 'influential publications like *Management Today* or *The Director*'. He also explained that one of his firm's tactics for attracting a particular company's business was to send its chief executive a copy of *The Corporate Personality*.[7]

Furthermore, the design press, which flourished remarkably in the entrepreneurial, service- and distribution-oriented climate of the

1980s, has inevitably been dependent on advertising revenue from the design profession and its clients. Unsurprisingly, the majority of articles in this specialized sector of the media have tended towards the reportage of the output or ideology of successful individual designers, design practices, or companies embracing design as a visible aspect of their corporate life. However, such examples have provided much of the source material for the many celebratory, design-centred narrative corporate histories which have, in turn, been constructed in comparative isolation from the wider political, economic, social, and cultural complexities of the market-place.

Of greater potential value to the historian of twentieth-century design are company, institutional, organizational and individual designer archives, although these too are often problematic as evaluative tools. Much depends on the extent to which the sheer bulk of

100

Sony Walkman advertisement, 1980s

This advertisement, with its constituent images drawn from several countries, literally shows the global nature of the Walkman, now adopted as a generic name for a product type launched in July 1979. First marketed in the United States as the Soundabout, in Sweden as the Freestyle, and in Britain as the Stowaway, the Walkman has been a phenomenal international success. It demonstrated typical Japanese ingenuity in producing a highly innovative product without a commensurately large investment in new technology.

FIRST, THE WALKMAN SENSATION.

NOW, A WALKMAN REVOLUTION.

The idea was simple: Simply create a new Sony Walkman so small it's about the same size as an ordinary cassette case. Sound easy? No, it sounds spectacular. Because even though now it's smaller and lighter, performance has actually been improved. And that took the revolutionary style of thinking Sony is famous for. The super sounding Walkman.

The World's Smallest HiFi

Walkman is guaranteed worldwide for 90 days under Sony's International Warranty System

The American Express card
was first introduced in 1958,
following the introduction of
the Diners Club card in 1950,
which itself stemmed from
American corporate credit
practices of the 1930s.
Since then credit cards have
become symbols of affluence
and status, instantly
recognizable as multinational
graphic images and
plastic counterparts to
global products such as
Levi's or Coca-Cola.

material in particular archives has been given over to editing, selection, or even destruction of potentially damaging evidence. Indeed, corporate confidential policies relating to boardroom minutes and sensitive policy decisions have in some cases resulted in the excising from the records of controversial or unfavourable comment.

Critiques of corporate power and influence

Writing from less design-oriented perspectives many other writers[8] have presented a different view of the power of the multinational corporation to influence social, economic, and political life. As the American economist J. K. Galbraith argued in his introduction to the 1974 British edition of his widely-read book, *The New Industrial State*:

> It is central to my case that power in modern industrial society resides with the large producing organisations—the corporations. So, far from being safely and resignedly subordinate to the market, as the neo-classical argument holds, they fix prices, and go on extensively to accommodate the consumer to their needs. And they also obtain from the state such further action as is needed to ensure a benign and stable environment for their operations.[9]

This, Galbraith argued, was brought about through the economic power of the large-scale corporation to compete with the state in terms of planning and influence. In 1968, General Motors had a gross revenue of $22.8 billion, equivalent to about one-eighth of the total receipts of Federal Government in the United States. It accorded with Galbraith's model of large-scale American capitalism in its ability, through sheer size, to influence government, control markets, and dictate prices and wage settlements for the whole automobile industry (only one element of its industrial activities), as well as establishing patterns of consumer taste.

Such critiques often assumed a more overt political dimension with the global marketing of products which were increasingly identified with a particular way of life. This assumed particular strength in the immediate post-1945 period when products such as Coca-Cola [**102**] and Levi's jeans became emblems of a 'democratic', essentially American, lifestyle in countries such as Japan [**103**] and Germany which were seeking to throw off their recent associations with oppressive political regimes. This process has intensified in the post-Berlin Wall era of the 1990s with the proliferation in the former Eastern bloc of McDonald's restaurants and other outlets and products identified with the overt values of consumerism and at least symbolic 'freedom of choice'.

Critiques of what has been termed American 'cultural imperialism' were often highly politicized, as in Ariel Dorfman and Armand

102

Cover of *Time* magazine showing Coca-Cola as the 'World's Friend', 15 May 1950
This celebrated illustration confirmed the way in which Coca-Cola had become a truly global product by the mid-century, much stimulated by its popularity amongst American troops stationed across the world during the Second World War and its aftermath. It came to be readily associated with the material values and desires of American consumer society, a symbol of material affluence.

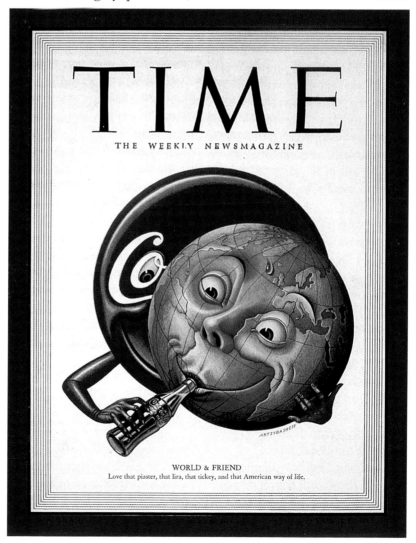

World War era with the employment of designers of the stature of Ettore Sottsass Jr. and Mario Bellini and the increasingly significant role given to cultural projection. The company's commitment to corporate identity design was recognized in 1974 when the American Institute of Architects awarded Olivetti the Industrial Arts Medal 'for a history of excellence in communicating its image through product design, corporate communications, architecturally distinguished manufacturing and merchandising facilities, and sponsorship of numerous social, educational, recreational, and cultural programs for both its employees and the public at large'.

In the United States corporate identity design also assumed increasing importance in the interwar years. The Container Corporation of America (CCA) was an important pioneer in this respect in the 1930s, largely through the enlightened patronage of the company's founder, the Chicago industrialist Walter P. Paepke. In 1936, wishing to communicate the company's commitment to a modern outlook and product quality, he employed the N. W. Ayer advertising agency as a means of bringing this about. In the same year he also appointed Egbert Jacobsen as Director of the company's new Design Department. Amongst those designers commissioned to produce advertisements were the French designers A. M. Cassandre and Fernand Léger, the former Bauhaus tutors Lázló Moholy-Nagy and Herbert Bayer, Herbert Matter, the Swiss emigré designer and poster artist, and the Hungarian-born graphic designer, Gyorgy Kepes. Combinations of photomontage with typography and other techniques associated with the European avant-garde were incorporated into company publicity, strongly influencing the outlook of other designers working for the company. Such strong links with European modernism were sustained by the establishment, in 1937, of the New Bauhaus in Chicago under Lázló Moholy-Nagy. Later becoming the School of Design, then School of Design in Chicago, and finally the Institute of Design,[15] a number of former Bauhaus graduates and masters were employed on the staff.

In the post-Second World War period Walter Paepke, Egbert Jacobsen, and Herbert Bayer were at the forefront of moves which sought to further understanding in business circles of the significant economic potential of design in industry. In 1951 Paepke inaugurated the first Design Conference at the Aspen Institute of Humanistic Studies in Colorado.[16] Initiating debate about the wider social, cultural, and philosophical implications of design it sought to bring together leading figures from design, industry, government, and education. At the 1951 meeting both Olivetti and the Container Corporation of America were cited as exemplars of the implementation of a consistent design policy in industry. Held annually, in 1954 it became incorporated as the International Design Conference in

Aspen (IDCA) and was soon established as a major forum for design debate, with contributions from leading designers, intellectuals, and industrialists from all over the world.

Design and the multinational corporation after 1945

As has been discussed in Chapter 4, the aspirations of those seeking to implement the modernist creed in the interwar years had been severely blunted by the rising tide of national identity in the increasingly difficult political and economic circumstances of the times. However, after the Second World War, with the widespread discrediting of totalitarian regimes and the waning of the power of imperialism in the Western industrialized world, the internationalizing values inherent in modernism no longer carried the same threat to national identity. With the postwar reorientation of traditional trading patterns and the need to develop new outlets many large-scale companies viewed the penetration of global markets as an increasingly important goal. As part of this strategy multinational corporations assumed the mantle of modernism, their international presence marked by efficient-looking buildings, products, and co-ordinated corporate design programmes.

As has been suggested earlier, the Olivetti company epitomized high standards for corporate identity design and implementation. It was particularly influential on the outlook of International Business Machines (IBM), a company which emerged as a world leader in the field of office equipment after the end of the Second World War. IBM's distinctive corporate style, which embraced everything from brochures and sign systems to dictating machines and company buildings, emerged after the appointment of the architect-designer Eliot Noyes as Consultant Director of Design in 1956 [**104**]. He had first worked on the IBM account in Norman Bel Geddes's office ten years earlier, continuing to work on a company retainer after setting up his own design practice in 1947. He brought in Paul Rand as Graphics Coordinator as well as a number of other design consultants including Charles Eames, George Nelson, and Edgar Kaufmann Jr. They were all heavily influenced by European modernism: Noyes had worked with the former Bauhaus masters Walter Gropius and Marcel Breuer at Harvard in the 1930s, and was Director of the Department of Industrial Design at the Museum of Modern Art (MOMA) in New York from 1940-2 and 1945-6; Paul Rand was well aware of European modernism in the interwar years, an interest stimulated by magazines such as the German *Gebrauchsgraphik*[17] and *Advertising Arts*; George Nelson had studied in Rome in the 1930s and, with the designer Henry Wright, co-edited *Architectural Forum*, a magazine which strongly promoted the modernist cause and frequently featured many aspects of corporate design; after a brief interregnum by Suzanne Wasson-Tucker, Edgar Kaufmann Jr. had succeeded Noyes as Director of the

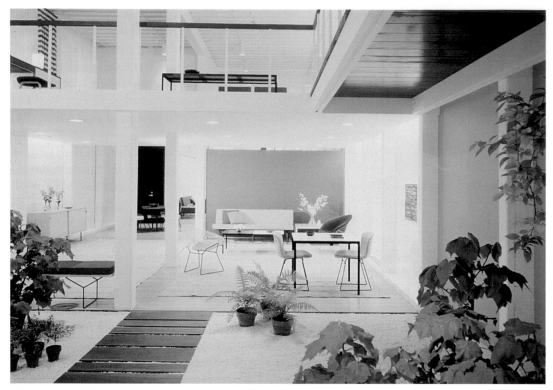

106
Knoll International furniture
showroom, USA, 1950s
The styling of the furniture
and spatial organization of this
interior typifies the
international modernism
projected by multinational
corporations after 1945. This
could be seen in the work for
Knoll by Eero Saarinen, Harry
Bertoia (whose famous lattice
steel wire Diamond chair
(1952) can be seen in the
centre of the floor) and by
Florence Knoll herself, whose
sideboard can be seen on the
extreme left. Hans and
Florence Knoll also forged
links with other leading
American and European
designers, producing furniture
under licence by Mies and
Breuer. The company
established a reputation for
Good Design much in line
with the aesthetic principles
espoused by Kaufmann at
MOMA, New York.

spirit underlying its corporate graphics, advertising, and packaging. It
should be considered, in passing, that a coherent design programme
did not in itself ensure market success: American Gillette took Braun
over, and further difficulties were experienced in the competitive
market-place of the early 1990s.

The work of a wide range of influential corporate identity consul-
tancies such as Chermayeff & Geismar Inc. of New York, Pentagram
of London or Total Design of Holland might be enumerated in this
context, along with many instances of a multinational corporate design
policy, such as those adopted by Philips,[19] Coca-Cola,[20] or Sony.[21]
However, there are other mechanisms worthy of attention which have
done much to support the globalization of specific products or cultural
values, many of them enshrined in the corporate ethos of companies
already discussed.

The role of museums and exhibitions in promoting a global sesign culture

While a growing number of museums are beginning to embrace wider
definitions of design culture in the twentieth century, the majority
have endorsed a policy which is centred on celebrated products or the
output of specific designers whose work is seen to embrace high stan-
dards of aesthetic distinction or cultural status. The twentieth-century
design galleries of many museums around the world have their roots in

the collection and display of objects which, it was originally felt, would 'improve' standards of taste and enhance the cultural well-being of their visitors. Furthermore, those charged with selection policies and the acquisition of material were generally drawn from a narrow social and cultural spectrum and, when they were bold enough to step outside their own national conventions of artistic excellence, often favoured objects which conformed to the modernist canon. The meanings of such clean, abstract forms, stripped of superfluous ornamentation and symbolically compatible with the modern machine-age production technology, have changed alongside the reshaping of cultural and political perspectives both before and after the Second World War, as has been discussed in Chapter 2 (and will be examined further in Chapter 8). As has been argued, modernist products became increasingly associated with notions of 'Good Design', opposed both to retrospective indulgence in historicizing ornament in domestic products on the one hand and to the science-fiction-inspired futuristic chrome fantasies and tail-fins of automobiles on the other. Modernist products were also seen as oppositional to notions of built-in obsolescence and ephemerality and thus, particularly when placed in a spotlit, pedestalized museum—rather than a social—context, assumed something of the status of 'design classic'.

Modernism and MOMA, New York

MOMA, founded in New York in 1929 'to encourage and develop the study of the modern arts and the application of such arts to manufacture and public life', did much to establish such an outlook. Its Department of Architecture and Industrial Art was established in 1932

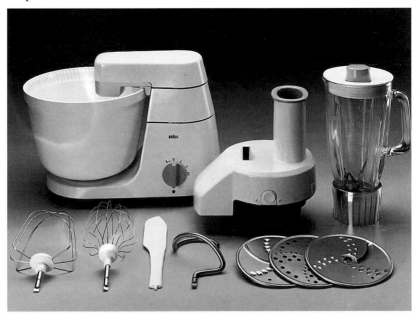

107 Gerd Alfred Muller and Robert Oberheim

Kitchen Machine KM 32, Braun, 1957

By the mid-1950s Braun emerged as a company with high aesthetic principles in product design, having forged links with the nationalist Hochschule für Gestaltung at Ulm. A design department was established at the company in 1956, the KM3 of the following year epitomizing the geometric clarity which was to be associated with Braun products for many years, particularly after 1960 when Dieter Rams became Braun's chief designer. A permanent display of Braun products was put on display at MOMA, New York, in 1958.

116 GK Design

Soy sauce bottle for Kikkoman
Corporation, Japan, late 1950s
This design did much to
establish the reputation of the
GK Design consultancy as well
as the Kikkoman company
which grew rapidly from its
origins as a family firm to a
large national company.
Although the elegant form of
the bottle in many ways
conforms to an international
modernist aesthetic it also
marks an effective design
solution to the marketing of soy
sauce in a table-top container,
much in the manner of the
ubiquitous tomato ketchup
bottle in the USA. Initially
Kikkoman was extremely
sceptical that this would be
effective in a market-place
dominated by tradition, but
it became a market leader.

ucts. This had been inspired both by the COID's London Design
Centre and the Den Permanente (established in 1931) exhibitions of
Danish Design, which received international prominence in 1958
through its receipt of the Italian Compasso d'Oro award. Finally, in
1969 the Japan Industrial Design Promotion Organization (JIDPO)
was established along the lines of the British Council of Industrial
Design. From 1975 it also became responsible for the Design
Development Programme for regional industries, funded both by
national and regional governments, which laid particular stress on
design as a management resource. A further initiative was the estab-
lishment in 1981 of the Japan Design Foundation (JDF), funded by
national and local government as well as commerce and industry.

Under the directorship of Kazuo Kimura, it aimed to promote Japanese design to the forefront of the international stage. It organized the Biennial Design Festival and Competition at Osaka, the first of which was held in 1983 and attracted considerable attention through the granting of the First International Honorary Award for the Encouragement of Design Activities to the British Prime Minister, Margaret Thatcher. More recently, in 1992, the International Design Centre Nagoya Inc. was established with a capital of $100 million as a quasi-governmental corporation with funding from national, regional, and local government as well as the business sector. The largest centre of its kind in Japan, its aims were to bring together community, industry, and the design profession, establishing an R & D centre, a design resource centre, and a design museum with a shopping mart open to the profession, industry, and the public.

Elsewhere in the Far East, Korea has a design promotion policy dating back to 1966, although the government's investment has been more heavily directed towards design education and exhibitions, bringing in educationalists from Japan and West Germany and funding overseas training and study tours. In 1970 the Korea Design and Packaging Center (DKPC) was established and a GD mark for 'good design' instituted in 1986, although it was largely funded by industry. The Taiwan Design Promotion Centre was founded in 1979 to raise the levels of industrial design in Taiwan and to improve perceptions of its products abroad, much of its budget deriving from the Ministry of Economic Affairs. In Singapore, the Singapore Trade Development Board has included design promotion amongst its activities since 1984 and, following the British Design Council's model of the early 1980s, paid for up to 75 per cent of a design consultancy's fees for firms using such expertise for the first time.

Professional design organizations

From the 1940s onwards there has been a significant increase in the number of design organizations, reflecting the growing number of professionals in the field as well as their perceived need to campaign collectively for greater recognition of their value to business, commerce, and society.

In the United States the Society of Industrial Designers was established in New York in 1944, initially with fourteen members (including Loewy, Bel Geddes, Teague, Deskey, Van Doren, and Russel Wright) but growing to almost 100 members by 1949. It aimed 'to improve the vocation of industrial design, by providing the mechanism through which the members of the profession can agree and take action on every type of common problem' as well as to promote better standards of industrial design education and to improve public and industrial understanding of their work. In order to provide a showcase for many

Pop to Post-Modernism: Changing Values

With a discernible shift of emphasis from production towards consumption[1] in the changing market conditions of the postwar period, questions were raised whether either the monolithic Fordist model, which had hitherto dominated approaches to manufacture for the mass market for much of the twentieth century, or the modernist aesthetic could cater adequately for the increasingly variegated tastes and desires of the consumer [**120**, **121**, **122**]. In this connection a number of critics, theorists, and designers became interested in the relationship between visual and linguistic 'signs', the correlation between the two being embraced in what has been termed semiotics. Writers such as the French sociologist Raymond Barthes, in his seminal text *Mythologies* of 1957,[2] the Italian theorist, critic, and design historian Gillo Dorfles, in *Il disegno industriale e la sua estetica*[3] (*Industrial Design and Its Aesthetic*) of 1963, and the American Robert Venturi, in *Complexity and Contradiction in Architecture*[4] of 1966 did much to open up debates about the perceived shortcomings of the modernist aesthetic.

Theoretical and critical reorientation

In the early 1950s Reyner Banham began working on his doctoral thesis, later published as *Theory and Design in the First Machine Age*.[5] It is an important text for design historians as it marks a very different approach to modernism from that of his doctoral supervisor, Nikolaus Pevsner, in his *Pioneers of the Modern Movement*.[6] Representing a shift in critical and theoretical circles, particularly that centred on the Independent Group[7] in London, with which Banham was closely associated, it was written at a time when modernist architecture, design, and theory began to be challenged by those who felt that the new postwar era was one which should embrace mass culture and advanced technology. An era of passenger jet transportation, growing affluence and consumer aspirations, expendability and obsolescence, the 1950s was also, according to Banham, 'the Second Machine Age, the age of domestic electronics and synthetic chemicals'.[8] He also clearly differentiated it from the First Machine Age, the era of modernism:

[in] the Second, highly developed mass production methods have distributed electronic devices and synthetic chemicals broadcast over a large part of society—television, the symbolic machine of the Second Machine Age, has become a means of mass-communication dispensing popular entertainment. In the First, however, only cinema was available to a broad public, whose home life was otherwise barely touched and it was in the upper middle-class homes that the First Machine Age made its greatest impact, the homes that could afford these new, convenient and expensive aids to gracious living, the homes that tend to breed architects, painters, poets, journalists, the creators of the myths and symbols by which a culture recognises itself.[9]

In the early 1950s, in the first phase of meetings of what became known as the Independent Group, considerable interest was expressed in science, technology, and the history of design, an emphasis which underlay Banham's firm belief in the liberating force of technology and his stress in *Theory and Design* on Futurism, which he saw as 'a turning point in theories of design' (unlike his doctoral supervisor, Pevsner, who considerably downplayed its significance in *Pioneers*). At the 1954–5 meetings of the Group—which included Peter and Mary Banham, Lawrence Alloway, Eduardo Paolozzi, Richard and Terry Hamilton, John McHale, Nigel Henderson, and Toni del Renzio— there was considerable interest in popular culture, advertising, and the media in the United States, exemplified in talks such as Banham's 'Borax or the Thousand Horse-Power Mink' of 1955, which considered the extravagant styling, sensuous advertising, and sexual symbolism of the American automobile. Technologically-inspired iconography influenced the styling of many other appliances as well as the seductive language which helped to advertise them, as recounted by John

McHale in a special Americana issue of the Royal College of Art magazine, *Ark* in 1956.

References to 'aquamatic action', 'jet spray', 'centrifugal clutch drive' in the washing machine, figure well in General Electric's new cooking range names—the Stratoliner and the Liberator. A quote like 'New Extra Hi-Speed Giant 2,600 Calrod Unit is 20 per cent faster than gas—by actual test' is straight out of '56 auto ad-speak, and with push-button control, 'a flick of your finger selects your cooking heat' as well as your gear change. Automatic 'cut-offs', 'oventimers', 'circuit-breakers', 'washer and sediment swirl-out' signalled the general preoccupation with robotics, and the 'WondR dial automatically pre-selects' everything from defrosting to the year's breakfasts.[10]

Twelve members of the IG were involved with the *This is Tomorrow* exhibition held at the Whitechapel Gallery in London in 1956. Many art historians, encouraged by particular reinterpretations by Banham and Alloway,[11] have seen this show as the genesis of Pop Art. They have placed particular emphasis on the environment created by John McHale, John Voelker, and Richard Hamilton, which included an American jukebox playing pop music, a publicity blow-up of Robbie the Robot from the film *The Forbidden Planet*, and a cut-out of Marilyn Monroe from *The Seven Year Itch*. However, Anne Massey has convincingly underlined the importance of design as 'the overarching con-

121 James Dyson

G-Force Cyclonic Vacuum Cleaner manufactured by Apex Inc., Tokyo, 1986 Designed in 1979, the striking colours of this sculptural, high-tech design mark it out as more than a functional object. Rather as the styling of food mixers in the 1950s (see **107**) increasingly demarcated them as objects to be displayed on kitchen work surfaces rather than stored in cupboards, so this product endowed the mundaneity of housework with associations of designer-chic in the icon-conscious 1980s. Unlike the kitchen appliance seen in **107**, this design is redolent with imagery and associations.

cept'[12] of the exhibition. *This Is Tomorrow* was visited by more than 19,000, was widely reported in the media, and thus brought some of these design-centred ideas before a wider audience.

That the potential liberating power of technology was not restricted to theoretical discussions amongst an educated artistic coterie, the interests of the art gallery-going public, or the prurient focus of the media was exemplified in Alison and Peter Smithson's design for a 'House of the Future' [123] which was shown at the *Daily Mail* Ideal Home Exhibition in Olympia, London, in 1956. During the mid-1950s these annual exhibitions were regularly visited by more than 1 million visitors. In 1956 in the Smithsons' vision of the early 1980s they could see a wide range of futuristic appliances and equipment, including remote-controlled radio-television and controls for raising sections of the floor for coffee or dining tables in the living room; an eye-level refrigerator, two eye-level ovens, one of which was microwave, and a dishwasher.

Another London-based group which embraced notions of expendability, obsolescence, and change as a sign of a vibrant, healthy society was Archigram which received its first public exposure at an exhibition at the Institute of the Contemporary Arts in 1963. Members of the group, disillusioned by the restrictive nature of contemporary architectural practice in Britain, looked to the world of science fiction for a prophetic insight into the future and, like Banham, placed their faith in

122 Richard Sapper

Kettle with bronze whistle, Alessi, 1983

Like the vacuum cleaner seen in **121**, this kettle became a cult icon in fashionable circles in the 1980s. Considerable attention was paid to design for the status-conscious kitchen, with products being made from high-quality materials. Sapper worked on several products for Alessi, including an extensive range of pans and kitchen utensils which was developed in conjunction with leading French and Italian chefs. It was manufactured in 1986 under the name *La Cintura di Orione*.

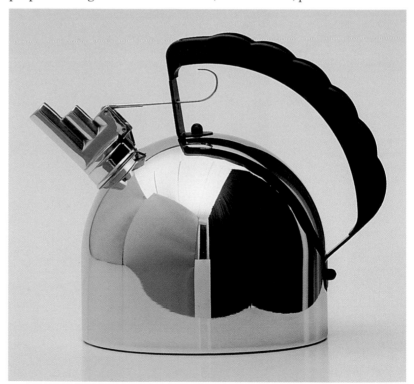

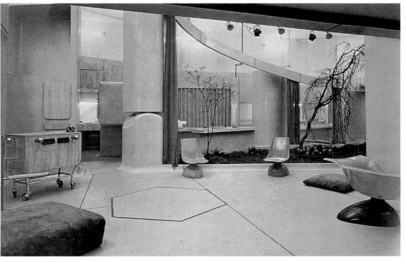

the latest technology—the space capsule, the rocket, the bathyscope, and the handypack. They rejected traditional forms of building and very much looked to a form of architecture which was determined by consumer need. Flexibility, individual choice, and an affinity with popular culture underlay many of their Utopian schemes such as the Walking City of 1964 and the Instant City of 1968.

In Establishment circles there was a clear difference of opinion about what was an appropriate form for modern design. American arbiters of taste, such as Edgar Kaufmann Jr. of the Museum of Modern Art in New York, had placed a very different interpretation of definitions of the requirements that modern design should fulfil from those in the Independent Group or Archigram in Britain. Kaufmann, who had warned British architects and designers about what he saw as the moral dangers of streamlining and styling for the sake of change in his celebrated 1948 article on 'Borax, or the Chromium-Plated Calf',[13] opined that modern design 'is the planning and making of objects suited to our way of life, our abilities, our ideals', that it should 'express the spirit of our times', and that it should 'serve as wide a public as possible, considering modest needs and limited costs no less challenging than the requirements of pomp and luxury'.[14] Clearly notions such as 'our way of life' or 'our ideals' epitomized a particular social and cultural sector of society.

At the Council of Industrial Design (COID) there was a similar resistance to American ideas of built-in obsolescence, 'style follows sales', and the lure of gadgetry, with a number of admonitory articles in the organization's magazine, *Design*. Richard Hamilton, painter and member of the Independent Group, was also a significant writer on design and, when he wrote about American practice in a 1960 *Design* article entitled 'Persuading Image',[15] John E. Blake wrote an accompanying editorial, 'Consumers in Danger',[16] in which he likened what

128 Ettore Sottsass
Carlton Bookcase, Memphis, 1981

This striking example of Sottsass's early work for Memphis reveals a deeply anti-functionalist attitude through its premium on colour, decoration, and experimentation with form and surface. Evolving from the experimentation of the Milanese avant-garde of the late 1970s, its visual richness ran counter to the wider contemporary inclinations of furniture production which stressed elegance and refinement.

extremely useful about contemporary design issues in Italy. The large exhibition was highly significant, not only for staging important debates about the sociocultural implications of design but because it marked a fundamental change of perspective for MOMA, which previously had tended to focus on the aesthetics of the individual object or celebrated designer.

Ettore Sottsass Jr. played a pivotal role in this changing avant-garde climate of the late 1960s and 1970s, having a wealth of experience in experimental as well as mainstream industrial design. Not only had he exhibited at the first postwar Triennale in 1947, but in 1956 he worked in the studio of the American designer George Nelson, before beginning a longstanding relationship as a consultant to Olivetti in the following year. After responding to the possibilities afforded by kitsch and American Pop in the early 1960s, Sottsass drew on an increasingly wide range of cultural references, exploring ideas relating to meditation and love as well as reconciling aspects of ancient mythology and symbolism with imagery drawn from the contemporary world. This drawing on other cultures was partly reinforced by his visit to India in 1961 and was particularly evident in his ceramic work of the period including the 'Ceramics of Darkness' and the 'Ceramics to Shiva' series of 1963 and 1964. Like a number of his contemporaries, he also explored the status and meaning of objects in a series of furniture designs and rooms for Poltranova from the mid-1960s, using the symbolism of mass culture. Furthermore, allying himself to the Utopian spirit of Radical Design he envisaged in his drawings and text for the *Planet as Festival* series of 1973 a world in which consumerism and the work ethic had no place but provided the launching point for a voyage of imaginative self-discovery.

From Studio Alchymia to Memphis

Studio Alchymia was founded by Alessandro and Adriana Guerriero in Milan in 1979. Its chief spokesman was the designer-writer Alessandro Mendini, and its main protagonists included Ettore Sottsass Jr., Paola Navone, Andrea Branzi, and Michele de Lucchi. The practice of 'Alchemy' implied a pursuit of the quest to turn base substances into gold, a philosophy which evoked considerable controversy and critical attention in much of the group's work which centred on the idea of 'banality': ordinary, everyday consumer objects were transformed, or re-designed, into objects of aesthetic contemplation through the application of colour, pattern, and additional elements. Through this process they harnessed the potential of what Sottsass described as 'non-cultural imagery', that is, imagery without conventional aesthetic status. Their output ranged from individual items of furniture through to total environments or performances and was often highly decorative, drawing upon references from Braun to Bauhaus and from kitsch to Kandinsky in the exploration of the communicative boundaries of design.

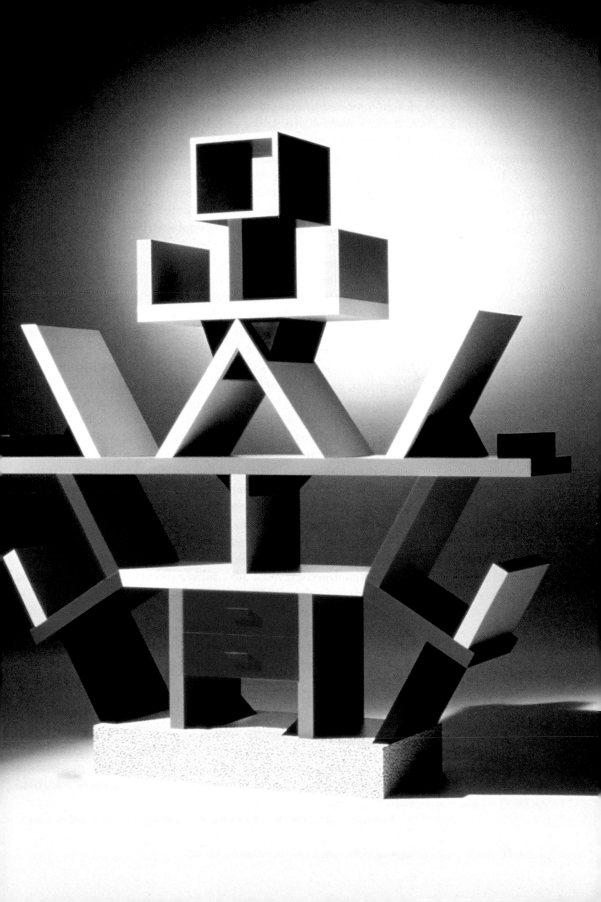

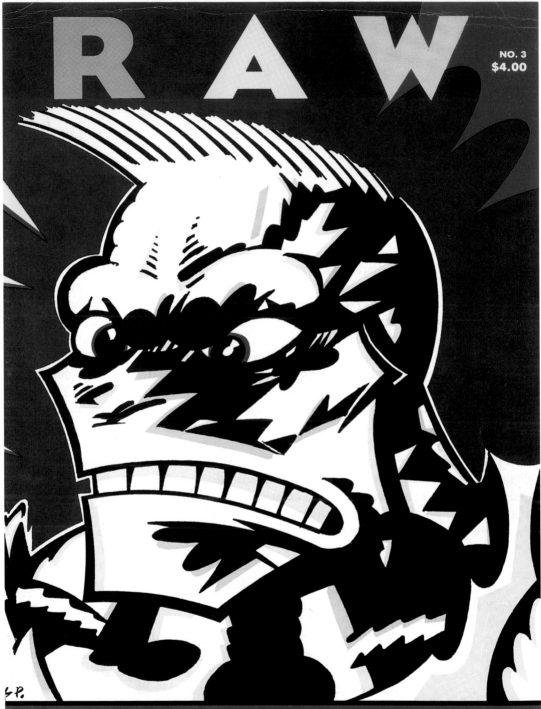

East—Japanese retailers such as Men's Bigi and Parco, Dutch Telecom, PTT, Bloomingdales in New York, and the Body Shop in England—reinforcing the concept of global potency of style in affluent industrialized societies.

Pop, punk, and Post-Modernism: an afterword

Pop in the early 1960s has often been interpreted as a youthful challenge to many traditionally accepted values,[34] and the vibrant, expendable consumer values that it furthered were not seen as a serious threat to the social status quo. However, from 1966, when hallucinogenic drugs, free love, and interest in eastern religions assumed an increasingly significant profile, the outlook began to change. Psychedelic patterns and imagery, associated with vividly colourful experience of

FontFont 5
New Exclusive fonts from FontShop

Berlinsans
Berlinsans Light EXPERT Roman EXPERT Demibold EXPERT Bold EXPERT

① ② ③ ④ ⑩ ㉑

POP DYNAMOE FLIGHTCASE

LED KARTON

Stamp Gothic

CONFIDENTIAL......

Mambo Light Medium Bold Initials

① ② ③ ④ ⑩ ㉑

Mambo

TYPEFACE FOUR

Du Duchamp
Du Chirico
Du Gauguin
Du Turner

LSD, appeared widely in posters, record covers, clothing and other surfaces, including shop fronts. Originating in West Coast America Psychedelic art was associated with alternative or 'hippy' lifestyles and found expression in the widely disseminated posters of Rick Griffin, Wes Wilson, and Victor Moscoso. Their counterparts in Britain included Martin Sharp, illustrator for the notorious magazine *Oz*,[35] and the partnership of Nigel Weymouth and Michael English (known as Hapsash and the Coloured Coat), best known for their mural and shop-front work. However, any perceived social or cultural threat which such design might be seen to embody was undermined by the high levels of commercialization of the style, which ceased to embrace any genuine fundamentals of an alternative lifestyle as soon as it became readily available 'off-the-peg' in a wide variety of retail outlets. A similar transformation can be seen to have taken place with Punk,

which some writers have seen as an affirmation of the working-class urban reality of unemployment, expressed through ripped, zipped, and 'dirty' dress that was 'the sartorial equivalent of swear words', or personal ornamentation and body-piercing associated with overtones of 'deviancy'. Ideas and information about music and events were communicated crudely through small-scale 'newsheets'. Often typed with hand-written deletions and insertions and photocopied such 'fanzines' were stapled together and produced in very small runs for local networks: better known examples include *Sniffin Glue* and *Ripped and Torn* which began in 1976. The impact of such work has been significant and within five years became a mainstream element of commercialized street style in the graphic work of Jamie Reid, Michael Garret, Peter Saville, and Neville Brody. The immediate impact of Punk's outcry against the establishment was relatively short-lived as 'offensiveness' was soon incorporated into mainstream cultural expression, with ripped and torn clothing soon mass-produced and available in fashionable boutiques. None the less, as a number of writers have argued, it did reassert Britain as a centre for new and original ideas in design.

But the rapid move from innovation to orthodoxy was not confined to street style. Many critics also drew attention to the ways in which positive and conscious moves to enrich the design and architectural vocabulary, as seen in the origins of the 'New International Style', might become devalued in what might be termed 'simplistic, reach-me-down formulae'. For example, in the book accompanying *The Design Now* exhibition in Frankfurt in 1988, Volker Fischer wrote of such formulae:

At three or four removes they may degenerate into a new form of kitsch, easy on the eye, tailor made for the suburban bungalow, with oriels and columnettes adorning facades across the land! Post-Modernism is basically characterised by the rediscovery of ornament, colour, symbolic connections and the treasure trove of the history of form.[36]

Nostalgia, Heritage, and Design

9

Nostalgia has played a significant role in the production and consumption of design throughout the twentieth century, whether in the late 1940s and 1950s mass-produced suburban developments by Levitt & Sons in traditional clapper-boarded American Cape Cod cottage style, the reaffirmation of 1950s and 1960s American motorcycle heritage in the Harley-Davidson Springer Softail and Heritage Softail Classic production models of the late 1980s,[1] Barbara Hulanicki's Biba boutiques and department store in London in the 1960s and 1970s (drawing on a changing panorama of sources from Victoriana and Art Nouveau to Art Deco and Hollywood), or the 'English Country Cottage' chintz-inspired interior décor promoted by Laura Ashley in the 1970s and 1980s. This 'sentimental longing for past times' is also closely bound up with notions of tradition and national identity, a number of which already have been addressed in Chapter 4. Furthermore, the variety of ways in which historical references can be harnessed is further complicated by the free use of, and potentially fresh meanings afforded by, quotations from the past by post-modern designers such as Philippe Starck in his *Richard III* armchair, a three-legged pastiche of the archetypal Club armchair of the 1930s or Robert Venturi in his *Chippendale Chair (with Grandmother Pattern)* produced by Knoll International of 1984.

Aspects of American heritage and Colonial Revival

Large-scale exhibitions were important vehicles for the reinforcing of ideas about identity and heritage in the twentieth century, just as they had been in the nineteenth. For example, the six million visitors to the Sesquicentennial Exhibition at Philadelphia, open from June to November 1926, could see a recreation of the main street of Philadelphia in 1776, complete with the Franklin Print Shop, the Paul Revere Forge and a Friends Meeting House. Even at the 1933 Chicago Century of Progress Exhibition reconstruction of the past also played a significant role, much as had been the case in large-scale imperial and colonial exhibitions in Europe such as the British Empire Exhibition at Wembley, London, of 1924 and the Exposition Coloniale in Paris of 1931. At Chicago in 1933 an important element of the display was the

Detail of 138

This was one of a number
of craft workshops at
Williamsburg which promoted
the Colonial Revival style.
Others included a forge and
pewter shop where
costumed craftsworkers
explained their work to visitors.
The carefully researched
restoration of Colonial
Williamsburg was conceived
as a means of establishing a
consciousness of a past
centred on the historic capital
of Virginia, promoting a set
of essentially Anglo-Saxon
and 'patriotic' values.

reconstruction of Fort Dearborn of 1833 and a replica of the log-cabin where Abraham Lincoln was born.[2] Furthermore, at the futuristic New York World's Fair of 1939, the governing Board of Design allowed traditional forms to be used in the Court of States which celebrated historical heritage: the New England states of Connecticut, Massachusetts, New Hampshire, Rhode Island, and Vermont collaborated on a joint exhibit featuring a replica of a sea-going schooner and a reproduction wharf and dockside which looked back to earlier trading days; in similar vein the Pennsylvania building was a replica of Independence Hall in Philadelphia, and the New Jersey building reproduced the Old Barracks where Hessian mercenaries in the service of Britain were overcome by Washington's forces at the Battle of Trenton in 1787.

Particular notions of American heritage had been prompted by a number of other concerns in the interwar years, including the setting up of the American Wing of the Metropolitan Museum of Art, New York, in 1924 and the Philadelphia Sesquicentennial Exhibition (celebrating the 150th anniversary of the signing of the Declaration of Independence) of 1926. In fact 1926 was a significant year as it saw the establishment of Greenfield village by the industrialist Henry Ford in Dearborn, Michigan, and the commencement of the restoration (funded by John D. Rockefeller Jr.) of colonial Williamsburg. The Index of American Design, sponsored by the Federal Arts Project[3] between 1935 and 1941 and originally co-ordinated by the textile designer Ruth Reeves, was a further important impetus in documenting a much more broad-based and inclusive portrayal of the heritage of the United States.

The Greenfield Village heritage concept was a means both of focusing contemporary attention on renowned American inventors and products and of clearly identifying their part in the shaping of what he saw as everyday American life from its origins in the colonial era. Much of the site was devoted to the reconstruction of an early American village that included a variety of archetypal buildings which symbolized, through their form and contents, the achievements and outlook of ordinary American people. Also incorporated into Ford's Greenfield Village scheme were a number of other buildings associated with major figures of American history, such as the Illinois courthouse where Abraham Lincoln first practised law. More significant in terms of the history of technology and invention in the United States, a field which Ford sought to emphasize in his particular portrayal of American history, were the reconstructions of Thomas Edison's Menlo Park, New Jersey, laboratory and the Wright Brothers' bicycle shop. Many other historical determinants in the shaping of American life were shown at the Henry Ford Museum, also on site, including Ford's collections of domestic appliances, furniture, clocks, and automobiles.

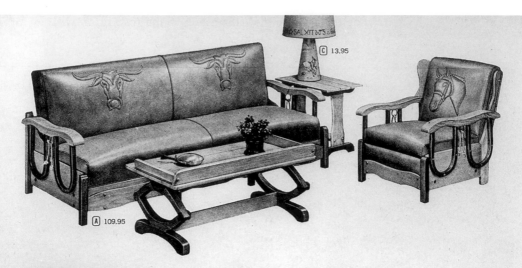

(A) 109.95

(C) 13.95

(B) 64.95

(E) 44.95

Western-styled Sofa-Bed Groups

FURNISH YOUR HOME IN THE RICH TRADITION OF THE AMERICAN WEST. These distinctive pieces offer frontier styling in the strong, practical construction of modern craftsmanship. Rounded "time-worn" effect edges, peg-effect trim and plank-top tables give authentic appearance—ideal for living room, den, basement or game room. Solid Hardwood construction—dowelled, corner-braced, hot-glued at points of strain to give added rigidity. Cotton and sisal padding for extra comfort.

DU PONT FABRILITE UPHOLSTERY—a Vinyl Plastic on strong fabric back for extra long wear on both Sofa-Bed groups. Highly resistant to peeling or cracking, Vinyl cleans easily with a damp cloth. You may choose from four striking colors: Chartreuse, Green, Saddle Tan or Deep Red.

BOTH SOFA BEDS open like (DGHJ), Pg. 505. Become 72x45-in. beds. 162 double-cone coil-springs in seat and back over No-Sag steel springs. Cotton and Sisal padding eliminates "coil-feel." Bedding compartment. Ht. 33 in. Seat 72x22½ in. Rear of back is Cotton Velourette in matching color.

BOTH LOUNGE CHAIRS: Covered all around with Plastic—fit into any room arrangement. Removable coil-spring 21x23½-in. seat cushion rests on No-Sag steel spring base for added comfort. Coil-springs in padded back. Height 32½ in.

BOTH PLATFORM ROCKERS: Rock with steel spring on stationary platform. Attached 22x22½-in. coil-spring seat cushion, No-Sag spring base. Coil-spring back. Height 32 in.

DURABLE PLASTIC-COVERED PIECES—BUY SINGLY OR SAVE ON 5-PIECE GROUP . . . ONLY 219.95

(A)(B) Combination of two finishes—"Driftwood," a gray natural finish contrasting with Light Walnut finish—both rubbed to a satiny smoothness. Authentic adaptations of old ox-yokes form arms. Handsome trapunto embossed steer heads on 80-in. long Sofa-Bed, a horse's head on both Lounge Chair and Platform Rocker. Note the unique Cocktail Table, inspired by buckboard seat on wagon springs—extra large planked top, 40x22 in. Height 16½ in. End Table top 22x13½ in. Height 21 in. Pay shipping charge from Austin, Texas Factory. Allow two weeks extra at Factory.*

66 A 4985 F—State Items or Groups and Upholstery Color wanted: Chartreuse, Green, Saddle Tan or Deep Red.
(A) SOFA-BED. Ship. wt. 165 lbs. $17 Down......Cash $109.95
(B) PLATFORM ROCKER. Ship. wt. 90 lbs. $10.50 Dn. Cash 64.95
SOFA-BED (A) AND LOUNGE CHAIR (above). Ship. wt. 235 lbs. $26.50 Down on Wards Credit Terms........or Cash $169.95
5-Pc. GROUP: Consists of Sofa-Bed, Lounge Chair, One Cocktail Table and Two End Tables. Shipping weight 330 lbs. Only $34 Down on Convenient Terms........or Cash $219.95

(C) WESTERN TABLE LAMP. Hand-decorated cowboy-and-steer design on composition base. Ht. 28 in. Wt. ea. 9 lbs. Mailable. 66 A 247 M—Natural-color paper Parchment shade, 16-inch diameter. Use with either group. Pair $26.95; Each..$13.95

RANCH-STYLE SOFA-BED 89.95 SOFA-BED AND PLATFORM ROCKER 134.95 5-PIECE GROUP 164.95

(D)(E) Light Gray finish—resembling the textured, yet smooth finish of Limed Oak. Handsome trapunto embossed heads of horses on 85-inch long Sofa-Bed—extra wide arms, so convenient for resting books. Chair backs not embossed. Cocktail Table has 30x16 in. top. Height 16 in. Buy pieces singly or in low-price groups. Lamp (C) sold above is ideal with this group. Pay shipping charges from Factory in Austin, Texas. Allow two weeks extra at Factory.*

66 A 4986 F—State Items or Groups and Upholstery Color: Chartreuse, Green, Saddle Tan or Deep Red.
(D) SOFA-BED. Shipping weight 155 lbs. $14 Down, Cash $89.95
(E) LOUNGE CHAIR. Ship. wt. 70 lbs. $4.50 Down, Cash 44.95
SOFA-BED (D) AND PLATFORM ROCKER (below). Wt. 245 lbs. 134.95
5-Pc. GROUP: Consists of Sofa-Bed, Platform Rocker, 1 Cocktail Table and Two End Tables. Ship. wt. 310 lbs........$164.95

*SOFA-BEDS AND CHAIRS on this page are covered to your order and shipped to you from the Factory. This elimination of handling expense results in lower prices for you. For details on Wards Convenient Monthly Payment Plan, see Page 968.

506 WARDS FED

(D) 89.95

The restoration of Williamsburg came to fruition with its formal opening in 1935, an event which was widely reported in the press and generated considerable public interest. Enthusiasm for the Colonial Revival had fluctuated since the Philadelphia Centennial International Exhibition of 1876, but was reawakened almost sixty years later by numerous features in magazines devoted to domestic interiors and decoration. Such a revival of interest in Colonial crafts was further invigorated by the opening in 1937 of the first of Williamsburg's reconstructed shops where crafts workers worked in the public gaze [**133**], explaining to visitors the processes and significance of their activities.[4] Furthermore, Williamsburg also supported the large-scale manufacture of Colonial reproductions through its Programme for the Promotion of Crafts which enabled manufacturers to reproduce a wide range of artifacts for the home to be put on sale at the Craft House in Williamsburg, selected retail outlets across the United States, and through mail-order. As has been shown by William Rhoads,[5] both the Williamsburg reconstruction and the phenomenon of Colonial revival were recognized as significant barriers to the wider acceptance of modernism in the United States. This attachment to the past was seen to be embraced by many in the interwar years, resurfacing with renewed vigour after 1945 when national identity and 'American values' once more became significant areas for concern [**134**].

The Index of American Design was largely a response to the campaigning activity of those who sought to revive interest in the Spanish Colonial style[6] and Hispanic crafts, to preserve the heritage of Indian tribal crafts, and to document a wider perspective of American decorative arts from the Colonial period onwards. This comprehensive survey consisted of more than 22,000 plates made by over 500 unemployed artists. Its multicultural embrace was far more wide-reaching than the monocultural and partial outlook of the Colonial Revival. More complex debates about identity and multiculturalism surfaced more potently in the post-1945 era, a difficult yet rewarding field of study which falls outside the scope of this particular volume on twentieth-century design. It is also an area of developing importance in the study of such concerns in the history of European design of the same period.

None the less, historical styles endured in the domestic sphere in the postwar years, as they did in Europe and elsewhere [**135**]. Even in the field of American diners,[7] archetypal heritage symbols of the streamlined era of the later 1930s, such historicizing design considerations began to assert themselves by the early 1960s. For example, the Kulman Dining Car Company of Newark, New Jersey, built its first diner in Colonial Revival style in Ocean City in 1962, marking a move away from the dominant stainless steel modernity of earlier models. Such an aesthetic, embracing such characteristics as wood-panelling,

Customagic Slipcovers advertisement, USA, 1950s
This advertisement reveals the variety of styles available to American consumers of the period. The fact that these Customagic Golden-Fleck Brocade Slipcovers would 'harmonize tastefully' with the 'Traditional chair with a floral pattern' seen in the bottom vignette would have been reassuring to the large number of people who bought reproduction furniture.

shaded lights on horizontally-suspended traditional wooden wagon wheels, and wall-mounted rifles, saddles, and gun belts, remained popular into the 1970s. Colonial Revivalism also featured in the home and business environment of the period when nostalgia became a more pronounced feature of middle-class houses and apartments. Historical styles were widely purchased across the economic spectrum, featuring in a wide range of contemporary magazines as well as in the products of named designers, such as William Baldwin, who explored the expressive possibilities of traditional forms in designs for furniture and interiors.

As interest in American folk art began to gain more widespread currency in this period, so a number of indigenous traditions such as stencilling, which had flourished from the late eighteenth to mid-nineteenth century, were reintroduced, particularly in period homes.

Other related folk-art traditions, such as painted floors and floor-cloths, were also re-explored, along with a revival of interest in the traditional forms of Amish, Mennonite, and other designs for patchwork quilts.

Nostalgia and the invention of tradition

Much nostalgic imagery in the packaging for, and surface decoration applied to, so many products is tied to a past which is characterized by non-specific space and time. In his discussion of nostalgia, *Yearning for Yesterday*,[8] Fred Davis drew attention to an article in the *New York Times* in February 1975 in which the spirit of contemporary nostalgia was described thus:

. . . today's nostalgia is at worst bittersweet, at least designed to bring some pleasure. Our fashions, decor and happenings evoke the thirties without the Depression, the forties sans the war, the fifties minus MacCarthyism. These harmless activities deserve no monopoly of the past.[9]

Davis also drew attention to the confusion that seemingly 'accurate' films could generate in their relentless search for authentic historical flavour. In relation to the enormously successful film, *The Sting*, he wrote:

. . . the problem of hypernaturalism's artificiality is further confounded by the cavalier imposition of pre-World War I rag-time music and 'big-store' con games onto the chic gangsterism of the twenties and the social protest atmosphere of the thirties. In short, the film was a historical mess, despite the apparently obsessive care taken by the makers to have everything look extra-real.[10]

Similarly, the apparent historical origins upon which many designs evocative of the past are based have little real foundation in fact. This theme is absorbingly explored in a variety of regional, cultural, and 'ethnic' contexts in Eric Hobsbawm and Terence Ranger's text of 1983, *The Invention of Tradition*,[11] which offers design historians a number of models which might usefully be explored further in their own field. The 'invention' of the naturally-based toiletries and quality foods firm of Crabtree & Evelyn in 1972[12] provides a parallel case in point, exuding as it did the spirit of Olde England through the historicist design of its shops. A strong scent of the past was also given off by its products and packaging [136] as well as the feeling of historical credibility afforded by the choice of names for the company's fictitious London 'proprietors' with their specific roots in English history: John Evelyn was a celebrated English diarist of the seventeenth century who wrote on food, was a horticulturist, and planned English country parks; George Crabtree, an English horticulturist, was a figure of the same period with an archetypally English name. However, Crabtree & Evelyn was in fact an American company, the founder of which, Cyrus

136 Peter Windett

Crabtree & Evelyn shop interior
and packaging, 1982

The invented English historic
pedigree of Crabtree & Evelyn
shops and packaging proved
a successful formula for
volume sales in Europe, the
United States, and elsewhere.

Harvey, sought out an English identity for the sale of its products in
the USA. This was supplied by the English designer Peter Windett
who was approached by Harvey before either the name or the company
logotype was arrived at: Windett's design solution for the logo was
based on a seventeenth-century woodcut of an apple tree. When the
company moved into direct retailing in the late 1970s the first shop that
Windett designed for it was based on the idea of the English apothe-
cary. Built in England, it was shipped out to Philadelphia, complete
with English cabinets, glass, brass fittings, wallpaper, and carpet; it was
later moved to the Crabtree & Evelyn outlet on Madison Avenue,
New York. As the company expanded, design of the American stores
was handed over to an American company, with design for the
European outlets being carried out by the London-based Prosper
Devas. In the mid-1980s Devas also designed an 'authentically English'
shop within the Matsuya department store in Tokyo.

Nostalgic packaging, with a high illustrative content, has provided a
fundamental aspect of the 'invented tradition' of the company's cor-
porate identity. As Windett said:

The illustrations—particularly with food—tend to tell a story, to portray an
image, not just of the products, but of their history. To depict the origin of gin-
ger in a ginger biscuit, for instance, we can do a very good, authentic drawing
of the West Indies, evoking an image of the quality and integrity of the prod-
uct. And then the text will have anecdotes, historical quotes.[13]

To help consolidate the 'manufactured' authenticity of its designs the
company looked to cottage industries and old family firms to supply its

products, a recipe which, combined with the other aesthetically-charged ingredients of shop design, packaging, and advertising, proved a highly successful formula in the 1970s and 1980s—the invention of tradition turned out to be a highly profitable marketing enterprise. By the late 1980s the company had 170 licensed or company-owned shops in North America, with eight in Britain and a small number of others in Europe and Japan. It also had almost 2,500 points of sale in 23 countries.

Design and the past in Britain in the post-1945 era

The notion that certain aspects of the past were lost for ever took on particular resonances from the late 1940s onwards, a feeling that was reinforced by the destruction of the Second World War and the realization that British Empire, previously a significant ingredient of the national historical and educational make-up, was coming inexorably to an end. A number of writers have viewed this period as a battleground for the reassertion of particular cultural positions.[14] Against such a backcloth there was a heightened spirit of self-consciousness about the national past. At the same time that the recently founded Council of Industrial Design (COID) was seeking to promote a modern aesthetic[15] and technological innovations were being promoted overseas there was a resurgence of interest in the traditions of British popular art and the rural crafts. This manifested itself in a variety of ways, ranging from books to exhibitions. Important texts included Charles Marriott's *British Handicrafts*, first published in 1943[16] as part of the British Council's series on British Life and Thought. The author sought to reconcile surviving handicrafts with contemporary needs since he felt that they 'encourage that use of the hand which is the crying need of a mechanical civilisation . . . and, above all, they bring into play the basic native qualities on which artistic excellence in the crafts ultimately depends.'[17] Margaret Lambert and the designer-illustrator Enid Marx contributed to the field of the history of popular art, producing an illustrated text on *English Popular and Traditional Arts* in 1946,[18] followed up by a far more detailed study in 1951.[19] The latter expressed the firm belief that a strong tradition of British cultural creativity was being lost to the postwar generation, a tradition which Lambert and Marx wished to preserve for posterity as a field of study. In the same year Barbara Jones's *The Unsophisticated Arts*[20] was published, described at the time as 'the first substantial publication on British popular art'.[21] Included in its scope were such miscellaneous elements as fairground roundabouts, the decoration of canal boats and their equipment, the design of rustic porches executed by a late nineteenth-century craftsman, and the picturesque detailing of riverside bungalows. In this, the Festival of Britain year, Barbara Jones and Tom Ingram also organized an exhibition of British Popular and Traditional

Art at the Whitechapel Gallery, London. Entitled 'Black Eyes and Lemonade', it celebrated the heritage of everyday life, including souvenirs of all kinds, football memorabilia, traditional shaped loaves, sweets, and other foodstuffs, as well as miscellaneous artifacts connected with the home, such as Toby Jugs and thatched cottage teapots.

There were other tangible elements of change which enhanced this renewed consciousness of the past. Following the disappearance of the regional companies with the nationalization of the railways in 1948, steam trains were gradually replaced with diesel and electric systems. Such developments encouraged the formation of railway preservation societies and led to the growth of interest in British railway history. Furthermore, the preservation of folk songs and a growing sense of the importance of oral history helped to maintain a sense of continuity with the past, an understanding of which was further enhanced by the emergence of industrial archaeology as a field of academic study. Conservation and preservation also became important rallying points for those who were opposed to the widespread speculative building developments which irretrievably changed the face of many cityscapes throughout Britain in the 1960s. A growing sense of 'Heritage in Danger' was articulated by Malcolm MacEwan and others during the 1970s,[22] a very different interpretation of 'heritage' from the adoption of Victorian values by Margaret Thatcher and her Conservative government in the 1980s.

In his thought-provoking book of 1985, *On Living in an Old Country: The National Past in Contemporary Britain*, Patrick Wright viewed the emergence of heritage as a concern which took on a very distinct character after 1979 when Margaret Thatcher came to power. He drew attention to her aim of 'restoring national pride and other old values back to the country at large' and the great patriotic fervour with which the National Heritage Bill of 1980 was greeted on its introduction in Parliament. He also viewed the National Heritage Memorial Fund as one of the Conservative government's first attempts 'to revive the spirit of the Second World War and to set up its own patriotic measure against that long-drawn-out betrayal known in more polite circles as the post-war settlement'.[23] Although Wright did not suggest that the conservation of heritage was crudely class-determined, he drew attention to the prevailing cultural values endorsed by the National Trust.

Founded in 1895, by 1985 the Trust boasted a membership of over one million and was one of the largest landowners in Britain. Concern for the landscape, identified with the essence of England, and the preservation of monuments were seen to be linked with a desire to preserve the social order. In the light of Peter Windett's choice of the apple tree as summarizing Englishness for the historically-vibrant, yet

myth-creating, logotype for Crabtree & Evelyn in the 1970s, it is per-haps interesting to note that when the National Trust was seeking to promote itself more forcibly through the creation of its own identity in the mid-1930s it eventually ran an invitation-only competition[24] in which the six preselected designers were only allowed to incorporate a lion, a rose, or a tree in their designs. The winning design by Joseph Armitage incorporated the oak-leaf as an effective communicator of the spirit of national heritage, a symbol which has endured to the pre-sent day.

The National Trust, like many more straightforwardly commercial companies, also entered into the market-place, selling traditional toi-letries, foodstuffs, and many other products exuding a strong sense of national heritage and history. The first National Trust shop opened in a country house in Saltram, Devon, in the late 1960s. Following the appointment of Roy Hallet as the Trust's Sales and Marketing Organizer in 1970 there was a rapid expansion of this commercial dimension: within 12 months there were 30 new retail outlets, all of which proved profitable; designers, notably the textile designer Pat Albeck, were brought in to develop such potential. In less than twenty years National Trust Enterprises had a turnover of £20 million with profits in excess of £3 million. During the same period the commercial possibilities of marketing the past have been taken up as an increas-ingly significant part of the museum economy, whether through the activities of such concerns as V & A Enterprises at the Victoria and Albert Museum or the souvenir shops of the vast number of heritage sites throughout Britain.

As has been seen from the above, as well as in Chapter 4, there has been a long-standing belief that the quintessential England lay in the countryside rather than the city. The traditional 'unpolluted' values of a rural heritage and a spirit of nostalgia located in a seemingly familiar yet historically unspecified past were frequently extolled in advertise-ments, packaging (particularly of foodstuffs), and a wide range of arti-facts. In the decades following the company's modest beginnings in the early 1950s as a producer of fabric prints in the Ashleys' Pimlico, London, flat the products of Laura Ashley fully embraced such ideals. The company became increasingly concerned with the marketing of a 'lifestyle' drawing strongly on the imagery associated with the country-side, commencing with clothing in 1967. A rapid expansion of the company's activities followed the opening of its shop in London's Fulham Road, the location of Terence Conran's first Habitat store, which had opened in 1964. In the late 1970s and 1980s Laura Ashley began to market ideas for complete interiors, retailing co-ordinating fabrics, wallpapers, and paints. The rural imagery employed, evocative of the idyllic country cottage and its surroundings, also proved attrac-tive to overseas markets: by the early 1980s there were twelve retailing

outlets in the United States as well as a number of others in major cities in Canada, Australia, and Germany; in addition there were mail-order facilities in several European and Scandinavian countries. The co-ordinated orthodoxy of cotton and chintz seen in the wallpapers, Country Furnishing fabrics and frills were evocatively promoted through the Laura Ashley *Catalogue*, an idea initiated in 1981 and further consolidated by the publication of a glossy ideas book, the *Laura Ashley Book of Interior Decoration*. The literally rose-tinted visions evoked by catalogue texts were exemplified by Laura Ashley's preface to the 1982 *Catalogue*, in which she declared:

Our aim each year is to study and review our prints and colours in the light of changing moods of lifestyle. Happily romanticism is more in the air than ever. If you bicycle from Chelsea to Hampstead the gardens are overflowing with roses and lavender . . .

In addition to the Chintz Collection so successfully introduced last year, we are launching a new Decorator Collection printed on Satin. These extra fine fabrics have enabled us to engrave flower prints as well as the more sophisticated geometric prints in a way never seen in our collections before.[25]

The marketing of retrospection was by no means confined to Laura Ashley and found expression in the output of ceramic manufacturers [**137**, **138**], wallpaper producers, textile companies, and others [**139**]. On both sides of the Atlantic the idea of the country house interior, first explored by (Sybil) Colefax & (John) Fowler in the 1930s, became a significant source of inspiration in the 1970s and 1980s, leading to a frequent sourcing of a range of patterns from the archives of long-established textile and wallpaper manufacturers: Arthur Sanderson & Co, who owned the original blocks for a range of Morris & Co designs, marketed a range of Arts and Crafts patterns; Tissunique of London,

Brunschwig & Fils, New York, and F. Schumacher & Co, USA, were among other notable exponents of such trends.

The past was also evoked in a revival of interest in traditional decorative techniques, fostered not only by the significant growth in the number of magazines devoted to interior design and decoration but by a continuing growth of Do-It-Yourself as a leisure activity. Techniques such as stencil work, rag rolling, and marbling were often featured in popular homemaking magazines, as well as advice notes in paint manufacturers catalogues aimed for the general public.

The heritage industry

During the 1980s there were other facets of the marketing of history which took on very specific forms, exploring aspects of the past which were seen to embody British national heritage. Such ideas have been discussed by Robert Hewison in his controversial book *The Heritage Industry*[26] of 1987. At that time heritage was reported to be the largest growth 'industry' in Britain, with a new museum opening every two weeks. The concept also found political support from the Conservative

138 Harold Holdcroft

Old Country Roses bone china tableware, Royal Albert (Royal Doulton), 1962 onwards
The world's best-selling tableware design, *Old Country Roses* has sold more than 100 million pieces all over the world since its introduction in 1962. Such was its popularity that in 1975 the range was extended from tableware to include vases, candlesticks, and other ornaments; later, other manufacturers produced the pattern on tablecloths and napkins. The fact that one pattern has been a high-selling range for more than thirty-five years should counsel against easy categorizations of taste and period.

139

'Victorian' designs from *Past Times* catalogue, Autumn, 1995

The Past Times company, launched in 1986, has more than 60 outlets in the UK and Ireland. In many overseas countries its products are also available by mail order, marketed from warehouses in the appropriate language and currency, including Japan, Germany, France, the United States, and Australia. The fact that a company can draw upon many historic styles and cultures, and achieve such a high volume of sales internationally shows the enduring appeal of the past for contemporary consumers.

government of the day, with English Heritage, an offshoot of the Department of the Environment, setting out to make the past 'marketable'. As has been seen above, this was paralleled by a number of demonstrably successful private enterprises, and it was therefore unsurprising that an All-Party Committee on the Environment should conclude that heritage could pay its own way. Proponents of the 'heritage industry' argued that the cultural end of the leisure industry would outgrow museum design as a medium for the interpretation of the past and that its efforts to interpret events, objects, and locations were sincere and highly organized. Giles Velarde, a heritage consultant, asserted:

heritage design, together with our heritage, is here to stay. It is a discipline we can export, it benefits the public and it can be profitable. The UK has a singular history and I, for one, am happy to see it in the safe hands of the designers currently operating in the field.[27]

None the less, there was considerable debate about the ways in which the 'heritage industry' was funded and promoted. Indeed, concern about the lack of regulation and professionalism in the field led the Carnegie UK Trust, an important body in the early days of heritage development, to withdraw from a front-line role and limit its funding to an investigation into standards and codes of practice within the field. Other bodies, such as the Centre for Environmental

Interpretation and the Society for the Interpretation of Britain's Heritage (founded in 1987), were similarly concerned.

Gillian Darley, writing in the *Financial Times* in 1989 drew attention to the high fees commanded by heritage consultants, as well as their ability to package the past for a wide range of clients, unconstrained by any sense of history tied to specific places. The chief target of her critique was the national-award-winning Mountfichet Castle and Norman Village at Stansted, Essex, which was promoted as 'the castle that time forget' and 'the 1066 village'.[28] The lack of historical specificity was similar to that of many designed artifacts of the nostalgia boom of the 1970s and 1980s. Darley drew attention to the obviously 'machine-cut timber' and 'modern cement' in the huts in the stockade, whilst

in the chapel, a calming tape of mediaeval choral music plays—only three hundred years ahead of itself. For this travesty of history the promoters have received more than their fair share of commendations and awards, including a British Tourist Authority trophy in 1986, a London Tourist Board Award in 1987, and a Carnegie Foundation commendation last year [1988].[29]

Kevin Walsh, in his 1992 book, *The Representation of the Past*, followed such criticism through into the financial sector which he saw as an underpinning element in heritage enterprise:

heritage organisations have no qualms in seeing their historical resources as a product to be marketed. Their target is the members of the ABC1 socio-economic groups. Such organisations judge success, not through how the public perceives or develops an understanding of the past, but by purely financial criteria. The columns of documents detailing performance of a site are headed with the labels 'Total Retail Sales', 'Target Income Achieved', 'Average Spend Per Head' (English Heritage Spread Sheet 1990). There seem to be only restricted attempts at assessing the educational quality or academic credibility of historic representations.

Success in a market, which is perceived as the natural benign context within which all human activity occurs, is complicit with a belief that the representation of the past is a practice devoid of politics.[30]

As will be seen in Chapter 10, environmental and ecological concerns also became increasingly important areas of contestation and debate in the design arena from the 1960s onwards. Just as concepts such as heritage, conservation, and preservation were balanced between the often conflicting pressures of ethics and enterprise, they too were subject to identification with marketing considerations and opportunities.

Design and Social Responsibility

The USA: design and consumer organizations

Although consumer rights have gradually evolved through the twentieth century it can be argued that their significance in any widespread societal sense emerged after the end of the Second World War. None the less, they evolved in a less structured way over a longer period of time, particularly in the United States. In the last quarter of the nineteenth century there were large population increases, significant moves from rural areas to the city, and dramatic improvements in transport and communication systems. A number of organizations were founded in the same period, including the pioneering Consumers' League in New York City in 1891 and the National Consumers' League in 1898 which, within five years, boasted 64 branches in 20 states. They came into being at a time when consumers were faced with an increasingly wide range of products, together with changes in shopping patterns: premium stamps were introduced by Sperry & Hutchinson in 1896, the A & P Company (the Great Atlantic and Pacific Tea Company) had launched its cash-and-carry 'Economy Stores' at around the turn of the century, and the first self-service grocery store, a Piggly-Wiggly, opened in Memphis, Tennessee in 1916.[1]

The majority of the most significant early steps in consumer protection were enacted in the area of food and hygiene.[2] However, as has been seen in Chapter 3, by the 1920s there was a rapid growth in sales of all kinds of goods, sustained by widespread advertising both on the radio and in printed media. Attention has already been drawn to a number of critical reactions to the commercialization of American life at this time; in the consumer sphere in 1927 Stuart Chase and Frederick J. Schlink published *Your Money's Worth: A Study in the Waste of the Consumers' Dollar*, an attack on contemporary advertising practices and the phenomenon of pressure selling. Schlink went on to found a Consumers' Club in White Plains, New York, which undertook product testing, leading to the establishment of Consumers' Research Inc. which did this on a much wider scale. Financed by its users, its recommendations covered a wide range of products across the whole consumer spectrum; lists of both approved and disapproved items were published. The Good Housekeeping Institute, the Delineator

Cover *Consumer Reports*,
Issue no. 1, May, 1936, USA

This magazine was published
by the Consumers Union,
founded in 1936. Initially
launched at a time of
economic uncertainty, its
testing of products and brand-
name goods provided the
increasingly bewildered
consumer with an informed
view about 'value-for-money'.
It sought to provide views
about a wide range of social,
health, safety, and
environmental concerns,
and came into its own as a
major campaigning body after
the Second World War.

Institute, and the New York Herald Tribune Institute, together with a
number of women's periodicals,[3] were also involved in the field of con-
sumer advice and protection. They had their testing laboratories and
often mounted exhibitions of home furnishings and kitchens which
local readers could visit. Indeed, many manufacturers used the Good
Housekeeping star, a symbol of product approval, as a means of pro-
moting their products. None the less, such developments should be put
into perspective. As one commentator, writing in 1934, remarked:

Only in recent years have there been any extensive studies of the ultimate con-
sumer as such. A university library may contain 600,000 books, with ten
directly classified under consumer. Of these, seven or eight will have been
written by advertising men or marketing agents interested in the consumer
only as a potential consumer. The consumer is . . . seldom considered.[4]

Contemporary consumer choice in America was considerable and

potentially confusing, with department stores and mail-order catalogues providing an enticing array of goods. In 1933, for example, in the field of domestic appliances alone sales figures exceeded 2 million clocks, 1 million refrigerators, 1 million washing machines, 800,000 electric toasters, 500,000 vacuum cleaners, and 350,000 food mixers.

In 1936 the Consumers' Union was founded in New York with an initial membership of about 4,000, soon emerging as a key pressure group for educated consumers. It sought to test products and supply the consumer with appropriate information about competing products as well as advice about social, economic, health, and environmental issues, and its findings were reported in its magazine *Consumer Reports* [**140**].

In the five years immediately following the end of the Second World War, the circulation of the *Reports* rose tenfold, reaching 500,000 in 1950. It continued to grow through the decade together with the reality of what J. K. Galbraith termed the 'Affluent Society', and by 1961 the Consumers' Union was publishing almost a million copies of the *Reports* with an estimated readership of four million. By 1970 the circulation had reached 1,800,000 which, together with other Consumers' Union publications, gave the organization an operating budget of about $10 million and enabled the employment of a staff of 300 at its Mount Vernon, New York, headquarters. Despite attaining a position of such apparent widespread social relevance it was, like its British counterpart the Consumers' Association, an organization which was supported mainly by the managerial, professional, and better-paid sectors of society—in other words, those who were best equipped to take care of themselves.

Britain: design and the consumer from the 1940s to the early 1960s

As has been seen in Chapter 5, in the immediate postwar years the State-imposed Utility Scheme for a wide range of goods produced to particular design specifications was felt to guarantee certain standards of quality, durability, and value-for-money. However, in reality this was increasingly open to question since manufacturers were given progressively more flexibility through a gradual relaxation of Utility manufacturing requirements. As a result they often sought to exploit the preferential tax treatment accorded Utility goods by keeping within the decreed price ceiling at the expense of quality materials and fabrication. The Government appointed the Douglas Committee to examine the implications of such practices. In its report of 1952[5] it concluded that consumers had a real need for advice that would assist them in distinguishing between genuine value-for-money and cheapness which simply represented false economy.

The Cunliffe Committee on the Organization and Constitution of

Cover from *Which?* magazine,
no. 1, 1957 (reprinted 1960)
Which? was the voice of the
Consumers' Association,
aiming to aid the consumer
by 'encouraging the efficient
manufacturer and exposing
the producer of shoddy goods
for the home and export
markets'. The first issue
featured the testing of ten
electric kettles: five of them
were condemned as having
serious drawbacks, and only
three recommended.
Aesthetics played no part
in the recommendation,
the report stating as an
afterthought that 'one big
advantage of the chromium
kettle is its appearance
and only the buyer can
decide whether it is worth
paying the extra'.

the British Standards Institute[6] (BSI) of 1950 had argued for the adop-
tion of a product certification scheme which would protect consumers
from substandard goods. Public representation in consumer affairs had
been slight, particularly on the various committees of the BSI. It was
argued that women's organizations should play an important role in
order that the implications of consumer standards should be com-
municated more effectively to the general public for, although these
bodies (such as the Good Housekeeping Institute[7] and the Electrical
Association for Women) had played a significant role in the field of
domestic design in the interwar years,[8] their impact had been limited
in this sphere. Accordingly, in 1951, the BSI established its Women's
Advisory Committee as a means of facilitating collaboration between
consumers, manufacturers, and retailers. This was followed by the
founding in 1955 of the BSI's Consumer Advisory Council (CAC)[9]
which, within two years, was informed by an Advisory Committee

with delegates from 24 women's organizations, effectively representing the views of three million women.[10]

In 1957 an independent organization, the Association for Consumer Research (soon retitled the Consumers' Association) launched the consumer magazine *Which?* [141] in competition with the BSI's CAC and its magazine *Shopper's Guide*, which also commenced publication in the same year. Rather like the Consumers' Union in the USA, *Which?* found an audience eager to assimilate its investigations into consumer goods: within twelve months its membership[11] had reached 84,000, rising to 434,000 within ten years.

Other early postwar developments in consumer awareness and design

Similar developments were taking place elsewhere, although often the emphasis was much more fully laid upon consumer education than consumer protection *per se*. For example, in Sweden consumer awareness had developed through a collaboration of state, industry, and the public. In the war years two pioneering bodies laid the foundations for later developments: Activ Hushallning (Active Housekeeping) was established in 1940 as a state body to advise on rationing, and the Hemmens Forskningsinstitut (HFI—Home Research Institute) in 1944 as an organization for research into all aspects of everyday life in the home. In its early researches the HFI worked on kitchen planning, a field which the Svenska Slödföreninigen (Swedish Society of Industrial Design) had previously examined, and kitchen tools. Such initiatives resulted in a standardized kitchen design and innovative designs for kitchen tools which were put into industrial production and marketed. In 1954 Aktiv Hushallning was taken over by the HFI, which in turn was renamed the National Institute for Consumer Information in 1957. There were four major divisions of the organization: domestic equipment; textiles; food, chemicals and technical items; and information. As well as producing reports, guides, and educational film strips, lectures, and material for the media the Institute produced three regular publications: *Köprad*, each issue of which was devoted to the testing of particular product types; *Räd Och Rön*, a newsletter; and *Konsumeninstitut Meddelar*, a technical publication about testing methodology aimed at industry. The National Institute also had a permanent exhibition on *The Home—Its Layout and Equipment* which sought to explain the scope of its work.

As had been the case in Britain from the late 1940s onwards there was also increasing concern about standards in manufacture and perception of them by the general public. In 1951 the Varudeklarationsnämden (VDN—the Institute for Informative Labelling) was established. The D-mark, as the labelling scheme became known, was different from the BSI's Kitemark in that it gave

the consumers a much fuller and more intelligible insight into product characteristics, with information on function, materials, and durability. Like the National Institute for Consumer Information, it also worked with the Svenska Slödföreninigen (Swedish Society of Industrial Design), the furniture research committee of which had also worked since 1948 on the testing and labelling of furniture.

In the early 1950s the Swedish example influenced developments in West Germany, particularly in the establishment of the Wohnberatung, advice and exhibition centres for the public to gain information on all aspects of home furnishing. The first of these was established by the Deutscher Werkbund in Mannheim in 1953, stimulated by the homes advice centres seen in the Swedish section of the 1949 Cologne Exhibition.

Critiques of industrialization and consumerism

A mere account of the evolution of consumer organizations and debate, however, gives a misleadingly simple picture of the position of design and the consumer in the fifteen years following the end of the Second World War. As will be seen below, the consumer's voice was comparatively muted in the wider context of increased levels of consumption in the Western industrialized world, with the advent of what the French termed the 'civilisation des gadgets'. It was not until the 1960s that significant shifts in consumer legislation began to acknowledge more fully the importance of individual consumer rights and of clarification of the responsibilities of the large-scale producers. Much of this shift was brought about through the strident writings of individuals such as Vance Packard, effective consumer campaigning by Ralph Nader, and the growing public disaffection with the ethics of the large-scale corporation. However, there had also been a long-standing tradition of assaults on the consequences of industrialization, a tradition which found many echoes in the postwar years, whether in debates about the social purpose of design surfacing at the Milan Triennali of the 1950s and 1960s, interest in the notion of 'small is beautiful' as articulated by Eugene Schumacher in the early 1970s, and growing public concerns about the wider environmental and ecological consequences of design, manufacture and consumption.

Ever since the early years of the Industrial Revolution there have been evident tensions between the material consequences of the development of industrialized capitalism and considerations of artistic and creative integrity. Although from the 1760s onwards there were a number of painters, such as Joseph Wright of Derby, who lucidly portrayed contemporary excitement at scientific discoveries,[12] by the late eighteenth century there were others, such as the English poet William Blake, who saw such developments as thwarting the freedom of the imagination and the senses through the imposition of rules and sys-

tems. Blake frequently denounced what he saw as the restrictiveness of the world of science and reason, symbolized in his 1795 colour print of Sir Isaac Newton where the scientist was depicted at the bottom of the sea, immersed in the waters of materialism. Newton was wielding a pair of compasses, symbols of measurement and regulation but also, in Blake's eyes, rational barriers to the exploration of the unconfined realms of the spiritually elevating world of the imagination. As the industrialization process gathered pace during the nineteenth century there were frequent, often eloquent attacks on its concomitants, particularly the division of labour and the cultural disruptiveness of technological development. A particular line of thought which contrasted medieval and nineteenth-century societies can be traced through writings such as Thomas Carlyle's *Signs of the Times* of 1829, the designer A. W. N. Pugin's *Contrasts* of 1836, and John Ruskin's *The Stones of Venice* of the early 1850s. In comparison with the spiritual wholesomeness of the Middle Ages Ruskin characterized Victorian society as oppressively materialistic, an outlook which was symbolized by the ostentatious and 'inappropriate' ornamentation which covered the surfaces of much contemporary, machine-produced design. His commitment to the values of 'truth to materials', honest workmanship, and the 'joy of making' lay at the philosophical roots of William Morris and his Arts and Crafts followers. As has been suggested in Chapter 1, this was a problematic outlook in so far as its social, cultural, and economic relevance was extremely limited for those most adversely affected by industrialization—unless its theoretical premises were reconciled with the realities of mass-production on a large scale. Similar lines of thought which attacked the consequences of industrialization, urbanization, and the anonymity of the large scale have continued throughout the twentieth century, albeit from a wider range of perspectives.

Consumerism, design, and critical perspectives in 1950s USA

In the 1950s the readership of *Consumer Reports*, generally drawn from the professional, educated sectors of society, were no doubt wary of the seductive advertisements and marketing techniques of those powerful motivators of material desires, the advertising agencies of Madison Avenue, New York, which increasingly explored the possibilities of motivational analysis in their quest to increase sales of products and services. It was this glossy allure that Vance Packard so vehemently attacked in his celebrated text of 1957, *The Hidden Persuaders*.[13] The first of a series of attacks on the profligacy and pretensions of consumer society, including *The Status Seekers* (1959) and *The Wastemakers* (1961), this colourful indictment of consumerism attracted considerable media attention. However, there were other aspects of everyday life which gave rise to wider consumer concerns. That key icon and status symbol of American material values in the 1950s, the large, heavily tail-

finned automobile [74], replete with quasi-baroque chrome fantasies masquerading as radiator grilles, began to fall under the increasingly suspicious gaze of consumer groups, campaigners such as Ralph Nader, and, somewhat belatedly, federal government. At this time, as J. K. Galbraith and others observed, the very size, economic muscle, and social influence of automobile producers such as General Motors allowed them to use design in ways which were of questionable benefit to society at large.

The phenomenon of rapid obsolescence, in the form of the annual model change, was a fundamental aspect of the buoyant automobile market of the 1950s as well as a key factor in maximizing profitability since even superficial changes (or styling) in design could lead to increasing sales. The 'newness' of models was often literally 'skin-deep'. The annual model change also meant that many rapid changes to automobile design were not thoroughly analysed in terms of their effects on performance, leading to a whole spectrum of deficiencies which were criticized by many involved in the infrastructure of the transport industry: insurers, mechanics, federal investigators, and others. Such design deficiencies included problems with visibility, steering, braking, and ease of maintenance and should be viewed in the context of an apparent lack of independence of the highway safety lobby. For example, in 1954 the President's Action Committee for Traffic Safety was established with Harlow K. Curtice, President of General Motors, as its first chairman, whilst the Vice-Presidents of General Motors and Ford sat on the Business Advisory Board.

Harley Earl's design innovation of the 'wrap-around' windscreen, inspired by the Lockheed P38 fighter plane, was first incorporated into the Oldsmobile division of General Motors mass-production lines from 1954, immediately catching the public imagination. However, ophthalmologists reported on the distortions to which its curvature gave rise, as well as problems of increased glare and double vision which could arise from its sculpted surfaces. Other windscreen innovations introduced by General Motors included the tinted windscreen, billed as a 'safety feature' and optimistically named 'E-Z-Eye'. It was heavily criticized in *Consumer Reports* in 1952 as well as specialist periodicals such as the *Journal of the Optical Society*, which in 1955 reported it as a hazard in night driving, although it continued to be promoted as a safety feature in General Motors publicity as late as 1965. During this period critical literature was increasing rapidly in volume, the most celebrated example being Ralph Nader's *Unsafe at Any Speed: the Designed-In Dangers of the American Automobile*.[14] As an indicator of corporate commitment to automobile safety at General Motors it was estimated that styling accounted for $700 per automobile as opposed to 23 cents for safety or, framed alternatively, in 1964 the corporation spent $1.25 million dollars on safety research whilst accruing $1,700

million in profits. At this stage it was estimated that General Motors was grossing $2.3 million per hour, more than any government outside the United States, with the exception of Britain and the USSR.[15] However, with the appointment of the Ribicoff Committee in 1965 to investigate automobile safety, such imbalances were addressed and a process set in train that resulted in the 1966 National Traffic and Motor Vehicle Safety Act, which impacted upon production models from 1968 onwards.

Growing recognition of the consumer voice in the United States

It was in the climate of such attacks on the consumerist, corporate-led way of life in the United States, articulated by Packard, Nader, and others that consumerism emerged as an important facet of the political agenda. President Kennedy's 1962 Consumer Message to Congress expressed a commitment to the establishment of a number of clear principles for the protection of basic consumer rights: the right to safety, the right to be informed (thus ensuring that the economic interests of the consumer were protected), the right to choose (ensuring fair competition), and the right to be heard (as a means of ensuring that the consumer's voice would be heard in the formulation of federal policy). Such a commitment resulted in the fierce opposition of the business lobby, particularly in the early stages of the Johnson administration, which was more conciliatory to such concerns than Kennedy had been. However, by the later 1960s the climate had changed, with consumer legislation again seen as a likely popular vote-winner rather than simply an impediment to support from the business sector. This period saw the enactment of legislation affecting not only automobile safety (1966) but also such areas as 'truth-in-packaging' (1966), 'truth-in-lending' (1968), as well as tighter controls over the production and advertising of food and drugs. Despite its centrality in the American economy and way of life, there has been a long-standing lack of public faith in the ethics of the large scale corporation, a conclusion which was supported by the conclusions of a wide range of opinion polls carried out in the 1960s, 1970s, and 1980s. For example, Gallup revealed that between 1973 and 1986 an average of only 29 per cent of those polled had confidence in big business, making it one of the least trusted of American institutions.[16] Harris too showed that the US population between 1966 and 1986, had little confidence in the leadership of such concerns. Although 55 per cent expressed confidence in 1966, the next highest figure was 29 per cent in 1973, settling down to a figure of less than 20 per cent in the 1980s.

Design and the consumer in Britain from the 1960s.

Despite the moves which took place in the consumer arena in Britain in the 1940s and 1950s it was not until the publication of the *Molony*

Report on Consumer Protection[17] of 1962 that matters began to take on a more critical edge. Many of the seemingly positive developments of the 1950s were criticized in the 214 recommendations contained within the Report. The periodical *Shopper's Guide* was considered suspect because of its sponsorship by the BSI which in turn received backing from manufacturers whose products might be criticized in its pages. Criticism was also directed at the Consumers' Association's *Which?* on account of its restriction to member-subscribers, who also tended to be drawn from the already well-informed sectors of society, and at the Good Housekeeping Institute, which had campaigned for better standards in consumer products in the interwar years. Molony had 'little confidence in the Institute, in the quality of its standards, in the reliability of its testing—or, therefore, in the value of its seal of approval'.[18] The British Standards 'Kitemark', a leading quality mark, was also found unsatisfactory on account of widespread consumers' ignorance of what it represented; also that BSI Consumer Standards were mainly concerned with safety rather than quality, performance, or durability.

The Council of Industrial Design (COID) was approved by Molony for its promotion of 'good design' but was seen as having limited relevance for the consumer since COID product approval, either through inclusion in the *Design Index* or the award of the Design Centre Label, was not based on any rigorous standards relating to considerations such as value-for-money, efficiency, durability, or even the routine checking of manufacturers' production to ensure maintenance of quality. There was also the danger that many consumers might feel the label had greater significance than its testing warranted, especially since there were no controls for its inappropriate use by manufacturers on their publicity. For Molony, attractive or 'good' design without sound performance was of little value for consumers.

Steps were taken by the COID to remedy such shortcomings in the following decade, with the imposition of more rigorous testing procedures and the establishment of closer relationships with a number of consumer groups.[19] As had been the case in the United States, the government undertook a more active role with the establishment of a national Consumer Council in 1963 and the passing of the Trades Description Act in 1968. Despite a number of hiccups, the position of the consumer was further consolidated in the 1970s.

The response of the design profession

In the post-Second World War era one of the main problems facing the design profession in terms of assuming a more responsible role in relation to society was its intrinsic economic dependence on business, manufacturing industry, and the retail sector. Furthermore, in their quest to establish wider professional recognition in such circles (as discussed in Chapter 7) any wider commitment on the part of designers to

142 Richard Buckminster
Fuller

Patent drawing from the
Dymaxion Bathroom, 1937
Buckminster Fuller was one
of the leading inventor-
designers of the twentieth
century and a strong critic
of what he regarded as the
wasteful practices of industrial
design, the encouragement
of obsolescence and
inessential use of materials
and resources. The Dymaxion
Bathroom, complete with all
fixtures, equipment, and
plumbing, was intended for
mass-production and
consisted of two major
components: the washbasin
and toilet, and the bath and
shower. Covering a floor space
of 5 feet square, it weighed
420 pounds and was
intended to be extremely
economical in terms of cost
and use of resources.

social, environmental, and moral concerns was inevitably tempered by the ideological thrust of their employers, actual and potential.

As has been seen earlier, the design theorist and inventor Richard Buckminster Fuller had been highly critical of the outlook of the American industrial design profession of the interwar years as well as the superficial 'fashion inoculation' of Bauhaus modernism.[20] He also expressed concern for the considerable wastage of energy in the Western industrialized contemporary world [**142**], suggesting that since only about 25 per cent of energy generated was actually utilized there were, at least theoretically, sufficient reserves to sustain three more societies. Such radical design thinking proved increasingly attractive to young designers and architects in the later 1950s and 1960s when there was a strong drive to explore alternative approaches to the solving of design problems. Accordingly, Buckminster Fuller travelled widely, lecturing on a variety of challenging themes to professional audiences around the world.[21] Another important figure who attacked

Cutlery designed for people with single-hand function, Ergonomi Design Gruppen, Sweden, c.1980

Ergonomi Design Gruppen (EDG), founded in Sweden in 1979 by Maria Benktzon and Sven-Eric Juhlin, specializes in ergonomic design, whether in the industrial sector or for everyday life, particularly for those with disabilities. With regard to the latter category one of the consultancy's aims was to produce design solutions with a high aesthetic content and style, rather than producing designs which were obviously demarcated as catering for 'special needs'. Although the cutlery shown here was available commercially it was part-funded by public agencies.

8050 1003
Skärhjälp
Slicing aid
Schneidehilfe
Planche à découper

8050 1002
Kniv med slätt blad (svart)
Smooth blade knife
Messer mit geradem blatt
Couteau coudé

8050 1001
Kniv med tandat blad (gul)
Serrated knife
Messer mit gezahntem blatt
Couteau long manche

8050 1101
Förskärare, vinklad
Angled carving knife
Messer, abgewinkelt
Couteau à découper coudé

8050 1016
Kniv inställbar
Knife, adjustable angle
Messer, einstellbar
Couteau, angle réglable

8040 2004
Sked RA
Spoon
Löffel
Cuillère

8040 2002
Gaffel RA
Fork
Gabel
Fourchette

8040 2007
Dessertsked RA
Spoon, for dessert
Löffel, klein
Cuiller, petit

8040 2006
Kniv RA
Knife
Messer
Couteau

the commercially-centred consumer drive of contemporary society, making a particular plea for a more broad-based redirection of design thinking, was Richard Neutra, who published *Survival Through Design* in 1954.

As has been seen in Chapter 8, there was a small but significant number of design groups in Italy which had pursued the idea of Anti- or Counter-Design, firmly rejecting involvement with mainstream commercial design. However, in the wider context of the design profession as a whole, a number of papers at the annual Aspen International Design Conferences took up several themes that challenged the design status quo, and these were followed through at the ICSID (International Council of Societies of Industrial Design) conference held in London in 1969 on the topic 'Design, Society and the Future' in which designers looked to the wider consequences of their actions. Important also was Victor Papanek's widely read text *Design for the Real World: Human Ecology and Social Change* of 1971, published in the United States only after being turned down by twelve publishers.[22] Since then the book has been the subject of many reprints and two revised editions and has been widely read by designers in many countries. However, in an extremely useful review of related literature, Pauline Madge noted that although 'it has long been considered the

one book which looks at the environment and the Third World from a design point of view, the subject matter is much wider than that and it is in fact much more about design in the "first" world and about consumerism than what would now be considered key environmental issues.'[23] Its moralizing, yet somewhat shrill, tone very much followed in the tradition of Vance Packard's anti-consumerist diatribes of the late 1950s and early 1960s and appealed far more to the idealism of many young designers than to those more firmly established in their profession who saw it as an attack on their integrity.

However, the design profession continued to respond (not least in the arena of theoretical debate) to the wider climate of opinion which had increasingly voiced concerns about the social, environmental, and ecological consequences of industrial and technological progress. Such thinking had been further prompted by concerns about energy heightened by the Middle Eastern War of 1973 and the conspicuous failure of the United States to win the Vietnam War despite vastly superior technological resources. In April 1976 the Royal College of Art in London hosted the ICSID conference on the theme 'Design for Need'[24] where a range of such concerns were (often provocatively) discussed, including design in the Third World and the possibilities of alternative technology, as well as wider political and social issues such as design for disability, one of six fields which Papanek had previously prioritized in *Design for the Real World*.[25]

There had been a growing professional involvement with design for the disabled and handicapped from the 1960s onwards,[26] and among those designers who emerged as recognized specialists within the field were the Swedes Maria Benktzon and Sven-Eric Juhlin who founded the Ergonomi Design Gruppen consultancy in 1979. Their best-known designs have included tableware, cutlery, and a cutting board and knife for the physically handicapped [**143**]. These provided design solutions which were marked not only by their capacity to address specific design problems, but also by their high aesthetic content which did much to rehabilitate them into the mainstream of everyday

144 Peter Opsvik and Hans Christian Menghshoel

Balans chair, 1979, Norway
This design represents a solution to the problems of providing beneficial posture for everyday tasks. Rather than simply conforming to the standardized notion of a conventional office chair (left), the *Balans* (right) has been worked out on ergonomic principles.

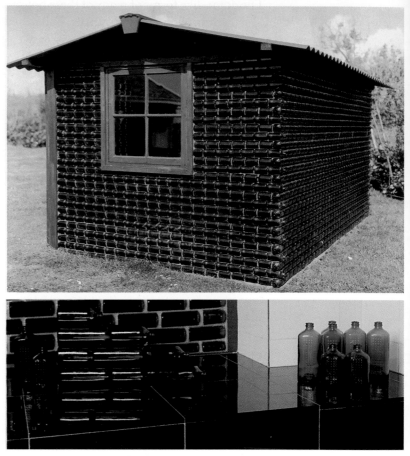

consumption [**144**]. In Britain groups working in this sector have included UDAP (Unit for the Development of Alternative Products), SCEPTRE (the Sheffield Centre for Product Development and Technological Resources), and LICT (the London Innovation Charitable Trust).[27]

Parallel concerns and design perspectives

The 1950s and 1960s had seen the emergence of a number of 'alternatives' to the conventional material values and social mores of consumer society [**145**]. An important manifestation was the hippy movement which took off on the West Coast of the United States, emerging from the 'beat'[28] and 'acid'[29] subcultures of the late 1950s and early 1960s. Key characteristics included a distaste for consumer society and commitment to 'doing one's own thing', resourcefulness, and creativity. In a number of ways, the hippies were responding to the wastefulness of society, an idea also articulated by Buckminster Fuller with particular reference to energy. For example, in the realm of housing many hippie dwellings were built from the waste of affluent society, as at Drop City [**146**], where significant use was made of discarded automobile panels.

The dome-like forms of many of these houses loosely echoed the dome constructions which Buckminster Fuller had evolved in the 1950s as well as being oppositional to the cube-like forms of conventionally constructed dwellings. Much of this thinking took on a more tangible form in publications such as *The Last Whole Earth Catalogue* of 1971, which was a practical guide to alternative living, advising the user/designer on everything from equipment to education which could be bought via mail-order. In Britain Peter Harper and Geoffrey Boyle edited a similar book, *Radical Technology*, which argued 'for the growth of small-scale techniques suitable for use by individuals and communities, in a wider social context of humanised production under workers' and consumers' control.'[30] Some of these ideas were explored and codified by the design and architectural critic and historian Charles Jencks together with Nathan Silver in *Adhocism: The Case for Improvisation* of 1972.[31] Embracing the underlying tenets of hippy philosophy they saw Adhocist design as a means of avoiding the delays engendered by specialization, bureaucracy, and hierarchical organizations, thus enabling the 'designer' to take immediate and purposeful action through the utilization of materials readily to hand. Although Jencks and Silver considered the use of catalogues as significant tools for the Adhoc 'designer' they appreciated their limitations in that they could not list all the products of a society nor present them in a way that pointed to uses for such artifacts out of their conventional context: what was needed was a 'resourceful' computer, cross-indexed to search out for the 'designer' the best component for the job. The aim of such thinking was to decentralize the design process, counteracting the restrictions imposed by advanced industrial systems. The social benefits of small-scale production were also emphasized in such influential texts as Eugene Schumacher's *Small is Beautiful: A Study of Economics as if People Mattered*[32] and Ivan Illich's *Tools for Conviviality*,[33] both published in 1973.

Other potent critiques of the preoccupations of mainstream design, in terms of profession, preoccupations, or social marginalization, emerged during the same years. Highly significant were feminist critiques committed to a more effective and user-centred approach to design which emerged in opposition to the celebration of design personalities and to the glossy, mythological worlds of advertising. At the root of such critiques was an assault on society's fundamentally patriarchal organization and outlook. As Cheryl Buckley, an important design historical contributor to such debates, argued in 1986:

Patriarchy has circumscribed women's opportunities to participate fully in all areas of society and, more specifically, in all sectors of design, through a variety of means—institutional, social, economic, psychological, and historical. The resulting female stereotypes delineate certain modes of behaviour as being appropriate for women. Certain occupations and social roles are designated

female, and a physical and intellectual ideal is created for women to aspire to. These stereotypes have had enormous impact on the physical spaces— whether at home or at work—which women occupy, their occupations, and their relationship with design.[34]

Feminist writers sought to redress the balance, drawing attention to the ways in which gender stereotyping has informed the design of clothing, toys, tools, and many other consumer products, has resulted in inadequate designs for women users, and has afforded women few opportunities in many sectors of the design profession which have traditionally been dominated by men.[35] A number of feminist groups, such as the Matrix collective, formed in 1980, sought to promote a feminist approach to architectural practice, involving consultation and the dissemination of information, advice, and design thinking. An exposition of their thinking was published in 1984, entitled *Making Space: Women and the Man-Made Environment*. As the title suggests, it argued that patriarchal values dominated in the design of domestic space and the urban environment, necessarily defining the role which women were to play within that context. Other women's groups of the period which involved design within their remit included the Women's Design Service (WDS) and the Women's Environmental Network (WEN), founded in 1988.

Green design
By the mid-1980s the concept of 'green design' began to gain increasing currency in the design press, evolving from the broader-based environmental and ecological concerns which had commanded attention in the previous decade. By this time the concept had emerged from its relatively marginalized position as an 'alternative' outlook to one which was increasingly recognized by the design profession, including large-scale consultancies such as the Michael Peters Group and Wolf Olins

146

Drop City, USA, 1960s

Drop City provided the venue for an 'alternative' lifestyle for hippies who 'dropped out' of mainstream society. Dome housing was often fabricated from the tops of cars purchased from scrapyards for 25 cents each, literally re-using the waste materials jettisoned by consumer society. Its form, loosely derived from the geodesic dome structures explored by Buckminster Fuller, was opposed to the box-like structures which typified suburban housing norms.

Body Shop product ranges, 1980s

Founded in 1976, the Body Shop has been a powerful advocate of ethical consumption in the High Street, with an emphasis on natural products and the use of re-fillable containers. By 1996 the company had over 1,400 shops world-wide, including 71 in Japan and 21 in Malaysia, as well as outlets in Singapore and Indonesia. The scale of the company's operations highlights the implicit contradiction in 'green' consumption since the act of consumption is still encouraged, albeit moderated by wider ethical considerations.

which considered it to be an important ingredient of design policy in the late twentieth century.

In the 1970s and 1980s in Britain the business success and high media profile of the toiletries and cosmetics company the Body Shop, founded by Anita Roddick in 1976, provided something of a public barometer against which to gauge the growing potency of ecological concerns in the market-place. Concepts such as the use of natural and recycled materials and refillable containers caught the public imagination [**147**].

The late 1980s saw a flurry of activity in exhibitions and publications centred on the concept of 'green design', including the mounting of the 'Green Designer' exhibition at the Design Centre, London, in 1986. John Elkington was involved in its organization and was the author and co-author of a number of texts which helped to articulate contemporary debate, both from the point of view of the consumer and business. These included *The Green Consumer Guide* of 1988,[36] and *The Green Capitalists* of the following year.[37] The 1990s continued to see frequent publication in the field, with texts such as Dorothy Mackenzie's *Green Design: Design for the Environment*,[38] Paul Burall's *Green Design*,[39] and Brenda and Robert Vale's *Green Architecture: Design for a Sustainable Future*,[40] all of 1991.

A survey on *European Management Attitudes to Environmental Issues* carried out in 1990 by the management consultants Touche Ross revealed that West German, Dutch, and Danish companies placed an increasing premium on the management of environmental concerns, with a significant percentage of companies committed to the alteration of product ranges in response to environmental considerations. Large-scale multinational corporations such as Philips and IBM endorsed such policies at senior management levels, whilst appliance manufacturers such as Zanussi moved to the adoption of a significant number

of key components in recyclable materials and energy-saving programmes in their washing machines.[41] Such developments, together with the availability of ethical, environmental, and ecologically-sound investment trusts on the Stock Market, contributed to the impression of an increasingly widespread commitment to environmental responsibility in the industrial sector. Furthermore, in a number of countries product-labelling schemes emerged as a means of marking out ecologically-sound goods: the best known of these was the German Blue Angel which was introduced in 1978; by 1990 its logo was carried on about 3,000 products that met specific environmental criteria, manufacturers paying for the right to use it. Similar schemes were introduced in Canada and Japan in the 1980s, the latter accompanying its logo with brief explanations as to the reasons for its endorsement.

However, the wider picture was often ambivalent, as a number of critics have pointed out. For example, in his celebrated book *On Living in an Old Country* of 1985[42] Patrick Wright pointed to the contradictions inherent in the Shell oil company's long-standing association with the English countryside, sustained through the publication of its *County Guides* in the interwar years, its later *Discover Britain* television advertisements, and Shell-National Trust Nature Trails of the 1970s and 1980s. He saw it as remarkable that such images should be associated with the preservation of the countryside whilst at the same time the company was implicitly threatening rural integrity through the pollution and environmental damage that would be engendered by the automobiles which it encouraged to tour. The association continued in

the later 1980s with the advertising of 'lead-free' petrol stations: one particular advertisement featured a remote Shell petrol station in the Scottish Highlands, accompanied by the textual claim that the company had 'introduced 1,287 conservation areas in Britain'. In Britain in the late 1980s even the colour green was often simply harnessed to the ecological cause, with the design consultants Addison Associates using it as a key element in their identity schemes for BP petrol stations, the Michael Peters Group deploying it as an important element of the visible face of the corporate identity for the newly-created Powergen electricity generating company, and John McConnell of Pentagram using the colour as a vital aspect of the newly-privatized electricity distribution network, the National Grid Company, symbolizing according to contemporary publicity 'both the environment and the vibrancy of the company's business'.

By this time it was clear that, in addition to the potential social and environmental benefits which might accrue, the whole field of green design also offered another marketing niche for designers to explore. As Elkington, Burke and Hailes remarked in *Green Pages: The Business of Saving the World* of 1988:

The green consumer is likely to be an increasingly important influence in the world of product design. Designers who ignore the fact, or who allow their clients to ignore it, risk losing out on some of the most exciting marketing opportunities of the eighties and nineties.[43]

Similar views from a design consultancy perspective were expressed by Wally Olins in *Corporate Identity: Making Business Strategy Visible through Design*, of 1989.[44]

None the less, there was at the same time a growing anxiety on the part of many campaigners for whom ecological and ethical concerns were of primary importance that many contemporary advocates of 'green design' were in fact still encouraging consumption: 'green capitalism' and 'green consumerism' were merely particular elements in the wider phenomenon of consumerism [148], albeit modified by ethical considerations. Such critiques were explored in Britain in Sandy Irvine's 1989 discussion pamphlet *Beyond Green Consumerism*[45] and in the United States in the 1991 publication *Green Business: Hope or Hoax?*[46] and have been subsumed into more radical propositions for the implementation of a more fundamentally ecological design policy. As Pauline Madge suggested in 1993:

While the first generation of publications on green design were 'how to do it' guides, written quickly to meet the demand for basic information, the next generation of publications in the 1990s is likely to be more considered and carefully researched, more critical and synergistic, more aware of the full complexity of design and sustainable development in both the developed and developing worlds.[47]

and *The International Style: Architecture Since 1922* (both published in New York: Museum of Modern Art, 1932).

12. The arguments at the Werkbund congress of 1914 were far more complex than this in terms of the internal politics of the Werkbund, the desire to create a modern, German style closely linked with industry, and differing perceptions of the nature of the export markets to which these goods were ultimately directed. This is articulated in some depth in Joan Campbell, *The German Werkbund: The Politics of Reform in the Applied Arts* (Princeton University Press, Princeton and Guildford, 1978), particularly in ch. 3, 'Cologne in 1914', 58–81.

13. Founded in 1902 by the writer and poet Ferdinand Avenarius, the Dürerbund sought to promote art in everyday life.

14. Some writers, most notably Marcel Franciscono, *Walter Gropius and the Creation of the Bauhaus in Weimar: The Ideals and Artistic Theories of Its Founding Years* (University of Illinois, Urbana, 1971), have argued that Gropius had never fully abdicated his functionalist tenets, and that shortages of money and industrial materials at the school, together with the energies he expended in promoting the school at the expense of a heavy personal involvement in the curriculum, have tended to disguise this fact.

15. Magdalene Droste, 'Women in the Arts and Crafts and in Industrial Design 1890–1933', in *Frauen im Design* (above, Introd. n. 9), 174–202.

16. This aspect of Bauhaus activity prior to the move to Dessau in 1925 is fully discussed in Anna Rowland, 'Business Management at the Weimar Bauhaus', *Journal of Design History* (1988), 153–75.

17. These include G. Naylor, *The Bauhaus Reassessed* (Herbert Press, St Neots, 1985), and H. Wingler, *The Bauhaus—Weimar, Dessau, Berlin, Chicago* (1962; new edn., MIT Press, Cambridge, Mass., 1977).

18. Op. cit. (above, n. 12), 5.

19. Droste (above, n. 15).

20. The complexities of this are discussed in Campbell (above, n. 12), 176–179.

21. Droste (above, n. 15), 197.

22. It was first published briefly in 1922, but the economic climate was too difficult to sustain it.

23. This is extensively considered by Nicholas Bullock, 'First the Kitchen—Then the Facade', *AA Files* (London, May, 1984), 59 ff.

24. Lihotsky and the Frankfurt kitchen are also usefully discussed in 'The Frankfurt Kitchen: Contemporary Criticism and Perspectives',

in *Frauen im Design*, (above, Introd. n. 9), pp. 160–9.

25. See J. Heskett, 'Modernism and Archaism in Design in the Third Reich', *Block*, 3 (1980) 13 ff. and 'Art and Design in the Third Reich', *History Workshop Journal*, 6 (1979), 139–53.

26. For further discussion of Corbusier's furniture designs see C. Benton, 'Le Corbusier: Furniture and the Interior', *Journal of Design History*, 3. 2/3 (1990), 103–24.

27. Although A. Branzi, *The Hot House: Italian New Wave Design* (Thames & Hudson, London, 1984), claims that the first Rationalist interior was in fact Ivo Pannaggi's Casa Zampini.

28. See e.g. B. Zevi, 'The Italian Rationalists', in D. Sharp (ed.), *The Rationalists: Theory and Design in the Modern Movement* (Architectural Press, London, 1978), 118–29.

29. Founded in Milan as *Casa Bella* in 1928 with an intended readership of women it became more progressively oriented under its new title, launched in 1934.

30. This title was first taken up at Monza in 1930.

31. These are usefully discussed in the introduction to *Scandinavia: Ceramics and Glass of the 20th Century* (Victoria and Albert Museum, London, 1989).

32. Originally founded under the Swedish parent company Rörstrand in 1874.

Chapter 3

1. (Harper, New York).

2. Charles Richards stated in his report on *Art in Industry* of 1929 that there were 55 schools teaching 'industrial design' in the United States, but that this was often linked to the use of museums as providers of exemplars and very much dominated by stylistic influences from the past, such as Art Nouveau or Arts and Crafts.

3. (1932; Dover reprint, New York, 1977), 21–3.

4. Autobiographical texts by industrial designers include R. Loewy, *Never Leave Well Enough Alone* (Simon & Schuster, New York, 1951), and *Industrial Design* (Faber, London, 1980), and H. Dreyfuss, *Designing for People* (Simon & Schuster, New York, 1955). N. Bel Geddes, *Horizons in Industrial Design* (above, n. 3), and R. Loewy, *The Locomotive: Its Esthetics* (The Studio, New York, 1937) are expansive and optimistic statements about the power of the industrial designer to alter the consumer's outlook, to improve the quality of life—and at the same time to increase sales. Rather more measured accounts of the profession may be found in W. D. Teague,

Design This Day: The Techniques of Order in the Machine Age (Harcourt Brace, New York, 1940), and H. Van Doren, *Industrial Design: A Practical Guide* (McGraw-Hill, New York, 1940).

5. Such historical accounts include Donald J. Bush's eulogistic *The Streamlined Decade* (George Braziller, New York, 1975) which centres on the stylistic rather than economic aspects of industrial design; there are many historical texts which focus on the achievements of individuals, such as *The Designs of Raymond Loewy* (exhibition catalogue, Smithsonian Institute, Washington, 1975) or A. Schönberger (ed.), *Raymond Loewy: Pioneer of American Industrial Design* (Internationales Design Zentrum, Berlin, 1990). A balanced account of the period may be found in J. Meikle, *Twentieth Century Limited: Industrial Design in America, 1925–1939* (Temple University Press, Philadelphia, 1979), in which relationships between design, business, and society are evaluated.

6. Miller (above, Introd. n. 7), 142.

7. (above, n. 4).

8. Such as K. C. Plummer, 'The Streamlined Moderne', *Art in America*, January/February 1974, 46–54, D. Gebhard, 'The Moderne in the US, 1920–1941', *Architecture Association Quarterly*, July 1970, 4–20, and D. J. Bush (above, n. 5).

9. W. D. Teague, 'Building the World of Tomorrow', *Art & Industry*, April 1939, 126.

10. See e.g. D. A. Hounshell, *From the American System to Mass-Production 1800–1932* (Johns Hopkins University Press, Baltimore, 1984).

11. E. J. O'Brian, *The Dance of the Machines: The American Short Story and the Industrial Age* (Jonathan Cape, London, 1929), 115.

12. A number of his writings are collected in J. Meller (ed.), *The Buckminster Fuller Reader* (Penguin, Harmondsworth, 1971).

13. 'The Comprehensive Man', revised text of a lecture given at the University of Oregon in 1959, in J. Meller (ed.) (above, n. 12), 134.

14. This is usefully and lucidly discussed in T. Gronberg, 'Cascades of Light: the 1925 Exhibition as *Ville Lumière*', *Apollo*, July 1995, 12–16.

15. The official reason given was that there were insufficient American goods which conformed to the official guidelines for the exhibition, which required designs displaying 'modern aspiration and real originality'. However, it is more likely that the lack of participation was due to the distance, cost,

and lack of clear economic advantage.

16. These included Lord & Taylor and Macy's in New York in 1928.

17. D. Naylor, *American Picture Palaces: The Architecture of Fantasy* (Van Nostrand Reinhold, New York, 1981), provides a useful account of this striking genre.

18. (Architectural Press, London, 1945), 4.

19. Many such developments are discussed in G. Wright, *Building the Dream: A Social History of Housing in America* (University of Chicago Press, 1981).

20. See e.g. S. Worden, 'Furniture for the Living Room: An Investigation of the Interaction between Society and Design in Britain from 1919 to 1939' (unpublished Ph.D. thesis, University of Brighton, 1980), and J. Attfield, 'The Role of Design within the Relationship between Furniture Manufacture and its Retailing (1935–65) with Initial Reference to the Firm of J. Clarke' (unpublished Ph.D. thesis, University of Brighton, 1992). Of more general interest, but providing useful starting points, are A. A. Jackson, *Semi-Detached London* (Allen & Unwin, London, 1973), and P. Oliver *et al.*, *Dunroamin: The Suburban Semi and Its Enemies* (Barrie & Jenkins, London, 1981). A useful introduction to the problems of interpreting the 'ordinary' room is by J. Porter and S. Macdonald, 'Fabricating Interiors: Approaches to the History of Domestic Furnishing at the Geffrye Museum', *Journal of Design History*, 3. 2–3 (1990), 175–82.

21. Perhaps the most significant attempt to examine furnishings and home decoration from a consumer's point of view is to be found in T. Putnam and C. Newton (eds.), *Household Choices* (Futures Publications, London, 1990).

22. The archives of the Ideal Home Exhibition are located in the Archive of Art & Design at Olympia, an outpost of the National Art Library (Victoria and Albert Museum).

23. 'The Salon des Arts Ménagers, 1923–83: A French Effort to Instil the Virtues of Home and the Norms of Good Taste', *Journal of Design History*, 7. 4 (1994), 267–75. This is also discussed in R.-H. Guerrand, 'Comfort', in J. de Noblet (ed.), *Design: Mirror of a Century* (Flammarion, Paris, 1993) 74–82.

Chapter 4

1. For a general reading of the significance of international exhibitions see P. Greenhalgh, *Ephemeral Vistas: the Expositions Universelles, Great Exhibitions and World's Fairs, 1851–1939* (Manchester University Press, 1988).

2. For the only authoritative account in

English of Polish design and vernacular traditions see D. Crowley, *National Style and Nation State: Design in Poland from the Vernacular Revival to the International Style* (Manchester University Press, 1992).

3. Some of these key issues are taken up in the exhibition catalogue *Art and Power: Europe under the Dictators 1930-45* (Hayward Gallery, London, 1995).

4. Hungary, like Poland sought to utilize a 'national' style derived from vernacular roots early in the century. See e.g. Katalin Keserü, 'The Workshops of Gödöllö: Transformations of a Morrisian Theme', *Journal of Design History*, 1.1 (1988), 1-23.

5. (Thames & Hudson, London), 15.

6. J. Gloag *The English Tradition in Design* (Penguin, London, 1947), 35.

7. The distinction that perhaps should be made between 'English' or 'British' involves a complex area of debate. For the purposes of this brief summary of British/English national identity I have tended to adopt the terminology adopted by contemporary commentators.

8. See e.g. A. Howkins, 'The Discovery of Rural England', in R. Colls and P. Dodd (eds.), *Englishness: Politics and Culture 1880/1920* (Croom Helm, London, 1986).

9. F. MacCarthy, e.g., *All Things Bright and Beautiful: Design in Britain from 1830 to Today* (Allen & Unwin, London, 1972), doesn't even mention it. See J. Woodham, 'Design and Empire: British Design in the 1920s', *Art History*, June 1980, 229-40, 'Images of Africa and Design at the British Empire Exhibitions between the Wars', *Journal of Design History*, 2.1 (1989), 15-33, or *The Industrial Designer and the Public* (Pembridge, London, 1983), for discussion of the field.

10. It attracted almost a further 10 million visitors in the following year.

11. See J. M. Mackenzie, *Propaganda and Empire: The Manipulation of British Public Opinion 1880-1960* (Manchester University Press, 1985) and id. (ed.), *Imperialism and Popular Culture* (Manchester University Press, 1986).

12. L. Weaver, *Exhibitions and the Arts of Display* (Country Life, London, 1925), 42.

13. [G. S. Holme], 'Where there is Non-Vision the People Perish', *Studio*, July, 1930.

14. C. Hussey, 'The Week-end House', *Guide des objects exposés dans le pavillon du Royaume Uni: 1937 Exposition Internationale Paris* (HMSO, London, 1937), 507.

15. Sir Thomas Barlow, speaking at the Council for Art and Industry meeting of 11 November 1937, file BT 60/40/2 at the Public Record Office, Kew.

16. *A Dream of England: Landscape, Photography and the Tourist's Imagination* (Manchester University Press, 1994); for the reference to *Picture Post* see the section 'Landscape for Everyone', 198-205.

17. (Faber, London).

18. A notable exception is Paddy Maguire, whose important article on 'Craft Capitalism and the Projection of British Industry in the 1950s and 1960s', *Journal of Design History*, 6.2 (1993), 97-114, includes some splendid examples of heritage props for the support of British displays abroad.

19. *Board of Trade Journal*, 13 April 1962.

20. 'Modernism and Archaism in Design in the Third Reich', *Block* (Middlesex Polytechnic), no. 3 (1980), 17-20, and 'Design in Interwar Germany', in W. Kaplan (ed.), *Designing Modernity* (above, n. 1.2), 257-85.

21. Seen also in the essay on 'Functionalism in Nazi Germany: Neoclassicism 1933-1945', in H. Fuchs and F. Burkhardt, *Product—Design—History: German Design from 1820 down to the Present Era* (Institute for Foreign Cultural Relations, Stuttgart, 1986).

22. Although a grandiose, updated form of Neo-Classicism was the favoured official style for all significant buildings and architectural schema.

23. S. Weissler, 'Imprisoned Within a Role: An Assessment of Arts and Crafts Production by Women Under National Socialism', in *Frauen im Design* (above, Introd. n. 9), 234-43.

24. For a full discussion of the political complexities of the DWB's activities after 1933, see ch. IX, 'The Werkbund and National Socialism', in J. Campbell, *The German Werkbund: The Politics of Reform in the Applied Arts* (Princeton University Press, 1979) 243-87.

25. Ibid. 275.

26. H. Fuchs and F. Burkhardt (above, n. 20).

27. Such as the Association of Decorative Arts and Industries, founded in 1920.

Chapter 5

1. R. Lynes, *The Taste-Makers: the Shaping of American Popular Taste* (1954; Dover, New York, 1980).

2. S. Giedion, *Mechanization Takes Command: A Contribution to Anonymous History* (1948; Norton, New York, 1969), 617-19.

3. 'The Consumer Markets: 1954-1959', *Fortune*, August 1954, 82. This was the last of the twelve articles.

4. pp. 96-101.

5. E. Larrabee, 'The Six Thousand Houses That Levitt Built', *Harper's Magazine*, 197 (1948), 82.

6. B. Friedan, *The Feminine Mystique* (1963; Penguin, Harmondsworth, 1972), 15–16.

7. R. Venturi, D. Scott Brown, and S. Izenour (MIT, Cambridge, Mass.), 1972.

8. See e.g. A. Hess, *Googie: Fifties Coffee Shop Architecture* (Chronicle, San Francisco, 1985).

9. (Bloomsbury, London).

10. Ibid. 4.

11. (Cambridge University Press).

12. 'Utility or Austerity', *Architectural Review*, January 1943, 3.

13. For fuller discussion see J. M. Woodham, 'Design Promotion 1946 and After', in P. Sparke (ed.), *Did Britain Make It: British Design in Context 1946–1986* (Design Council, London, 1986), 23–37, and 'The Post-War Consumer: Design Propaganda and Awareness, 1945–1965', in N. Hamilton (ed.), *From the Spitfire to the Microchip: Studies in the History of Design* (Design Council, London, 1985), 6–11.

14. *The Enemies of Design* (Design & Industries Association), 3.

15. For further discussion of this see e.g. ch. 5, 'Propaganda and Organisation of Modern Design', in J. M. Woodham, *The Industrial Designer and the Public* (Pembridge, London, 1983).

16. Many aspects of the cultural orientation of the early years have been discussed in J. M. Woodham, 'Managing British Design Reform I: Fresh Perspectives on the Early Years of the Council of Industrial Design', *Journal of Design History*, 9.1. (1996), pp. 55–65. See also J. M. Woodham, 'Managing British Design Reform II', *Journal of Design History*, 9, 2, 101–15.

17. In addition to the BCMI Reports, an extensive range of COID/Mass Observation-related material can be consulted in the Design Council Archive in the Design History Research Centre, the University of Brighton, and at the Mass-Observation Archive at the University of Sussex.

18. *A Designer's Trade* (Allen & Unwin, London, 1986).

19. *An Eye for Design* (Max Reinhardt, London, 1987).

20. Ed. M. Banham and B. Hillier (Thames & Hudson, London 1951).

21. 'The Style: Flimsy . . . Effeminate?' in M. Banham and B. Hillier, op. cit. 190–8.

22. 'The influence of the Festival of Britain on design today', *Journal of the Royal Society of Arts*, June 1961, 503–15.

23. (above, n. 2. 27), 39.

24. D. P. Doordan, 'National Agendas for Italian Design after 1945', paper given at 'Design, Industry and Government Initiatives: Past, Present and Future' international conference at the University of Brighton, November 1995 (to be published).

25. A catalogue was also produced: R. M. Rogers, *Italy at Work: Her Renaissance in Design Today* (Istituto Poligrafico dello Stato, Rome, 1950).

26. In 1948 Handicraft Development Inc. and CADMA were reorganized as the Compagna Nazionale Artigiania (CNA).

27. An exhibition of Olivetti products and graphics was put on in 1952, two years before the company opened its striking New York showroom on Fifth Avenue.

28. This is discussed in G. Berghaus, '*Girlkultur* (above, n. 2.8), 193 ff.

29. *Design Quarterly*, 40 (1958), 1–27.

30. E. Wilkinson, *Japan versus Europe* (Penguin, Harmondsworth, 1983), offers a very useful insight into changing perceptions of Japan in Europe over the previous hundred years or more.

31. *Hansard* (London), 23 November 1950, 500.

32. The quotation relates to a visit by the President of the British Cycle and Motor Manufacturers to Earl's Court in November 1951: Board of Trade Records, Public Record Office, Kew, File BT 11/4452. It is significant, however, that pencilled in the margin is the comment of a Board of Trade official who declared 'Far too complacent. Quality has improved.'

33. *Time*, 23 February 1961.

34. (Wiley, Chichester).

35. The initials of the consultancy stood for Group Koike, in honour of their professor who had done much to stimulate their interest in the emergent discipline of industrial design.

36. A very useful detailed account of all the major developments is contained in JETRO, *Japan's Post War Industrial Policy: Economic Programs in the Reconstruction and Expansion Periods* (Japan External Trade Organization, Tokyo, Japan, 1985). For some aspects of export history see JETRO, *A History of Japan's Postwar Export Policy: Japanese Experience* (Japan External Trade Organization, Tokyo, 1983).

37. Interviewed by the author in Tokyo, November, 1985 when Takeshi Inoue was Director of the Overseas Division of GK Industrial Design.

Chapter 6

1. (Cambridge University Press (first edition 1983), 1992. That six editions were needed in under ten years perhaps points to its particular applicability to such concepts in 1980s Britain.
2. W. Olins, *Corporate Identity: Making Business Strategy Visible through Design* (Thames & Hudson, London, 1989), 13.
3. That this was seen as an increasingly important aspect of the opportunity for corporate communication is evidenced by texts such as J. Grinling, *The Annual Report: A Guide to Planning, Producing and Promoting Company Reports* (Gower, London, 1986).
4. (above n. 2), 132.
5. F. H. K. Henrion and A. Parkin, *Design Co-ordination and Corporate Image* (Studio Vista, London, 1967), 7.
6. (above, n. 2), 9.
7. S. Baker, 'Re-reading *The Corporate Personality*', *Journal of Design History*, 2.4 (1989), 275–6.
8. These include J. K. Galbraith, *The New Industrial State* (Hamish Hamilton, London, 1967), G. Bannock, *The Juggernauts: the Age of the Big Corporation* (Penguin, Harmondsworth, 1973), and A. Mattelart, *Multinational Corporations and the Control of Culture: the Ideological Apparatuses of Imperialism* (Harvester, Brighton, 1979).
9. (Penguin, Harmondsworth), 12.
10. (Ediciones Universitarias de Valparaíso, Chile). An English edition, *How to Read Donald Duck: Imperialist Imagery in the Disney Comic*, with a foreword by David Kunzle, was published by International General, New York, 1975.
11. Doyle Dane Bernbach was founded in New York in 1949 and soon expanded with offices worldwide. Highly successful, it set new standards of co-operation between copywriters and art directors, with visual elements carrying equal editorial weight to that of advertising copy.
12. A. Mattelart, *Multinational Corporations and the Control of Culture* (above, n. 8).
13. The corporate implications of armies are considered in L. Mumford, *Technics and Civilisation* (1934; Routledge & Kegan Paul, London, 1962).
14. The overt symbolism of regimes such as Mussolini's conception of a 'Roma Secunda' and Hitler's Third Reich have been considered in Chapter 3. Wally Olins considers the latter in *The Corporate Personality* (Design Council, 1962). One might look back considerably further to, e.g., the city states and courts of the Renaissance, with the institution of programmes for building and cultural patronage as a means of projecting particular notions of corporate identity.
15. From 1949 it became part of the Illinois Institute of Technology. For further discussion of the early debates and politics of the institution see A. Findeli, 'Design Education and Industry: the Laborious Beginnings of the Institute of Design in Chicago in 1944', *Journal of Design History*, 4.2 (1991), 97–115.
16. Discussed more fully in ch. 9, 'The Aspen Muse and the Twilight of Modernism', in J. Sloan Allen, *The Romance of Commerce and Culture* (University of Chicago Press, 1983).
17. For an extremely useful discussion of the form, content, and influence of this magazine see J. Aynsley '*Gebrauchsgraphik* as an Early Graphic Design Journal, 1924–1938', *Journal of Design History*, 5.1 (1992), 53–72.
18. This has been discussed interestingly in ch. 6, 'Design in the Office', by A. Forty, *Objects of Desire: Design and Society 1750–1980* (Thames and Hudson, London, 1986).
19. See J. Heskett, *Philips: A Study of the Corporate Management of Design* (Trefoil, London, 1989).
20. S. Bayley, *Coke! Coca-Cola 1886–1986: Designing a Megabrand* (Conran Foundation, London, 1986).
21. S. Bayley (ed.), *Sony: Design* (Conran Foundation, London 1982).
22. A. Drexler, 'Introduction' to *Charles Eames: Furniture from the Design Collection* (MOMA, New York, 1973), 3.
23. (MOMA, New York, 1950).
24. Quoted in *Design Process Olivetti 1908–1978*, exhibition catalogue, Frederick S. Wight Art Gallery (Olivetti, Ivrea, 1979), 19.
25. The findings were published and illustrated in 'The 100 "Best Designed" Products', *Fortune*, April 1959, 135–41. This was subsequently enlarged and published as J. Doblin, *100 Great Product Designs* (Van Nostrand Reinhold, New York, 1970).
26. As in B. Radice, *Memphis: the New International Style* (Electa, Milan, 1981); I. Vercelloni, 'A New International Style', *House and Garden*, February 1982, 108–17; H. Cumming, and A. Van Tulleken, 'Memphis Design and Other International Styles', *Art and Design* (London), March 1986, 50–7.
27. The Officina was launched in 1983 as the experimental arm of the metal goods manufacturer, Alessi.
28. See e.g. Volker Fischer (ed.), 'Micro-Architecture', in *Design Now: Industry or Art?* (Prestel Verlag, Munich, 1989), 207–40.

29. (Wright Art Gallery, University of California, Los Angeles, 1979, 19). The term *Piazza* implied architectural structures and spatial relationships: these were defined by the forms of the tea and coffee pots, sugar bowl, and milk jug, set within the spatial definitions of their tray.

Chapter 7

1. (HMSO, London).
2. M. Gray, 'SIAD: The First Forty Years', *The Designer*, October 1970, 4.
3. Board of Trade, *Report of the Committee appointed by the Board of Trade under the Chairmanship of Lord Gorell on the Production and Exhibition of Articles of Good Design and Everyday Use* (HMSO, London, 1932).
4. *Art and Industry: The Principles of Industrial Design* (Faber & Faber, London, 1934).
5. (Faber & Faber, London).
6. (Cambridge University Press).
7. The most important of these were Industrial Art in relation to the Home, held at Dorland Hall, London in 1933, and Contemporary Industrial Design, held at the same venue in 1934.
8. e.g. N. Carrington, *Industrial Design in Britain* (Allen & Unwin, London, 1976), F. MacCarthy, (above, n. 1.2), J. Woodham, *The Industrial Designer and the Public* (Pembridge, London, 1983), and R. Stewart, *Design and British Industry* (John Murray, London, 1987).
9. (Design Council, London, 1983), 36.
10. R. Stewart (above, n. 8).
11. This was reflected in the growing amount of literature in the field, ranging from texts which sought to validate the profession to those which were to act almost as handbooks for those involved: e.g. F. A. Mercer, *The Industrial Design Consultant: Who He Is and What He Does* (Studio, London, 1947), J. Gordon Lippincott, *Design for Business* (Paul Theobald, Chicago, 1954), F. Ashford, *Designing for Industry: Some Aspects of the Product Designer's Work* (Sir Isaac Pitman, London, 1955), J. Pilditch and D. Scott, *The Business of Product Design* (Business Publications Ltd, London, 1965), and D. Goslett *The Professional Practice of Design* (1960; rev. edn., Batsford, London, 1971).
12. See e.g. J. Sorrell, *The Future Design Council* (Design Council, London, 1994). This, and much of the surrounding debate, is covered by Charlotte Benton in her review of the book in the *Journal of Design History*, 7.4 (1994), 310–12.
13. For further discussion of the State's involvement with design in Poland see

D. Crowley, 'Building the World Anew: Design in Stalinist and Post-Stalinist Poland', *Journal of Design History*, 7.3 (1994), 187–203.
14. See e.g. M.H., 'Design in Russia', *Industrial Design*, April 1963, 72–5, R. Hutchings, 'USSR', *Design*, January 1976, 48–9, J. Woudhuysen, 'Soviet Design: Quality Consumer Goods at Last', *Design*, January 1978, 27, and J. Lott, 'Trying to Sort Out the Soviet Union', *Design*, October 1981, 36–7.
15. *Design in Ireland: Report of the Scandinavian Design Group in Ireland* (Irish Export Board, Dublin, 1961).
16. S. Freedgood, 'Odd Business, This Industrial Design', *Fortune* (New York), February 1959.
17. This is a process which has continued as many emerging industrialized nations have given an increasing priority to design.
18. (Pembridge, London, 1981), 48.
19. 'Overseas Review: Ulm', *Design*, June 1959, 53–6.
20. 'Review Article: Hochschule für Gestaltung Ulm: Recent Literature', *Journal of Design History*, 1.3–4 (1988), 249–56.
21. H. Jacob, 'HfG: A Personal View of an Experiment in Democracy and Design Education', *Journal of Design History*, 1.3–4 (1988), 221–34. Other views may be found in B. Meurer, 'Modernity and the Ulm School', in J. De Noblet (ed.), *Design: Reflections of a Century* (Flammarion, 1993). For a women's perspective see G. Müller-Krauspe, 'There Were 26 of Us: Women at the HfG' in *Frauen im Design* (above, Introd. n. 9), 254 ff.
22. (Council of Industrial Design, London).
23. The use of design methods can be studied in the hospital bed project carried out at the Industrial Design (Engineering) Research Unit at the Royal College. This is examined in *Industrial Design and the Community* (Lund Humphries, London, 1967), 17–56.
24. W. E. Woodson, *Human Engineering for Equipment Designers* (University of California Press, Berkeley, 1954).
25. See e.g. H. Murrell, 'How Ergonomics Became Part of Design', in N. Hamilton (ed.), *From Spitfire to the Microchip* (above, n. 5.13), 72–6.
26. (above, n. 3.4).
27. (1966; rev. edn., Penguin, Harmondsworth, 1976).
28. (Hodder & Stoughton, London).

Chapter 8

1. This was noted by the sociologist David Riesman in *The Lonely Crowd* (1950; Yale University Press, New Haven, 1961).

2. (Éditions du Seuil, Paris, 1957). An English translation by A. Lavers was published by Jonathan Cape, London, 1972.

3. (Capeli Editore, Bologna).

4. (Museum of Modern Art, New York).

5. *Theory and Design in the First Machine Age* (Architectural Press, London, 1960).

6. See above, Introd. n. 3.

7. In a recent publication it has been argued forcibly that the history of the IG has been 'mythologised' and that the role of design in the Group's activities has been unduly overshadowed by the emphasis on fine arts. See A. Massey, *The Independent Group: Modernism and Mass Culture in Britain 1945–59* (Manchester University Press, 1995). See also A. Massey and P. Sparke, 'The Myth of the Independent Group', *Block*, 10 (1985), 48–56.

8. (above, n. 5, 7th impression, 1977), 10.

9. Ibid.

10. 'Technology and the Home', *Ark*, 19 (1956), 26.

11. See esp. ch. 8, 'The Myth of the Independent Group: Historiography and Hagiography' in A. Massey (above, n. 7), 109–27.

12. Ibid. 98.

13. *Architectural Review*, August 1948, 88–93.

14. *What is Modern Design?* (Museum of Modern Art, New York, 1950), 7. However, he began to accept a wider canon of taste by the end of the decade in his article 'The Design Shift 1950-1960', *Industrial Design*, 7 (August 1960), 50–1.

15. *Design*, 134 (1960), 28–32. A number of his views on design are contained in his *Collected Words* (Thames & Hudson, London, 1992).

16. *Design*, 134 (1960), 25.

17. *Block*, 4 (1981), 44 ff.

18. This rather indicates that the homogenizing effects of US culture are only one aspect of Hoggart's concerns about the erosion of the British way of life since the tubular steel chair was, at least in its origins, an emblem of modernism,or the International Style which many reacted against in the interwar years as it did not embrace national characteristics.

19. *The Uses of Literacy* (Penguin, Harmondsworth, 1977 edn.), 248.

20. See e.g. N. Whiteley, *Pop Design: Modernism to Mod* (Design Council, London, 1987), or C. McDermott, *Street Style: British Design in the 80s* (Design Council, London, 1987).

21. Part 1, 1959, and Part 2, 1960 (London Press Exchange, London).

22. See e.g. N. Whiteley (above, n. 20).

23. *Architectural Review*, October 1967, 255–7.

24. The organization was undergoing something of a shift away from its concentration on consumer goods towards capital goods and engineering, a shift which was endorsed in its reconstitution as the Design Council, 1972.

25. (above, n. 4), 22. Although published in 1966 it was written in 1962.

26. J. Jacobs, *The Death and Life of Great American Cities: the Failure of Town Planning* (Random House, New York, 1961), and P. Blake, in the rather more sensational *Form Follows Fiasco: Why Modern Architecture Hasn't Worked* (Little, Brown and Company, Boston, 1977), are typical examples of such critiques.

27. (Academy, London).

28. *The Hot House* (above, Ch. 2, n. 27), .

29. 'Memphis and Fashion', from *Memphis: Research, Experiences, Results, Failures and Successes of New Design* (Thames & Hudson, London, 1984), 187.

30. V. Fischer (ed.), *Design Now: Industry or Art?* (Prestel-Verlag, Munich, 1989), 74.

31. J. Thackera, (ed.), *New British Design* (Thames & Hudson, London, 1986), 11.

32. A. Greiman, *Hybrid Imagery: the Fusion of Technology and Graphic Design* (Architecture Design and Technology Press, London, 1990), provides a résumé of her work from the late 1970s onwards.

33. J. Wozencroft, *The Graphic Language of Neville Brody* (Thames & Hudson, London, 1988). For more recent discussion of his work see J. Wozencroft, *The Graphic Language of Neville Brody 2* (Thames & Hudson, London, 1994).

34. See e.g. N. Whiteley (above, n. 20).

35. T. Palmer, *The Trials of Oz* (Blond & Briggs, London, 1971).

36. (above, n. 30), 87.

Chapter 9

1. See P. Stanfield, 'Heritage Design: the Harley-Davidson Motor Company', *Journal of Design History*, 5.2 (1992) 141–55.

2. These instances and others are discussed in Jeffrey Meikle's useful essay, 'Domesticating Modernity: Ambivalence and Appropriation, 1920-1940', in W. Kaplan (ed.), *Designing Modernity* (above, n. 1.2), 143–67.

3. Which was in turn funded by the Works Progress Administration (WPA), established under Roosevelt.

4. In many ways this paralleled the use of crafts workers in British imperial exhibitions.

However, there were often ideological distinctions to be made, as at Wembley 1924, where (black) African crafts workers were working under the public gaze. The message of British imperialism was that Britain was the centre of industrial manufacture and that the colonies provided her with raw materials. In general colonial output was on a scale that was not seen as economically threatening but which none the less held an exotic allure.

5. See William B. Rhoads, 'Colonial Revival in American Craft: Nationalism and the Opposition to Multicultural and Regional Traditions', in J. Kardon (ed.), *Revivals! Diverse Traditions 1920–1945: The History of Twentieth Century Craft* (Abrams, New York, 1994), 41–54. A number of other essays in this volume are very useful, particularly in relation to wider ethnic and cultural concerns. However, in this more limited discussion of (white, Anglo-Saxon Protestant) heritage see especially Harvey Green 'Culture and Crisis: Americans and the Craft Revival', pp. 31–40.

6. Seen in the foundation of the Society for the Revival of Spanish-Colonial Arts in 1925 (renamed the Spanish Colonial Arts Society in 1929). It also promoted a Spanish Arts Shop to market traditional crafts.

7. The streamlined 'Modern Diner' in Pawtucket, RI, of *c.*1940, manufactured by Sterling Diners of Merrimac, Mass., was placed on the National Register of Historic Places.

8. *Yearning for Yesterday: A Sociology of Nostalgia* (Collier Macmillan, London, 1979).

9. Ibid. 109.

10. Ibid. 90.

11. (Cambridge University Press, Cambridge, 1992).

12. Although, prior to taking up the name of Crabtree & Evelyn, the company marketed soaps in a small shop in Cambridge, Mass., in the 1960s.

13. T. Reese, 'When More Is More', *Print*, March–April 1987, 84.

14. These included K. Walsh, *The Representation of the Past: Museums and Heritage in the Post-Modern World* (Routledge, London, 1992). He considered that the war had posed a threat to the status of the ruling classes and that in its aftermath there was a perceived need to preserve what they stood for.

15. Although there was a period in the 1950s when the COID worked with the Rural Industries Bureau and embraced certain aspects of the crafts within its orbit.

16. (British Council/Longmans Green & Co., London).

17. Ibid. 22.

18. (Collins, London).

19. *English Popular Art* (Batsford, London).

20. (Architectural Press, London, 1951). This publication was the culmination of a series of articles which Jones had been producing for the *Architectural Review* since 1944.

21. *Burlington Magazine* (London), September 1952, 203.

22. Such as P. Cormack, *Heritage in Danger* (New English Library, London, 1976).

23. In other words, the Welfare State implemented by Clement Attlee's Labour Government in the later 1940s.

24. The original competition attracted about 300 entries, none of which was felt to be appropriate.

25. Preface by Laura Ashley to the *Laura Ashley Home Furnishings Catalogue 1982* (Laura Ashley, Carno, Powys, 1982).

26. *The Heritage Industry: Britain in a Climate of Design* (Methuen, London).

27. 'Time Will Tell', *Design Week*, November 1990.

28. Other examples are cited in P. J. Fowler, *The Past in Contemporary Society: Then, Now* (Routledge, London, 1992), particularly in ch. 11, 'Exploiting the Past', 129–38.

29. G. Darley, 'History as Bunk', *Financial Times* (London), 2 December 1989, p. xvii. However, the criteria employed included such issues as catering, car parking, and toilet facilities, as well as sales literature. Authenticity and intelligence of historical presentation was subject to no factual or qualitative assessment.

30. (above, n. 14), 129.

Chapter 10

1. This was an innovation of Clarence Saunders who patented the idea in 1917.

2. The 1906 Pure Food Bill, spurred on by Upton Sinclair's horrific account of the malpractice of the American meat-packing industry in his publication, *The Jungle*, was passed despite the opposition of the powerful Chicago-based industrial lobby.

3. Such as the *Ladies Home Journal* and the *Woman's Home Companion*.

4. J. G. Brainerd, 'Introduction', *The Ultimate Consumer: A Study in Economic Illiteracy* (The Annals of the American Academy of Political and Social Science, Philadelphia, May 1934), p. ix.

5. *Report of the Purchase Tax/Utility Committee* (HMSO, London, 1952).

6. Originally established in 1901 as the British Engineering Standards Committee. For further historical details see C. Douglas Woodward, *BSI: The Story of Standards* (British Standards Institute, London, 1972).

7. The British Good Housekeeping Institute was started in 1924, later than its American counterpart, together with its magazine *Good Housekeeping*.

8. Many aspects of such developments have been discussed by S. Worden, 'A Voice for Whose Choice? Advice for Consumers in the Late 1930s', in T. Bishop (ed.), *Design History: Fad or Function?* (Design Council, London, 1978), 41–8.

9. Originally known by the more long-winded title of Advisory Council on Standards for Consumer Goods.

10. For a fuller discussion of women's consumer groups in postwar Britain see ch. 7, 'Consumer Awareness', in Jonathan M. Woodham, *The Industrial Designer and the Public* (above, n. 7.8), 90–8.

11. *Which?* was available by subscription only, unlike the American *Consumer Reports* which could be purchased off the shelf.

12. See, e.g., the discussion of such work in F. Klingender, *Art and the Industrial Revolution* (1947; Paladin, St Albans, 1972). Although scholarship in relation to many of the artists has moved on from the 1968 revised and enlarged edition of the original text, it remains an important contribution to discussions of scientific and cultural change in the 18th and 19th centuries.

13. (1957; Penguin, Harmondsworth, 1960).

14. (Grossman, New York, 1965). For further detailed criticisms and bibliographic references see also J. W. Eastman, *Styling vs. Safety* (University Press of America, 1984).

15. According to Nader in his address to the National Consumer Assembly, Washington, DC, in November 1967, reprinted in G. S. McClelland, *The Consuming Public* (H. W. Wilson, New York, 1968), 102 ff.

16. These and other poll statistics are drawn from ch. 11, 'Morality and the Marketplace', in P. Blumberg, *The Predatory Society: Deception in the American Marketplace* (Oxford University Press, 1989).

17. *Final Report on Consumer Protection* (HMSO, London, 1962).

18. Ibid. 112.

19. See above, n. 10.

20. As discussed in his article of 1961 on 'Influences on My Work' reprinted in J. Meller, (ed.), *The Buckminster Fuller Reader* (above, n. 3.12) 44–68.

21. Many of these lectures are reprinted in J. Meller, op. cit.

22. It had been first published in Stockholm, Sweden in 1970 under the title *Miljon och Miljonera* (*The Milieu and the Millions*). It was published in paperback in Britain by Granada, St Albans, in 1974. The revised editions came out in 1984 and 1991, the latter published by Thames & Hudson, London.

23. P. Madge, 'Design, Ecology, Technology: A Historiographical Review', *Journal of Design History*, 6.3 (1993), 149–66. See also Frank Jackson's review of the 1991 edition, also in the *Journal of Design History*, 6.4 (1993), 307–10.

24. The papers were published by J. Bicknell and L. McQuiston (eds.), *Design for Need: The Social Contribution of Design* (Pergamon Press, Oxford, 1977).

25. e.g. the design of teaching and training devices for the retarded, handicapped, and disabled; also design for medicine, surgery, dentistry, and hospital equipment.

26. See e.g. S. Goldsmith, *Designing for the Disabled* (2nd edn., McGraw-Hill, New York, 1967). A number of aspects relating to bathrooms and related equipment are discussed in chs. 20 and 21 in A. Kira, *The Bathroom* (rev. edn., Penguin, Harmondsworth, 1976).

27. The outlooks of these groups are described in N. Whiteley, *Design for Society* (Reaktion, London, 1993), 110–13.

28. In 1967 Ettore Sottsass Jr. described the houses of the Beat poets as places free of objects and books—what he saw as 'parking spaces' from which life might be reinvented.

29. LSD, one of a number of hallucinogenic drugs favoured by such countercultures.

30. P. Harper, G. Boyle, and the editors of Undercurrents, *Radical Technology* (Wildwood, London, 1976), 5.

31. (Secker & Warburg, London).

32. (Blond & Briggs, London).

33. (Calder & Boyars, London).

34. 'Made in Patriarchy: Toward a Feminist Analysis of Women and Design', *Design Issues*, 3.2 (1986), 4.

35. For further discussion of such issues see e.g. C. Buckley, op. cit.; J. Attfield and P. Kirkham (eds.), *A View from the Interior* (above, Introd. n. 10); and ch. 4, 'Feminist Perspectives', in N. Whitely, *Design for Society* (above, n. 27). The latter provides a basic run-through of a number of key texts and approaches.

36. J. Elkington and J. Hailes, *The Green Consumer Guide: From Shampoo to*

Champagne—High Street Shopping for a Better Environment (Victor Gollancz, London, 1988).

37. J. Elkington and T. Burke, *The Green Capitalists: How Industry Can Make Money and Protect the Environment* (2nd edn., Victor Gollancz, London, 1989).

38. (Lawrence King, London).

39. (Design Council, London).

40. (Thames & Hudson, London).

41. Such as the Zanussi Nexus 'Jetstream RS' washing machine.

42. *On Living in an Old Country: The National Past in Contemporary Britain* (Verso, London).

43. (Routledge, London).

44. (above, n. 6.2), ch. 8, 205–6.

45. Discussion paper No. 1 (Friends of the Earth, London).

46. C. and J. Plant (eds.) (Green Books).

47. (above, n. 23), 161.

List of Illustrations

The publisher would like to thank the following individuals and institutions who have kindly given permission to reproduce the illustrations listed below.

1. Giacomo Balla: Futurist clothing from the *Manifesto Futurista*, 1914. © Giacomo Balla Estate, Rome.
2. Cover of Sears Roebuck Catalogue, *Consumers Guide*, no. 108, 1899. Sears, Roebuck & Co., Hoffman Estates, IL.
3. Parlour Suites from the Sears Roebuck Catalogue, 1897. Sears, Roebuck & Co., Hoffman Estates, IL.
4. Hermann Haas: Stoneware tableware, tea and coffee service and children's playset for Villeroy & Boch, shown at the Deutscher Werkbund Exhibition at Cologne, 1914. Bauhaus-Archiv, Museum für Gestaltung, Berlin (from Deutscher Werkbund Jahrbuch, 1915).
5. Fritz Hellmut Ehmcke: Deutscher Werkbund cigar box, 1914. Die Neue Sammlung, Staatliches Museum für Angewandte Kunst, Munich.
6. The Hamburg Room at the Deutscher Werkbund Exhibition at Cologne, 1914. Werkbund-Archiv, Museum der Alltagskultur des 20. Jahrhunderts, Berlin (from Deutscher Werkbund Jahrbuch, 1915).
7. Peter Behrens: AEG Showroom, Berlin, *c.*1912. Werkbund-Archiv, Museum der Alltagskultur des 20. Jahrhunderts, Berlin (from Deutscher Werkbund Jahrbuch, 1913).
8. Peter Behrens: 1912 brochure advertising nickel-plated and brass AEG Kettles, designed 1909. Tilmann Buddensieg, Berlin.
9. Edward Johnston: Signage for London Underground Electric Railways, post-1916. London Transport Museum.
10. Cover for *RED* magazine, Czechoslovakia, 1928.
11. Qian Jun-tao: *Ahead of the Times*, published by Ahead of the Times Magazine Association, Shanghai, January 1931.

12. Installation view of the *Machine Art* exhibition, Museum of Modern Art, New York, March 5 through April 29, 1934/photo Wurts Brother, © 1996 Museum of Modern Art, New York.
13. Tea and Coffee Service from the *Deutsches Warenbuch*, 1915. Werkbund-Archiv, Museum der Alltagskultur des 20. Jahrhunderts, Berlin.
14. Gerrit Rietveld: Interior of the Schröder House, Utrecht, 1924. © Centraal Museum, Utrecht/photo Ernst Moritz.
15. Gerrit Rietveld: Exhibition at Metz & Co. department store, Amsterdam, showing dining area and glass sideboard, 1933. Centraal Museum, Utrecht, © Beeldrecht Amsterdam/photo RSA.
16. W. H. Gispen/J. Kamman: Giso Lamps poster, 1928. Stedelijk Museum, Amsterdam.
17. Sports clothes by Stepanova and graphics for *Dobrolyet* by Rodchenko from *LEF* magazine, Moscow, 1923. David King Collection, London.
18. Textile designs by Popova, from *LEF* magazine, Moscow, 1923. David King Collection, London.
19. Late 1920s textile, USSR. David King Collection, London.
20. Walter Gropius: Director's Office at the Bauhaus, Weimar, 1923: Bauhaus-Archiv, Museum für Gestaltung, Berlin/photo F. Karsten, London.
21. Ruth Hollós: tapestry, Dessau, 1926. Bauhaus-Archiv, Museum für Gestaltung, Berlin/photo H.-J. Bartsch.
22. Herbert Bayer: brochure advertising Bauhaus products, 1925. Torston Bröhan GmbH, Düsseldorf. Benedikt Taschen Verlag GmbH, Cologne.
23. Marianne Brandt: Teamaker, 1928/30. Brass and ebony. Torsten Bröhan GmbH, Düsseldorf.
24. Wilhelm Wagenfeld: Lighting from *Das Frankfurter Register*, 17, 1931. Bauhaus-Archiv, Museum für Gestaltung, Berlin.
25. Grete Schütte-Lihotzky: Blueprint for

the Frankfurt Kitchen, 1924. Germanisches Nationalmuseum, Nuremberg.

26. Benita Otte and Ernst Gebhardt: Haus am Horn kitchen, Bauhaus Exhibition, 1923. Bauhaus-Archiv, Museum für Gestaltung, Berlin.

27. Hermann Gretsch: Model 1382 service, Porzellanfabrik Arzberg, 1931. Die Neue Sammlung, Staatliches Museum für Angewandte Kunst, Munich.

28. Le Corbusier: Interior of Pavillon de l'Esprit Nouveau, Exposition Des Arts Décoratifs et Industriels, Paris, 1925. Museum des Art Décoratifs, Paris/Editions A. Lévy/ © DACS, 1997.

29. Ufficio Tecnico Olivetti: Olivetti office at Ivrea with *Synthesis* tubular steel furniture, *c*.1935. Cantilevered tubular steel. Archivio Olivetti, Milan.

30. Salon furniture, Nordiska Kompaniet, 1917. Kungliga Biblioteket, Stockholm (from Svenska Slödföreningens Tidskrift, 1927).

31. Wilhelm Kåge: *Praktika I*, model X, *Weekend* pattern dinner service for Gustavsberg, 1933. Gustavsberg Porslin (Keramiskt Centrum), Gustavsberg.

32. Alvar Aalto: *Paimio* armchair, no. 41, 1931/2. Plywood. Alvar Aalto Museum, Jyväskylä/photo M. Kapanen.

33. Alvar Aalto: Garden Room displayed at Paris International Exhibition, 1937. Artek Archive/Foto Studio H. de Sarian.

34. Marion Dorn: Hand-knotted wool rug, Wilton Royal Carpet Factory Ltd., *c*.1937. Board of Trustees of the Victoria and Albert Museum, London.

35. Adolf Syszko-Bohusz and Andrej Pronaszko: Boudoir furniture, Presidential Castle, Wisla, 1930. Chromium-plated tubular steel. Muzeum Narodowe, Warsaw (from Architektura ï Budownictwo, 1931).

36. Adolf Syszko-Bohusz and Andrej Pronaszko: Hall and cloakroom furniture, Presidential Castle, Wisla, 1930. Muzeum Narodowe, Warsaw (from Architektura ï Budownictwo, 1931).

37. Marbett's (White Tower) Restaurant, Camden, NJ, 1938. Tombrock Corporation, New Canaan, CT.

38. Raymond Loewy: Cover of *Time* magazine, 31 October 1949. Katz Pictures, London/© 1939 Time Inc., reprinted by permission.

39. Raymond Loewy: Coldspot Refrigerator for Sears Roebuck, 1935. Sears, Roebuck & Co., Hoffman Estates, IL.

40. Carl Breer and associates: De Soto *Airflow* automobile, Chrysler Corporation, 1934. Chrysler Corporation.

41. Staubsauger: *Champion* vacuum cleaner, Type OK, Holland, late 1930s. Chromium-plated. Die Neue Sammlung, Staatliches Museum für Angewandte Kunst, Munich.

42. Battle of the Centuries: Dishwashing contest between Mrs Drudge and Mrs Modern (using a 1940 Westinghouse dishwasher) at the New York World's Fair, 1939/40. Westinghouse Electric Corporation, Pittsburgh, PA.

43. General Motors Exhibit at the New York World's Fair 1939/40, showing envisaged street scene of 1960 with General Motors buses and cars. Lerner-Zim World's Fair Collection, National Museum of American History, Smithsonian Institution, Washington, DC.

44. Jacques-Emil Ruhlmann: Interior of the *Hotel d'un Collectioneur*, Exposition des Arts Décoratifs et Industriels, Paris, 1925. Philippe Garner, London.

45. André Fréchet, Lahalle and Lavard: Reception hall for the Studium-Louvre Pavilion, Exposition des Arts Decoratifs et Industriels, Paris, 1925. Jean-Loup Charmet, Paris.

46. Jaap Gidding: Foyer of the Tuschinki Cinema, Amsterdam, 1918–21. ANP Foto, Amsterdam.

47. Stanislaw Brukalski: Interior of the America Bar, on the ocean liner *MS Bathory*, 1936. Muzeum Architektury, Wroclaw (from Architektura ï Budownictwo, 1936).

48. Cedric Gibbons/Richard Day: Art Deco set for the MGM film *The Kiss*, 1929. Turner Entertainment Co./© 1929 Turner Entertainment Co. All rights reserved.

49. Eric Slater: Vogue shape teaset, Shelley Potteries, Longton, 1930. Geffrye Museum, London.

50. Y. Utida and Y. Matsui: Interior of the Japanese Pavilion at the New York World's Fair, 1939. Lerner-Zim World's Fair Collection, National Museum of American History, Smithsonian Institution, Washington, DC.

51. Jósef Czajkowski: Chair for the office in the Polish Pavilion at the Paris Expositions des Arts Décoratifs et Industriels Modernes, 1925. Central Library of the Academy of Fine Arts, Kraków/photo Paivel Grawicz.

52. Jósef Czajkowski and Wojciech Jastrzebowski: Office interior in the Polish Pavilion, Paris, 1925. Central Library of the Academy of Fine Arts, Kraków/photo Paivel Grawicz.

53. V. Maslov: *The Tractor*, textile design, USSR, late 1920s. State Russian Museum, St Petersburg/photo Scala, Florence.

88. Arne Jacobsen: Cutlery, AJ pattern, produced by A. Michelsen, Copenhagen, 1957. Royal Copenhagen Ltd., Frederiksberg (made by Georg Jensen, Silversmiths).

89. Kartell: Cover page from the company magazine *Qualität*, no. 6, Winter 1957. Kartell SpA, Noviglio (Milan)/Von Wedel srl.

90. Marco Zanuso & Richard Sapper: Television 201 for Brionvega, 1969. Acrylic. Brionvega SpA, Cernusco sul Naviglio (Milan).

91. *Isabella* coupé, Borgward, West Germany, 1956. Ullstein Bilderdienst, Berlin.

92. Käte Gläser: Model no. 1 Living Room furnished by the Deutscher Werkbund, Berlin, 1953. Werkbund-Archiv, Museum der Alltagskultur des 20. Jahrhunderts, Berlin.

93. One of the Bijenkorf department store displays from 'Pioneers of Today' display, Amsterdam, 1961. Premsela Vonk/Gemeentemuseum, Amsterdam.

94. Stiletto Studios: Consumer's Rest, no. 11 lounge chair prototype, 1986 (prototype developed in 1983). Remodelled and varnished supermarket trolley. Cooper Hewitt National Design Museum, New York/Art Resource.

95. TR 610 Pocket Transistor Radio, Sony, 1958. Advertising Archives Ltd., London/Sony.

96. 'You Meet the Nicest People on a Honda' advertising campaign in the USA, late 1950s. American Honda Motor Co. Inc./Honda Motor Europe Ltd., Reading.

97. Pre-Pentagram: Lucas Identity Programme: Constituent Companies (before redesign), illustrated in Pentagram, 1970s. Lucas Varity PLC.

98. Pentagram: Lucas Identity Programme: Constituent Companies (after redesign), 1975s. Lucas Varity PLC. Pentagram Design Ltd., London.

99. Stanley C. Meeston: McDonald's at Des Plaines, Illinois, 1955. McDonald's Corporation, Oak Brook, IL.

100. Sony Walkman advertisement, 1980s. Advertising Archives Ltd., London/Sony.

101. American Express Credit Card, 1990s. American Express.

102. Cover of *Time* magazine showing Coca-Cola as the 'World's Friend', 15 May 1950. Katz Pictures, London/© 1950 Time Inc.

103. Levi's advertisement, Japan, early 1980s: 'Since 1850 Jeans Have Been Called Levi's in the USA'. Levi Strauss Japan.

104. Eliot Noyes: Selectric typewriter, IBM, 1961. IBM United Kingdom Ltd.

105. Corporate logos: Paul Rand for IBM (1956) and Westinghouse (1960), Henrion Design for KLM (1964), Wolff Olins for BT (1991). Allan Cooper Design Associates (IBM logotype is a registered trademark of the International Business Machines Corporation); Westinghouse Electric Corporation, Pittsburgh, PA; KLM Royal Dutch Airlines; British Telecom.

106. Knoll International furniture showroom, USA, 1950s. The Knoll Group, New York.

107. Gerd Alfred Muller and Robert Oberheim: Kitchen Machine KM 32, Braun, 1957. Braun AG, Kronberg/Taunus.

108. 'Good Design Show' organized by Edgar Kaufmann Jr. for MOMA, NY, 1951. Chicago Merchandise Mart/Museum of Modern Art, New York.

109. Frank Gehry: Interior of the Vitra Design Museum at Weil am Rhein, 1989. Vitra Design Museum, Weil am Rhein, Freibourg/Arcaid, London.

110. Publicity for Scenicruiser Greyhound bus, designed by Raymond Loewy Associates, 1954. Greyhound Lines Inc., Dallas, TX.

111. Philippe Starck: Toothbrush for L'Oréal/Goupil Laboratories, France, 1990. L'Oréal/Goupil SA, Cachan.

112. Robert Venturi: *Village*, 4-piece tea and coffee set, Swid Powell, 1986. Swid Powell, New York/ Venturi, Scott Brown & Associates Inc., Philadelphia, PA/photo Matt Wargo.

113. Kazumasa Yamashita: 5-piece tea and coffee set, *Tea and Coffee Piazza* series, Alessi, 1983. Alessi SpA, Crusincllo.

114. W. H. Gispen: Poster for the Nederlandsche Bund voor Kunst in Industry (BKI), 1941. Stedlijk Museum, Amsterdam.

115. Toshiba Rice Cooker, 1957. Toshiba Corporation (Europe), London.

116. GK Design: Soy sauce bottle for Kikkoman Corporation, Japan, late 1950s. GK Design Group Inc., Tokyo.

117. Hans Gugelot *et al.*: M125 Furniture system, 1957. Stadt Ulm (HfG-Archiv).

118. King's Fund Mark I Hospital Bed, manufactured by J. Nesbit-Evans & Co., 1960s. J. Nesbit-Evans & Co., Wednesbury.

119. Henry Dreyfuss: Joe and Josephine anthropometrics charts, 1960s. *Used with the permission of* Henry Dreyfuss Associates, New York.

120. Toshiyuki Kita: *Wink* Chair, Cassina, 1980. Cassina SpA, Meda (Milan).

121. James Dyson: *G-Force Cyclonic Vacuum Cleaner* manufactured by Apex Inc., Tokyo, 1986. Dyson Appliances Ltd., Malmesbury/photo Ian Dobbie.

122. Richard Sapper: Kettle with bronze whistle, Alessi, 1983. Alessi SpA, Crusinello.

123. Alison and Peter Smithson: 'House of the Future', Ideal Home Exhibition, London, 1956. Ideal Home.

124. John Stephen attending the opening of Carnaby House in Via Margutti, Rome, 1967. Hulton Getty Picture Company Ltd., London.

125. Vivienne Westwood: *Savages* collection, 1981. Rex Features, London.

126. Zanotta stand at the Eurodomus 3, Turin, featuring the *Blow* inflatable chair, designed by Jonathan De Pas, Donato D'Urbino, Paolo Lomazzi, and Carla Scolari, 1967. Zanotta SpA, Nova Milanese.

127. Archizoom Associati, *Naufragio di Rose* dream bed, 1967. Andrea Branzi Architetto, Milan.

128. Ettore Sottsass: *Carlton Bookcase*, Memphis, 1981. Memphis srl, Milan.

129. Hans Hollein: Interior of the Austrian Travel Centre, Vienna, 1976–8. Studio Hollein/photo Jerzy Surwillo.

130. Gary Panter, Art Spiegelman and Françoise Mouly: *Raw* magazine cover, no. 3, 1981. © 1981 RAW Books, New York and Gary Panter.

131. Tom van den Haspel and Henk Elenga: Front cover of *Lecturis*, 1981. Lecturis, Eindhoven.

132. Neville Brody: Brochure cover for *FontFont 5*, Fontshop International, 1992. Neville Brody/Research Studios Ltd., London.

133. Colonial Williamsburg's Ayscough's Cabinet Making Shop, 1937. Colonial Williamsburg Foundation, Williamsburg, VA.

134. Western-styled Sofa-beds, Montgomery Ward, 1950s. Montgomery Ward, Chicago, IL.

135. Customagic Slipcovers advertisement, USA, 1950s. Advertising Archives Ltd., London.

136. Peter Windett: Crabtree & Evelyn shop interior and packaging, 1982. Crabtree & Evelyn, London.

137. *Baroque* service in porcelain, no. 9355, Zsolnay Ceramics Factory Hungary, 1945 onwards. Design Center KFT, Budapest.

138. Harold Holdcroft: *Old Country Roses* bone china tableware, Royal Albert (Royal Doulton), 1962 onwards. Royal Doulton PLC., Stoke-on-Trent.

139. 'Victorian' designs from *Past Times* catalogue, Autumn, 1995. Past Times/Historical Collections Group PLC., Witney.

140. Cover *Consumer Reports*, Issue no. 1, May 1936, USA. Consumers Union, New York.

141. Cover from *Which?* magazine, no. 1, 1957 (reprinted 1960). Which Ltd./The Consumers' Association, London.

142. Richard Buckminster Fuller: Patent drawing from the *Dymaxion Bathroom*, 1937. © 1960 Allegra Fuller Snyder. Buckminster Fuller Institute, Santa Barbara, CA.

143. Cutlery designed for people with single-hand function, Ergonomi Design Gruppen, Sweden, c.1980. Ergonomi Design Gruppen, Bromma.

144. Peter Opsvik and Hans Christian Menghshoel: *Balans* chair, 1979, Norway. Håg as, Oslo.

145. John Habraken: Early wooden prototypes of WOBO bottle and WOBO House, early 1960s. A. H. Heineken, Amsterdam.

146. Drop City, USA, 1960s. Architectural Association Photo Library, London/photo Charlene Koonce.

147. *Body Shop* product ranges, 1980s. The Body Shop International PLC, Littlehampton/photo Apertures.

148. Neville Brody: Men's Bigi frisbee, 1990. Neville Brody/Research Studios Ltd., London.

The publisher and author apologize for any errors or omissions in the above list. If contacted they will be pleased to rectify these at the earliest opportunity.

Bibliographic Essay

This bibliography should be used in conjunction with the chapter footnotes, a number of which provide evaluative commentary as well as useful textual references. It is intended to point the way for further study and research in many areas of the history of twentieth-century design.

1: Towards the Twentieth Century

General introductory texts on twentieth-century design

Among useful discussions of approaches to the study of design history in the twentieth century are Penny Sparke, *An Introduction to Design and Culture in the Twentieth Century* (Allen & Unwin, London, 1986), Hazel Conway (ed.), *Design History: A Students' Handbook* (Allen & Unwin, London, 1987), Adrian Forty, *Objects of Desire: Design and Society 1750–1980* (Thames & Hudson, London, 1986), and John A. Walker, *Design History and the History of Design* (Pluto, London, 1989). The latter considers the widest range of possible approaches to the subject, embracing theoretical and feminist concerns (on which there is a valuable chapter by Judy Attfield). Also of considerable significance in this respect is the pioneering collection of essays edited by Judy Attfield and Pat Kirkham, *A View from the Interior: Feminism, Women and Design* (Women's Press, London, 1989; rev. edn. 1995).

For a broad overview of a number of more specific areas of design activity reference may be made to John Heskett's concise, thematically-organized text, *Industrial Design* (Thames & Hudson, 1980). Much more weighty in terms of length of text and number of illustrations is Jocelyn de Noblet (ed.), *Industrial Design: Reflections of a Century* (Flammarion/APCI, Paris, 1993), which contains essays by various specialists, many of which provide useful introductions to particular facets of design from the late nineteenth century onwards. For the study of the history of interior design Paula Yates

provides a useful overview in her essay on 'Thirty Years of Growth in the Literature of Interior Design', *Journal of Design History*, 4.4 (1991), 241–50, whilst Stephen Calloway, *Twentieth Century Decoration; the Domestic Interior from 1900 to the Present Day* (Weidenfeld & Nicolson, London, 1988), is a well-illustrated account of mainstream 'designer' interiors. More open-ended is my own *Twentieth Century Ornament* (Studio Vista, London, 1990), which covers issues of ornamentation across a wide range of design media, including anonymous as well as attributed designs. Philip Meggs provides a solid and informative, if unexciting, account of graphic and communication design in *A History of Graphic Design* (Allen Lane; London, 1983). However, its emphasis is on the appearance of design rather than its wider social and cultural significance. More challenging and rewarding in terms of historical approach is Christopher Breward's introduction to the history of fashion, *The Culture of Fashion* (Manchester University Press, 1995), although this deals with a larger timescale. Clive D. Edwards, in his *Twentieth Century Furniture: Materials, Manufacture and Markets*, (Manchester University Press, 1994), offers an essentially British-centred study with an emphasis on issues of production and consumption.

There have also been a number of accounts of the use of materials in the twentieth century, such as Ezio Manzini, *The Material of Invention* (Arcadia, Milan, 1986), which provides a theoretical and philosophical approach to the study of new materials. On plastics there are Sylvia Katz, *Plastics Design and Materials* (Studio Vista, London, 1978), Sylvia Katz, *Plastics: Common Objects, Classic Designs* (Abrams, New York, 1984), and Penny Sparke (ed.), *The Plastics Age: From Modernity to Post-Modernity* (Victoria and Albert Museum, London, 1990), all of which are more straightforwardly historical texts than Manzini's. By far the most complete study

to date is Jeffrey Meikle, *American Plastic: A Cultural History* (Rutgers University Press, New Brunswick, 1995). His extensive use of archival sources and exhaustive referencing makes it a definitive, yet very readable, volume.

Differing approaches to the study of the history of design

A wide range of debates about possible approaches to the history of design by authors such as Clive Dilnot and Cheryl Buckley were published in *Design Issues* in the 1980s, at that time published by the University of Chicago Press. These have been conveniently gathered together in Section III on 'Writing Design History', in Victor Margolin (ed.), *Design Discourse: History, Theory, Criticism* (University of Chicago Press, 1989). The references, particularly in Dilnot's articles, also provide a useful checklist for those wishing to examine the historiography of the subject prior to the mid-1980s. More recently, in the spring of 1995, *Design Issues* (now published by MIT, Cambridge, Mass.) devoted an entire issue to debates about the nature and relative value of the history of design and its significance within the wider embrace of design studies.

Museological concerns and the history of design

For a range of museological perspectives and concerns relating to the history of design one of the most useful collections of essays is that edited by Peter Vergo, *The New Museology* (Reaktion, London, 1991), which contains a helpful select bibliography. This is an important area for reflection since museum collections and displays, being often based on aesthetic distinctiveness rather than wider social or broad cultural significance, have played a determining role in the ways in which many writers, historians, and the general public have interpreted particular aspects of design. Also published by Reaktion is John Elsner and Roger Cardinal (eds.), *The Culture of Collecting* 1994, which also provides useful insights into collecting and display from a range of psychological, theoretical, historical, and social perspectives.

Material culture, social anthropology, and the history of design

A number of design historians have laid increasing stress on studies in material culture and social anthropology as a means of moving attention away from the traditional design-historical emphasis on named designers and movements towards a focus on the consumption of design. Texts which are often cited in this context include Mary Douglas and Baron Isherwood, *The World of Goods: Towards an Anthropology of Consumption* (Allen Lane, London, 1975), Daniel Miller, *Material Culture and Mass-Consumption* (Blackwell, Oxford, 1987), and Grant McCracken, *New Approaches to the Symbolic Character of Consumer Goods and Activities* (Indiana Press, Bloomington, 1988). A more recent publication offers a number of possible approaches to the use of objects to interpret the past: Steven Lubar and W. David Kingary, *History from Things: Essays on Material Culture* (Smithsonian, Washington, DC, 1993). Perhaps of more immediate practical use to historians wishing to initiate an exploration of design from a consumer perspective is Tim Putnam and C. Newton (eds.), *Household Choices* (Futures Publications, London, 1990).

Encyclopaedias and dictionaries of design

There are also many indexes and encyclopaedias of twentieth-century design, of which one of the most affordable, Guy Julier, *Encyclopaedia of 20th Century Design and Designers* (Thames & Hudson, London, 1993), is one of the best, with a wide range of topics and intelligent definitions. Useful for the study of the history of graphic design is Alan and Isabel Livingstone, *Encyclopaedia of Graphic Design* (Thames & Hudson, London, 1992), which covers a wide variety of designers, countries, movements, periodicals, typefaces, and related concerns. Of larger-scale indexes with an emphasis on design the most useful and comprehensive in relation to recent design-historical writing and criticism is the *Design and Applied Arts Index* (Design Documentation, Bodiam, 1987–), which covers more than 200 periodicals and is available on CD-ROM. A number of design-related developments in the earlier part of the century are listed in the *Art Index* (H. Wilson, New York, 1933–). Although it covers the period from 1929 to the present day its design coverage is limited by the comparatively modest range of dedicated design periodicals embraced by its searches. Also useful for research into twentieth-century designers is the three-volume *Designers International Index* (Bowker-Saur, London, 1991). Edited by Janette Jagger and Roger Towe, it provides references to a wide range of designer-oriented published material throughout the century. In this respect Colin Naylor, *Contemporary Designers* (St James Press, London, 1990), is also a handy resource. However, it should be borne in mind that a number of such design-led publications tend to celebrate the success of

individual designers rather than provide any penetrating analysis of the wider social, cultural, or economic impact of design in everyday life, thus reinforcing many of the tendencies seen as limiting and partial by feminist historians, social anthropologists, and many of those active in the field of academic design historical research. Of considerable importance in the development of design-historical studies is the location of appropriate and useful primary sources. For this a good starting point is Gillian Varley, *Art & Design Documentation in the UK and Ireland: A Directory of Resources* (ARLIS/UK & Ireland, 1993).

Journals

In response to the growing interest of design historians in the consumption of design, studies in material culture, and the historical significance of social, economic, business, cultural, and other considerations, the range of journals carrying design historical material has expanded considerably over the past fifteen years. The *Journal of Design History* (Oxford University Press, 1988–), is the mainstream periodical in the field.

Twentieth-century industrialization, technological and cultural change

There are a number of books relating to the impact of industrialization on everyday life which provide a useful backcloth for the study of twentieth-century design. These include C. Singer (ed.), *A History of Technology*, v. *The Late Nineteenth Century, c. 1850–1900* (Clarendon Press, Oxford, 1958), H. J. Habakkuk, *American and British Technology in the Nineteenth Century* (Cambridge University Press, 1962), and S. B. Saul, *Technological Changes: the United States and Britain in the Nineteenth Century* (Methuen, London, 1970). More recent is Colin Chant (ed.), *Science, Technology and Everyday Life 1870–1950* (Open University/Routledge, London, 1989). Still useful is Siegfried Giedion, *Mechanisation Takes Command: A Contribution to Anonymous History* (Oxford University Press, 1948), which examines the ways in which technology has impinged upon human activities such as eating, sleeping, washing, and bathing. Encompassing broader cultural concerns are Raymond Williams, *Culture and Society 1780–1950* (Penguin, Harmondsworth, 1958), and C. Harvey, G. Martin, and A. Scharf, *Industrialization and Culture 1830–1914*, (Macmillan, London, 1970), which contains a number of key extracts from important original

texts. Charles Harvey and Jon Press, *William Morris: Design and Enterprise in Victorian Britain* (Manchester University Press, 1991), provides a number of useful fresh insights into a widely-researched field and D. A. Hounshell's absorbing study, *From the American System to Mass Production 1800–1932* (Johns Hopkins University Press, Baltimore, 1984), is an extremely valuable tool for the study of design, society, and cultural change in the United States.

Later nineteenth- and early twentieth-century design: key texts

Design in the late nineteenth and early twentieth centuries has been widely covered in a number of publications including Gillian Naylor's important text *The Arts and Crafts Movement* (Studio Vista, London, 1971). Its subtitle, 'A Study of Sources, Ideals and Influences on Design Theory' indicated her location of the Arts and Crafts in a broader context, particularly in terms of its legacy for modernist designers. Turn-of-the-century developments are also the focus of Bernard Denvir's compilation of contemporary documents and criticism entitled *The Late Victorians: Art, Design and Society 1852–1910* (Longmans, London, 1988). Nikolaus Pevsner's classic *Pioneers of Modern Design: From William Morris to Walter Gropius* (Penguin, Harmondsworth, 1975), which had undergone a number of revisions since its appearance in 1936 as *Pioneers of Modern Movement*, traces a very particular line of development from mid-nineteenth-century design reform in England to progressive design thinking in Continental Europe, which acknowledged a more central place for the machine in design production. Herwin Schaefer, *The Roots of Modern Design* (Studio Vista, 1970), offers an alternative account of the emergence of a functional tradition in modernism of the early twentieth century, looking to its roots in the long-standing recognition of functionalism in vernacular design rather than the work of leading design reformers of the nineteenth century. Reyner Banham, *Theory and Design in the First Machine Age* (Architectural Press, 1960), another landmark text in the genesis of the history of design, provides a far more through-going analysis of early twentieth-century avant-garde movements, emphasizing the roles of Italian Futurism and Expressionism, which were largely ignored by Pevsner.

Design in Germany before 1918

German design for the years leading up to the

end of the First World War is well-covered in John Heskett, *Design in Germany 1870–1918* (Trefoil, London, 1986), which draws on a significant and fresh range of contemporary evidence. Also significant in scholarship for the period is Tilmann Buddensieg, *Industriekultur: Peter Behrens and the AEG* (MIT, Cambridge, Mass., 1984). Indispensable for an examination of the origins of the Deutscher Werkbund as well as the broader picture of cultural, political, and economic change, is Joan Campbell's scholarly book, *The German Werkbund: The Politics of Reform in the Applied Arts* (Princeton University Press, 1978). Examining the same period from a feminist perspective is Magdalena Droste's essay on 'Women in the Arts and Crafts and in Industrial Design 1890–1933', in *Frauen im Design: Berufsbilder und Lebenswege seit 1900* (Design Center, Stuttgart, 1989), 174–202.

French design before 1914
Although not considered at length in Chapter 1, French design has commanded a considerable literature, particularly at the luxury end of the market, such as C. Arminjon *et al.*, *L'Art de Vivre: Decorative Arts and Design in France 1789–1989* (Thames & Hudson, London, 1989). One of the best scholarly studies is Nancy Troy, *Modernism and the Decorative Arts in France: Art Nouveau to Le Corbusier* (Yale University Press, London, 1991).

Austrian design before the First World War
Many aspects of Austrian design are covered in Werner Schweiger, *Wiener Werkstätte: Design in Vienna 1903–1932* (Thames & Hudson, London, 1985), although the highly-researched and detailed text has received some mild criticism on account of the painstaking emphasis on detail at the possible expense of analysis of the wider social, cultural, and economic significance of design. More approachable in this respect is Jane Kallir, *Viennese Design and the Wiener Werkstätte* (Thames & Hudson, London, 1986).

Design in Italy in the early twentieth century
For Italian developments a general account is given in Penny Sparke, *Italian Design 1870 to the Present* (Thames & Hudson, London, 1988). More detailed in its coverage of industrial design of the period is Vittorio Gregotti, *Il disegno nel prodotto industriale* (Electa, Milan, 1982). For material relating to the late nineteenth and early twentieth centuries the essay by Manfredi Nicoletti on 'Art Nouveau in Italy', in Nikolaus Pevsner and J. M. Richards,

The Anti-Rationalists: Art Nouveau Architecture and Design (Architectural Press, London, 1973), covers much still relatively unfamiliar ground. (*The Anti-Rationalists* is also useful for many other aspects of turn-of-the century design in Spain, Austria, France, former Czechoslovakia, Hungary, Germany, and Britain.) Much of the passionate, violent, often misogynist, spirit of Futurism can be gleaned from a reading of their original proclamations, many of which are reprinted in Umberto Apollonio (ed.), *Futurist Manifestos* (Thames & Hudson, London, 1973). Dennis Doordan's essay on 'Political Things: Design in Fascist Italy', in Wendy Kaplan (ed.), *Designing Modernity: The Arts of Reform and Persuasion 1885–1945* (Wolfsonian/Thames & Hudson, Miami/London, 1995), examines the politics of Futurism from its beginnings through to the Second World War. Many other facets of Futurism can be found in Pontus Hulten's well-illustrated *Futurism & Futurisms* (Thames & Hudson, London, 1987), which provides much detailed information on the subject, as does Caroline Tisdall and Angelo Bozzolla, *Futurism* (Thames & Hudson, London, 1977).

2: Design and Modernism

Modernism has commanded a high profile in terms of design-historical publication for well over fifty years for the reasons outlined in the main body of the text. Related historiographic issues have been considered in the footnotes to the main text. A useful entry to a number of modernist debates may be found in Paul Greenhalgh (ed.), *Modernism in Design* (Manchester University Press; Reaktion, London, 1990), which examines the field from a number of ideological and national perspectives, including Germany, France, the United States, Britain, Sweden, Italy, and Spain. Particularly useful is Tim Benton's essay on 'The Myth of Function' in which the problems of using terms such as 'functionalism' are critically probed.

Modernism in German design
German modernism is addressed in a large number of texts. The activities of the Deutscher Werkbund, an organization keenly advocating modernism, are covered thoroughly in Joan Campbell's authoritative account, *The German Werkbund: The Politics of Reform in the Applied Arts* (Princeton University Press, 1978). Lucius Burckhardt (ed.), *The Werkbund: Studies in the History and Ideology of the Deutscher Werkbund 1907–1933* (Design Council, London, 1980), also examines the role of Werkbund

organizations in other countries in addition to Germany.

German modernism: the Bauhaus
As suggested in the main text, the Bauhaus, and the many publications emanating from it and its staff and students, has played an important role in the dissemination of a modernist ideology. H. M. Wingler, *The Bauhaus—Weimar, Dessau, Berlin, Chicago* (1962; new edn., MIT, Cambridge, Mass., 1977), charts this comprehensively, drawing extensively on archival documentation and photographs. The bibliography is also useful. Gillian Naylor, *The Bauhaus Reassessed: Sources and Design Theory* (Herbert Press, London, 1985), examines the theoretical outlook of Bauhaus teachers in a wider context. Also valuable in opening up debate about the early years of the Bauhaus is M. Franciscono, *Walter Gropius and the Creation of the Bauhaus in Weimar* (University of Illinois, Chicago, 1971). Giving a contemporary 1930s retrospective, and partial, view of the achievements of the Bauhaus is a book originally published to accompany a 1938 exhibition at the Museum of Modern Art, Herbert Bayer, Walter Gropius, and Ise Gropius, *Bauhaus 1919–1928* (1938; Secker & Warburg, London, 1975). Considerably later is the Royal Academy exhibition catalogue, *50 Years Bauhaus* (London, 1968), which provides a useful compendium of quotations, illustrations, and documents. For a rather different perspective reference should be made to S. W. Weltge, *Bauhaus Textiles: Women Artists and the Weaving Workshop* (Thames & Hudson, London, 1993), an area of Bauhaus activity often downplayed because most of the weavers were women. Magdalene Droste, in her essay on 'Women in the Arts and Crafts and Industrial Design' in *Frauen im Design* (above, p. 261), considers such issues as well as Gropius's attitudes to women. Droste has also written *Bauhaus: 1919–1933* (Bauhaus Archiv/Taschen, Cologne, 1990).

The Frankfurt kitchen and domestic organization
For discussion of the Frankfurt Kitchen see the essay in *Frauen im Design* (above, p. 261), 160–9, which also has a useful range of references. Another valuable essay on this theme is Nicholas Bullock, 'First the Kitchen—Then the Facade', in *AA Files* (May 1984, reprinted in the *Journal of Design History*, 1.3–4, 177–92), which also references widely, both with regard to German practice and American precedent and contemporary practice. Sonja Günter, *Lilly Reich 1885–1947:*

Innerarchitektin, Designerin, Ausstellungsgestalterin (Deutsche Verlagsanstalt, Stuttgart, 1988), discusses the work of an important woman designer in the field. Over the past twenty years there has been a growing literature focused on women and domestic technology. Ruth Schwartz Cowan has been an important contributor to such debates, commencing with her 1976 essay on 'The "Industrial Revolution" in the Home: Household Technology and Social Change in the Twentieth Century', which was reprinted in Thomas Schlereth (ed.), *Material Culture Studies in America* (American Association for State and Local History, Nashville, Tenn., 1982), a volume which contains other interesting work in the field of material culture. Cowan's book, *More Work for Mother: The Ironies of Household Technology from Open Hearth to the Microwave* (Pantheon, New York, 1983), is very useful. Periodicals such as *Technology and Culture* and the *Journal of American Culture* also offer a large number of articles on the theme.

Modernist design in France
For links between France and Germany see the weighty exhibition catalogue *Berlin/Paris: Rapports et Contrasts France-Allemagne 1900–1933* (Pompidou Centre, Paris, 1978), which covers a broad sweep of visual and cultural activity, including industrial design, graphic, and architecture, as well as literature, film, music, and theatre. It is well illustrated, and the essays are thoroughly referenced. For a discussion of the place of modernism in France in the interwar years Nancy Troy (above, p. 261) provides a scholarly insight. For Corbusier's own views *The Decorative Art of Today* (1925; trans. J. Dunnett, Architectural Association, London, 1987) provides a clear exposition.

De Stijl and modernism in the Netherlands
Nancy Troy, *The De Stijl Environment* (MIT, Cambridge, Mass., 1983), offers a thorough introduction to the work and theoretical concerns of the group, as does Paul Overy, *De Stijl* (Thames & Hudson, London, 1991). Useful also is C. Blotkamp *et al.*, *De Stijl: The Formative Years* (MIT, Cambridge, Mass., 1982). Although in the main texts the emphasis on design has centred on the avant-garde, the modernist vocabulary was widely adopted in housing, leisure, and industrial development of the interwar years, and there is much useful material in the English language. Many aspects are taken up in the Stedelijk Museum's *Design in Industry in the Netherlands 1850–1950*, which

has useful introductory essays and information on a number of manufacturers and retail outlets. Although there is a strong architectural emphasis there are a number of good publications on modern architecture with useful sections on design. These include the Stedelijk Museum, *Het Nieuwe Bouwen: Amsterdam 1920–1980* (University of Delft, 1982), and Boymans-van Beuningen Museum, *Het Nieuwe Bouwen in Rotterdam 1920–1960* (University of Delft, 1982), both of which have a full English translation.

Scandinavian modernism in the interwar years
For Scandinavian design see D. McFadden (ed.), *Scandinavian Modern Design 1880–1980* (Abrams, New York, 1982), which presents a well-illustrated overview of the field, though never penetrating deeply into the wider social, economic, or political circumstances in which design was produced and consumed. On a more focused plane Jennifer Opie, *Scandinavian Ceramics & Glass in the Twentieth Century* (Victoria and Albert Museum, London, 1989), offers some useful distinctions between designs in the different Scandinavian countries, with a sound discussion of modern movement concerns, as does E. Zahle (ed.), *Scandinavian Domestic Design* (Methuen, London, 1963). Gillian Naylor's essay on 'Swedish Grace . . . or the Acceptable Face of Modernism', in P. Greenhalgh (above, p. 261) is a sound and interesting account of developments in Sweden, with a good range of references. The essays by Penny Sparke and Arthur Hald in Nicola Hamilton (ed.), *Svensk Form: A Conference About Swedish Design* (Design Council, London, 1981), are also good summaries of contemporary Swedish issues. For Swedish furniture design of the period a valuable insight is afforded by Gunilla Frick's essay 'Furniture Art or a Machine to Sit On? Swedish Furniture and Radical Reforms', *Scandinavian Journal of Design History* (Danish Museum Of Decorative Art, Copenhagen), 1 (1991), 77–116. For Finnish design in a number of media, see G. Schildt, *Alvar Aalto: The Complete Catalogue of Architecture, Design and Art* (Academy, London, 1994), a comprehensive and exhaustive study of Aalto's work.

Modern design in Britain between the wars
Still useful in discussions of modernism in Britain is the Hayward Gallery exhibition catalogue, *Thirties—British Art and Design before the War* (Arts Council, London, 1979), with introductory essays, many illustrations, and bibliography. Fiona MacCarthy, *A History*

of British Design 1830–1979 (Allen & Unwin, London, 1979), provides an overview although from a perspective largely sympathetic to the Design and Industries Association, which wavered between the progressive tenets of the avant-garde in Europe and the legacy of the Arts and Crafts. Noel Carrington, *Industrial Design in Britain* (Allen & Unwin, London, 1976), covers similar territory. The earlier sections of my own brief text *The Industrial Designer and the Public* (Pembridge, London, 1983), provide a rather broader perspective. From a very different and highly significant perspective D. L. LeMahieu, *A Culture for Democracy: Mass Communication and the Cultivated Mind between the Wars* (Clarendon Press, Oxford, 1988), offers a thorough analysis of the cultural location of the modernist debate in England.

Italian modernism
The modern movement in Italy is succinctly discussed in Leonardo Benevolo's essay on 'The Beginning of Modern Research 1930–1940', in Emilio Ambasz (ed.), *Italy: the New Domestic Landscape* (Museum of Modern Art, New York, 1972). Ellen Shapiro's article 'The Emergence of Italian Rationalism', in *Architectural Design*, 51. 1/2 (1981), and Bruno Zevi, 'Gruppo 7: the Rise and Fall of Italian Rationalism' in the same issue, both provide good, brief introductions to the national and international aspirations of the group, whilst Silvia Danesi and Luciano Patteta, *Il razionalismo e l'architettura durante il fascismo* (Electa, Milan, 1976), offers a more comprehensive and well-illustrated catalogue of architectural developments. A broader overview of key developments in Italy is provided by Penny Sparke, *Italian Design 1870 to the Present* (Thames & Hudson, London, 1988).

Modernism in Eastern Europe
G. Gibian and H. W. Tjalsma (eds.), *Russian Modernism: Culture and the Avant-Garde, 1900–1930* (Cornell University Press, New York, 1988), introduces many key issues in Russia. D. Elliott, *New Worlds: Russian Art and Society* (Thames & Hudson, London, 1986), and *Art into Production: Soviet Textiles, Fashion and Ceramics 1917–35* (Museum of Modern Art, Oxford, 1984), I. Yasinskaya, *Soviet Textile Design of the Revolutionary Period* (Thames & Hudson, London, 1983), N. Lobanov-Rostovsky, *Revolutionary Ceramics: Soviet Porcelain 1917–1927* (Studio Vista, London, 1990), all provide useful

information, written and visual. For packaging and poster design see M. Anikst (ed.), *Soviet Commercial Design of the Twenties* (Thames & Hudson/Alexandria Press, London, 1987), and S. White, *The Bolshevik Poster* (Yale University Press, New Haven, 1988). There are a number of monographs on individual designers of which S. O. Khan-Magomedov, *Alexander Rodchenko: the Complete Work* (MIT, Cambridge, Mass., 1987), is one of the most informative. For other aspects of Eastern European modernism see David Crowley's authoritative, well-written and referenced *National Style and Nation State: Design in Poland from the Vernacular Revival to the International Style* (Manchester University Press, 1992). Exhibition catalogues provide useful introductory studies in the English language to a number of design themes in eastern Europe, though almost always centred on the avant-garde. Useful examples include *Constructivism in Poland 1923–1926* (Kettle's Yard, Cambridge, 1986), *Constructivism in Poland 1923–1926* (Museum Folkwang, Essen, 1973), and *Czech Avant-Garde Art, Architecture and Design of the 1920s and 30s* (Museum of Modern Art, Oxford/Design Museum, London, 1990). Reference may also be made to V. Slapeta, *Czech Functionalism 1918–1938* (Architectural Association, London, 1987).

3: Commerce, Consumerism, and Design

Industrial design in the United States
Jeffrey Meikle, *Twentieth Century Limited—Industrial Design in America* (Temple University Press, Philadelphia, 1979), is one of the most reliable and thorough considerations of American interwar design, locating it within a broad social, economic, and cultural context. Particularly valuable is his discussion of sources, which range from archives, indexes, and periodicals through to contemporary and historical texts. (His survey of literature centred on the history of American design, but within a broader American studies framework, 'American Design History: A Bibliography of Sources and Interpretations', *American Studies International*, 23. 1 (April 1985), 3–40, is another key source for American design-historical study.) Less demanding, but providing a useful overview, is Donald J. Bush, *The Streamlined Decade* (Braziller, New York, 1975), although it inclines towards a style-oriented account. Arthur J. Pulos, *American Design Ethic, A History of American Industrial Design to 1940* (MIT, Cambridge, Mass., 1983), written from the perspective of a designer, provides an informative examination of many significant

developments in the period under discussion. Conceived in relation to a major exhibition at Brooklyn Museum was the comprehensive, well-illustrated text by R. G. Wilson *et al.*, *The Machine Age in America 1918–1941* (Abrams, New York, 1986), which addresses the theme from a variety of cultural perspectives. A thorough analysis of advertising and consumption patterns in the interwar years is provided by Roland Marchand, *Advertising the American Dream: Making Way for Modernity 1920–1940* (University of California Press, Berkeley, 1985).

American exhibitions and the technological imperative
For the large-scale exhibitions of the period see J. E. Findling, *Chicago's Great Worlds Fairs* (Manchester University Press, 1995), Robert W. Rydell, *World of Fairs: the Century of Progress Expositions* (University of Chicago Press, 1993), and chapter 9 of J. Meikle (see above) which focuses on the New York World's Fair of 1939/40 and is well referenced. For visual information reference may be made to Richard Wurts, *The New York World's Fair 1939/40* (Dover, New York, 1977), and Larry Zim *et al.*, *The World of Tomorrow: The New York World's Fair* (Harper & Row, New York, 1988).

Wider concerns in American interwar design: interiors, architecture, and housing
Karen Davies's exhibition catalogue on the theme of *At Home in Manhattan: Modern Decorative Arts, 1925 to the Depression* (Yale University Art Gallery, New Haven, 1983) is well worth examining and contains a number of useful references. Covering American as well as European issues, with a leaning towards the decorative arts, are two important and very readable texts by Martin Battersby, *The Decorative Twenties* (1969) and *The Decorative Thirties* (1971), both republished in revised editions by Herbert, London, in 1989. Alastair Duncan, *American Art Deco* (Thames & Hudson, London, 1986), C. Robinson and R. H. Bletter, *Skyscraper Style: Art Deco New York* (Oxford University Press, New York, 1975), Carol Krinsky, *Rockefeller Center* (Oxford University Press, 1978), and H. Wirz and R. Striner, *Washington Deco: Art Deco in the Nation's Capital* (Smithsonian, Washington, DC, 1984), are among the more useful of the many books devoted to American Deco. The cinema is also an important vehicle for conveying stylistic ideas both modernizing and historicizing, whether in the buildings themselves or on the screen.

Reference may be made to D. Naylor, *American Picture Palaces: the Architecture of Fantasy* (Van Nostrand Rinehold, New York, 1981), Thames Television, *The Art of Hollywood* (London, 1979), D. Atwell, *Cathedrals of the Movies* (Architectural Press, London, 1981), and D. Sharp, *The Picture Palace* (Thames & Hudson, London, 1969).

Design and everyday life in the United States
For many aspects of everyday (as well as designer-conceived) furniture production reference should be made in Sharon Darling's scholarly *Chicago Furniture: Art, Craft, & Industry, 1833–1983* (Norton, New York, 1984). Wider patterns of housing may be examined in Gwendolyn Wright, *Building the Dream: A Social History of Housing* (Pantheon, New York, 1981), whilst something of vernacular roadside culture may be gleaned from collections of photographs with brief texts, such as P. Hirschorn, *White Towers* (MIT, Cambridge, Mass., 1979). From a sociological perspective the contemporary way of life is examined in R. S. and H. M. Lynd, *Middletown: A Study in Contemporary American Culture* and *Middletown in Transition: A Study in Cultural Conflicts*, both published by Harcourt Brace, New York, in 1929 and 1937, respectively.

French design and commerce in the interwar years
Many aspects of French Art Deco may be seen in Yvonne Brunhammer, *The Nineteen Twenties Style* (Paul Hamlyn, London, 1969), the collected essays in *Cinquantenaire de L'Exposition de 1925* (Musée des Arts Décoratifs, Paris, 1977), Patricia Bayer, *Art Deco Interiors: Decorative and Design Classics of the 1920s* (Thames & Hudson, London, 1990), and Nancy Troy (above, p. 262).

British design and commerce in the interwar years
Nikolaus Pevsner, *An Enquiry into Industrial Art in England* (Cambridge University Press, 1937), presents a survey of patterns of taste in Britain of the 1930s, showing many of the best selling lines across a range of products. Several of the chapters, especially 7 and 8, in Paul Oliver *et al.*, *Dunroamin: The Suburban Semi and Its Enemies* (Barrie & Jenkins, London, 1981), look at everyday commercial consumption in aspects of home decoration and furnishing. Looking across the broad spectrum of design activity and consumer goods is the Hayward exhibition catalogue, *The Thirties* (Arts Council, London, 1979). The whole area of shopping and consumerism may be approached through Bill Lancaster,

The Department Store: A Social History (Leicester University Press, London, 1995).

4: Design and National Identity
A useful, succinct introduction to issues of national identity is Jeremy Aynsley's *Nationalism and Internationalism: Design in the 20th Century* (Victoria and Albert Museum, London, 1993). Nicola Gordon Bowe (ed.), *Art and the National Dream: the Search for Turn of the Century Vernacular Design* (Irish Academic Press, Dublin, 1993), provides interesting insights from various national perspectives offered by leading specialists, as does the well-illustrated collection of essays in Wendy Kaplan (ed.), *Designing Modernity: The Arts of Reform and Persuasion 1885–1945* (Wolfsonian/Thames & Hudson, Miami/ London, 1995).

National identities as represented at international exhibitions
International exhibitions, venues where the projection of national identity and cultural values has been an important consideration, are well covered in Paul Greenhalgh, *Ephemeral Vistas: Expositions Universelles, Great Exhibitions and World's Fairs, 1851–1939* (Manchester University Press, 1988), which also contains a useful bibliography of major sources. The large exhibition catalogue, *Art and Power: Europe Under the Dictators 1930–45* (Hayward Gallery, London, 1995), provides an important range of essays. Centred on the Paris International Exhibition of 1937, Rome, Moscow, and Berlin, they provide an excellent flavour of contemporary political and cultural tensions and their visual and material expression. The historian Eric Hobsbawm offers some interesting thoughts in *Nations and Nationalism since 1750—Programme, Myth, Reality* (Cambridge University Press, 1990).

Design and identity in Germany
B. Taylor and W. van der Will (eds.), *The Nazification of Art: Art, Design, Music, Architecture and Film in the Third Reich* (Winchester Press, Winchester, 1990), contains many useful essays for study of the key issues, particularly that by John Heskett on 'Modernism and Archaism in the Third Reich', reprinted from 1980. Heskett further develops this idea in Wendy Kaplan (see above) in 'Design in Inter-War Germany'. B. Hinz, *Art in the Third Reich* (Blackwell, Oxford, 1980), has something to say of design in his discussion of art and architecture of the period. For a broad insight into the social

and political context see e.g. D. F. Crewe, *Nazism and German Society 1933–45* (Routledge, London, 1994).

British design and national identity
Frederique Huygen, *British Design: Image and Identity* (Thames & Hudson, London, 1989), is interesting as a foreign appraisal of British design by the design curator at the Boymans Van Beuningen Museum, Rotterdam. Also raising some interesting issues is Paul Greenhalgh's essay in Wendy Kaplan (see above) on 'The English Compromise: Modern Design and National Consciousness 1870–1940'. John Taylor, *A Dream of England: Landscape, Photography and the Tourist's Imagination* (Manchester University Press, 1994), provides a compelling insight into a range of concerns from a documentary standpoint and also provides an extremely useful bibliography. A number of essays in Raphael Samuel (ed.), *Patriotism: the Making and Unmaking of British National Identity*, vols. 1, 2, and 3 (Routledge, London, 1989), provide useful historical adjuncts to the discussion. Imperialism was an important ingredient in material culture of the period and many aspects are covered in John Mackenzie (ed.), *Imperialism and Popular Culture* (Manchester University Press, 1986) and *Propaganda and Empire—the Manipulation of British Public Opinion 1880–1960* (Manchester University Press, 1985).

Other useful texts
Commune di Milano, *L'anni trenta, arte e cultura in Italia* (Mazotta, Milan, 1982), is a very comprehensive coverage of almost all aspects of design in the 1930s. David Crowley, *National Style and Nation State: Design in Poland from the Vernacular Revival to the International Style* (Manchester University Press, 1992), provides an engaging account of the tensions between national and international identity.

5: The Second World War: Reconstruction and Affluence

General surveys
K. Hiesinger, *Design Since 1945* (Thames & Hudson/Philadelphia Museum of Art, London, 1983), provides a broad, rather art-historically conceived survey of major developments in design for the home and is subdivided into various design media. There are many other survey volumes such as Peter Dormer, *Design Since 1945* (Thames & Hudson, London, 1993), but they are mainly rather lightweight surveys with the emphasis on style

rather than examination of issues of economics or consumption. A useful overview of more helpful published sources may be found in Victor Margolin, 'Postwar Design Literature: A Preliminary Mapping', in Margolin (ed.), *Design Discourse: History, Theory, Criticism* (University of Chicago, 1989).

Postwar developments in design in the United States
For a broad view of postwar developments in the United States reference may be made to Arthur J. Pulos, *The American Design Adventure 1940–1975* (MIT, Cambridge, Mass., 1988). George Nelson and Henry Wright, *Tomorrow's House: A Complete House for the Home-Builder* (Simon and Schuster, New York, 1946), was widely read in the immediate postwar housing drive. Nelson's outlook as a designer is comprehensively covered in Stanley Abercrombie, *George Nelson: the Design of Modern Design* (MIT, Cambridge, Mass., 1995), which also contains a full bibliography. For a broader picture of American housing styles and aspirations Gwendolyn Wright, *Building the Dream: A Social History of Housing in America* (Pantheon, New York, 1981).

Design and consumption in the United States in the postwar years
Other dimensions of suburban life can be seen in Herbert Gans's dense study, *The Levittowners: Ways of Life and Politics in a New Suburban Community* (Pantheon, New York, 1967). Also revealing is the gender perspective afforded by Betty Friedan's classic *The Feminine Mystique* (1963); Penguin, Harmondsworth, 1965), which examines the pressures on American suburban women to conform to a particular set of social mores.

Indispensable as a catalyst for thought about consumerist aspiration of the 1950s is Thomas Hine, *Populuxe* (Bloomsbury, London, 1987), although its use for further research is limited by a lack of references. Stephen Bayley, *Harley Earl and the Dream Machine* (Weidenfeld & Nicolson, London, 1990), provides a glamorous account of exuberant car styling, with references also to the involvement of women in the design process. Looking at the wider picture of influences on consumption are texts such as Karal Ann Marling, *As Seen on TV: The Visual Culture of Everyday Life in America in the 1950s* (Harvard University Press, Cambridge, Mass., 1994).

Design in Italy after 1945
Surveys of postwar Italian design are provided

in Anty Pansera and Alfonso Grassi, *Atlante del Design Italiano 1940–1980* (Fabbri, Milan, 1980), and their *L'Italia del Design: Trent'Anni del Dibattito* (Marietti, Casale Monferrato, 1986); still handy is V. Gregotti's essay, 'Italian Design 1945–1971', in Emilio Ambasz (ed.), *Italy: The New Domestic Landscape—Achievements and Problems of Italian Design* (MOMA, New York, 1973). Many concerns of the avant-garde are covered in the appropriate chapters in Andrea Branzi, *The Hot House: Italian New Wave Design* (Thames & Hudson, London, 1984). *Il Design Italiano degli Anni '50* (Editoriale Domus, Milan, 1985), usefully covers the work of a number of leading designers and firms in the period. For consideration of a wider range of social, political, cultural, and economic issues Z. Baranski and R. Lumley, *Culture and Conflict in Postwar Italy* (Macmillan, London, 1990), is helpful. Penny Sparke, ' "A Home for Everybody?": Design, Ideology and the Culture of Home in Italy, 1945–1972', in P. Greenhalgh (above, p. 261), examines a wide range of social and cultural issues in her examination of design.

British design 1940–1960
In Britain Utility design is succinctly covered in J. Daniels, *Utility Furniture and Fashion 1941–1951* (Geffrye Museum, London, 1974). Penny Sparke (ed.), *Did Britain Make It? Critical Issues in British Design of the Last 40 Years* (Design Council, London, 1986), contains a number of useful essays about a variety of aspects of British design since 1945. The second half of my own study, *The Industrial Design and the Public* (Pembridge, London 1983), covers the same period and provides a range of references and bibliography. Very useful for following up a number of directions in Anthony Coulson, *A Bibliography of British Design 1851–1970* (Design Council, London, 1979). For the 1950s Lesley Jackson, *The New Look—Design in the Fifties* (Thames & Hudson, London, 1991), straightforwardly charts design of the period with an inclination towards the higher echelons of the marketplace. S. Macdonald and J. Porter, *Putting on the Style: Setting Up Home in the 1950s* (Geffrye Museum, London, 1990), is rather more ambitious in its approach.

Japanese design after the Second World War
For design in Japan see Penny Sparke, *Japanese Design* (Michael Joseph, London, 1987). For a broad consideration of changing Western cultural responses to Japan

Endymion Wilkinson, *Japan versus Europe* (Penguin, Harmondsworth, 1983), provides an interesting perspective. Joseph J. Tobin (ed.), *Re-Made in Japan: Everyday Life and Consumer Taste in a Changing Society* (Yale University Press, New Haven, 1992), examines many aspects of consumerism in Japan, with a useful introductory essay by the editor.

Other European design developments after 1945
Other European developments may be studied in G. Staal and H. Wolters (eds.), *Design in the Netherlands 1945–1987* (Stichting Holland in Vorm, Gravenhage, 1987), a wide-ranging, well-illustrated study, *Les Années 50* (Centre Georges Pompidou, Paris, 1988). For Germany see M. Erlhoff (ed.), *Designed in Germany since 1949* (Prestel, Munich, 1990), which provides a broad picture of German postwar design. An overview may also be found in H. Fuchs and F. Burckhardt, *Product-Design-History: German Design from 1820 down to the Present Era* (Institute of Foreign Cultural Relations, Stuttgart, 1985).

Eastern European design after 1945
Eastern European design developments in the postwar years are not generally well covered. However, for developments in Poland David Crowley, 'Building the World Anew: Design in Stalinist and Post-Stalinist Poland', *Journal of Design History*, 7.3 (1994), 187–203, provides important insights. Containing an interesting range of illustrations and charting a broad picture of Russian design since the First World War is Alexander N. Lavrantiev and Yuri V. Nasarov, *Russian Design: Tradition and Experiment 1920–1991* (Architectural Design, London, 1995). For a comprehensive visual survey and year-by-year chronology of design developments in postwar Hungary see *Örökség: Tárgy—és Környezetkultúra Magyarországon/Heritage: Design and Man-Made Environment in Hungary* (Mücsarn ok Design Center, Budapest, 1985). For very much more recent developments the essays on Hungary and Russia by Hugh Aldersey-Williams in *Nationalism and Globalism in Design* (Rizzoli, New York, 1992) provide a gloss. More substantial is Angela Schönberger (ed.), *The East German Take-Off: Economy and Design in Transition* (Ernst & Sohn, Berlin, 1994), which contains a number of short essays about design since November 1989 and was produced to accompany a travelling exhibition of the same title.

6: Multinational Corporations and Global Products

General trends in the literature of the history of design and multinationals

There has been a considerable growth of literature in this area of design and business activity, although it has tended to be dominated by a journalistic, pro-corporate, outlook. Hugh Aldersley-Williams in *Nationalism and Globalism in Design* (Rizzoli, New York, 1992) covers a wide range of issues in the recent past, examining developments in a range of mainline industrialized nations in Europe, Scandinavia, North America, and the Far East, but also including emerging competitors such as South Korea and Singapore. India and Egypt are also considered. More typical of the general literature in the field is Murray J. Lubliner, *Global Corporate Identity: the Cross-Border Marketing Challenge* (Rockport Publishers, Rockport, Me., 1994), a slickly presented set of case studies of companies with large multinational clients.

The documentation of corporate design: self-promotion and self-appraisal

As indicated in the main text, design consultants and companies have themselves written about the importance of corporate design as an element of business strategy. The problems that this can raise for design historians are carefully appraised in Steve Baker, 'Re-reading *The Corporate Personality*', *Journal of Design History*, 2.4 (1989), 272–95. As the title of the article may indirectly suggest, Wally Olins, *The Corporate Personality: An Enquiry into the Nature of Corporate Identity* (Design Council, London, 1978), is considered to be an important text in this vein; Olins, a leading consultant on corporate design, has also written *Corporate Identity: Making Business Strategy Visible through Design* (Thames & Hudson, London, 1989). Other books written from a design-oriented perspective include F. H. K. Henrion and A. Parker, *Design Co-ordination and Corporate Image* (Studio Vista, London, 1967), John and Avril Blake, *The Practical Idealists: Twenty-Five Years of Designing for Industry* (Lund Humphries, London, 1969), James Pilditch, *Communication by Design: A Study in Corporate Identity* (McGraw-Hill, Maidenhead, 1970), and David Bernstein, *Company Image and Reality: A Critique of Corporate Communications* (Holt, Rinehart & Winston, Eastbourne, 1984).

Design consultancies have also produced their own celebrations of success in the publication of case studies. This genre is typified by Peter Gorb (ed.), *Living by Design: the Pentagram Partnership* (Lund Humphries, London 1978). Corporations also have had numerous supportive studies devoted to their activities, often sponsored and published by themselves, such as the catalogue for the Frederick S. Wight Art Gallery, UCLA, *Design Process Olivetti 1908–1978* (Olivetti, 1979); Stephen Bayley, *Coke! Coca-Cola 1886–1986: Designing a Megabrand* (Conran Foundation, London, 1986), and *Sony Design* (Conran Associates, London, 1982), play a similar promotional role, as does the text by A. Morita, *Made in Japan: Akio Morita and Sony* (HarperCollins, New York, 1994). The German company Braun is the main focus of Francois Burckhardt and Inez Franksen, *Design: Dieter Rams &* (Gerhardt, Berlin, 1981). Other corporate histories may be traced in books such as N. Fry, *The IBM World* (Eyre Methuen, London, 1974). Among the more penetrating analyses of design within a corporate set-up has been John Heskett, *Philips: A Study of the Corporate Management of Design* (Trefoil, London, 1989), which provides an account of the design policy of one company, although it too is tinged with partiality.

Multinational cultural trends: the promotion of 'Good Design'

The literature of a Good Design aesthetic in America emerged positively in the 1930s with the MOMA, New York, 1934 *Machine Art* Exhibition but gained a considerable impetus through the output of the museum in the post-Second World War period. Arthur Drexler and Greta Daniel, *Introduction to the 20th Century Design from the Collection of the Museum of Modern Art* (MOMA, New York, 1959), promoted a very modernist viewpoint whilst Edgar Kaufmann, Jr. in *What is Modern Design?* (MOMA, New York, 1959), moved more emphatically towards a definition of Good Design, a theme taken up in the exhibitions of the same name which ran from 1950 to 1955. For a historical critique of such developments see Terence Riley and Edward Eigen's essay 'Between the Museum and the Marketplace: Selling Good Design', in MOMA, *The Museum of Modern Art at Mid-Century: At Home and Abroad* (MOMA/Abrams, New York, 1994), 150–79, which contains many useful references to MOMA's propagandist outlook of the 1950s, particularly with regard to the large retailing display at the Merchandise Mart, Chicago. This Good Design ethos, rooted in the modernist aesthetic of the interwar years (but divorced from any of its

wider social and political involvements), also found expression in the furniture and interiors of many companies, often produced by firms such as Herman Miller and Knoll. For these see Ralph Caplan, *The Design of Herman Miller* (Whitney Library of Design, New York, 1976), and E. Larrabee and M. Vignelli, *Knoll Design* (1981; Abrams, New York, 1989). For designers involved in corporate work see e.g. Paul Rand, *Thought on Design* (1946; rev. edn., Studio Vista, London, 1970), and *A Designer's Art* (Yale University Press, New Haven, 1985), or Pat Kirkham, *Charles & Ray Eames: Designers of the Twentieth Century* (MIT, Cambridge, Mass., 1995).

Broader horizons and critiques of corporate power
Giving a broader cultural perspective of American developments is J. S. Allen, *The Romance of Commerce and Culture* (University of Chicago Press, 1983). For other perspectives, the American economist J. K. Galbraith refers critically to the enormous power wielded by corporations in *The New Industrial State* (Hamish Hamilton, London, 1967), as does G. Bannock in *The Juggernauts: the Age of the Big Corporation* (Penguin, Harmondsworth, 1973). More radical in its criticism is A. Mattelart, *Multinational Corporations and the Control of Culture: the Ideological Apparatuses of Imperialism* (Harvester, Brighton, 1979).

7: Design Promotion, the Design Profession, and Design Management

The design profession
The development of the design profession has been covered in Penny Sparke's brief volume, *Consultant Design: The History and Practice of the Designer in Industry* (Pembridge, London, 1983), which traces the main threads from the nineteenth century through to the 1980s. Much of the shaping of the design profession took place in the United States in the 1920s and 1930s, as discussed in Chapter 3, as well as in the context of multinational corporations and the growth of corporate identity in the post-1945 era examined in Chapter 6. Since the Second World War design management has emerged as an increasingly important preoccupation of the profession, following on from publications such as Herbert Read (ed.), *The Practice of Design* (Lund Humphries, London, 1946), Joshua Gordon Lipincott, *Design for Business* (Paul Theobald, Chicago, 1954) and Dorothy Goslett, *The Professional Practice of Design* (1960; rev. edn., Batsford, London, 1971).

Systematic approaches to design and the design methods movement
The development of a systematic approach to design was an increasingly important consideration for designers seeking wider professional validation, an outlook endorsed in the curriculum of the Hochschule für Gestaltung (HfG) at Ulm, the literature for which has been surveyed by Robin Kinross in a review article in the *Journal of Design History*, 1.3–4 (1988), 249–56. The institution's own journal, *Ulm*, published between 1958 and 1959, and again from 1962 to 1968, with text in German and English, is the most direct way of gaining an insight into the curriculum, as well as the ideology of both staff and students. Worthy of attention also is H. Lindinger (ed.), *Ulm Design: the Mortality of Objects, Hochschule für Gestaltung* (Ernst and Sohn, Berlin, 1990). Following on from developments in Ulm in the late 1950s and 1960s an interest in design methods emerged with key publications such as D. G. Thornley (ed.), *Conference on Design Methods* (Pergamon, Oxford, 1963), which contained a number of landmark essays by Christopher Alexander, J. Christopher Jones, and others. L. Bruce Archer's *Systematic Method for Designers* (Council of Industrial Design, London, 1965), reveals an Ulm-influenced outlook, whilst a more rounded approach can be examined in J. Christopher Jones, *Design Methods: Seeds of Human Futures* (Wiley, London, 1970). Significant also for such thinking has been Nigel Cross who has written extensively in the field, including *Design Methods Manual* (Open University, Milton Keynes, 1975).

Design management
Michael Farr, *Design Management* (Hodder & Stoughton, London, 1966), was a significant landmark in the development of the field, one which assumed particular importance in the 1980s and 1990s. The Society of Industrial Artists and Designers' (SIAD) Design Management Group was founded in London in 1981, publishing *Design Management Seminars* (SIAD, London, 1983). In similar vein the London Business School Design Management Seminars, which dealt with such issues as design identity, corporate strategy, and product innovation, were published through another key figure in the definition and development of the field, Peter Gorb. His edited papers, *London Business School: Design Talks* (Design Council, London, 1988), were followed by another set, also edited by him, entitled *Design Management: Papers*

from the London Business School (Architecture, Design & Technology Press, London, 1990). Other publications include M. Oakley, (ed.), *Design Management: A Handbook of Issues and Methods* (Blackwell, Oxford, 1990), and Liz Lydiate (ed.), *Professional Practice in Design Consultancy: A Design Business Association Guide* (Design Council, London, 1992). Anne Valkonen (ed.), *Qualities of Success* (University of Industrial Arts, Helsinki, 1993), contains eleven essays drawn from the proceedings of the Second International Conference of Design Management at the University, relating to such themes as corporate identity and design management education.

8: Pop to Post-Modernism: The Assault on Modernism

Pop design: its origins and influence
Pop design has been covered in texts such as Nigel Whiteley, *Pop Design: Modernism to Mod* (Design Council, Design Council, 1987), which contains a wide number of references to contemporary articles as well as a large number of illustrations. Useful too, in its focus on the significance of mass-culture in Britain after the war, is Anne Massey, *The Independent Group: Modernism and Mass Culture in Britain, 1945–1959* (Manchester University Press, 1995), which has an excellent bibliography. Of particular value is chapter 8, 'The Myth of the Independent Group: Historiography and Hagiology', which demonstrates the shortcomings of traditional interpretations of the Group's cultural location in British art and design of the period. Something of a contemporary critical outlook on design may be gleaned from one of the key participants, in Richard Hamilton, *Collected Words* (Thames & Hudson, London, 1992). The activities of Archigram are covered in Peter Cook, *Archigram* (Studio Vista, 1972). Certain aspects of the wider influence of Pop in Italy may be seen in chapter VI, 'Pop Realism', of Andrea Branzi (above, p. 267), or in Penny Sparke, *Ettore Sottsas Jr.* (Design Council, London, 1982).

Some key texts relating to Post-Modernism
There has been an extensive literature devoted to Post-Modern design, early considerations emerging in such texts as Gillo Dorfles, *Il Disegno e la sua Estetica* (Capelli Editore, Bologna, 1963), and Robert Venturi's landmark *Complexity and Contradiction in Modern Architecture* (Museum of Modern Art, New York, 1966). Also widely influential has been Robert Venturi, D. Scott Brown, and S. Izenour, *Learning from Las Vegas* (MIT, Cambridge, Mass., 1972). Other well-known contributions have included Charles Jencks's two books, *The Language of Post-Modern Architecture* (Academy, London, 1973), and *What Is Postmodernism?* (Academy, London, 1986). John Thackera (ed.), *Design After Modernism: Beyond the Object* (Thames & Hudson, 1988), also contains useful material; well-illustrated is Michael Collins and Andreas Papadakis, *Post-Modern Design* (Rizzoli, New York, 1989). Architectural Design, *The Post-modern Object: AD. An Art and Design Profile* (Academy, London, 1987) provides another survey. A more theoretical perspective is embraced in B. C. Brolin, *Flight of Fancy: the Banishment and Return of Ornament* (Academy, London, 1985); also useful in this respect are D. Harvey, *The Condition of Postmodernity: An Enquiry into the Origins of Cultural Change* (Oxford University Press, 1990), and J.-F. Lyotard, *The Post-Modern Condition: A Report on Knowledge*, (1986); translated for Manchester University Press, 1989). John Docker, in *Postmodernism and Popular Culture: A Cultural History* (Cambridge University Press, 1995), considers the problems of analysis of consumption in a stimulating manner, providing a number of potential approaches for the contemporary design historian.

Post-Modern design: the international dimension
The international nature of Post-Modernism is exemplified by Memphis, for which there is an extensive literature. Barbara Radice, *Memphis* (Thames & Hudson, London, 1984), gives an informative, if descriptive, account of the group's aims and achievements, and is ultimately more useful than texts such as Richard Horn, *Memphis: Objects, Furniture and Patterns* (Running Press/Quarto, Philadelphia, 1985). Many wider issues concerning design and decoration across the whole period are considered in Volker Fischer (ed.), *Design Now: Industry or Art?* (Prestel, Munich, 1989). A number of national perspectives may be seen in Hugh Aldersley-Williams, *New American Design: Products and Graphics for a Post Modern Age* (Rizzoli, New York, 1988), Andrea Branzi (above, p. 267), and John Thackera, *New British Design* (Thames & Hudson, London, 1986). For a different cultural perspective there are a number of useful essays in M. Miyoshi and H. Harootunian (eds.), *Postmodernism in Japan* (Duke University Press, Durham, NC, 1989).

9: Nostalgia, Heritage, and Design

There has been a considerable body of writing about tradition, nostalgia, and heritage over the past twenty years, the 1980s being a prolific decade in this respect. Although the literature cited below is mainly centred on British publications, such concerns have emerged elsewhere. Nostalgia and tradition have resonances in design and marketing in many other countries, including Japan, as seen in M. Ivy's essay on 'Critical Texts, Mass Artefacts: the Consumption of Knowledge in Postmodern Japan', in M. Miyoshi and H. Hirootunian (above, p. 270).

Amongst the more noteworthy contributions by British authors have been David Lowenthal, *The Past Is a Foreign Country* (Cambridge University Press, 1985), Robert Hewison, *The Heritage Industry* (Methuen, London, 1987), and Patrick Wright, *On Living In an Old Country* (Verso, London, 1985) all of which were important landmarks. Useful also are the articles on historical representation contained in Robert Lumley (ed.), *The Museum Time-Machine* (Routledge, London, 1988). Eric Hobsbawm and Trevor Ranger (eds.), *The Invention of Tradition* (1983; Cambridge University Press, 1992), also provides an interesting range of differing approaches to the subject. Other useful texts include John Corner and Sylvia Harvey (eds.), *Enterprise and Heritage: Crosscurrents of National Culture* (Routledge, London, 1991), Russell Keat and Nicholas Abercrombie (eds.), *Enterprise Culture* (Routledge, London, 1991), K. Walsh, *The Representation of the Past: Museums and Heritage in the Post-Modern World* (Routledge, London, 1992), and Peter J. Fowler, *The Past in Contemporary Society: Then, Now* (Routledge, London, 1992), which examines the issue of heritage from many standpoints, albeit conditioned by an expertise in archaeology. Nostalgia is helpfully considered in Fred Davis, *Yearning for Yesterday: A Sociology of Nostalgia* (Macmillan, London, 1979). Useful also for consideration of a wide number of debates about heritage and nostalgia, particularly the use of photography as historical evidence, is Raphael Samuel, *Theatres of Memory*, i. *Past and Present in Contemporary Culture* (Verso, London, 1995). However, the text has attracted a certain amount of criticism on account of his attacks on the defenders of a puritanical approach to heritage interpretation.

10: Design and Social Responsibility

Design and consumer protection

Consideration of consumer organizations has been somewhat underplayed in many histories of design history, despite the fact that the implementation of standards, both national and international, has been an important facet of twentieth-century design production. A number of these concerns in relation to Britain have been covered in C. D. Woodward, *The Story of British Standards* (British Standards Institution, London, 1972), which examines major developments from the beginning of the century to the date of its publication. Covering a narrower period is J. Perry's account, *The Story of Standards* (New York, 1955), in which such issues are viewed from an American standpoint. From a wider angle American consumer rights are discussed in a wide range of essays included in D. A. Aaker and G. S. Day (eds.), *Consumerism: Search for the Consumer Interest* (2nd edn., Free Press, New York, 1974). Particularly useful with regard to the history of the American Consumers' Union is chapter 12, an essay on 'Consumer Action Programs of the Consumers' Union', by Colston E. Warne, one-time President of the CU. Covering similar ground is a section on 'The Role of the Consumers' Union' (reprinted from *Business Week*, 23 December, 1967, in G. S. McClellan, *The Consuming Public* (H. W. Wilson, New York, 1968), which also contains other useful information on many aspects of changing American legislation and consumer campaigning: Ralph Nader is featured in a section entitled 'A One Man Crusade' which was reprinted from *Newsweek*.

Moral crusaders and attacks on consumer society

There has been a spate of colourful writing against the manipulation of the consumer, typified by Vance Packard, *The Hidden Persuaders* (1957; Penguin, Harmondsworth, 1960). This was followed by his equally committed *The Waste-Makers: A Startling Revelation of Planned Obsolescence* (Longman, London, 1960). A similar sensational tone was adopted by Ralph Nader in his indictment of the American automobile industry, *Unsafe at Any Speed: the Designed-In Dangers of the American Automobile Industry* (Grossman, New York, 1965).

For a broad sweep of the wider issues in Britain see my brief chapter, 'The Post-war Consumer: Design Propaganda and Awareness, 1945-1964', in Nicola Bailey (ed.), *From Spitfire to Microchip: Studies in the History of Design from 1945* (Design Council, London, 1985). For a thorough examination of the ways in which advertising techniques were seen to be significant in this context, Cynthia White,

*The Women's Periodicals Press in Britain
1946–1976* (Royal Commission on the
Press, HMSO, London, 1977), is extremely
informative.

Indictments of the design profession
A number of those connected with the design
world have published indictments of those in
their profession, including Richard Neutra,
Survival Through Design (Oxford University
Press, New York, 1954). More notable, perhaps,
for their quantity if not consistent quality, are
the extensive writings of Buckminster Fuller,
to whom reference has been made in the text
and footnotes. For an informative overview
of his ideas, reference may be made to
R. Buckminster Fuller and Robert Marks,
The Dymaxion World of Buckminster Fuller
(1960; rev. edn., Doubleday Anchor, New
York, 1973), which also contains a useful
range of illustrations as well as a full account
of Fuller's design projects and philosophy.
For a more recent text on Fuller, Martin
Pawley, *Richard Buckminster Fuller* (Trefoil,
London, 1990), offers a more detached
analysis. In addition to J. Meller (ed.),
The Buckminster Fuller Reader (Penguin,
Harmondsworth, 1972), reference may also
be made to R. Buckminster Fuller, *Utopia
or Oblivion: the Prospects for Humanity*
(Penguin, Harmondsworth, 1970).

Design, the designer, and social responsibility
Victor Papanek's text on *Design for the Real
World: Human Ecology and Social Change*
(1971; rev. edn., Thames & Hudson, 1991), has
been widely read, although the extent of its
actual impact upon the workings and attitudes
of the design profession is harder to gauge.
There have been several attempts to examine
the wider moral and social implications taken
up by Papanek, as in Nigel Whiteley, *Design
for Society* (Reaktion, London, 1993). There
is a lot of useful factual information for those
concerned with the examination of issues
of design and responsibility in the late
twentieth century, although ultimately
Whiteley provides more of a moral crusade
against the excesses of consumer society
than any weighty historical analysis. The
media attention paid to campaigning
individuals such as Anita Roddick,
co-founder of the Body Shop, has perhaps
underlined the commercial dividends that
can accrue from 'ethical consumerism',
as seen in her journalistic autobiography,
Anita Roddick: Body and Soul (Ebury Press,
London, 1991).

Design and the disabled
Little design-historical scrutiny has been
focused on design for the disabled, although
this has been examined in such books as K.
Bayes, *Designing for the Handicapped: the
Mentally Retarded* (G. Godwin, London, 1971),
and Alexander Kira, *The Bathroom Book* (rev.
edn., Penguin, Harmondsworth, 1976). This
is an area also usefully, albeit briefly, covered
by Nigel Whiteley (above), chapter 3,
'Responsible Design and Ethical Consuming'.
A wide range of recent initiatives in a number
of countries are referenced in the *Design and
Applied Arts Index* (above, p. 259). Swedish
design consultancies such as Ergonomi Design
Gruppen and A & E Design have been
particularly significant in the field. A brief
survey of their work may be seen in 'Not
Visibly Disabled', *Form*, Sweden, 85, no. 663,
70–3, 100, 102, 124–6.

The design profession and responses to wider social and environmental concerns
Design conferences also provided important
fora for debate, as seen in Reyner Banham
(ed.), *The Aspen Papers: Twenty Years of Design
Theory from the Design Conference in Aspen*
(Pall Mall Press, London, 1979), a number of
which were concerned with broader social,
environmental, and philosphical concerns.
The ICSID conference on 'The Relevance of
Industrial Design' was published as a book of
the same title by Edinburgh University Press,
Edinburgh, 1973. A number of the wider issues
of design and social responsibility were also
examined in J. Bicknell and Liz McQuiston
(eds.), *Design for Need: the Social Contribution
of Design* (Pergamon/ICSID, Oxford, 1977),
which included a number of significant
contributions from the Royal College of Art
conference of the same title of the previous
year, many of them morally and emotionally
charged.

Design and ecology: the emergence of Green Design
Many of the wider issues relating to the
historiography of design and ecology are
indicated in Pauline Madge's extensive
article 'Design, Ecology, Technology:
A Historigraphical Review', *Journal of
Design History*, 6.3 (1993), 149–66. There
was a steady stream of publications in the
1960s and, more particularly, the 1970s,
when Martin Pawley, *Garbage Housing*
(Architectural Press, 1975), examined the
potential of recycling and secondary-use
design. The late 1980s and 1990s have been

marked by a spate of publications on many aspects of 'green design' and 'green consumerism', including Dorothy Mackenzie, *Green Design: Design for the Environment* (Lawrence King, London, 1991), and a number of others to which reference has been made in the chapter footnotes. Victor Papanek has also updated his own position in *The Green Imperative: Ecology and Ethics in Design and Architecture* (Thames & Hudson, London, 1995). Those texts that have emanated from a design consultancy background, such as Mackenzie's, have tended to endorse the consumer process, albeit mediated by wider ethical considerations. A number of wider considerations of the economic implications of environmentally responsible design have been taken up in publications such as D. Pearce *et al.*, *Blueprint for a Green Economy* (Earthscan Publications, London, 1989), and K. Turner (ed.), *Sustainable Environmental Management* (Bellhaven, London, 1988).

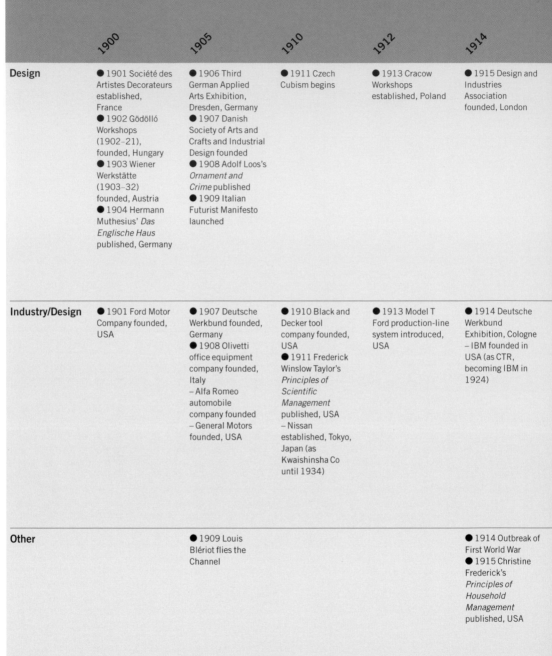

	1900	**1905**	**1910**	**1912**	**1914**
Design	● 1901 Société des Artistes Decorateurs established, France ● 1902 Gödöllő Workshops (1902–21), founded, Hungary ● 1903 Wiener Werkstätte (1903–32) founded, Austria ● 1904 Hermann Muthesius' *Das Englische Haus* published, Germany	● 1906 Third German Applied Arts Exhibition, Dresden, Germany ● 1907 Danish Society of Arts and Crafts and Industrial Design founded ● 1908 Adolf Loos's *Ornament and Crime* published ● 1909 Italian Futurist Manifesto launched	● 1911 Czech Cubism begins	● 1913 Cracow Workshops established, Poland	● 1915 Design and Industries Association founded, London
Industry/Design	● 1901 Ford Motor Company founded, USA	● 1907 Deutsche Werkbund founded, Germany ● 1908 Olivetti office equipment company founded, Italy – Alfa Romeo automobile company founded – General Motors founded, USA	● 1910 Black and Decker tool company founded, USA ● 1911 Frederick Winslow Taylor's *Principles of Scientific Management* published, USA – Nissan established, Tokyo, Japan (as Kwaishinsha Co until 1934)	● 1913 Model T Ford production-line system introduced, USA	● 1914 Deutsche Werkbund Exhibition, Cologne – IBM founded in USA (as CTR, becoming IBM in 1924)
Other		● 1909 Louis Blériot flies the Channel			● 1914 Outbreak of First World War ● 1915 Christine Frederick's *Principles of Household Management* published, USA

● 1917 De Stijl founded, Holland
– Svenska Slödföreningen exhibition *The Home*, Stockholm
– Wilhelm Kåge joined Gustavsberg ceramics company, Sweden, as art director
– Standards Commission of German Industry established
– Russian Constructivism established

● 1919 Bauhaus founded, Weimar, Germany, with Walter Gropius as first director

● 1920 Devetsil Group (1920–31) founded, Czechoslovakia
– Vkhutemas art and design school established, Moscow

● 1923 First Triennale exhibition, Monza, Italy
– Bauhaus Exhibition, Weimar
– First Salon des Arts Ménagers, Paris
– Le Corbusier's *Vers Une Architecture* published

● 1924 British Empire Exhibition, Wembley, London
● 1925 Bauhaus moves to Dessau, Germany
– Exposition des Arts Décoratifs et Industriels, Paris
– Cranbrook Academy of Art established, USA

● 1926 Gruppo 7 founded, Italy
– Praesens group established, Poland
– Ład design group established, Poland
● 1927 Weissenhof Siedlung Exhibition, Stuttgart, Germany
– General Motors established its Art and Colour Section

● 1916 BMW motor works founded, Germany
– Gispen metalware company founded, Netherlands

● 1918 Matsushita electronics company founded, Japan

● 1921 Braun domestic appliances company founded, Germany
– Alessi metalware company founded, Italy

● 1923 Herman Miller furniture company founded

● 1925 Chrysler Corporation founded, USA

● 1926 Container Corporation of America founded, USA
● 1927 Cassina furniture company launched

● 1916 First Piggly-Wiggly self-service grocery store, USA
● 1917 October Revolution, Russia

● 1918 End of First World War

● 1922 Mussolini takes power Italy
– Stalin elected General Secretary of Central Committee, USSR

● 1926 Edna Meyer's *Der Neue Haushalt* published
– Fritz Lang's film *Metropolis*
● 1927 Chase and Schlink's *Your Money's Worth: A Study in the Waste of the Consumer's Dollar* published, USA

	1928	**1930**	**1932**	**1934**	**1936**
Design	● 1928 Bratislava School of Applied Arts established, Czechoslovakia – *Domus* magazine launched, Italy – CIAM (1928–56) initiated – AUDAC founded, USA ● 1929 Museum of Modern Art, New York, founded – Raymond Loewy established his industrial design office, New York – Union des Artistes Modernes (UAM) founded in Paris	● 1930 Stockholm Exhibition, Sweden – Society of Industrial Artists founded, London ● 1931 Den Permanente established, Copenhagen	● 1932 The International Style exhibition, MOMA, New York – Bel Geddes's *Horizons* published, USA – Bauhaus moved to Berlin – *De 8 en Opbouw* periodical established, Netherlands ● 1933 Bauhaus closed – Council for Art and Industry appointed, London	● 1933–4 A Century of Progress International Exhibition, Chicago, USA ● 1934 Machine Art Exhibition, MOMA, New York – Herbert Read's *Art and Industry* published – Schönheit der Arbeit division of the Labour Front established, Germany	● 1936 Nikolaus Pevsner's *Pioneers of the Modern Movement* published, UK ● 1937 Exposition Internationale des Arts et Techniques dans la Vie Moderne, Paris, France – Nikolaus Pevsner's *Enquiry into Industrial Art in England* published
Industry/Design		● 1930 Pininfarina automobile design company established, Italy	● 1933 Boeing 247 and Douglas DC-1 passenger aircraft launched, USA – Istituto per la Ricostruzione Industriale established, Italy	● 1934 Erco lighting company founded, Germany – Pullman Car Corporation, M10,000 locomotive for Union Pacific railway, USA ● 1935 Jaguar motor company established Coventry, Britain	● 1937 Saab founded, Sweden (diversifying from aircraft manufacture to automobiles and other commodities after the Second World War)
Other	● 1928 First Five-Year Plan, USSR ● 1929 Wall Street Crash, USA	● 1930 *Fortune* magazine established	● 1932 Sheldon and Arens's *Consumer Engineering: A New Technique for Prosperity* – Aldous Huxley's *Brave New World* – Adoption of Second Five-Year Plan, USSR ● 1933 New Deal, USA – Hitler comes to power as Chancellor, Germany	● 1934 Socialist Realism presented at first Soviet Writers Congress, USSR	● 1936 Consumers' Union formed, USA – First regular television broadcasts by BBC, Britain – Charles Chaplin's film *Modern Times* – Outbreak of Spanish Civil War – Front Populaire elected, France

● 1939–40 New York World's Fair, USA

● 1940 Harold Van Doren's *Industrial Design: A Practical Guide* published, USA

● 1942 Utility Design programme introduced, Britain
● 1943 Design Research Unit founded, Britain

● 1944 Council of Industrial Design (COID) founded, Britain
– Libby-Owens-Ford 'Day After Tomorrow' Kitchen tour, USA

● 1946 Britain Can Make It Exhibition, London
– RIMA Exhibition of Popular Furnishing, Milan, Italy
● 1947 Society of Industrial Designers founded, USA
– Office for Supervision of Aesthetic Production established, Poland

● 1949 *Design* magazine founded, London

● 1943 IKEA founded, Sweden

● 1945 Brion Vega radio and television manufacturing company founded, Milan, Italy

● 1946 Arteluce lighting company founded, Italy
– Sony electronics company founded (as TTK), Japan
– Knoll furniture company founded, USA

● 1948 Honda motor company founded
● 1949 Gavina furniture company founded, Italy
– Kartell plastics company founded, Italy
– Porsche motor company founded, Germany

● 1939 Outbreak of Second World War

● 1940 Commercial television launched in the USA
– Activ Hushalling established, Sweden

● 1944 Hemmens
– Forskningsinstitut established, Sweden (becoming National Institute for Consumer Information in 1957)
● 1945 End of Second World War

● 1947–51 First Levittown, Long Island, USA

● 1948 Marshall Plan for European postwar recovery

	1950	**1952**	**1954**	**1956**	**1958**
Design	● 1950 'Italy at Work: Her Renaissance in Design Today' touring exhibition, USA ● 1950–5 Edgar Kaufmann Jr. organized 'Good Design' Exhibitions at MOMA, New York ● 1951 Festival of Britain – Aspen International Design Conferences inaugurated, Colorado, USA	● 1952 Independent Group formed, London ● 1953 Hochschule für Gestaltung, Ulm, offers first courses – Rat für Formgebung founded, Germany	● 1954 *Stile Industria* magazine founded, Italy – *Industrial Design* magazine founded, USA – Compasso d'Oro design awards launched, Italy	● 1956 Design Centre of COID opens, London ● 1957 GK Industrial Design Associates founded, Japan – Design Awards scheme launched by Council of Industrial Design, London – MITI establish G-Mark Design Awards scheme, Japan – ICSID founded	● 1958 Exposition Universelle, Brussels ● 1959 MITI Design Division established, Japan
Industry/Design	● 1951 Konosuke Matsushita visits USA on industrial fact-finding tour	● 1953 First General Motors 'Motorama' exhibition, New York – First Frigidaire 'Kitchen of Tomorrow' event, New York			● 1958 First IKEA shop opened, Sweden
Other	● 1951 Outbreak of Korean War		● 1955 First McDonald's restaurant opens, USA – Disneyland opens, USA	● 1957 Launch of Sputnik satellite – Treaty of Rome and launch of European Common Market – Vance Packard's *Hidden Persuaders* published – Formation of Consumers' Association, Britain	

1960 **1962** **1964** **1966** **1968** **1970**

● 1960 Reyner Banham's *Theory and Design in the First Machine Age* published, London
– Dieter Rams appointed Design Director at Braun, Germany
– Bauhaus Archive established in Darmstadt, Germany
– Council of Design and Aesthetics of Industrial Production established, Poland

● 1963 ICOGRADA founded
– Archigram group and magazine *Archigram* founded, London

● 1964 Terence Conran's first Habitat shop opened, London
● 1965 Kilkenny Design Workshops founded, Ireland

● 1966 Robert Venturi's *Complexity and Contradiction in Modern Architecture* published, USA
– Superstudio and Archizoom groups founded, Italy
– *Ottagono* design periodical launched, Italy

● 1968 Hochschule für Gestaltung, Ulm, closed
● 1969 Centre de Création Industrielle founded, Paris, France
– JIDPO established, Japan

● 1971 Victor Papanek's *Design for the Real World* published, USA and elsewhere

● 1961 First manned spacecraft orbits the earth, USSR
– Construction of Berlin Wall

● 1963 Betty Friedan's *The Feminine Mystique* published

● 1964 Tokyo Olympic Games
● 1965 Ralph Nader's *Unsafe at Any Speed* published

● 1967 Arab-Israeli Six Day War

● 1968 Student unrest, Paris and elsewhere
● 1969 Apollo 11 and 12 (USA) and man's first moon walks
– First flight by Anglo-French supersonic airliner, Concorde
– Woodstock music festival, USA

	1972	1974	1976	1978	1980
Design	● 1972 *Italy: the New Domestic Landscape* exhibition, MOMA, New York	● 1975 Conseil Supérieur de la Création Esthetique Industrielle established, France	● 1976 ICSID 'Design for Need' Conference, London – Studio Alchymia founded, Milan, Italy ● 1977 Charles Jencks's *The Language of Post-Modern Architecture* – Centre Georges Pompidou opened, Paris, France – Danish Design Council established – Design History Society founded, Britain	● 1979 Ergonomi Design Gruppen founded, Sweden – Taiwan Design Promotion Centre established	● 1981 Japan Design Foundation established – Giugaro Design consultancy founded, Italy – Memphis Design group formed, Milan, Italy
Industry/Design					
Other	● 1973 American forces withdraw from Vietnam – International oil crisis – Eugene Schumacher's *Small is Beautiful* published	● 1975 Death of Franco, Spain			● 1980 Second oil crisis

 1982 **1984** **1986** **1988** **1990** **1992**

● 1982 Domus
Academy founded,
Milan, Italy
● 1983 Osaka
International Design
Festival established
on biennial basis,
Japan

● 1984 *Design
Issues* journal
founded, USA
– Salón
Internacional de
Disegno del
Equipamiento para
el Habitat (SIDI)
established, Spain
● 1985 Plan Créatif
consultancy
founded, France

● 1986 GD 'Good
Design' Mark
instituted, Korea

● 1988 *Journal of
Design History*
founded, Britain
● 1989 Design
Museum founded,
London

● 1992
International
Design Centre
established,
Nagoya, Japan
● 1994 Design
Council
reorganized,
Britain
– Design Centre,
London, and
regional offices of
Design Council
closed, Britain

● 1982 Swid-
Powell tableware
company founded,
USA
● 1983 Alessi
Officina research
and experimental
division established,
Italy

● 1982 Falklands
War
● 1983 Compact
disc is launched

● 1984 Apple
Macintosh PCs
marketed

● 1989 Demolition
of Berlin War and
demise of Eastern
– European
communist regimes.

● 1990
Reunification of
Germany
● 1991 Gulf War
– Start of civil war,
Yugoslavia
– Collapse of
Communist regime
USSR

Index

Oxford History of Art

Titles in the Oxford History of Art series are up-to-date, fully illustrated introductions to a wide variety of subjects written by leading experts in their field. They will appear regularly, building into an interlocking and comprehensive series. In the list below, published titles appear in bold.

WESTERN ART

Archaic and Classical Greek Art
Robin Osborne

Classical Art From Greece to Rome
Mary Beard & John Henderson

Imperial Rome and Christian Triumph
Jas Elsner

Early Medieval Art
Lawrence Nees

Medieval Art
Veronica Sekules

Art in Renaissance Italy
Evelyn Welch

Northern European Art
Susie Nash

Early Modern Art
Nigel Llewellyn

Art in Europe 1700–1830
Matthew Craske

Modern Art 1851–1929
Richard Brettell

After Modern Art 1945–2000
David Hopkins

Contemporary Art

WESTERN ARCHITECTURE

Greek Architecture
David Small

Roman Architecture
Janet Delaine

Early Medieval Architecture
Roger Stalley

Medieval Architecture
Nicola Coldstream

Renaissance Architecture
Christy Anderson

Baroque and Rococo Architecture
Hilary Ballon

European Architecture 1750–1890
Barry Bergdoll

Modern Architecture
Alan Colquhoun

Contemporary Architecture
Anthony Vidler

Architecture in the United States
Dell Upton

WORLD ART

Aegean Art and Architecture
Donald Preziosi & Louise Hitchcock

Early Art and Architecture of Africa
Peter Garlake

African Art
John Picton

Contemporary African Art
Olu Oguibe

African-American Art
Sharon F. Patton

Nineteenth-Century American Art
Barbara Groseclose

Twentieth-Century American Art
Erika Doss

Australian Art
Andrew Sayers

Byzantine Art
Robin Cormack

Art in China
Craig Clunas

East European Art
Jeremy Howard

Ancient Egyptian Art
Marianne Eaton-Krauss

Indian Art
Partha Mitter

Islamic Art
Irene Bierman

Japanese Art
Karen Brock

Melanesian Art
Michael O'Hanlon

Mesoamerican Art
Cecelia Klein

Native North American Art
Janet Berlo & Ruth Phillips

Polynesian and Micronesian Art
Adrienne Kaeppler

South-East Asian Art
John Guy

Latin American Art

WESTERN DESIGN

Twentieth-Century Design
Jonathan Woodham

American Design
Jeffrey Meikle

Nineteenth-Century Design
Gillian Naylor

Fashion
Christopher Breward

PHOTOGRAPHY

The Photograph
Graham Clarke

American Photography
Miles Orvell

Contemporary Photography

WESTERN SCULPTURE

Sculpture 1900–1945
Penelope Curtis

Sculpture Since 1945
Andrew Causey

THEMES AND GENRES

Landscape and Western Art
Malcolm Andrews

Portraiture
Shearer West

Eroticism and Art
Alyce Mahon

Beauty and Art
Elizabeth Prettejohn

Women in Art

REFERENCE BOOKS

The Art of Art History: A Critical Anthology
Donald Preziosi (ed.)